Advances in Paleoimaging

Advances in Paleoimaging

Applications for Paleoanthropology, Bioarchaeology, Forensics, and Cultural Artifacts

To Paul, Tina, Jack & Bean, with Big Love! Dad

Ronald G. Beckett and Gerald J. Conlogue

CRC Press
Taylor & Francis Group
Boca Raton London New York

CRC Press is an imprint of the
Taylor & Francis Group, an **informa** business

First edition published 2020
by CRC Press
6000 Broken Sound Parkway NW, Suite 300, Boca Raton, FL 33487-2742

and by CRC Press
2 Park Square, Milton Park, Abingdon, Oxon, OX14 4RN

© 2021 by Taylor & Francis Group, LLC

CRC Press is an imprint of Taylor & Francis Group, LLC

ISBN: 978-1-138-70359-9 (hbk)
ISBN: 978-1-315-20308-9 (ebk)

Typeset in Minion
by Deanta Global Publishing Services, Chennai, India

Gerald J. Conlogue

It has been almost a decade since the first book, Paleoimaging: Field Applications for Cultural Remains and Artifacts (CRC Press, 2010), was published. At that time, I recognized the radiographers who were not only my teachers but also role models. Of course, I continue to dedicate this work to those individuals and all radiographers, but for this edition I'd like to include the application specialist, David Bugg, and service engineers, Bob Kowalski and Bob French, who made it possible for me to attempt to master the Toshiba Aquilion® unit.

The decision to not only revise but also expand the content required reverting to lessons learned from very demanding and respected past mentors and professors. Therefore, to Lawrence R. Penner, Harvey Levine, Michael Adess, William J. Foreyt, Kenneth Kardong, E. Leon Kier, and John Ogden.

I'd like to repeat my dedication to my son, Byron, his wife, Nicole, and my son, Michael, for their encouragement and continuing acceptance of my eccentricities. To my daughter, Keanau, who has also demonstrated tolerance over the years, and to her husband, Kevo, and my grandson, Deion. Finally, to my wife, Shar Walbaum, for her support in every endeavor and adventure I've undertaken. Without her initial encouragement and inspiration, I never would have embarked on the path that has led me to the submission of this manuscript.

Ronald G. Beckett

As with the first edition, this book is dedicated not only to those many individuals who have helped me to develop my endoscopic and scientific skills, but also to those who have enhanced my understanding of pathophysiology among the living. LeRoy Johansen, Steven McPherson, Bud Spearman, Robert Kaczmarek, Dean Hess, and Harold McAlpine, who collectively taught me how to be a respiratory therapist and to never be satisfied with the status quo, and provided a model to follow in research and scholarly work. To Drs. William Ludt and Michael McNamee, who consistently challenged my understanding of clinical medicine and disease states and encouraged me to know more.

To Ralph "Buster" Beckett, whose early twentieth century work in agricultural research sparked my desire to understand the world around me. To my parents, Howard and Terry Beckett, who taught and encouraged me to "play in the sand," no matter how old I was. To my sons, Matthew, Paul, stepson, James, and daughter, Julie, who have always been supportive of my interests and efforts and from whom I continue to learn so much. And to my wife, Katherine Harper-Beckett, who has supported so many projects and helped me find ways to get things done. Katherine has held me up on so many occasions with her quiet strength and sincere belief in me, and without her support my efforts would be less than complete.

Contents

APPENDICES

Foreword

Ron Beckett and Jerry Conlogue have assembled *the* authoritative and comprehensive treatment of the field of paleoimaging. This book is the culmination of two careers in the world of clinical imaging, with all that expertise creatively and critically applied to the paleoimaging world. This volume is firmly grounded in the basics. "The basics" including everything from the fundamentals of X-radiation, to the "how to's" of radiography in the field, to strategies for the most effective operation of sophisticated computed tomography (CT) scanners. The worlds of industrial and medical imaging are evolving at "light speed" and that evolution is well captured here in the chapters that discuss the different forms of computed tomography, digital radiography, and magnetic resonance imaging (MRI). But we are also reminded that advanced digital infrastructure is not available everywhere, so the plane radiography chapter includes an extensive discussion of the use of film and the contrast media chapter includes specimens prepared decades ago, making techniques developed before the personal computer relevant to today's paleoimagers.

I have been fortunate to work with Ron and Jerry for over 20 years and I have witnessed the incorporation of cutting-edge technology into a well-grounded approach to paleoimaging that can get the job done anywhere. I have seen darkrooms set up in bathrooms, closets, and snap-together tents. The technology changed in 2013, when I joined Beckett, Conlogue, and other colleagues in Quito, Ecuador, to study a collection of mummy bundles originally from Peru. That project was a microcosm of this volume, starting with photography, endoscopy, and plane radiography and then, on a return visit, incorporating CT of a select sample of mummies. Here the plane radiography was done using computed radiography (CR) technology instead of traditional film, which greatly increased our efficiency, allowing us to shoot 37 bundles in a week. Since then, Beckett and Conlogue have moved to digital radiography (DR) technology and their efficiency is even greater.

The example of the project in Quito illustrates an important factor that is also a key organizing principle of this volume—*strategy*. In Quito, we each had specific tasks and were able to process the mummy bundles quickly and efficiently. Chapter 9 of this edition is about the development of specific strategies for different paleoimaging projects. This approach reflects the years of Beckett and Conlogue's experience in the imaging suite, in the lab, in museums, and in remote field sites where the lack of planning can lead to the failure of a project.

Another organizing philosophy that underlies this volume is *teamwork*. Ron and Jerry have fostered a wide and varied network of relationships with students and scholars, with specialists from the clinical realm and those from the bioarchaeological realm, and with people from academia and the general public. That is because everything that they do has the highest integrity, they incorporate others into high-functioning teams, and they are generous with their own talents and expertise. The contributors to chapters in this volume include many members of that network and the richness of the chapters that arise from this collaboration reflects the unique expertise that each contributor brings to the table. This network also features strongly in the collaborative approach to the interpretation of paleoimages, which is encapsulated in the phrase "diagnosis by consensus" (Beckett 2017; Wade et al. 2019).

One very exciting feature of this volume is the separate volume *Case Studies for Advances in Paleoimaging and Other Non-Clinical Applications*. The breadth of the case studies is remarkable and, once again, it reflects the rich and diverse experience that Ron and Jerry have accumulated over the past decades. There are mummies and other paleoimaging subjects on every continent (save perhaps Antarctica), and these two scientists have seen a good portion of them. These cases bring the discussion of strategies and techniques vividly to light and they give the reader a view into the amazing experiences that Ron and Jerry have had as they travel the world, endoscope and X-ray machine in hand, willing to take on significant challenges with the goal of shedding new light on the past lives of people and their artifacts.

This volume, with its accompanying volume of case studies, will become the must-have reference set for anyone with an interest in paleoimaging—whether seeking to do it themselves or to better understand how an

imaging study has been done. This book is the distillation of encyclopedic knowledge of imaging in general, of interesting and unusual applications, and of great talents in the areas of flexibility and adaptability. The breadth of applications will be relevant to interested parties well beyond bioarchaeology.

Andrew J. Nelson, Professor, Archaeology/ Bioarchaeology, Department of Anthropology, Western University, London, Ontario, Canada

References

1. Beckett, R.G. 2017. Digital data recording and interpretational standards in mummy science. *International Journal of Paleopathology* 19: 135–141.
2. Wade, A.D., Beckett, R.G., Conlogue, G.J., Garvin, G.J., Saleem, S.N., Natale, G., Caramella, D., Nelson, A.J. 2019. Diagnosis by consensus: A case study in the importance of interdisciplinary interpretation of mummified pathological conditions. *International Journal of Paleopathology* 24: 144–153.

Preface

Medical and industrial imaging methods have become powerful tools in both the documentation and data collection procedures found in many non-traditional settings. In this book, two of the most preeminent experts in the field serve as volume editors, providing an in-depth examination of the current and growing range of imaging tools and techniques currently available on the market. These editors and their contributing authors—top practitioners in the field—explain how these techniques can be applied to all aspects of forensic and archaeological analysis. In addition to providing useful data for analysis, these powerful tools have the added benefit of being non-destructive, thereby preserving the remains or artifacts for future analysis with yet-to-be-developed technologies. The authors began this work to provide a basis for understanding the application of various imaging modalities in archaeological, anthropological, bio-anthropological, and forensic settings. Filled with over 350 images, the writing draws on the editors' global experience in the paleoimaging of cultural remains and artifacts, offering a view of the diverse environments in which field paleoimaging is conducted. The book will be an essential reference for conservators, museum archivists, forensic anthropologists, paleopathologists, archaeologists, and anyone looking to gather imaging information and perform non-destructive research on historical or culturally significant artifacts or remains, or in the process of a forensic investigation.

Acknowledgments

All paleoimaging work is teamwork. We have been fortunate to have been invited to collaborate on a great many research endeavors around the globe. We need to acknowledge many researchers and colleagues from whom we have learned so very much about the exciting "time travel" we all get to experience through our common interests.

Yvette Bailey, MD
Jelena Bekvalac
Nicholas Bellantoni
Dario Piombino-Mascali
Jeff Sorobello
Larry Pernick
Jane Buikstra
Maureen Daros
George Grigonis
Hanna Polasky
Emad Hamid, MD
Anthony Fishetti, DVM
Victoria McCoy
Dick Horn
David Hunt
Lorna Tilley

Joe Mullins
Paul Nader, DVM
Warren Raymond
Eddy Rosenblatt, MD
Andrea Gernon
Andrew Wade
Anna Dhody
Josh Berstein
Bruce Kaiser, PhD
Bob Brier
Roger Colton
Janet Monge
Sonia Guillen
Bernardo Ariaza
Ripley's Believe it or Not®
Bruker
Mütter Museum
National Geographic Channel USA
National Geographic Channel International
National Geographic Society
Paleopathology Association
Yale Peabody Museum of Natural History
Rosicrucian Egyptian Museum

Contributors

James Adams, DO
Kirksville College of Osteopathic Medicine
Kirksville, Missouri

Kyler Douglas, BS
Kirksville College of Osteopathic Medicine
Kirksville, Missouri

Alicia Giaimo, MBA-HCM, MHS, RT(R)(M)(BD), ARRT
Radiologic Sciences Program
Department of Diagnostic Imaging, Quinnipiac University
Hamden, Connecticut

Ramón Gonzalez, MD
Department of Radiology and Biomedical Imaging
School of Medicine, Yale University
New Haven, Connecticut

William Hennessy, MHS, RT(R)(M)(QM), ARRT
Department of Radiologic Sciences
Quinnipiac University
Hamden, Connecticut

Robert Lombarbo, BSRT(R), ARRT
Adjunct Faculty
Diagnostic Imaging Program Quinnipiac University
Hamden, Connecticut

and

Office of the Chief Medical Examiner for the State of Connecticut
Farmington, Connecticut

Alan G. Lurie, DDS, PhD
Department of Oral Health and Diagnostic Sciences
University of Connecticut School of Dental Medicine
Farmington, Connecticut

Andrew J. Nelson, PhD
Department of Anthropology and Chemistry
University of Western Ontario
London, Canada

and

Royal Ontario Museum
Toronto, Canada

John Posh, RT(R)(MR)
Metrasens
Lisle, Illinois

Fátima Alba Rendón-Huerta
Guanajuato City, Mexico

Sahar N. Saleem, MBBCH, MSc, MD
Department of Radiology—Kasr Al Ainy Faculty of Medicine
Cairo University
Cairo, Egypt

Solomon Segal, MD
Kirksville College of Osteopathic Medicine
Kirksville, Missouri

Mark Viner, FCR, MSc, HDCR(R), DipFMS, DipFHID, MCSFS
Cranfield Forensic Institute
Defence Academy of the United Kingdom
Shrivenham, United Kingdom

and

Barts and The London School of Medicine and Dentistry
Queen Mary University
London, United Kingdom

Michael J. Wright
Director – Vestigium Lux S.A de C.V
Guanajuato City, Mexico

Bruce Young, PhD
Department of Anatomy
Kirksville College of Osteopathic Medicine
Kirksville, Missouri

Péter Zádori, PhD, MD
Moritz Kaposi Teaching Hospital
Dr. József Baka Diagnostic, Radiation Oncology, Research and
 Teaching Center
Kaposvár, Hungary

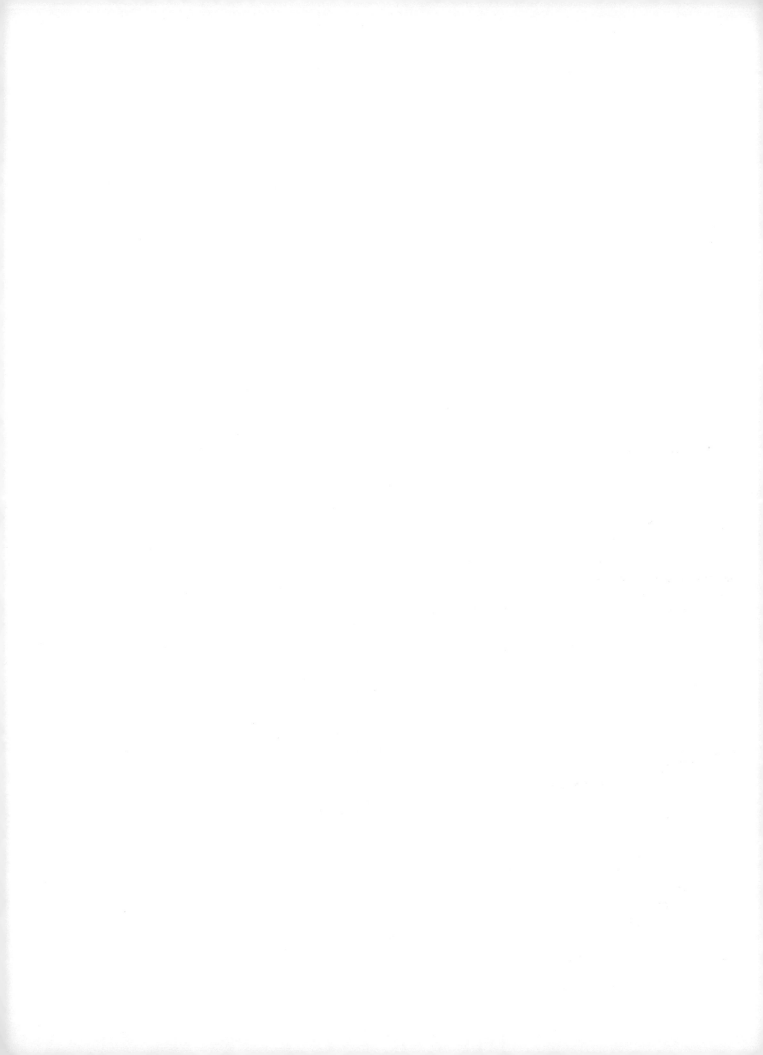

Photography Associated with Paleoimaging: With Notes on Videography, LiDAR, Ground Penetrating Radar, and 3D Surface Scanning

1

RONALD G. BECKETT, FÁTIMA ALBA RENDÓN-HUERTA, AND MICHAEL J. WRIGHT

Contents

Photography

Photography has had a close interwoven relationship to anthropology for many years. Ever since the inception of the field of anthropology as a science, photography has played a role. Photography 'demonstrated' what was being described in research reports and helped make findings concrete. Photography in anthropology has evolved into a subspecialty within the broader context of the field. Debates continue on whether a professional, trained in the skills and art of photography, should be employed in field studies or rather if photographs taken by other experts can suffice.

Photography tries to capture on film two major aspects of a field research study. One is to provide, via the photograph, evidence and documentation of the research and context as it relates to the specific objectives. The second is to try to capture the 'experience' of the field study and its subjects. It is the intent of photographic documentation to objectify that which is being observed. In doing so, photography documents the experience as well as the subject matter. It is difficult to see a photograph of an elaborate tomb with ample grave goods and a mummified human being and not have an emotional experiential response. We are all only human after all.

It is not the intent of this chapter to debate or describe the role of photography in the broader anthropological or archaeological context, but rather to describe its role as an adjunct to paleoimaging. The use of photography as an adjunct to paleoimaging is less concerned with its place in visual anthropology and more focused on evidentiary documentation of subject, context, procedure, and field adaptation or modifications. The intent is to provide a more objective application rather than using it as a tool to elicit some type of deep human response. With that said, photography as one of the multimodal tools in paleoimaging not only provides scientific documentation but may also produce images that can move the heart as well. Although the ideal would be to have a professional photographer who also possesses skills in anthropology as a paleoimaging team member, this is not always feasible. Typically, the paleoimagers themselves act as the project photographers. Photography, in most scientific fields, is usually considered as an artistic discipline—as if art did not imply rigorous methodologies or technical explorations. Rather, photography is a conceptual vehicle for global comprehension of fieldwork and for the measurement and control of the variables around archaeological finds or museum pieces.

With the advent of digital photography, images can be reviewed, discarded, re-shot, cropped, and stored in a very short period of time. A basic knowledge of photographic variables and their manipulation to maximize data collection is required.

Photography in paleoimaging is grounded in the forensics approach of evidence collection. The photograph should be objective, not staged, and honest. Each photograph should contain an image with and then without a scale. Photography should be objective-driven and the photographic images should be utilized in the daily review of data. Radiographic, endoscopic, observational, and photographic data will all, in their own way, contribute to the case at hand. The photographic record

1

can be used to justify a novel approach to problem solving in the field and visually explain abstract situational variables or contextual settings. Furthermore, the paleophotographer has to self-question how photographs support the research and all the members of a professional team involved in a project. The photographs invite them to observe the subject with different perspectives for professional empathy and complementarity. The photograph further serves to present research project data to other professionals who could not be in the field. In this way, additional professional input may be acquired through examination of the photographic image. The electronic age has made this an even greater possibility. Messaging or emailing a photograph to a colleague far away during the course of the study can provide instructive feedback as to what additional data need to be collected while the team is still on site.

While the photographic data should be collected with objectivity in mind, the area of anthropological research is filled with images that may serve to describe the human species' journey on this planet. Objective-based photographs have the potential to evoke an emotional response. Consider the radiographic image of the mummified remains of an infant under study by a team of anthropologists and paleoimagers (Figure 1.1). Photographs of this type document study activities while at the same time serve to record and describe the culture of science. Another observer may see the photograph of the busy research team as an invasion of the sanctity of the dead. One picture speaks a thousand words and may evoke as many human responses as well.

The basic intent of paleophotography in support of paleoimaging projects is not to manipulate study environments or create works of art, but some essential photographic approaches are helpful in gathering the appropriate objective-based images. These images exist to authenticate objects, to provide evidence regarding conservation efforts and deterioration, to act as surrogate collections for research duties, to amass documentary evidence, or as potential objects of art, all to inform science or technology with essential didactic purposes.

The first approach is that of standard photography using ambient lighting. The standard photograph records what is there and at times captures important features that the observer may have missed during direct observational methods. As an example, using standard photography in a case of a mummy prepared with an arsenic solution and using the forensic photography principle of documenting everything from every aspect, a photograph was taken of the posterior surface of the mummy under investigation. The photograph revealed parallel linear depressions on the buttocks of the mummy, suggesting that in this case the mummy was prepared or dried on a rack (Figure 1.2). The research team had examined this mummy several times prior to this investigation and yet it was the photograph that 'saw' what was not observed.

Filtered photography can be very useful as well. Filtered photography as a documentary tool to image cultural modifications such as tattoos will better differentiate the target from the background. While many

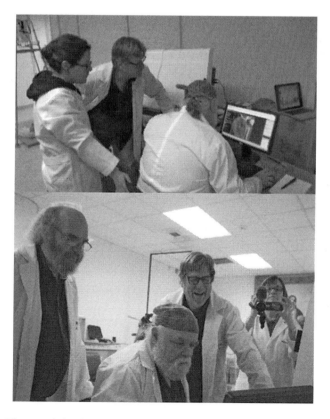

Figure 1.1 Photography used to capture the 'culture' of research in action.

Figure 1.2 A photograph of the underside of a mummy known as 'Sylvester' demonstrated several impressions (arrows) indicating that this mummy was likely placed on a drying rack during the mummification process.

filters exist and their applications are well beyond the scope of this text, infrared filtering in photography is quite useful in bringing out a tattooed image from the surrounding skin, whereas ultraviolet light may help differentiate among tissue types or surface structures not discernible to the naked eye.

Lighting is an important aspect of photography. While most photography used in support of paleoimaging projects employ ambient light, additional lighting may be required. When additional lighting is used it should be staged to reduce any shadowing or overdramatizing of the setting. Another useful lighting technique in support of paleoimaging projects is that of raking the light over the subject. Because of the behavior of light, raking can often improve the observer's understanding of the textures on the surface of the subject (Figure 1.3).

As stated, the use of photography associated with paleoimaging projects should be objective-based. While not limited to these objectives, photography should include the following traits as a minimum:

1) The subject(s)—The subject should be photo documented from every angle possible without harming the subject. The varied views of the subject(s) provide paleoimagers with additional information from which to develop approaches to the imaging tasks at hand. The initial photographs are intended to be a general survey of the subject(s). However, if a particular entrance route for the endoscopic procedure is seen, for example, it can be documented using an appropriate photographic technique, such as macro photography. Later in the study, a more scientific or forensic approach will be used.
2) The context—The context of the imaging study should be photo documented. In addition to the physical conditions of the study environment, the cultural and physical context of the regional area often supports the understanding of the paleoimaging data collected. For example, in a large population, paleoimaging study findings indicate that there are a lot of healed fractures that are typically associated with falls. It would be critical that the terrain surrounding the burial area or near the archaeological context associated with the burials be photo documented as the photographs inform the paleoimaging interpreters about the possible nature and cause of the fracture patterns being disclosed by the radiographs.

The general environment associated with the study at hand should be photographed with respect to those environmental features that may impact the work to be done. In addition, the context from where the cultural remains or artifacts came is critical as it may assist in the interpretation of paleoimaging data. The environmental conditions may help to explain taphonomic characteristics of the cultural remains as artifacts, as well as human and animal remains, continue to interact with their environment over time (Aufderheide, 2003). These photographs may include documentation of nearby waterways, urban sprawl, evidence of flood plains, landslides or cave ins, and documentation of current climatic characteristics to name a few. Photographs of where the cultural material was found is also critical, as often a microclimate exists that can further explain the condition of the remains or artifacts. These photographs may include tombs, a cliffside, or other burial aspects, such as wrappings and enclosures that may have impacted mummification or the state of preservation of the remains. If radiographic or endoscopic images are later transported to specialists in other countries, photographs of the regional environmental conditions and the specific burial sites may be critical in interpreting what is seen on the paleoimaging data.

3) Work environment/conditions—Of equal importance is the photographic documentation of the specific paleoimaging environment, exactly where the work is to be conducted. On many occasions, field paleoimaging is conducted in very tight settings, such as in caves, tombs, and remote research facilities. Photographic documentation of these variables not only provides a record of the working conditions but

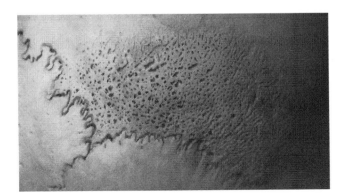

Figure 1.3 A photograph demonstrating the lighting technique known as 'raking,' which accentuated the target observation. Additionally, macro photography contributed to the detail of the target anomaly.

may also assist future researchers who are planning a field paleoimaging project in the same or a similar environment. Photographic documentation of how logistical challenges were resolved is also useful information to future research teams. Any feature of the environmental setting that may pose a safety risk should be photographed as well. Paths, walkways, stairs, ladders, streams, electrical supply outlets, and generators are just a few examples of what should be photographed in order to document the challenges and adaptations used to get the paleoimaging project underway.

4) Technology and technique—Field conditions often present the paleoimaging team with unique challenges regarding the application of the imaging instrumentation. Specific ways in which field problems are solved with regards to the set up and application of imaging modalities should be documented in order to provide future researchers with ideas on how to solve complex technological problems in the field. Photography in association with radiographic paleoimaging should include photo documentation of the available utilities, the X-ray tube support system, the image receptor support system, the exam 'table' as the subjects are radiographed, and a photograph from the perspective of the X-ray tube projection angle. This tube perspective photograph helps those who are not familiar with reading radiographic images to gain a sense of orientation using the photograph of the part of the subject's anatomy as a guide to understanding the X-ray image. Photography in association with endoscopic paleoimaging should include photographic documentation of the technical set up and instrumentation. Of great importance is a photograph of each entry point used to introduce the endoscope. These entrance points should be photographed with scale. If an artificial opening is made to provide access to the internal cavities, before and after procedure photographs must be taken to document the changes to the subject. Any unique instrumentation should be photo documented as well as any new or innovative technique. If a biopsy procedure is conducted, photographs of the sample need to be taken with scale to document the approximate size of the sample. The labeled container holding the biopsy material too should be photo documented, creating a chain of evidence.

5) Macro photography of specific targets—As the study or subject dictates, close-up photography should be conducted (see Figure 1.3). This may be required for a variety of reasons. Impressions from wrapping textiles present on the skin, anomalous findings such as tattoos, apparent entry wounds, burns or fractures, are all examples of when macro photography should be employed. Also, should any damage to the subject occur during the course of the study, photo documentation should be made.

6) Before and after—Each subject involved in the study should have before- and after-study photographs taken. These photographs will serve to document the condition of the study subject and to assure that no damage was done in the course of the paleoimaging project. Time stamping the photographs is important as well.

 a. Before and after: Case study—While we were researching the collection of medical mummies in Modena, Italy, on display were two preserved full human integumentary systems. During our paleoimaging study, the museum curator accused our team of causing cracks in one of the specimens. Fortunately, our team included a professional photographer who was able to produce a time-stamped digital photograph of the subject in question and document that the cracks were there before our paleoimaging study began (Figure 1.4). The curator was satisfied with this evidence and withdrew his accusation.

A critical aspect of the photographer's roll is for the image capture process to be informed by publication imaging integrity and standards. One critical aspect of such standards is to assure that the photographer reports all technical settings, lighting used, special techniques, software details, and an accurate documentation of any post-processing applied to a given image. The chronology and location of image acquisition should be reported reserving alternate location images for comparison purposes only. Post-processing of an image requires special attention in that contrast and brightness manipulation should not be used to cause data to 'disappear.' In some situations, such manipulations may be required to highlight or accentuate critical features not clearly visible on the original image. In these cases, the original must be presented along with the manipulated image, demonstrating the justification for such manipulations as related to the study objectives. Post-processing manipulations must always be justified and reported. Post-processing is a critical concern when dealing with

Figure 1.4 A photograph taken before paleoimaging examination verifying the condition of the subject prior to the study.

images captured from advanced paleoimaging methods such as digital radiography, computed radiography, and magnetic resonance, and will be discussed in the appropriate chapters of this text.

The manipulation of images using image-processing software can in fact be a form of intentional or unintentional scientific misconduct. Because of this potential, most professional publications have drafted strict guidelines for the acquisition and publication of images. Not understanding how the data acquisition and analysis software work and not reporting any manipulations can easily lead to unintended interpretations. Examples of such guidelines are provided to authors from most scientific journals. An excellent example of these guidelines can be found at the following website https://www.nature.com/authors/policies/image.html. Referring to these guidelines for image acquisition and reporting helps to maintain the ethical integrity of a given study and supports the argument for having a professional photographer familiar with such requirements as a member of the research team.

Videography

Video documentation of procedures and workflow has been increasingly utilized in bioarchaeological field studies. Video documentation has the advantage of capturing the research in process and may assure ethical practice. Digital video formats have allowed researchers in the field to collaborate in real time with other researchers across the globe. Smart phones, computer cameras, hand-held cameras, GoPro®-type devices, as well as high-end professional video instrumentation have all become commonplace in the field.

The value added to the research efforts of a given project is that the video record allows the researchers to review when and what was done as well as the conditions. The videos can also be used to critique how the work was accomplished in terms of efficiency. Basically, the video provides an additional perspective to the still photography in terms of documenting the subject, context, technology application, targeted documentation, and care in handling the subjects. Video has the advantage of producing real-time audio commentary associated with the image, allowing for a valid record of research-in-motion.

While paleoimaging research is often focused on specific biological questions, such as sex, age at death, paleopathology, funerary practices, and so on, videography contributes to yet an additional layer of depth in a given research setting by providing data for visual anthropological analysis. Any given research project has a mini-culture related to the context, the individuals involved, the subjects, and the many contributors from the broader current culture. This allows researchers to frame additional research questions targeting the research 'experience' itself.

Visual anthropology is the collection of anthropological and ethnographical data representing communication-in-context while studying perception and significance. Visual anthropology research uses images for the description, analysis, communication, and interpretation of human behavior (Edwards, 1992). It encompasses the use of still photography, film, video, and non-camera-generated images, in the recording of ethnographic, archaeological, and other anthropological contexts. In the case of paleoimaging field research, visual anthropology contributes to understanding the culture of the research experience and how it can be visually interpreted and expressed (Collier and Collier, 1986). These images become artifacts of the paleoimaging research culture while further documenting the nature of the remains and associated artifacts.

While qualitative in nature, analysis can produce quantitative research questions as well. For example, initial videography can be used to review methods and practices with an eye toward the examination of work efficiency and team interactions. Modifications to 'work' can be hypothesized, put into practice, and evaluated in

terms of outcomes and efficiency, thus contributing to the overall current and future research efforts.

In one such case, our team was researching 38 mummy bundles from the Maranga culture at the Museo Jacinto Jijón y Caamaño in Quito, Ecuador. The team was multidisciplinary and included two bioarchaeologists, two paleoimagers (computed radiography and endoscopy), and two documentarians (still photography and videography). The research plan included four distinct stations with the intent of establishing an efficient work-flow pattern (Figure 1.5). After reviewing the video documentation at the end of the first day, modifications to the flow were deemed necessary to avoid down time for any of the four stations. The changes resulted in greater efficiency and use of time and space.

Videography also contributes to knowledge mobilization. Videographs can provide documentation of active research for educational purposes, future research approaches, and museum display presentations as well as public media dissemination. Videography is a valued addition to the paleoimaging research process and complements the field photography efforts.

Light Detection and Ranging (LiDAR)

Images from photographic 'drones' are being converted to topographical and photogrammetry data in order to construct 3D models of an archaeological area. Satellite documentation adds additional data from a variety of light-detecting and sensing technologies that go beyond the visible spectrum (Rowlands and Sarris, 2006; Lasaponara and Masini, 2011; Chase et al, 2011; Corns and Shaw, 2009). Light detection and ranging, or

LiDAR, instrumentation includes a laser, a special GPS receiver, and a scanner, which are typically attached to an airplane or helicopter for use over a wide area. LiDAR is a remote sensing method that uses light to measure distances to Earth. These distances vary according to the topography and structure on the surface. The light is a pulsated laser. These pulses can be used to produce exact data about the characteristics of Earth's surface.

Primarily used in archaeology to locate otherwise unseen sites of archaeological interest, LiDAR is included in the arsenal of paleoimaging methods since it creates an image of past cultural centers associated with cultural remains and artifacts.

The principle of operation of LiDAR devices is straightforward and is based on the principle of light reflection. The laser uses rapid pulses of laser light at a surface, some at up to 150,000 pulses per second. A sensor then measures the time it takes for each pulse to reflect back. Given that the speed of light is a constant and known, the LiDAR instrument can then calculate the distance between itself and the surface. (Figure 1.6). The basic conceptual formula for the principle of operation is Distance = (Speed of Light × Time of Flight)/2. The accuracy is very high. Using different wavelengths, features such as tree canopies can be factored out of the image, resulting in a 'scan' or complex map of the underlying surface (Figure 1.7). It is important to recall that LiDAR does not penetrate the surface but only scans what is on the surface.

LiDAR has made great contributions to the discovery of new or suspected sites of archaeological interest. Given its use in archaeology regarding the location of otherwise unseen sites, LiDAR is included in the arsenal of paleoimaging methods, since it locates and creates an

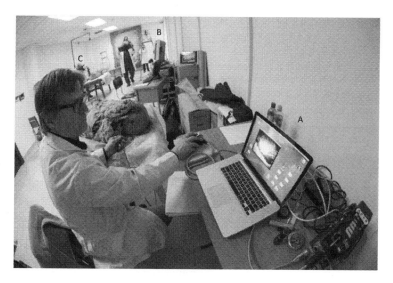

Figure 1.5 A photograph showing the workflow of a study in Quito, Ecuador. Stations shown are endoscopy (A), radiography (B), and anthropometry/archaeometry (C). The image also captures the 'culture' of research in action.

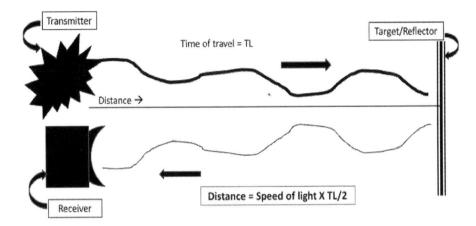

Figure 1.6 Laser light of specific wavelengths is transmitted to a target structure with the reflected beam returning to the receiver. The distance to the object from the transmitter can then be calculated.

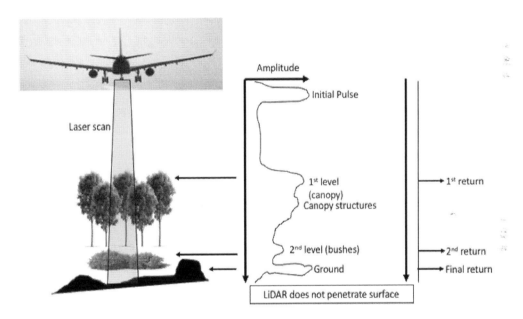

Figure 1.7 LiDAR suspended from an aircraft creates signal return at each level of reflection. In this example, levels 1 and 2 are factored out, leaving only the 'image' of the surface demonstrating contours and structures, if any.

image of past cultural centers, road systems, and structures associated with water mobilization, which are then associated with the cultural remains and artifacts of a given study.

Ground Penetrating Radar

LiDAR assists in locating objects on the large scale such as surface and some subsurface structures, roads, and so on. Another tool, ground penetrating radar (GPR), has been used to assist in locating and imaging subsurface features within the bioarchaeological construct (Zhao et al, 2013). The principle of operation is conceptually the same as LiDAR, except GPR uses radio waves rather than light waves. The radio waves are in the microwave band (UHF/VHF frequencies) of the radio spectrum. The radio waves penetrate the earth's surface and a receiver determines how long it took that sound wave to return, indicating structural variations below the surface. Subsurface structures and stratigraphy cause reflections that are picked up by the receiver. Data may be plotted as profiles, as plan-view maps isolating specific depths, or as 3D models. Some of the uses in the bioarchaeological field are the location and characteristics of subterranean structures, tombs, and burials.

While GPR has proven to be useful, the method has a variety of limitations. Generally, in bioarchaeology settings, low-frequency antennas are used. One of the greatest limitations to the utility of GPR is when

the subterranean environment has a highly 'reflective' make up. Moisture or wet soil inhibits the effectiveness of GPR. Depth penetration may also be a limiting factor. GPR has good penetration when there are dry sandy soils or massive dry materials like granite, limestone, and concrete. If there are moist or clay-like soils, penetration is limited. Additionally, sub-grade debris can reflect the radar signal minimizing depth penetration. Rocky or heterogeneous subsurface environments scatter the GPR signal, weakening the signal and thus decreasing the reliability of the findings. When using low-frequency GPR, the size of the target may limit its detection. Generally, the smaller the object, the more challenging it would be to identify. Since the images can be rendered in 3D, GPR can be a useful tool in the paleoimaging arsenal. With that said, the interpretation of the images can be very challenging and requires that the user possess a unique set of skills including archaeology, geophysics, geology, and statistical physics.

Those readers wanting to learn more about GPR are referred to the literature. A good starting point would be *Geoarchaeology and Archaeomineralogy* (Eds. R. I. Kostov, B. Gaydarska, M. Gurova). 2008. Proceedings of the International Conference, 29–30 October 2008 Sofia, Publishing House 'St. Ivan Rilski,' Sofia, 320–324.

3D Surface Scans

Another method of data collection can be found in 3D surface scanning. 3D surface scans provide a way for the researchers to create a 3D digital model (stereolithography) of a real object or environment. The scans allow for analysis of shape, appearance, and condition.

There are a variety of scanning devices ranging from simple hand-held units and mounted turntable units, to large environment scanners. Additionally, the technology varies, and each device has its own limitations. A device based on optical technologies will be challenged to image shiny, mirrored, or transparent objects, for example.

Collected 3D data is useful for a wide variety of applications in bioarchaeology. 3D laser surface scanning provides documentation of cultural remains and artifacts and assists in the preservation of museum collections. The data can be used to conduct facial reconstructions, approximate features of deceased individuals, and create 3D models of materials that can be used for student practice or display (Kuminsky and Gardiner, 2012). There is great value in 3D modeling in that many eyes can view the object, providing a more rigorous analysis and interpretation. Research potentials can be expanded by using the objects in either digital format or

as an actual model to pose and answer broader research questions. Given the potential for a virtual examination, there is great benefit in educational settings.

Summary

The relationship between photography and the documentation needs of paleoimaging research is clear. During a paleoimaging project, the photographer must be aware not only of what needs to be documented but also of when the documentation should take place. This knowledge comes only from ample fieldwork experience as a member of the paleoimaging team. We have used forensic photographers as well as professional photographers experienced in anthropological and archaeological settings as paleoimaging team members, with excellent results. New photographers or students may also function as the team photographer only if the team anthropologist, paleoimager, or seasoned fieldwork photographer properly mentors them. A key point of this chapter is that there must be a team member who is responsible for the photographic documentation needs of the team and associated project. Each team member has his or her own area of expertise. If the paleoradiographer or endoscopist also tries to serve as the team photographer, important information will potentially be missed. An individual dedicated to and skilled in photography will make critical contributions to the outcome of the paleoimaging research project.

References

Aufderheide, A.C. 2003. *The Scientific Study of Mummies.* Cambridge: Cambridge University Press.

Chase, A.F., Chase, D.Z., Weishampel, J.F., Drake, J.B., Shrestha, R.L., Slatton, K.C., Awe, J.J., and Carter, W.E. Airborne LiDAR archaeology, and the ancient Maya landscape at Coracol, Belize. *Journal of Archaeological Science.* 2011;38:328–398.

Collier, J., and Collier, M. 1986. *Visual Anthropology: Photography as a Research Method* (revised and expanded edition). Albuquerque, NM: University of New Mexico Press.

Corns, A., and Shaw, R. High resolution 3-dimensional documentation of archaeological monuments and landscapes using airborne LiDAR. *Journal of Cultural Heritage.* 2009;10:72–77.

Edwards, E. (ed.) 1992. *Anthropology and Photography*, 1860–1920. London: Royal Anthropological Institute.

Kuminsky, S., and Gardiner, M. Three-dimensional laser scanning; Potential uses for museum conservation and scientific research. *Journal of Archaeological Science.* 2012;39:2744–2751.

Lasaponara, R., Masini, N. Satellite remote sensing in archaeology: past, present and future perspective. *Journal of Archaeological Science*. 2011;38:1995–2002.

Rowlands, S., and Sarris, A. 2006. Detection of exposed and subsurface archaeological remains using multi-sensor remote sensing. *Journal of Archaeological Science*. 2006;34:795–803.

Zhao, W., Forte, E., Pipan, M., Tian, G. Ground penetrating radar (GPR) attribute analysis for archaeological prospection. *Journal of Applied Geophysics*. 2013;97:107–117.

https://www.nature.com/authors/policies/image.html

Endoscopy in Anthropological and Archaeological Applications

2

RONALD G. BECKETT

Contents

Description of Method and Rationale

Anthropological and archaeological research often relies on what can be seen using direct or macroscopic examination. This method is limited to what can be seen on the surface or through existing openings into the remains or objects. The direct observation approach does not inform researchers as to what lies below the surface or within remains or objects of interest. In the past, destructive approaches such as autopsies have allowed researchers access to internal environments (Aufderheide and Rodriguez-Martin, 1998). For the last two decades non-destructive methods of visual data collection have become methods of choice as they preserve the remains for future study and avoid ethical challenges. Endoscopy is a non-destructive approach that can gather images from within objects of interest, providing otherwise inaccessible data for interpretation and allowing for a more rigorous scientific study of past peoples and artifacts. While endoscopy is invasive, when applied correctly it can be a powerful non-destructive method for data collection within the context of anthropological and archaeological research (Aufderheide 2003).

Endoscopy is a method that 'looks inside' bodies or objects. In medical practice, endoscopy is employed in a variety of medical procedures for both diagnostic and therapeutic purposes. The images allow access to and visualization of body organs or cavities with air space. The nature of the application of endoscopy is such that, unlike other imaging modalities, the instrument is passed directly into the target structure.

Endoscopy has been employed in bioarchaeological research to gather data from mummified and skeletal human remains, archaeological objects such as ceramics, and archaeological sites prior to excavation for a number of years. Endoscopy has a long history of application in anthropological and archaeological research settings. Its first use was soon after the development of the flexible fiber optic endoscopes (FFEs) in the1970s (Tapp et al.,1984; Beckett and Guillen 2000). More recently, an increased variety of applications for endoscopic technology have been realized. Endoscopy has been used to assist in data collection for a variety of anthropological research questions. Among these are assisting in the determination of age at the time of death (Duclos et al. 2000; Beckett et al. 1999a), imaging biomechanical stress (Bravo et al. 2003a,b), assessment of paleopathological conditions (Conlogue et al. 2008a; Beckett et al. 1999b; Beckett et al. 2003), analysis of burial practices and mummification technique (Nelson et al. 2007; Conlogue et al. 2008b; Beckett and Nelson 2015; Ordonez et al. 2015; Beckett et al. 2017), dentition analysis, and soft tissue or bone biopsy for histological and pathological determinations (Ventura et al. 2004). Additionally, biopsy or material collection for chemical analysis or radiocarbon dating, as well as artifact analysis of objects wrapped within mummy bundles, have been accomplished using endoscopy. Endoscopy has been used in extreme field settings and in pre-excavation tomb evaluation (Beckett

and Conlogue 2010). Endoscopy has also been used in conjunction with light reflectance/absorption methods (Beckett et al. 2007). Newer applications for endoscopy continue to be developed.

The major advantage of the endoscopic method lies in its flexibility and portability. Endoscopic instrumentation has a wide variety of technological variations that can be applied to unique settings. When used in conjunction with varied imaging technologies, the video endoscope (VE) has been able to assist with the collection of otherwise unavailable data. Because the endoscope is seeing 'what cannot be seen' within an enclosed body cavity or space, the method is best used in conjunction with other imaging modalities (Kim et al. 2006). In fieldwork, X-ray systems work well in concert with endoscopy (Beckett and Conlogue 1998). In laboratory settings, advanced imaging methods such as computed tomography (CT) scanning and fluoroscopy are complementary to endoscopic applications (Beckett and Conlogue 2010; Posh and Beckett 2000). Endoscopic images may alleviate the need to autopsy mummified human remains, which helps researchers maintain appropriate respect for the deceased while increasing our understanding of the path of human life on earth. The limitations of the method will be described later in this chapter.

Early in its application to bioanthropological studies, endoscopy was conducted using the medical model in that the remains were brought to the hospital, a target was determined by analysis of imaging data, and a biopsy was conducted or an artifact was retrieved. The major drawback to the medical model is that the remains require transportation, risking not only damage but also shifting of contents within the remains or within the wrappings, thus altering the internal spatial relationships, which in turn could lead to misinterpretation of collected data.

More recently, endoscopy has been employed in museums and in the field in remote research locations adopting the anthropological and archaeological model for data collection (Figure 2.1). Data has been collected on site at the point of excavation, which helps to maintain the original context of the discovery. Data collected in this fashion maintains the original position and spatial relationship of the information, which decreases the potential for misinterpretation. The techniques of endoscopy are minimally invasive and typically do not require openings to be made into the remains as such openings usually already exist. Using the anthropological and archaeological model, large sample sizes are researched, improving the interpretability and statistical power of the collected data. This is in stark contrast to the medical model, which cannot accomplish the same goals.

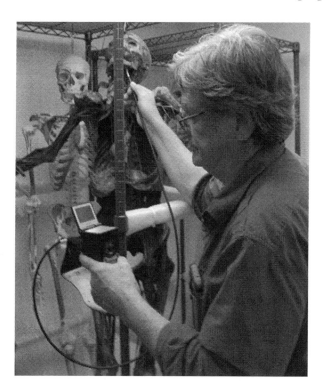

Figure 2.1 Portable flexible VE employed in a museum collections room setting.

It is the intent of this chapter to provide the reader with application guidelines regarding the use of endoscopy in anthropological and archaeological research. This section includes an examination of the technical aspects and principles of operation of endoscopic instrumentation, data collection, and recording methods, and an examination of the limitations of this method. Endoscopic applications to bioarchaeological research are presented in the companion case studies book by the same editors.

There are multiple technological variations that are important to consider regarding the use and limitations of this method. Of those, diameter of the insertion tube, lens variability, and portability are the greatest considerations. Both medical and industrial endoscopes have been used in research projects involving mummies, ancient artifacts, and archaeological excavations. Biopsies or artifact retrieval are often conducted with endoscopy. A more detailed description of this method can be found in *Paleoimaging: Field Applications for Cultural Remains and Artifacts*, by Beckett and Conlogue, CRC Press, 2010.

Instrumentation

Endoscopy can be described as looking inside an object, person, or an animal with a tool designed to provide direct visualization of a target object or cavity. Endoscopy

is also utilized to explore enclosed spaces hidden from direct visualization. Although we usually relate the use of an endoscope to the medical professions, endoscopy has been widely applied to the industrial arena as well. Early endoscopes were essentially straight tubes of varied lengths and diameters. A light source was secured to the insertion end and visualization was accomplished by looking through the tube. In the early 1970s, fiber optic technology had advanced to the point where fiber optic bundles could be tightly bound in an insertion tube encased in flexible material. This gave the endoscope flexibility while still providing a lighted viewing area and enhanced visualization through a lens at the distal tip of the instrument. Maneuverability was provided by fine wire remote control of the tip of the scope, giving the operator the ability to negotiate the endoscope within body cavities or organs.

Medical endoscopes were developed and configured in terms of diameter and length as related to the medical need and target organ structure. Industrial endoscopes developed as related to unique applications. A still camera could be attached to the eyepiece of the endoscope and internal parts of a human or object could be photo documented. Soon, small video cameras were added to the possible ways by which data could be collected. It wasn't until the 1990s that VEs were developed. A VE is different than standard endoscopes in that the video camera itself has been miniaturized and positioned at the distal end or tip of the flexible instrument. This allows for greater resolution and data collection with greater interpretability. Current state-of-the-art systems collect and record images in high definition. Compact flash drives and SD cards are now the most common method for data recording. 3D imaging using endoscopy has also been employed.

Endoscopes can use various light sources, including 'cold' light sources, which can be quite compact, making the instrument extremely portable. The only other necessary instrumentation required for the VE is a camera control unit (CCU), which controls the exposure conditions of the video signal. The CCU is also compact and easily portable. Newer field endoscopes have the CCU unit as a part of the hand-held operator interface (Figure 2.2). There are even non-articulating systems that can be attached directly to a smart phone. Currently these 'quick look' endoscopes (Figure 2.3) have a larger diameter and thus may be limited in application.

Medical versus Industrial Endoscopes

Medical endoscopes were developed and configured as related to the medical need and target organ. Medical endoscopes can be either flexible or rigid. Flexible

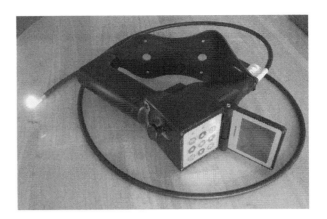

Figure 2.2 A self-contained, battery-operated flexible VE designed for use in remote locations. The hand-held proximal end houses the directional and exposure controls as well as manages data storage. The unit has still shot and video capabilities.

Figure 2.3 Two examples of 'quick look' systems. These instruments have no directional controls.

scopes are required for such target organs as the lungs or the colon, while ridged scopes are commonly used for arthroscopy techniques as well as trans-thoracic, trans-abdominal, and trans-pelvic endoscopy. Medical applications of endoscopy include both diagnostic and therapeutic goals. When used in anthropology and archaeology, endoscopy is employed primarily as a diagnostic tool providing direct visualization for data analysis and recording, and biopsy tissue sampling.

Industrial endoscopes developed as related to application. Industrial endoscopes can also be either flexible

or rigid. Flexible scopes are used in situations where the structure has numerous curves or turns to be negotiated, such as the internal works of a jet engine. Rigid industrial scopes, also called borescopes, are used when the path to the target object is straight ahead. Industrial endoscopes are also used in police work, giving officers the ability to 'see' into a room or around corners. Endoscopes have also been used for continuous surveillance and looking into closed compartments for contraband.

Medical and industrial endoscopes are different in design due to their specific applications. The internal fiber optic bundle, lensing, and optics are essentially the same on both medical and industrial scopes. However, the insertion tubes of medical scopes are covered with a flexible sheath, which allows for decontamination between patients. In contrast, the insertion tubes of industrial scopes are housed in a stainless-steel mesh, which gives them greater durability, or a flexible sheath. When selecting an endoscope for use in the field or remote areas, the added durability of the industrial scope is a plus. The supportive equipment used in medical endoscopy, such as light sources, CCUs, visualization and recording equipment, can be bulky as it is designed for use within a medical facility. It is often mounted on a cart, which can be moved about the medical facility or permanently mounted in an endoscopy suite. In contrast, industrial endoscopic supportive equipment is designed to be portable and is therefore smaller, lighter, more durable, and can be battery operated for remote applications.

Both medical and industrial endoscopes are available in a variety of diameters and can be as small as 1.9 mm. There are fiber optic systems in use that are small enough to travel inside a blood vessel. Medical and industrial endoscopes also vary in length. A 60 foot (18.28 meters) industrial endoscope is available and has applications for pre-excavation tomb analysis in field settings. Endoscope characteristics such as length, diameter, maneuverability, lensing (near focus, far focus, right angle, stereo lens for measurements, etc.), light source, data collection, portability, and durability all provide an instrument selection that is capable of being matched to specific research objectives.

In order to fully understand the application of the endoscope in anthropological and archaeological research, it is important to understand its functional components. We will describe the VE, as this variation of endoscopes holds the most potential for directed research. This potential rests in the image capturing capability and in its flexibility of application.

The video endoscopic system is comprised of the scope itself, a light source for illumination, a CCU, a system for recording data, a system for visualization, varied lens options, and biopsy or retrieval tools.

Anatomy of a Video Endoscope

A VE can best be understood as a system having three components. The three components include the control head at the proximal end, the insertion tube, and the tip at the distal end of the insertion tube.

The insertion tube refers to the main body of the endoscope. In the case of the FFE, the insertion tube is a flexible tube available in various lengths and diameters. Within the insertion tube is a series of continuous flexible glass fibers, which serve to deliver light from an external light source (Figure 2.4). In a conventional FFE, additional glass fibers also return the image to an ocular lens at the proximal end, where the target can be visualized and the image recorded as a still image or video. In contrast, the modern VE has a miniature video camera at its distal tip, eliminating the need for the fiber optics. This has the advantage of improving the durability of the instrument, as after frequent use glass fibers can break creating dark spots on the image.

The distal tip of the VE houses the video capture component and, like a video camera, can be affixed with various lenses including close-up lenses, distant-view lenses, wide-angle lenses, right-angle lenses, and split-screen, stereo, or 'binocular' lenses for measurement applications (Figure 2.5). The distal tip is

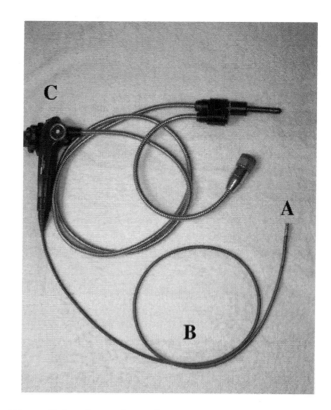

Figure 2.4 Industrial FFE showing (A) the distal tip housing the miniature image capture system, (B) the flexible insertion tube, and (C) directional and exposure controls. The instrument is attached to an external CCU and light source.

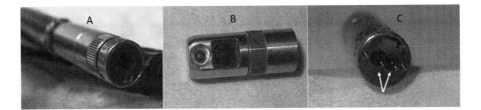

Figure 2.5 An example of various lens options for some VEs. (A) a wide-angle lens, (B) a 90-degree right-angle lens, and (C) a stereoscopic lens (arrows) used for taking measurements of internal structures as well as 3D applications.

also maneuverable from controls found at the proximal end. The lens selection characteristic allows the researcher to match the lens, and therefore the image and data collected, to the research objects and to adapt to imaging challenges within any given subject or object of study.

The proximal end of the VE has various components and is the command center of the scope. Directional controls, which are manual or electronic depending on the scope type, can manipulate the direction of the tip of the VE in four directions while it is within an object. The tip of some scopes can be manipulated by more than 90 degrees in all directions. This allows the operator to seek out targets without having to have a direct path. Coupled with the lens variations at the tip, the VE becomes an extremely flexible imaging tool. The proximal end also houses the commands for the CCU. Depending on the options available on the CCU, the proximal end can command such functions as freeze frame, digital zoom, image capture and storage, brightness control, white balance, and field of view manipulation (Figure 2.6). If equipped, the proximal end command center can also control digital measurement applications. This allows for measurement of objects within the subject of analysis.

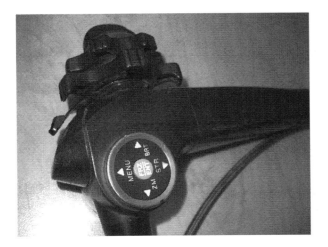

Figure 2.6 Proximal end controls various functions. Freeze frame, digital zoom, image capture and storage, brightness control, white balance, and field-of-view manipulation are available on most units.

Light Source

In order to see within closed objects devoid of ambient light, light is provided to the VE by a cold (low-heat producing) light source. A fiber optic light guide connects the light source with the VE. Light can then travel through the fiber optics of the VE and illuminate the field of view at the distal tip. Light sources vary in their configuration and should match the application at hand. For example, in field applications, compactness, portability, and battery operational capabilities are the major considerations. Light sources are available that weigh approximately 4 pounds, about the size of a hair dryer, and can be operated by battery. These basic light sources are simple in their operational aspects as well with an on/off control and a brightness control. The light is typically derived from a halogen bulb. If the endoscopic application is to be conducted in a laboratory setting, additional light source options become available. Higher wattage light is available as well as additional controls such as filters, exposure indexing, and air pumps.

Portable VE systems will also employ illumination directly at the distal tip, avoiding the need for fiber optics altogether. The distal tip illumination systems are usually LED lights that receive their power from batteries housed in the proximal end (Figure 2.7). The LED output is regulated via a brightness function also located at the control center at the proximal end of the instrument.

Camera Control Unit

Some endoscopes have the CCU as an integrated part of the hand-grip proximal end. Others may have a stand-alone unit. The stand-alone CCUs are compact and do not detract from instrument portability. The CCU receives and processes the image from the camera at the distal tip of the VE. The controls on the CCU are similar to those found on the proximal end of the VE and may have additional exposure settings such as automatic gain control, which amplifies a dark image. The CCU prepares the image for export to a monitoring device and the various image-storing devices that will be described later.

Figure 2.7 LED lights used for illumination at the distal tip of the VE eliminating the need for fiber optics.

Biopsy and Retrieval Tools

Once a target within an object has been visualized and recorded, the research goals may call for biopsy of ancient tissue or artifact retrieval. Various tools are available for these procedures. Tissue biopsy can be carried out much as it is in living subjects and a wide variety of tools are available. Fine-needle biopsy is the method of choice in that it leaves the target organ well intact. However, the yield from fine-needle biopsy is often small and may impair analysis. Ancient tissue is dry and brittle and these conventional biopsy methods often produce a low yield. Alternate tools with larger retrieval capacity are often necessary. Long narrow tweezers or varied forceps can be employed.

Some VEs do not have a biopsy channel, as do their medical counterparts. To remedy this, two methods are available. The first is to affix a biopsy channel to the external surface of the VE (Figure 2.8). This of

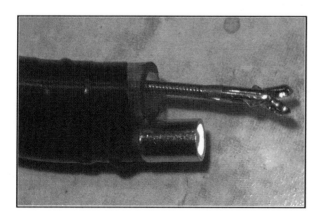

Figure 2.8 External biopsy channel secured to the distal tip of a VE that does not have a biopsy channel. Note biopsy forceps extruding from attached channel.

course increases the diameter of the system and may decrease flexibility regarding insertion routes. The second approach is similar to the laparoscopic medical procedure in that visualization is provided from one point of entry, while the biopsy tool is introduced into the field of view from another. Artifact retrieval can be accomplished using these same procedures (Figure 2.9).

Data Recording

The image outputs available on most CCU units are standard video signals such as s-video, HDMI, and BNC outputs. This allows the CCU to send the image to a video monitor for operator observation during a procedure. Digital output allows the image to be sent to a digital recording device such as an optical disk or computer. If a mini digital video camera, equipped with an s-video in port and a monitoring screen, is used, it may function as both a monitor and an image storage device. Using a mini digital video camera has great field applicability as they are compact and have the further advantage of being able to capture through the lens images on the research site, of the subject, and other project variables. Also available for image monitoring and image capture are miniDV recording decks and DVD recorders. The miniDV recording deck is similar to the miniDV camera but does not have through-the-lens capability since it does not have a lens for input. The DVD recorders are limited in that additional monitoring must be considered.

The current standard for data recording from a modern portable VE is the use of a microSD memory card similar to what we use on digital cameras. Other potential storage devices include flash drives and stand-alone external hard drives. These options reduce the necessary equipment components required in that the digital storage device is integrated into the CCU at the hand-held proximal end of many units. Depending on the instrument, the data may be saved in HD formats. The data can also be saved as a .tiff or .jpeg file as well as video files such as an MP4. The data may then be transferred or transmitted to other devices and shared electronically, allowing for interpretational input or real-time educational purposes.

Limitations of Method

As with any technology, endoscopic methodology has its limitations. While some of these limitations are unavoidable, others can be minimized or eliminated. The limitations associated with endoscopy applications

Laparoscopic Biopsy Approach

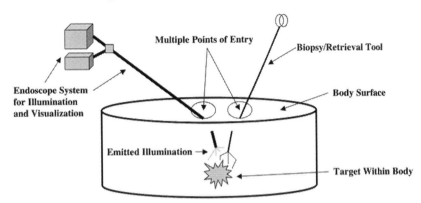

Figure 2.9 Schematic of the laparoscopic approach to biopsy using the VE for illumination and visualization with the biopsy/retrieval tool entering the field from another opening.

in bioarchaeological research will be presented in two broad categories: limitations inherent to the instrumentation, and limitations associated with the personnel applying endoscopic methods.

Technologic Limitations Associated with Endoscopy

As previously described, endoscopy requires a route of access into the body cavity, object, mummy wrapping, or other target space. While endoscopes do come in a wide variety of diameters and lengths, at times an access route does not present itself. Often, another paleoimaging modality such as X-ray or CT has identified an area of special interest within the mummy or artifact. This area of interest may be a unique ceramic or metallic burial inclusion or a calcified lymph node. No matter the case, the decision to create an entry route for the introduction of an endoscope should be weighed carefully. A risk to benefit analysis should be conducted to assure that the potential information gained would be worth making an access route (Beckett and Conlogue 2010). Further, there should be a high probability of a successful biopsy or retrieval. If the decision is made to move forward and create an opening, we have been successful in using a flap-like opening that can be closed following the procedure. The smallest diameter endoscope should be selected and the most direct route should be chosen that would have the greatest possibility of success. The procedure should be well documented and directed by alternate imaging methods as indicated. Careful notation and or identification of the modification needs to be made both on the surface of the mummy or object and in the interior of the object using pre- and post-procedure radiographic documentation.

Even if there is access to internal body cavities or archaeological objects, another limitation of the endoscopic method is the potential lack of maneuverability. The space entered by the endoscope may be so narrow that the only view is that which is directly in front of the lens. While imaging data can still be collected, this lack of maneuverability can be a major limitation of this method.

Another major limitation to the images derived from endoscopy is the interpretability of the data. The data obtained from endoscopic methods is descriptive rather than qualitative. In desiccated human remains, the internal organs are often not in their typical anatomical position. Thoracic cavity contents can be found in the abdominal or pelvic cavities. Depending on the degree of taphonomic change, the morphologic features of organs, tissues, and other anatomic structures can be very different from those seen in a well-preserved mummy and certainly different from living or recently dead humans or animals. The characteristics of desiccated tissues and organs, as well as their potential morphologic appearance, must be well understood by those who are conducting the study.

If the endoscope is to be used to collect tissue samples for histological or DNA analysis, an additional limitation is that of potential contamination of the sample. Even with the most careful adherence to sample collection protocol, this limitation poses a great risk to the success of such procedures. Great care must be taken to control for any cross-contamination potential in this endoscopic application.

It is important to realize that even though the endoscopic procedures are non-destructive, they are invasive. Any time an instrument is introduced into a body or artifact, there is a great risk of destructing some material. Typically, this is due to 'scope drag.' Scope drag

occurs when the operator does not protect the entry route on insertion and subsequent manipulation of the endoscope. The endoscope may also become destructive internally if the operator is too aggressive when trying to access or maneuver the distal end of the endoscope within the body or artifact. Care must be taken to avoid this limitation by taking care to protect the access point and to be certain not to force the endoscope into spaces within the body or artifact that it will not 'flow' into naturally, or with dependent manipulation.

Since internal anatomic landmarks may not be as reliable in a desiccated mummified body, it is often difficult for the endoscopist to be certain as to their regional or exact endoscopic location within that body. Location verification via X-ray, CT, or fluoroscopy is essential prior to recording images produced with the endoscope in a given position (Figure 2.10). Position verification adds validity to the image description attained from the endoscope.

A major archaeological concern with the use of endoscopic methods is that of illumination limitations within a large enclosure such as a coffin, tomb, or room. Standard endoscopes, both medical and industrial, do not have illumination capacities to accommodate a larger hollow space. The endoscopist must be prepared and develop slave lighting strategies for these circumstances.

Limitations of Personnel

Perhaps the greatest limitation to endoscopic methods used in anthropology and archaeology is that of adequate knowledge regarding instrumentation variability. Medical personnel conducting endoscopic research in

mummified remains or artifacts will be well versed in the application of a wide variety of medical endoscopes and supportive technologies, but may not be aware of the many variations of industrial endoscopic instrumentation and supportive technologies that are available. This lack of knowledge of instrumentation variation can greatly limit any given research effort and impede the data collection process from this method.

Another major human limitation is that of minimal experience with the instrumentation associated with endoscopic methods, as well as the issues associated with the interpretation of data collected by this method. Experience is critical in the reliability of the technique selected and the resultant images. Medical personnel are accustomed to viewing anatomical structures and anomalies within the given context of living or recently dead humans. In this context, anatomy is in a reasonable morphologic state and position within the body. This is not the case in mummified remains. Given that the internal environment of desiccated bodies, tissues, and organs may present with marked variation in morphology and in anatomical positions, lack of experience in this imaging modality in this setting can lead to dramatic interpretational errors. These interpretational errors may render the data and quality of the study questionable. Those wishing to employ endoscopic methods would do well to train with a seasoned research team familiar with their use and with the interpretation of data from these anthropological and archaeological applications.

Finally, another human limitation to this method is in the reporting not only of the results from an endoscopic study, but also of the technique and instrumentation used (Beckett 2007; Beckett and Conlogue 2010). If endoscopy use in anthropologic and archaeological research is to continue to advance, reproducible studies must be reported. The report should include minimally the instrument used by name/type, diameter and length, light source, lens, image capture system, access route, body cavity or artifact examined, and major findings. The report should also include supporting photographs of the procedure as well as radiographic verification of endoscope position within the remains or object (Beckett and Conlogue 2010). An example of a standard reporting form for endoscopic procedures can be found in the appendix of this book.

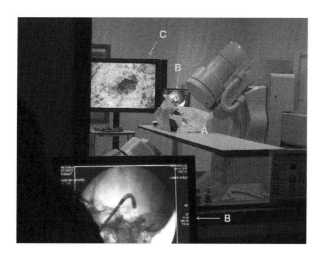

Figure 2.10 A fluoroscopic interventional C-arm system employed to document the position of an endoscope in the skull within the box (A). The fluoroscopic image appears on monitors (B) inside and outside of the fluoroscopy control room, while the endoscopic image is displayed on the monitor in the room (C).

References

Aufderheide, A.C. 2003. *The Scientific Study of Mummies.* Cambridge, UK: Cambridge University Press.

Aufderheide, A.C. and Rodriguez-Martin, C. 1998. *The Cambridge Encyclopedia of Human Paleopathology.* Cambridge, UK: Cambridge University Press.

Beckett, R.G. and Conlogue, G.J. 2010. *Paleoimaging: Field Applications for Cultural Remains and Artifacts.* Boca Raton, FL: CRC Press (Taylor & Francis).

Beckett, R.G. 2007. Paleoimaging—Standards for Endoscopic and Reflectance Applications in Anthropological Studies. Paper presented in live video conference with Forensic Anthropology & Bioarchaeology Graduate Program, October, for Pontificia Universidad Católica del Perú. Lima, Peru.

Beckett, R.G., Bravo, A. Conlogue, G., and Guillen, S. 2003. Dead Men Breathing: The Prevalence of Intrathoracic and Extrathoracic Pulmonary Paleopathologies Among 83 Chachapoya Mummies, Leymebamba, Peru. *Papers on Paleopathology presented at the 30th Annual Paleopathology Association Meeting,* Tempe, Arizona, April. *Supplement to Paleopathology Newsletter,* June issue.

Beckett, R.G. and Conlogue G. 1998. Video Enhanced Fiberoptic Examination of Skeletal Material and Artifacts with Radiologic Correlation. *Papers on Paleopathology presented at the 25th Annual Meeting,* March 31–April 1, 1998. *Supplement to Paleopathology Newsletter,* No. 102, June issue.

Beckett, R.G., Gerald Conlogue, and David Henderson. 2007. Light Reflectance Signatures Among Mummified Organs with Endoscopic Guidance and Radiographic Correlation—A Preliminary Study. Paper presented at the 34th Annual North American Paleopathology Association Meeting, April, in Philadelphia, PA.

Beckett, Ronald G., Gerald Conlogue and Roger Colton. 1999a. Endoscopic Evaluation of Segmented Sternum with Radiographic Correlation in a Peruvian Infant: Implications for Aging of the Individual. Papers on Paleopathology presented at the 26th Annual Meeting, April 27–28, 1999, Supplement to Paleopathology Newsletter, No. 106, June issue, ISSN 0148-4737.

Beckett, Ronald G., Michael McNamee, and Janet Monge. 1999b. Endoscopic Evidence of Lymphadenopathy in a Mummified Peruvian Woman from Pachacamac. Papers on Paleopathology presented at the 26th Annual Meeting, April 27–28, 1999, Supplement to Paleopathology Newsletter, No. 106, June issue, ISSN 0148-4737.

Beckett, Ronald G. and Sonia Guillen. 2000. Field Videoendoscopy – A Pilot Project at Centro Mallqui, El Algarrobal, Peru. Papers on Paleopathology presented at the 27th Annual Meeting, April 11–12, 2000. Supplement to Paleopathology Newsletter, No. 110, June issue.

Bravo, Anthony, Gerald Conlogue, Ronald Beckett, Andrew Staskiewicz, Larry Engel, and Sarah McGann. 2003a. A Paleopathological Examination of Eighteen Mummies from the Church of the Dead, Urbania, Italy. Papers on Paleopathology presented at the 30th Annual Paleopathology Association Meeting Tempe, Arizona April. Supplement to Paleopathology Newsletter, June issue.

Bravo, Anthony, Gerald Conlogue, Ronald Beckett, and Larry Engel. 2003b. Exploring the Myth and Paleopathologies of Mummies from a Turkish Tomb, Amasya, Turkey. Papers on Paleopathology presented at the 30th Annual Paleopathology Association Meeting, Tempe, Arizona, April. Supplement to Paleopathology Newsletter, June issue.

Conlogue, Gerald, Ronald Beckett, John Posh, Yvette Bailey, David Henderson, Gary Double, and Thomas King. 2008b. Paleoimaging: The Use of Radiography, Magnetic Resonance and Endoscopy to Examine Mummified Remains. *Journal of Radiology Nursing,* 27(1):5–13.

Conlogue, Gerald, Ronald Beckett, Yvette Bailey, and Jiazi Li. 2008a. A Preliminary Radiographic and Endoscopic Examination of 21 Mummies at the "Museo De Las Momias" in Guanajuato, Mexico and the Importance of a Team Approach to Image Interpretation. Paper presented at the 35th Annual Meeting of the Paleopathology Association, April 8–9, in Columbus, OH.

Duclos, Laura, Ronald Beckett, Sonia Guillen, and Gerald Conlogue. 2000. Endoscopy as an Adjunct to Determining Age at Death in Mummified Remains. Papers on Paleopathology presented at the 27th Annual Meeting, April 11–12, 2000. Supplement to Paleopathology Newsletter, No. 110, June issue.

Kim, Seok Bae and Jeong Eun Shin, Sung Sil Park, et al. 2006. Endoscopic Investigation of the Internal Organs of a 15th-Century Child Mummy from Yangju, Korea. *Journal of Anatomy,* 209(5):681–688 (November).

Maria Patricia Ordonez, Ronald Beckett, Andrew Nelson, Gerald Conlogue. 2015. Paleoimagen y análisis bio-anthropológico de la colección Maranga del Museo Jacinto Jijón y Caamaño. Anthropologia Cuadmos de Investigación, No. 15, julio-diciembre (2015), pp. 63–79.

Nelson, Andrew, Gerald Conlogue, Ronald Beckett, John Posh, Rethey Chhem, Edwin Wright, and James Rogers. 2007. Multi-Modality Analysis of Variability in Transnasal Craniotomy Lesions in Egyptian Mummies. Paper presented at the 34th Annual North American Paleopathology Association Meeting, April, Philadelphia, PA.

Posh, John and Ronald Beckett. 2000. A Comparison of Two Nondestructive Techniques for the Evaluation of Endocranial Features—Videoendoscopy and Virtual Fly Through Computed Tomography. Papers on Paleopathology presented at the 27th Annual Meeting, April 11–12. Supplement to Paleopathology Newsletter, No. 110, June issue.

Ronald G. Beckett, Andrew J Nelson. 2015. Mummy Restoration Project Among the Anga of Papua New Guinea. *The Anatomical Record,* 298(6):1013–1025.

Ronald G. Beckett, Gerald J. Conlogue, Orlando V. Abinion, Analyn Salvador-Amores, Dario Piombino-Mascali. 2017. Human Mummification Practices Among the Ibaloy of Kabayan, North Luzon, Philippines. *Papers on Anthropology,* XXVI(2), 24–37.

Tapp, Edmund., P. Stanworth, and K. Wildsmith. 1984. The Endoscope in Mummy Research. In *Evidence Embalmed,* ed. Rosalie David and Eddie Tapp, pp. 65–77. Manchester, UK: Manchester University Press.

Ventura, Luca, Paula Leocata, Ronald Beckett, Gerald Conlogue, G. Sindici, A. Calabrese, V. Di Giandomenico, and Gino Fornaciari. 2004. The Natural Mummies of Popoli. A New Site in the Inner Abruzzo Region (Central Italy). *Antropologia Portuguesa,* 19:1–2 (ISSN 0870-0990 Pub. Spring, 2002).

XRF (X-Ray Fluorescence)

RONALD G. BECKETT

3

Contents

Introduction and Rationale

One of the challenges in bioarchaeological research is the determination of the nature of organic or inorganic structures discovered from the application of conventional paleoimaging methodologies. Standard radiographs, photographs, and endoscopy can capture images of structures within an enclosure or within a mummy bundle, yet the composition of those structures cannot be derived from these images alone. X-ray fluorescence (XRF) is a non-destructive analytical technique used to determine the elemental composition of materials. Knowing the elements that make up a target object or structure can help answer broader research questions. XRF analysis provides a means to deconstruct target objects down to their basic elemental make up.

XRF has been used in archaeology and bioarchaeology to help answer a variety of questions. One-way XRF has been used is to determine the elemental make up of soils. Knowing the constituent parts of soils and quantifying their relative concentrations allows researchers to answer questions about the environmental impact on the decomposition or mummification of human or animal remains. Further, soil analysis informs the researchers about burial site lifeways and can help determine if a body was moved to the point of discovery from another location. The original location, or original site of interment, may also be determined. When studying a group of related mummies from a given region, XRF can describe the nature of the varied sites in terms of their homogeneity or soil variations. If body treatments such as clay or vegetal substances were employed in the ritualistic treatment of a corpse, elemental analysis using XRF methodology can not only identify those substances, but also determine their point of origin. This adds to our understanding of funerary rituals and can help unravel questions about mummification practices as well (Figure 3.1).

Considering anthropogenic mummification, a variety of embalming methods and substances have been used over the span of human mummification. The Chinchorro culture of the Atacama Desert were the first to anthropogenically mummify their dead using a variety of substances including vegetal matter, ash paste, manganese, and pigments. In the late nineteenth century, embalmers experimented with a variety of chemical solutions, including metals such as arsenic, nickel, mercury, and others. Using XRF elemental analysis, the constituents of embalming solutions can be identified. The chemical make up of the solution may also assist in identifying the temporal context associated with the case under study. In some cases, the information derived from XRF analysis as related to embalming solutions, arsenic for example, informs researchers about the safety of working with those remains.

The nature of artifacts associated with bioarchaeologic research can also be determined using XRF technology. Various metals such as silver, gold, copper, and lead used as adornments of the dead can all be described through elemental analysis. Medical mummies were created using a variety of substances including waxes, varnishes, and injections employing metal-based solutions. Some tissue types too can be differentiated using XRF methodology. This is helpful when trying to determine what tissues are present and qualifying the state of preservation of remains. In some cases, artifact inclusions such as stones, bullets, weaving tools, and

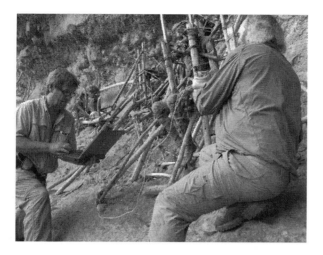

Figure 3.1 Portable XRF analysis of the ritualistic clay application to a smoked-body mummy in the fringe highlands on Papua New Guinea.

so on, can all be differentiated using XRF technology (Figure 3.2).

Being a non-destructive method, XRF allows researchers to analyze samples without altering them. This has obvious great value for bioarchaeologists who can analyze large and valuable artifact assemblages that would have been off-limits to destructive procedures. As with other imaging methods, data derived from XRF analysis should be interpreted in concert with other paleoimaging data. Also, the interpretation of the meaning of the data needs to be conducted by a multidisciplinary team to arrive at a consensus. Several case studies using XRF analysis and data

interpretation are included in the companion book of case studies.

Principle of Operation

XRF analyzers determine the chemistry of a sample by measuring the fluorescent (or secondary) X-ray emitted from a sample when it is excited by a primary X-ray source. It is beyond the scope of this discussion to describe the principle of operation in great detail. We will rather describe the critical characteristics that will provide a working knowledge of XRF technology. We will focus on the portable hand-held instrumentation that is most appropriate for bioarchaeological research.

Basically, XRF uses an X-ray source to create a beam with enough energy to cause an excitation of electrons in the inner shells of atoms. The interaction of the X-ray beam with the inner shell results in a displacement of the electrons from their orbital positions surrounding an atom. The displacement occurs when the energy from the X-ray beam is greater than the binding energy of the electrons it is interacting with. As this occurs, a burst of energy is released that is specific to a given element. The XRF instrument utilizes a detector that registers this energy and categorizes it by element.

The instrument can differentiate energies between and among elements because each atom, or element, holds its electrons in fixed positions dictated by specific energies, thus determining their orbits. The spacing between orbital shells is unique to the atoms of each

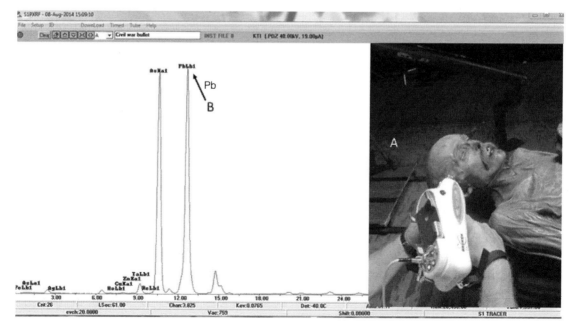

Figure 3.2 XRF analysis of 'bumps' on the surface of the face of a late-nineteenth century mummy (A). The elemental trace demonstrated that the 'bump' was in fact a civil war lead buckshot lodged under the skin (B).

element. Thus, an atom of copper has different electron shell spacing than arsenic and so on. As the electrons are displaced from the innermost shell, the atom corrects the instability as an electron from a higher shell moves down to fill the void. This is referred to as fluorescence (Figure 3.3).

Since electrons in the higher shells have higher binding energies, when they move inward energy is lost. The energy loss is equivalent to the energy delta between the two shells dictated by the distance between them. As mentioned, this distance is unique to the atoms of each element, making identification possible.

Since these fluorescence energies are unique, the quantity of each element present in the target sample is presented as a proportion of the whole. Such quantifications can inform the interpretation regarding the main elements involved in a sample. This is usually calculated by the instrument itself or by external software.

The fluorescence process is very rapid, which makes the elemental distinctions stable in just a few seconds. In a case where the interest is learning if a dry tissue structure has been immersed in a particular embalming solution, like arsenic for example, if arsenic is present in great proportions the results will require only a few seconds. However, if the entire elemental make up is the goal, it will often take a few minutes to get the readings from lower concentration elements. Elements with lower atomic numbers require special consideration as there are fewer electrons in outer shells. Filters can be applied to the instrumentation to assure detection of energy changes as well as a vacuum pump to reduce extraneous interference.

Instrumentation

It is beyond the scope of this chapter to describe in detail the intricacies of XRF instrumentation. While there are several manufacturers of hand-held XRF instruments, the major components include an X-ray source, detector, and onboard analytical hardware and software. Hand-held XRF instruments are also referred to as pXRF, for portable X-ray fluorescence (Figure 3.4). The instrument most often reported in the literature as being used in archaeology or anthropology is the 'Tracer' series from Bruker Elemental®. The key in determining which XRF device to use is that the researcher must consider the intended application. Variables to consider include the element range that can be detected by a given instrument, the ease of operation, the portability, and the reliability of the device. If broad anthropological and archaeological questions are being asked in a research project, the instrument with the greatest diversity in terms of detection range would be the logical choice (Figure 3.5). In one study in the fringe highlands of Papua New Guinea, the research objectives were broad and included not only clay analysis but also biological and plant material, thus the most complete instrument was selected (Figure 3.6). Conversely, if the study has a narrow focus, like testing for specific contaminants in water sources, a less complete system would suffice.

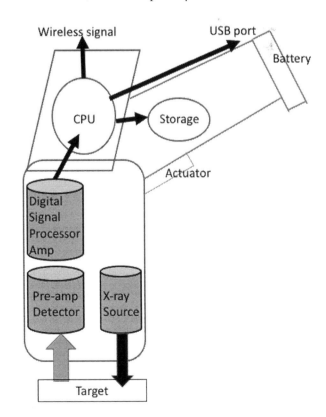

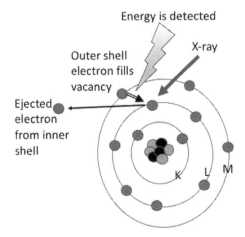

Figure 3.3 As the X-ray source enters the sample, inner shell electrons (K, L) are ejected from their location causing an outer shell (M) electron to move inward to create stability. The energy released by this movement is detected and is referred to as fluorescence.

Figure 3.4 Schematic representation of the functional parts of a portable X-ray fluorescence instrument.

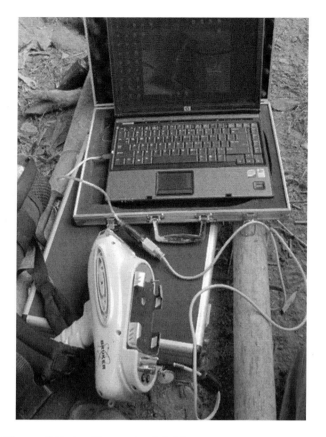

Figure 3.5 A self-contained field pXRF unit.

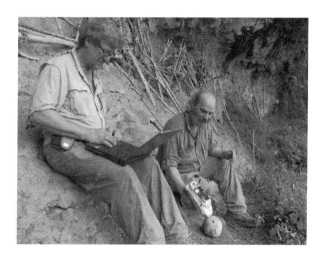

Figure 3.6 Field XRF unit in use in a cliff rock shelter gallery containing mummified and skeletal remains of the Anga of Papua New Guinea.

The instrumentation is continually getting more portable with onboard computers for data collection, graphing, and analysis. Some units can be connected remotely to a computer via Bluetooth and wireless internet technology. Instrumentation is on the expensive side, with modern units starting at about USD 75K and moving upwards from there.

Data Recording/Reporting

Using the XRF data requires skills and knowledge of how the data is collected and of its intended use. Generally, the data collected from hand-held XRF instrumentation can be qualitative, quantitative, or semi-quantitative. The desired form of data presentation is dictated by the research goal, the application, and the sample type. In some cases, quantification is not possible as strict criteria need to be met. Interpreter error can be made when a quantitative presentation of the data is collected in situations where accuracy and repeatability cannot be attained. There are cases where semi-quantification can help when making comparisons between and among samples. It is imperative then that the operator be aware of the available data analyses appropriate for a given research application.

Qualitative Approach

The first and most straightforward data presentation is qualitative. Once the instrument detector counts the number of fluorescent X-ray energies specific to an element, the raw data is presented in a spectrum graph. In the spectrum graph, the x-axis is the element-specific energy with the y-axis being the actual counts or pulses represented by peaks. The more pulses detected for a given element signature, the higher the peak on the spectral graph. When comparing samples with the same elements, the one showing the higher peak for that element has a greater concentration of that element.

The spectrum graph is qualitative, in that it tells the user only that that element is present in the sample, but not how much of that element is in the sample. The qualitative assessment using the spectrum graph is ideal for many types of bioarchaeological research in that it is excellent for non-homogeneous or non-uniform samples, which is typical of archaeological material. Here we discover what was in the sample, but not how much was in the sample. If there is a peak, that element is present (Figure 3.7).

Quantitative Approach

As the descriptor implies, XRF data can be used to determine the absolute quantity of an element present in the sample. This is reported as parts per million or as a percent weight. In order to accomplish these calculations, the instrument must be calibrated with samples having known concentrations of the elements of interest. A calibration curve can then be created and, using the raw qualitative data, quantitative analysis can be achieved.

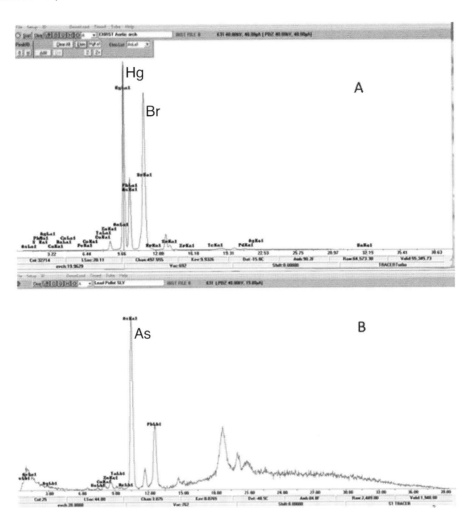

Figure 3.7 Examples of elemental analyses. Trace (A) shows high levels of Hg and Br used to pigment arteries in a medical model prosection. Trace (B) shows high levels of arsenic used in a preservative cocktail leading to mummification.

The calibration method varies among instrument manufacturers, but basically the difference may only be in how the calibration curve is generated. Once the curve is created using calibrating samples with known concentration, the unknown concentration of that element can be determined. For example, if we detect arsenic is present and we now want to know how much arsenic is present, we need to calibrate the instrument with samples with known concentrations of arsenic, produce a calibration cure, and plot our raw data against that curve.

There are some limitations to the quantitative approach for bioanthropological applications. For correct quantitative values, certain criteria need to be met. First, the sample must be homogeneous with no layers or inclusions. The raw data helps determine the homogeneity of the sample. In most cases in anthropology, we are dealing with tissues and tissue types, which makes quantification difficult. In archaeology, artifact analysis may find this approach helpful. Second, as described in the previous paragraph, the calibration material needs to

be appropriate for the sample. Finally, the sample must be thick enough to absorb all incoming X-rays from the instrument without the X-rays passing through the target sample. Given these criteria, the quantification approach to data use has less applicability in biological systems but may be applicable to artifacts and certainly to soil or clay composition analysis.

Semi-Quantitative Approach

Using the raw data to make between- or among-sample concentration comparisons is possible using the semi-quantitative approach. When the criteria for quantitative analysis cannot be met, semi-quantitative analysis can provide information regarding the relative concentration of elements to examine the variances between samples. For example, population 'A' has 33% more arsenic present when compared to population 'B.'

This approach can be useful in bioanthropological settings as inter-group comparisons are highly

informative when attempting to restructure the life experiences of past peoples.

Limitations

The limitations associated with XRF applications lie primarily in operator error or application mismatch. It is important to be well versed in the principle of operation of XRF instrumentation and to be aware of its inappropriate application. The X-ray beam size limits the analysis field. If, for example, in a ceramic artifact only one location is assessed, the results may not be representative of the entire object. Right under the beam there may be an element that is not representative of the overall object. If that element is of high value, like gold for example, the research may erroneously state that this is a ceramic with an inner crust of gold. In these cases, it is best to sample several regions of the object to get an idea of the average, or at best a more complete elemental profile.

There are a variety of circumstances were the depth of penetration may be limited. If surface analysis is conducted, the surface of that object may have reacted with the environment or undergone taphonomic change over time. Without penetration, the analysis of the surface alone would not be reflective of the entire object. In these cases, adjustment of the X-ray source output would be warranted.

Plane Radiography, Digital Radiography, Mammography, Tomosyntheses, and Fluoroscopy

4

GERALD J. CONLOGUE, ROBERT LOMBARDO,
WILLIAM HENNESSY, MARK VINER, AND ALICIA GIAIMO

Contents

Terminology

Before initiating a discussion regarding radiography, it appears obligatory to consider an assortment of terms that have been bandied about for several decades. Since the authors contributing to this chapter are radiographers, professionals on both sides of the Atlantic Ocean and educated in the science and art of radiography, there are no more appropriate individuals suited for clarification.

The first consideration, should the term be *plain* or *plane* radiography? The former has been frequently used (Nepple, Martel, Kim, Zaltz, and Clohisy, 2012; O'Rahilly, Müller, Carpenter, and Swenson, 2008) suggesting straightforward, unadorned or less complex. Hall (2000) suggested dropping the modifier plain or the other common term *conventional* because neither were necessary. However, since it forms the basis for all the imaging modalities that will be considered in subsequent chapters employing X-ray, plain seems a rather derogatory-sounding definition and outdated. Similarly, conventional suggests pertaining to some standard that may be interpreted as using film as the image-recoding media rather than a digital process. The term *plane*

appears more appropriate. Whether recorded on glass plates or film, an early radiograph rendered a 3D object into the 2D plane of the image receptor. As will be discussed later in this chapter, other modalities that were developed directly considered *planar imaging*: conventional tomography produced a sharp image in a plane parallel to the tabletop; computed tomography acquired images in a plane perpendicular to the surface of the tabletop; and in multi-detector computed tomography, although it collects a volume of data, algorithms permit the data to render multi-planar images.

The second source of confusion is based on positioning terminology. There are two principal conventions for the description of positioning patients that can be transferred to objects. The first approach considers the path of the X-ray beam and the initial surface it comes in contact with. For example, an anterior-posterior (AP) projection of the chest: the X-ray beam first penetrates the patient's anterior or ventral surface and exits their back, dorsal, or posterior surface that is against the image receptor.

The other standardized custom relates to the position of the patient. If a right-posterior oblique of an abdomen is requested, the patient is first placed on the

X-ray table on their back or supine. The individual is then rotated a specific number of degrees depending on the specific examination, for example 45°, so they are resting on their right side to achieve a right-posterior oblique or RPO. Another example would be a left lateral. In this case, the patient's left side is against the image receptor.

Finally, the terms portable and mobile radiography need to be clarified. Hall (2000) felt the former suggested that the *X-ray machine* could be carried; however, the units available in clinical facilities today are far too heavy, so he preferred the term *bedside*. Certainly, in the context of this book, bedside would be a poor descriptor. Mobile is a much better designation for an X-ray unit that is capable of being transported to different areas and floors of a hospital. But, once again, in the context of the non-traditional applications, for an X-ray unit that can be carried into the field, portable is preferable.

Origin

The recognized origin of radiography can be attributed to a specific date. On December 28, 1895 Professor Wilhelm Conrad Röntgen handed his preliminary findings report describing his discovery to the Physical Medical Society of Würzburg, Germany (Dibner, 1963). Since Röntgen did not completely understand the process he had observed, he assigned the mathematical term for an unknown, "x," to the phenomenon (Donizetti, 1967). Following the astonishing claims, the biographer of Lord Kelvin stated that Kelvin, president of the Royal Society, was initially skeptical and regarded the announcement as a hoax (Thompson, 1976). Because Röntgen was meticulous in his description of the process, by early 1896 many scientists in Europe and America were not only confirming his findings but also replicating his work. In April 1896, with the installation of X-ray equipment at both St Bart's and The Royal London hospitals, clinical radiography became incorporated into medical practice in London. Other major cities in Europe and North America rushed to integrate this technology into hospitals and explore the possible applications.

Although X-ray production has gone through technical improvements, the requirements remain fundamentally the same as described by Röntgen: two electrodes, a negative, termed a cathode, and a positive known as an anode placed within a vacuum tube created by evacuating all the air from within the tube (Figure 4.1). The process of producing X-rays depends on three factors within the X-ray tube: a source of electrons at the cathode; a force to accelerate the electrons from the cathode to the anode; and the anode or target,

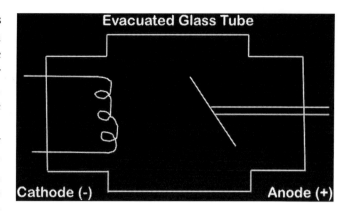

Figure 4.1 The basic design of an X-ray tube: a negatively charged cathode and positively charged anode with an evacuated glass tube.

the site of interactions between the projectile electrons and the atoms comprising the target.

Production of X-Rays

The quantity of electrons available at the cathode is directly proportional to the milliamperage, *mA*, setting on the X-ray control panel. The total quantity of X-rays produced is dependent on another exposure factor, time, a setting also found on the control panel. The longer the exposure, usually designated by seconds (s), the greater the amount of X-rays emitted from the X-ray tube. Therefore, the total X-ray output is expressed in terms of milliamperage multiplied by the exposure time or *mAs*. Certain control panels will have separate mA and time settings (Figure 4.2), while others will combine the two settings and only have a mAs control (Figure 4.3).

Figure 4.2 A Ratheon RME 325R control panel with separate mA (A) and time (B) settings. Note the arrows indicating which direction to turn the time knob for "lighter" or "darker" exposure times. Prior to 2002, the autopsy assistant and not a trained radiographer took the X-rays at the Office of the Chief Medical Examiner for the State of Connecticut.

Figure 4.3 The control panel on a Shimadzu Mobile Art Evolution™ unit with an mAs setting (arrow) automatically selecting mA and time.

The acceleration of the electrons across the tube is directly proportional to the kilovoltage (kV), the third principal control panel setting (Figure 4.4A and B). An increase in the kV results in greater acceleration of the electrons, and therefore a more forceful interaction with the atoms that comprise the anode or target. Two types of interactions, termed *bremsstrahlung* or *brems* and *characteristic*, transform the electrical energy into X-ray energy at the target.

Before describing the interactions, a brief digression to discuss atomic structure is necessary. A more thorough examination of relevant atomic structure can be found elsewhere (Bushong, 2013; Bushberg, Seibert, Leidholt, and Boone, 2012). In the most basic consideration, the atom consists of a nucleus containing positively charged protons and neutrally charged neutrons. The number of protons within the nucleus determines the element. For example, if the nucleus contains one proton, the element is hydrogen, while the presence of 74 protons indicate the element tungsten. Atoms with the same number of protons, but different number of neutrons, are termed isotopes. Because they contain the same number of protons, they are the same element; for example, hydrogen has three isotopes all with a single proton. The stable isotope, elemental hydrogen, lacks a neutron, while deuterium has a single neutron and tritium two neutrons. The higher the number of protons, the increased probability of a greater number of isotopes. For example, cobalt has 27 protons, but the number of neutrons ranges from 20 to 48. A consequence of larger numbers of total particles within the nucleus is instability, which results in spontaneous breakdown of nucleus and ejection of particular material and energy collectively termed *radioactivity*. The amount of time required for an isotope to lose half its radioactivity is termed *half-life*. The latter is very precise for each isotope. For example, carbon 14 (6 protons and 8 neutrons), which is a naturally occurring isotope, has a half-life of 5,730 years, and therefore can be employed to determine the antiquity of organic material. Cobalt 60 (27 protons and 33 neutrons) has a half-life of 5.2713 years and can be used as an imaging source in industrial applications. But, more about isotopes and their role in imaging later.

The third atomic particle in this basic consideration of atomic structure is the negatively charged electron. In an atom with a balanced charge, the number of electrons orbiting the nucleus is equal to the number of protons. Electrons occupy specific orbits at particular distances from the nucleus. As stated in Bushong (2013), orbitals are designated by letter with the *K-shell* closest to the nucleus and the farthest identified as *Q-shell*. In addition, each orbital can accommodate a certain number of electrons. Due to electromagnetic force, opposite charges attract, so the K-shell electrons are subjected to the greatest attraction force or *binding energy* to the positively charged protons in the nucleus. Moving away from the nucleus, K- to Q- shells, the electrons are held in with lower energies (Figure 4.5).

Figure 4.4 (A) The kVp selector (arrow). Note that all three selectors, mA, kV, and timer, are knobs that rotate to make the selection. (B) The kVp selector (arrow) on the Shimadzu mobile unit. Note that increases or decreases of either kVp and mAs are achieved by pushing "–" or "+" buttons.

Figure 4.5 A schematic diagram of atomic structure: the central nucleus (solid circle) contains the positively charged protons (p) and neutrally charged neutrons (n), while electrons occupy ground-state orbitals identified as K through Q.

Bremsstrahlung or *brems* interaction, translated from German as "*braking*," is an interaction between the negatively charged projectile electron and the positively charged nucleus in the target material. Since opposite charges attract, the process is dependent on the proximity of the projectile electron traveling between the innermost K-shell and the nucleus. The strong attraction of the nucleus results in the projectile electron slowing down or losing energy and changing direction. The lost energy is transformed into X-ray energy by emission of an X-ray photon. The closer the electron trajectory is to the nucleus, the higher the resulting energy of the photon (Figure 4.6).

The other type of interaction at the target is termed *characteristic*. In this situation, the projectile electron strikes a K-shell electron with sufficient energy to knock the atomic particle out of orbit. The vacant orbital is quickly filled with an electron from an outer orbital, such as the L- or M-shell. The difference is

that electron-binding energy between the two orbitals is transformed into X-ray energy by emission of an X-ray photon. Since each element has specific orbital electron-binding energies, the X-ray energy produced is *characteristic* of that element (Figure 4.7). The practical significance: the manufacturer selects the target element based on the intended application. For example, molybdenum, with an atomic number of 42 and an average characteristic energy of 19 kiloelectron-volts (keV), provides a penetrating power most suitable for mammography. However, tungsten, with an atomic number of 74 and the higher average characteristic energy of 69 keV, is more appropriate for penetrating bone and therefore better suited for general radiography purposes.

Because both brems and characteristic radiation result from interactions outside the nucleus, they are considered *extra-nuclear* in origin. When the exposure terminates, X-rays are no longer produced and the area is then radiation free. However, with isotopes, the radiation originating with the nucleus is constantly produced and unless proper shielding is employed, presents a continuing exposure hazard.

X-rays are one type of electromagnetic radiation (EM); other forms include radiowaves, microwaves, and visible light. Although all forms travel at the speed of light, each type can be categorized by one of three characteristics: wavelength, frequency, or energy (Figure 4.8). The relationships among these parameters are well defined by the following equations:

$$\text{Wavelength}\,(\lambda) \times \text{frequency}\,(\mu) = \text{speed of light}\,(c)$$

$$\text{Frequency}\,(\mu) \times \text{Planck's constant}\,(h) = \text{Energy}\,(E)$$

$$\frac{ch}{\lambda} = E$$

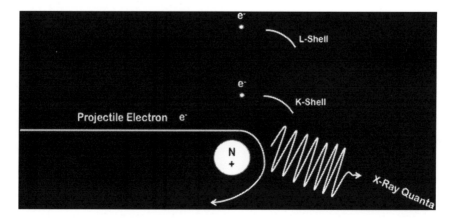

Figure 4.6 The creation of bremsstrahlung or brems X-ray quantum. The negatively charged projectile electron from the cathode travels between the K-shell and the positively charged nucleus in the anode or target. Since opposite charges attract, the projectile electron slows down and changes direction. The lost kinetic energy is converted to a quantum of X-ray energy.

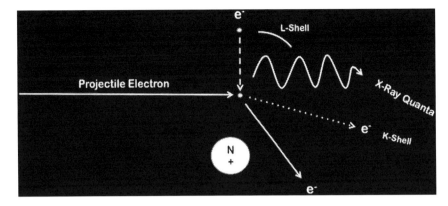

Figure 4.7 The creation of a characteristic X-ray quantum. The projectile electron strikes the K-shell electron in the target atom, knocking it completely out of its orbital. The vacancy in the K-shell is filled with an electron from an outer orbital, in this example, the L-shell. The difference in the binding energies of the two shells is given off as a quantum of X-ray energy.

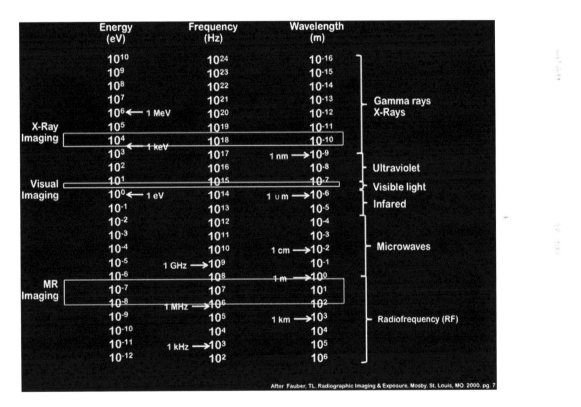

Figure 4.8 Components of the electromagnetic spectrum expressed as energy (electron-volts, eV), frequency (Hertz, Hz), and wavelength (meters, m).

The smallest quantity or unit of EM is termed a *photon* or *quantum*. The principal similarities and differences between each type of EM are clearly defined by the properties exhibited by each quantum. Radiographers, individuals educated in the physics or science and art of radiography, utilize the specific properties of X-ray to produce images in medical and non-medical situations. Since the objective here is not to serve as a physics text, only a brief description of selected properties and associated applications will be discussed and illustrated.

X-Ray Properties

1. Travels at the speed of light. Since both visible light and X-rays travel at the speed of light if a door is opened to a darkroom before the film can be safely stored, regardless of how quickly the door is closed, the unprotected film will be exposed.
2. Electrically neutral. Since X-ray quanta are not affected by electrical or magnetic fields, they cannot be focused the same way a stream of electrons can be directed.

3. Can remove electrons orbiting the nucleus resulting in ionization of matter. There are several applications and consequences associated with this property. First, it provides a method to detect radiation exposure in the air with apparatuses such as ionization chambers, pocket dosimeters, and Geiger–Müller counters. In addition, ionization of air is employed in automatic exposure control devices to terminate an exposure once a sufficient quantity of radiation has penetrated an object. Second, ionization of tissues is the basis for considering X-rays as both a biological hazard and a means of treating malignant tissues. Finally, the breaking of chemical bonds creating ions is the foundation for the next property, photographic effect.

4. Photographic effect (PE). A complex property most commonly associated with visible light, the PE defines the interaction between quanta and light-sensitive crystals in an emulsion. Because of this property, it is possible to record the image on an appropriate receptor. In fact, any light-sensitive film or photographic paper can be employed to record a radiographic image (Figure 4.9A–E). A more detailed discussion will be found in the section considering recording media.

5. Quanta diverge from the source and travel in a straight line (Figure 4.10). This property also has a number of imaging implications. The central portion of the X-ray beam is perpendicular to the source; however, the farther from the beam center and the source, the greater the angle of divergence and therefore distortion of the image. This effect is more pronounced at a shorter *source-to-image receptor-distance*, SID. Therefore, greater SIDs will result in radiographs with less image distortion in the central portion of the beam (Figure 4.11).

Magnification and distortion are another consequence of divergence of the X-ray beam. *Magnification* is equal enlargement of the entire image, whereas distortion is unequal magnification across the receptor. If the X-ray source is perpendicular to the image receptor and the object under study is parallel to

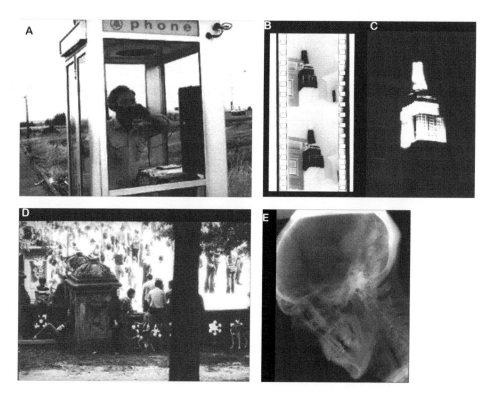

Figure 4.9 (A) 35mm photographic film printed on photographic paper. (B–C) Two frames of 35mm cine X-ray film (B) that is sensitized to low levels of the blue-green light emitted from a fluoroscopic screen printed on standard photographic paper (C). (D) 35mm cine X-ray negative taken in bright sunlight, printed on 14″ × 17″ X-ray film and finally digitized at 300 dots per inch (dpi). (E) Illford photographic paper loaded into a non-screen film holder and exposed at 55 kVp and 1000 mAs.

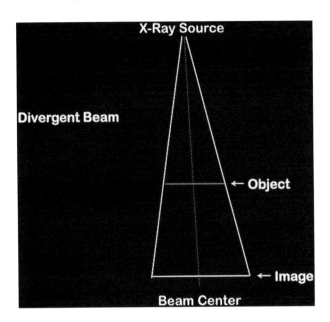

Figure 4.10 The beam of X-ray quanta diverge from the source and travel in a straight line.

Figure 4.11 A device created by Robert Lombardo using 16 3-in (8-cm) PVC pipes (A) The object was radiographed at 40-in (100-cm) SID (B), and 72-in (183-cm) SID (C) with the X-ray beam centered to the level of the metallic screws (arrow). Note that the least distortion is observed at the level of the central portion of the X-ray beam. In addition, distortion is more evident farther from the center of the beam and at the shorter SID.

Figure 4.12 A radiograph of a corrugated box: (A) is the top of the box farthest from the image receptor; (B) is the bottom of the box; and (C) holes to serve as finger grips in both sides of the box. The corrugations are parallel; however, due to divergence, they appear to diverge from where the center of the X-ray beam entered the box. Since the top and bottom of the box are parallel to the image receptor, both are magnified.

Figure 4.13 One side of the box (arrows) was elevated and the radiograph repeated. Now, both the bottom and top are no longer parallel to the image receptor and are therefore distorted.

the image receptor, the resulting radiograph will be magnified (Figure 4.12). However, if the object is not parallel to the image receptor or the receptor is not perpendicular to the source, the part of the object farther from the receptor will appear larger and the portion closer will appear smaller. This unequal magnification is termed *distortion* (Figure 4.13). All radiographs of complex-shaped objects will possess both magnification and distortion. Therefore, unless the magnification can be determined, it is not possible to obtain accurate measurement from radiographs. Since the SID is set by the person taking the radiographs, if the *object-to-image receptor-distance* (OID) is known, it is possible to calculate the *magnification factor* (MF), with the following formula (Figure 4.14):

$$SID - OID = Source\text{-}to\text{-}Object\ Distance\,(SOD)$$

$$\frac{SID}{SOD} = Magnification\ Factor\,(MF)$$

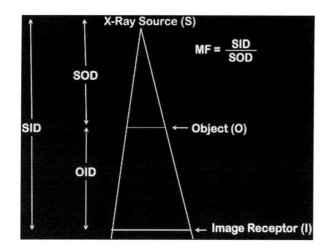

Figure 4.14 The formula used to calculate the magnification factor, where SID = Source-to-Image receptor-Distance, SOD = Source-to-Object Distance, and OID = Object-to-Image receptor-Distance.

Once the magnification factor has been calculated, the percent magnification (%M) can be derived using the following formula:

$$(MF-1)(100) = \%M$$

If an approximate MF needs to be calculated, for example in the case of a possible object within a mummy bundle, a plane midway through the bundle and parallel to the imaging plane can be used. Knowing full well that anything in the upper half of the bundle will be magnified more and in the lower half magnified less, this will provide a reasonable approximation.

Also, because of divergence, the beam intensity obeys the *inverse square law*. Basically, the intensity of the X-ray beam will vary inversely to the square of the distance from the X-ray source. For a number of reasons, discussed in more detail later, the SID may vary from a previous study. The following formula will be used to calculate the new intensity (Figure 4.15A–B):

$$In = Io\left(\frac{Do}{Dn}\right)^2$$

Where: In = the new intensity; Io = old intensity; Do = old distance; and Dn = new distance.

The distance measurements will be in either inches or centimeters and the radiation intensity measurements will be recorded as *rads* or *Grays* (*Gy*). The consequence of the distance change

is a required adjustment of the X-ray intensity, more specifically the mAs. The formula for that correction is known as the *direct square rule* and is defined as follows (Figure 4.16):

$$mAs_n = mAs_o\left(\frac{Dn}{Do}\right)^2$$

Where: mAs_n = the new mAs; mAs_o = the old mAs; Dn = new distance; and Do = old distance.

If a distance change is necessary, using this calculation will allow an accurate mAs to be determined without having to experiment with different settings, and possibly avoid wasting time, valuable film, and chemicals.

6. Unlike light, X-ray quanta cannot be reflected. However, since visible light and X-ray both exhibit equivalent divergence, it is possible, using a device known as a *light beam diaphragm* (UK) and *collimator* (US), to view the area that will be exposed to the X-ray beam. A light source is placed below the window in the X-ray tube where the X-ray beam emerges (Figure 4.17). A mirror is placed in the path of the X-ray beam and angled to reflect the light beam at the same angle as the X-ray beam that penetrates the mirror. Below where the X-ray and light beams combine are movable lead shutters that will permit the beams to be restricted or collimated to the desired area.

7. Instead of removing electrons from an orbit, quanta can cause electrons to be elevated to an excited state. The duration the electron remains in the excited condition is determined by the type of crystalline material comprising the image receptor. If, following the termination of the exposure, the electron returns to ground state in less than 10^{-8} s, the process is termed *fluorescence* (Figure 4.18). Fluorescence is the property that Röntgen observed in 1895 (Eisenberg, 1992). Crystals of certain materials, phosphors, will convert a single high-energy X-ray quantum into many lower-energy visible light quanta, therefore intensifying the photographic effect. Film holders equipped with intensifying screens will require less X-ray flux, therefore lower mAs and, as a result, less radiation dose than film holders without screens. A more thorough discussion will be presented in the image receptor section.

Other types of material, photostimulable phosphors, used in one approach to digital

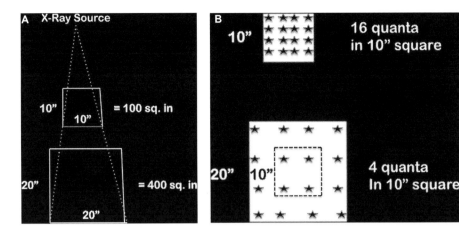

Figure 4.15 (A) Inverse square law. If an x-ray beam covers an area of 100 square inches (645 cm^2) and if the SID is doubled, the new area will encompass 400 square inches (2,580 cm^2). (B) Inverse square law. Since quanta diverge and travel in a straight line, the same total number of quanta would be found in each to the two areas. However, within the area at double the distance, only a quarter of the quanta will be found in the original area.

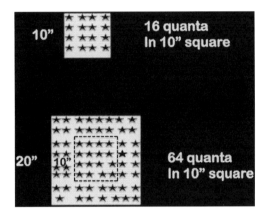

Figure 4.16 Direct square law. After doubling the distance, the mAs must be increased by a factor of four to ensure that the same number of quanta will be found within the original area at the new distance.

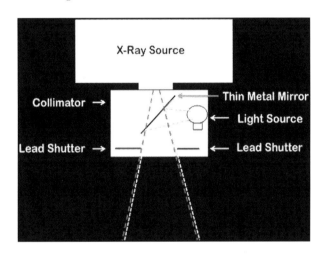

Figure 4.17 The collimator is a device that is equipped with lead shutters to permit adjustment of the area that will be irradiated. The device also contains a light source. Both visible light and X-ray quanta diverge at the same angle and travel in a straight line. However, since light can be reflected off a thin metal mirror, but X-rays will pass through the mirror, both the X-ray and light beams can be aligned to indicate the irradiated area.

imaging, *trap* electrons in the excited position until another form of energy, such as laser light, permits them to return to the ground state, releasing the trapped energy in the form of visible light (Figure 4.19). More regarding the process employed in digital radiography later.

Fluorescence is also employed with fluoroscopy. Unlike with plane radiographs, which can be compared to single image snap shots, with fluoroscopy, the X-ray output is continuously recording real-time motion as long as the exposure switch or pedal is activated. In order to reduce exposure, the fluorescent screen is coupled to an electronic image-intensification system and the entire process is recorded digitally. Fluoroscopy will also be discussed in a separate section.

8. Can adjust the beam penetration and differential attenuation (Figure 4.20). A radiograph is the result of differential attenuation. Dense material, such as bone, attenuates more X-radiation, with the result that the region on the processed image appears white. Less-dense material, such as muscle, permits more X-rays to reach the film, producing a shade of gray. Air attenuates very few quanta from the X-ray beam, resulting in a dense or black appearance on the processed radiograph. As stated above, increasing the kV increases the speed of the electrons traversing between the cathode and anode. As the electron speed increases, the average energy and frequency increase and the wavelength of the resulting quanta decreases. An X-ray of

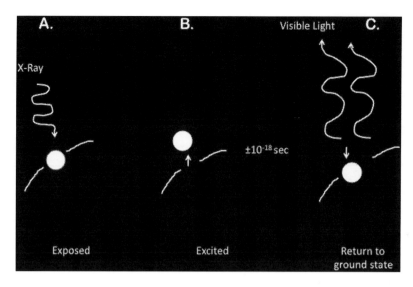

Figure 4.18 (A) The process of fluorescence results from a single X-ray quantum imparting energy into an outer shell electron in certain crystalline materials. (B) The electron will be elevated into an excited state where it will remain for approximately 10^{-18} seconds. (C) As the electron returns to the ground state, many lower-energy light quanta will be released.

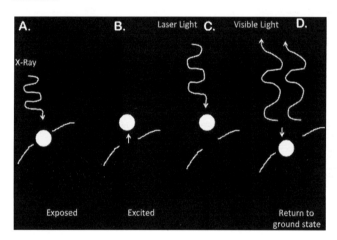

Figure 4.19 (A) When an X-ray quantum interacts with an outer shell electron in a photostimulable phosphor, (B) the electron will absorb a portion of the energy and be elevated to an excited state. The electron will remain in the elevated position until (C) a laser light interacts with the excited electron, causing it to (D) return to the ground state and release the stored energy as many quanta of visible light.

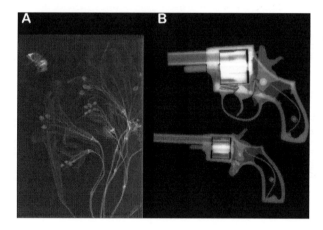

Figure 4.20 With radiography, the beam penetration can be adjusted to produce acceptable images of anything, from an insect and flowers, at 15 kV at 2 mA for 20 minutes (A), to two revolvers, at 250 kV at 4 mA for 10 seconds (B).

shorter wavelength and higher-frequency and energy will increase the penetration of the bone, resulting in a grayer appearance or *washing out* the less dense material on the processed film. Therefore, as a consequence of penetration, kV also controls radiographic contrast. *Contrast* may be defined as the difference between black and white. High contrast, black, white, and a few shades of gray would result from lower kV settings. As the kV is increased, attenuation decreases, resulting in more shades of gray or lower contrast.

9. Generated as a heterogeneous beam. Recall two types of interactions, termed brems and characteristic, take place in the target material. The maximum or peak energy is determined by the kilovoltage setting, commonly noted as *kVp*. The average energy of the X-ray beam, measured in kilo-electron volts, keV, is approximately 30% of the kVp set (Carlton and Adler, 1992) (Figure 4.21). Metallic filters, such as copper, can be added to remove the *softer* or lower energy component of the beam, resulting in a higher average energy. The use of filters will be discussed later.

10. Produces secondary and scatter radiation. Two principal consequences are relative to this property. First, scatter radiation permitted to reach

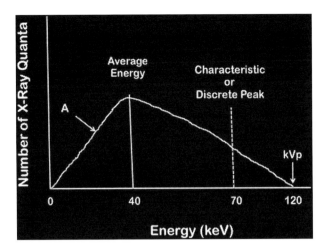

Figure 4.21 The graphic representation of the X-ray spectra generated at a setting of 120 kVp. The two interactions at the target are represented by: (1) The continuous spectrum (A) produced by bremsstrahlung or breaking interaction between the projectile electron and the target material, in this representation tungsten. The graph extends from "0" to the maximum or peak setting for the particular exposure, in this case 120 kV. The average energy output during the exposure is approximately 30% of the kVp setting. (2) The characteristic or discrete peak (dashed line) that is dependent on the atomic number of the target material and therefore unique to that material. In the case of a tungsten target, it is about 70 keV.

the exposed film will degrade the image by introducing noise and reducing the contrast or creating more shades of gray. There are several approaches to minimizing scatter radiation. The earliest form of beam-restricting device was termed a *cone*. Cones were manufactured either straight or flared (Figure 4.22). Unfortunately, although the device successfully reduced scatter, it did not allow visualization of the area to be irradiated. By the 1960s, collimators provided a method not only to minimize scatter radiation but also to restrict the X-ray beam to an area slightly larger than the object under examination and reduce the patient dose. In addition, placing an X-ray-absorbing material, such as lead sheeting, under the image receptor will prevent radiation that penetrated the back of the receptor from scattering back and exposing the film.

In the clinical setting, another approach to eliminating scatter radiation, usually on body parts thicker than about 12 cm (5 in), is to employ a device known as a secondary radiation grid, often referred to as simply a *grid*. Increased object thickness is generally compensated by increased kVp settings. As kVp is increased, the probability of scatter radiation increases.

Figure 4.22 Two styles of flare cones that would be placed under the window of the X-ray tube.

The device consists of alternating thin strips of a material that absorbs X-rays, *radiopaque*, and material that permits the unobstructed passage of X-rays, *radiolucent*. The efficiency of a grid is based upon two characteristics. The first is *grid ratio*, defined as the height of the radiopaque strip divided by the width of the radiolucent interspacing material (Figure 4.23). The higher the grid ratio, the more efficient the device is at eliminating scatter; however, the greater the mAs or increased kVp and subsequent radiation dose required to produce a satisfactory image (Table 4.1). The other grid characteristic is termed *grid frequency* and is defined as the number of radiopaque strips per centimeter. The higher the frequency, the less distinct the radiopaque grid lines demonstrated on the processed image.

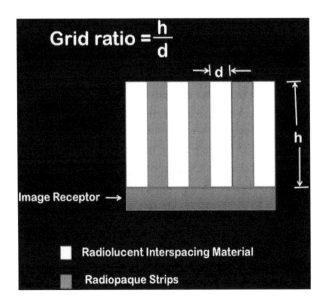

Figure 4.23 The grid ratio is calculated by a ratio of the height of the radiopaque strips to the thickness of the radiolucent interspacing material.

Table 4.1 Grid Ratios and the Corresponding Adjustment in mAs or kVp

Grid Ratio	Increase	
	mAs	kVp
No-Grid	1	0
5:1	2	+8 to 10
6:1	3	+10 to 12
8:1	4	+13 to 15
12:1	5	+20 to 25
16:1	6	+30 to 40

After Bushong (2013: 204)

Two of the most common types of grids encountered are reciprocating and stationary (Figure 4.24). Both types are positioned in front of the image receptor. With the former, the grid is incorporated into a larger device commonly known as a *Bucky*, which includes the image receptor tray built into the table. The term *Bucky* is a reference to Gustav Bucky, who, along with Hollis Potter, developed the device originally known as a Potter–Bucky diaphragm in 1913 (Gagliardi and McClennan, 1996). The grid moves back and forth, or has a reciprocating motion during the exposure, totally blurring out the radiopaque *grid lines* on the processed image.

A stationary grid can be placed over (Figure 4.25) or incorporated into the construction of a cassette (Figure 4.26). Generally, the radiopaque strips will be angled to match the beam divergence at a specific SID and this is identified as a *focused grid*. With this type of grid, it is important to ensure that the center of the X-ray beam is aligned to the center of the grid. In addition, the grid must be perpendicular to the X-ray beam. If the device is tilted or angled, the radiopaque strips will absorb the diverging quanta instead of the scatter, producing an effect known as grid cut-off. However, when employed in a situation with a high kVp setting, the grid is an excellent device to *clean up* the scatter and improve the image quality (Figure 4.27). In order to ensure that the proper settings are selected, all grids will have a label indicating the grid ratio, frequency and, if it is focused, the SID range (Figure 4.28).

A method to reduce the effects of scatter radiation without the use of a grid is a technique termed the *air gap*. When the cassette is placed next to the object, scattered quanta exiting the object will reach the image receptor, degrading the processed radiograph. Unlike in the use of a grid to absorb the scatter radiation, the cassette is placed at least 8 in (20 cm) from the object. This space or air gap results in the scatter quanta missing the image receptor (Figure 4.29; see Figure 4.98).

Possibly more significantly, secondary or scatter radiation presents a biological safety hazard not only to the X-ray equipment operator, but also to unaware individuals who may be standing within or walking past the area irradiated. Radiation protection will be discussed in a subsequent chapter.

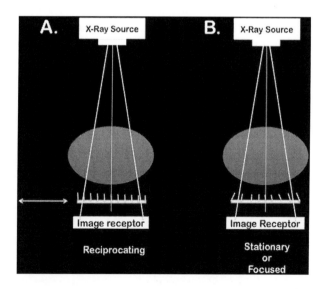

Figure 4.24 Grids are devices used to absorb scatter radiation. (A) Reciprocating grids are found above the image receptor tray, known as a Bucky, built into the X-ray table. During the exposure this type of grid moves rapidly from side to side to pick up scatter radiation. (B) Stationary grids are constructed so that the vertical lead strips match the angle of the divergent X-ray beam and are therefore designed to be utilized at specific distances.

X-Ray Source

X-ray sources can be divided into two general categories: medical and industrial. The latter will be discussed in a subsequent chapter. The medical group can be subdivided into fixed facilities and mobile units. Examples of the former would be found in major medical centers (Figure 4.30) and small imaging facilities (Figure 4.31). With the integration of digital recording systems into medical imaging approximately 20 years ago, it has become increasingly more difficult to just bring an object into a facility to X-ray. Digital systems that are designed for healthcare applications often require specific information to be entered into *fields* within the control interface, such as patient's name and an accession number, before an exposure can be made. When the object under investigation is not a patient, it may not be appropriate or possible to fill all the required fields before an image can be acquired. In addition, digital images are usually automatically saved into an archival system and billing to a patient's insurance provider is generally associated with the completion of an imaging study. Under certain

Figure 4.25 The front (A) and back (B) of a clip-on grid. Note the corners on the back (black arrows) that will hold the cassette in place. The view from the side (C) shows the cassette in place behind the grid.

Figure 4.26 A grid cassette (A) next to a regular cassette (B). Note the grid is thicker and heavier than the regular cassette.

circumstances, imaging studies cannot be carried out unless an insurance provider is guaranteed. In some cases, it may be possible for such *defaults* to be changed using software *administrator* privileges, and the relevant instruction manual will be able to provide guidance on this point.

Another type of fixed unit is a cabinet system, which is designed for the examination of specimens and, although also found in medical centers and hospitals, it would generally be confined to the pathology department (Figure 4.32). Because the unit is completely lead-lined, it is considered self-contained but extremely heavy, therefore not easily moveable. Older cabinets, constructed before the advent of digital recording systems, are still available and, while more than 40 years old, they still function reliably. A longer discussion

Figure 4.29 When the cassette is placed next to an object and no grid is employed, the scattered quanta (arrows) can reach the image receptor (A). With a space or air gap (dashed arrow) between the object and the cassette, the scattered quanta will miss the image receptor (B).

Figure 4.27 Two radiographs of a step wedge device taken at 80 kVp and 6.3 mAs. The high kV setting generated scatter radiation that partially obscured the image of the device (A). The second radiograph (B) used the same exposure setting; however, the image receptor was placed in a Bucky tray. The scatter radiation was absorbed by the reciprocating grid built into the Bucky tray.

regarding digital imaging cabinets will be provided later in this chapter.

Mobile X-ray sources provide more flexibility than the fixed units. Many medical mobile units, found in hospitals, are free of the constraints of an electrical outlet because they are battery operated. The latter are required not only to produce the electricity for an X-ray

exposure, but also to power a drive motor to move the machine. Unfortunately, due to the size of the batteries, the units are extremely heavy, confined to the floors in the hospital, and they require periodic recharging (Figure 4.33).

Radiography undertaken away from a medical facility, regardless of it being in a remote region in the cloud forest of Peru or in a museum located in the center of a metropolitan area, is considered field radiography. The X-ray source for field applications must be truly portable and there are several alternatives available. Several years ago, operational, older, low output dental X-ray tubes were readily obtainable. In addition, medical and veterinary units manufactured in the 1960s–70s could be purchased (Figure 4.34A–B). Although they are inexpensive, the weight of the X-ray tube and generator averaged about 80 lbs (36 kg) (Figure 4.35). However, today

Figure 4.28 The label on back of the clip-on grid, indicating the frequency (85 lines per inch), the grid ratio (8:1), and the SID range (40–72 inches).

Figure 4.30 A Toshiba Kalare X-ray unit in the Diagnostic Imaging Program suite at Quinnipiac University in North Haven, Connecticut that might typically be found in a medical center or free-standing imaging facility: X-ray source (A); collimator (B); Bucky tray for the image receptor (C). The X-ray source is mounted onto a system (D) attached to the ceiling to permit movement of the X-ray tube; the image intensifier is mounted on the fluoroscopic component of the unit (E).

Figure 4.31 X-ray unit found at the Office of the Chief Medical Examiner for the State of Connecticut: Toshiba Rotanode X-ray source (A); collimator (B); Bucky tray (C) that is not connected to the X-ray system and therefore is equipped with a stationary or focused grid; X-ray tube mount system attached to the floor (D).

a combined X-ray source/control unit equipped with high-frequency generator, capable of outputs up to 100 kVp and weighing less than 25 lbs (10 kg), costs approximately US$12,000 (Figure 4.36).

Portable units are either operated by a simple domestic power supply or, in the case of some modern units, by high-capacity batteries. Some units are equipped with automatic line voltage detection and compensation systems that enable their use in situations where the electricity supply is not inherently stable; some also facilitate

Figure 4.32 The Kubtec XPERT® 80, a digital self-contained X-ray cabinet system that might be found in a pathology department of a medical center (A). Older systems, such as a 1970s vintage Faxitron cabinet system (B), can still be found and provide excellent sources for film or CR image receptors.

Figure 4.33 A battery-operated Shimadzu Mobile Art Evolution X-ray unit in position to take an exposure (A). The X-ray tube rotated in position over the control area in preparation to be moved (B).

the use of electricity supplied from a portable generator. Once the X-ray source has been selected, a mechanism to support it must be either purchased (Figure 4.37A–B) or fabricated (Figure 4.38). The disadvantage of the support provided by the X-ray source vendor is the weight of the device, which may be as much as 50 lbs (23 kg). In order to support the X-ray source, regardless of the position selected, the device must be heavy enough to prevent the system from toppling over. Optimally, the fabricated support should weigh as little as possible, but no more than 12 lbs (5 kg). However, generally this approach will operate only in one direction, such as a vertical or horizontal support (Figure 4.39). The basis for a fabricated X-ray tube support should be simple while providing flexibility for various situations.

Approaches range from simply attaching the X-ray tube to a pole with duct tape (Figure 4.40), attaching a steel plate to a sawhorse (Figure 4.41), or even employing the base of a bathtub seat (Figure 4.42). The next step is to determine the height required to cover the largest-size object to be radiographed (Figure 4.43). Generally, at a 40-in (100-cm) SID, the X-ray beam can cover an area of 17 × 17 in (43 × 43 cm). Under certain conditions, the X-ray source can be placed on the floor and the image receptor placed on a support device above the object of interest (Figure 4.44).

Anodes, Heat Units, and Focal Spots

As previously indicated, the anode or target is the site where the projectile electrons, accelerated from the cathode, interact with the target material to produce X-ray energy. Anodes can be divided into two general categories: stationary or rotating. The earliest X-ray tubes utilized the stationary anode design; however, the process of X-ray generation is very inefficient, with approximately 1% of the electrical energy converted to X-ray and the remaining 99% lost in the form of heat. Due to this inherent problem, the output of the stationary anode X-ray tubes generally did not exceed 80 kVp and 15 mA. In order to more effectively dissipate heat, but unfortunately not increase the efficiency of the process, rotating anodes were developed that could also handle much higher outputs up to 140 kV and 300 mA at very short exposure time in the millisecond range.

The total heat units (HU) are determined by four factors: the kVp, responsible for accelerating the electrons across the tube; the mA, controlling the quantity of electrons available at the cathode; the exposure time, determining the total quantity of electrons interacting with the anode; and finally the current waveform, representing the voltage fluctuation produced by alternating current. The latter is the only factor that has not

Figure 4.35 A Korean War vintage Picker Army Field Unit was easily disassembled, but the components together weighed about 80 pounds, (26 kilograms): X-ray source (A); control component (B).

been previously referred to, but requires a little more consideration.

Three types of current are available for X-ray production: single-phase; three-phase; and high-frequency. Single-phase current (1Ø) is what most of us are familiar with in our everyday lives in the United States, used to operate all electrical appliances. It is an alternating current, which in the United States means the current changes direction every 1/120 of a second or does one complete cycle in 1/60 of a second (Figure 4.45). The term 60-cycle current refers to the number of complete cycles in a second. In Europe, instead of 60 cycles, it is generated at 50 cycles in a second. The direction of the current flow is indicated as positive (+) and negative (–) with the voltage going from zero to peak in the "+" direction, back to zero before reaching peak in the "–" direction, then returning to zero, all in 1/60 of a second. The X-ray tube, however, only operates on direct current and can only utilize the positive (+) phase of the cycle. In addition, a pulse of X-ray will only be produced when the voltage reaches peak, hence the term kilovoltage peak or kVp

Figure 4.34 (A) A 1970s vintage GX (General X-Ray) Model 303 mobile X-ray system: housing for the X-ray source (solid arrow); collimator (dashed arrow). (B) A disassembled 1960s GE 15 mA portable unit being prepared for shipping: X-ray source (solid arrow A) and control component (solid arrow B).

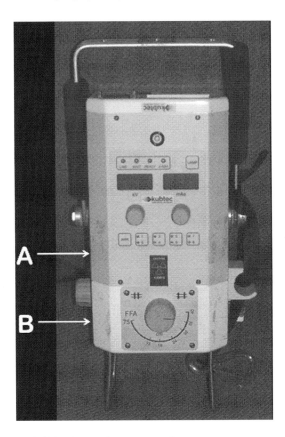

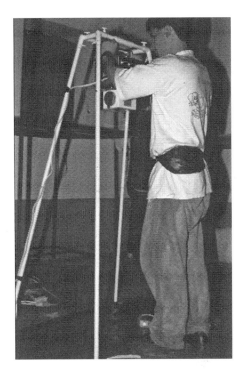

Figure 4.38 Joey Sallizar of Centro Mallque in Ilo, Peru setting up a fabricated X-ray source support device.

Figure 4.36 The Kubtec Extend® 100HF is a compact twenty-first century X-ray source combining X-ray source with control component (A) and collimator (B), and weighing less than 25 pounds (10 kilograms).

(Figure 4.46). Consequently, with single-phase current, there is only one pulse every 1/60 of a second. However, there is a method, termed *rectification*, that *flips* the negative phase so that there will be two peaks per 1/60 of a second (Figure 4.47). With this arrangement, it would be possible to reduce the exposure time in half to deliver the same quantity of X-ray, but between the peaks the voltage returns to zero, producing a 100% voltage fluctuation also termed *voltage ripple*. Nevertheless, single-phase results in the greatest voltage fluctuation and is the least efficient when producing X-rays. However, during the time between pulses, the X-ray tube has the opportunity to cool, therefore affecting heat production the least. Old dental and medical portable radiograph units were typically single-phase equipment, and were also the least expensive.

With three-phase current (3Ø), three simultaneous voltage waveforms are produced, but out of phase with each other (Figure 4.48). There are two principal advantages to this approach: there are more X-ray pulses per second, and the voltage never drops to zero

Figure 4.37 (A) The GX 1970s era X-ray tube support device provided by the manufacturer: X-ray source attachment mechanism (solid arrow) and support device (dashed arrow). (B) The twenty-first century Kubtec support device (dashed arrow) for the much smaller X-ray source (solid arrow).

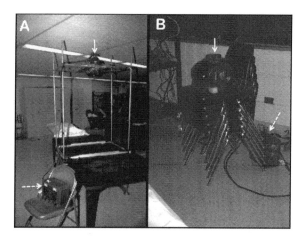

Figure 4.39 (A) The 1950s vintage X-ray tube (solid arrow) mounted onto an electro-mechanical tubing (EMT) frame set up for a vertically directed X-ray beam. The control unit (dashed arrow) was placed on a folding chair. (B) For the horizontal beam, the X-ray tube (solid arrow) had to be removed from the EMT tubing frame and placed on a stack of chairs to achieve the required height. Note the control unit (dashed arrow) placed on the floor.

Figure 4.40 A GE 15 mA portable X-ray tube attached to a wooden pole with duct tape as a support system (Beckett and Conlogue 2010: 38).

Figure 4.41 A 1950s era Keleket X-ray tube attached to a steel plate (solid arrow) by a thumbscrew (dashed arrow). The steel plate was fastened to a sawhorse to complete the support system. With this configuration, vertical- (A) and horizontal-beam (B) radiographs were acquired.

Figure 4.42 The top of a bathtub seat (A) was removed to create an X-ray tube stand (B).

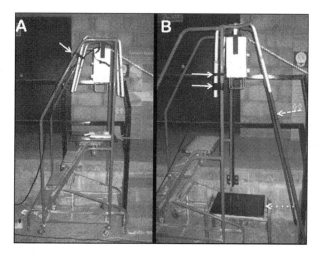

Figure 4.43 (A) At the Museum of London in 2013, the bath seat was incorporated into a stepladder X-ray tube support system. With the X-ray tube bolted to the bath seat, two legs of the seat were taped to the rails of the stepladder (solid arrow) and the CR plate (dashed arrow) placed on the top step. (B) In order to create a longer SID, two legs of the bath seat were taped to the support legs of the ladder (solid arrows) and two extension tubes (dotted arrow) were inserted into the remaining legs of the seat. The CR plate (dashed arrow) was placed on a small table below the X-ray tube.

(Figure 4.49). A consequence of more frequent pulses of X-ray and lower-voltage fluctuation is less time for the X-ray tube to cool and greater heat production. Voltage fluctuation or ripple can be reduced further and X-ray pulses increased by applying rectification to the wave-form (Figure 4.50). However, this increased efficiency results in greater HU per exposure. Until the 1990s, three-phase equipment, un-rectified and rectified, was commonly found in hospitals and free-standing imaging facilities.

The most efficient X-ray production results from incorporating high-frequency generators into the construction of the equipment (Figure 4.51). During the past several decades, advances in electronics have led to

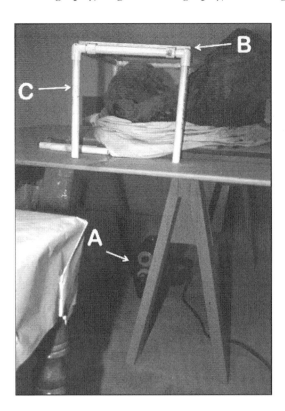

Figure 4.44 In a study in Amasya, Turkey, the X-ray source was placed on the floor (A) and the image receptor (B) was placed on a frame (C) constructed with PVC pipe.

Figure 4.45 Single-phase current generates one complete cycle every sixtieth of a second or 60 cycles in one second.

Figure 4.46 Because the X-ray tube can only utilize current flowing in one direction, direct current, only the "+" phase can produce a pulse of X-ray when the voltage reaches peak.

a great reduction in the size of electrical components, now making it possible to increase efficiency in the vast majority of X-ray units, including mobile and portable equipment currently manufactured. The only unfortunate consequence to increased efficiency is a rise in heat production.

Because stationary anodes require more time to dissipate heat than rotating anodes, a longer interval is necessary between successive exposures. The delay will allow the tube to cool, thus preventing damage to

and premature failure of the X-ray tube. In the clinical setting, due to the time required after an exposure to reposition the patient, this would not be a problem. However, in many non-traditional applications, only a few seconds may be required between exposures.

In the clinical setting, the calculation of HU is no longer essential. Modern equipment, particularly with high-frequency generators, will generally not permit an exposure to be made until the anode has cooled sufficiently. The duration between exposures in the clinical setting is usually also longer than in non-clinical application. In addition, if large objects are the focus of the study, multiple exposures with a single image receptor may be required. Therefore, the formula used to calculate HU and the interpretation of an anode heating/cooling curve graph (Figure 4.52) will be briefly considered. The calculation of HU is straightforward for single-phase current (Figure 4.53). However, because more heat is produced with the more efficient three-phase and high-frequency current, the formula is slightly modified. Once the HU have been calculated, it is then necessary to refer to the heating/cooling graph previously mentioned.

An example for the need to calculate HU and refer to a cooling graph was a study of the Winged Victory of Samothrace, a nineteenth century plaster replica of the second century BC marble sculpture of the Greek goddess Nike, located at the Slater Museum in Norwich, Connecticut. The curators at the museum wanted to learn the position of the internal support rods within the sculpture. Making the study more difficult, the statue was on a pedestal approximately 15 ft (4.6 m) above the museum floor. The closest the X-ray source could be positioned to include the entire wing resulted in a 22-ft or 264-in (671-cm) SID. In order to determine an acceptable exposure setting, a scaffold was erected alongside the statue

Figure 4.47 Single-phase rectified current flips the negative phase of the waveform to produce two X-ray pulses, but between the peak pulses the voltage still drops to zero.

Figure 4.48 Three-phase current generates three simultaneous waveforms slightly out of phase with each other.

and a single radiograph was taken with a 40-in (100-cm) SID at 90 kVP and 120 mAs. Since the maximum output of the X-ray source at 90 kVp was only 40 mAs, three exposures were necessary to achieve the total 120 mAs.

Using the direct square (see X-ray property #5), it was determined that a total of 131 exposures were required at 90 kVp and 40 mAs (Figure 4.54). Once the exposure factors were determined, it was possible to calculate the HU per exposure for the high-frequency generated X-ray source (Figure 4.55). With that data, it was possible to refer back to the anode heating/cooling curve to determine the cooling time of about 15 seconds between exposures (Figure 4.56). However, to be cautious, the time was extended to 30 seconds. The total time to complete the required 131 exposures along with the extended cooling period was approximately 90 minutes.

One other important note before leaving the discussion regarding current: in the United States, Canada, Mexico, and a few other countries, standard current is 110–120 volts at 60 Hz. However, in most of the rest of the world, electricity is generated at 220–230 volts at 50 Hz. It is imperative that the X-ray system and available

Figure 4.49 Three-phase current increases the number of X-ray pulses per second and reduces the voltage fluctuation, but the negative phase of each wave still cannot be utilized.

Figure 4.50 Three-phase rectified current doubles the X-ray pulses per second, and reduces the voltage fluctuation, but increases heat production.

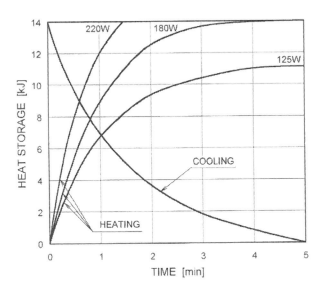

Figure 4.52 Anode heating/cooling curve for three Toshiba X-ray tubes.

current be matched or irreversible damage will be done to the unit. Some X-ray systems, such as the Sedecal unit manufactured in Spain, have an automatic switch that will adjust to the incoming voltage, while other units may have an internal switch that can be manually adjusted. If the unit cannot be adjusted, as in the case of the Kubtec™ XTEND 100HF, a mismatch will require a transformer to be introduced between the unit and the electrical outlet (Figure 4.57). The same requirements must be considered if the study is at a remote site and a gasoline generator is required as a power source. To ensure proper selection of a transformer or generator, contact the equipment vendor.

The actual area of the anode bombarded by the stream of electrons is termed the *actual focal spot*. In order to project the resulting X-ray beam out of the X-ray tube, the target face is angled. The degree of anode angulation determines the size of the projected area termed the *effective focal spot* (Figure 4.58). If film is the sole image-recording media, without using an intensifying screen, then the effective focal spot also determines

the maximum resolution available employing that particular X-ray tube. For example, a unit with a 1.0 mm effective focal spot cannot produce a sharp image of an object less than that size. This is not the case with a digital image receptor. That case will be considered shortly.

It is important to recognize that the use of a small focal spot will result in the generation of X-rays and thus a resultant heat over a smaller area, which will in turn limit the heat loading and thus output of the tube. For this reason, clinical, fixed diagnostic X-ray units generally have multiple effective focal spots, for example 1.0 and 2.0 mm. Units with multiple focal spots will have a greater selection of mA choices or *stations*. Lower mA stations would include 50 and 100 assigned to the smaller focal spot, while the larger focal spot would be employed for higher mA values, such as 150, 200, or 300 (Figure 4.59). Portable or mobile units typically are equipped with a single effective focal spot, generally

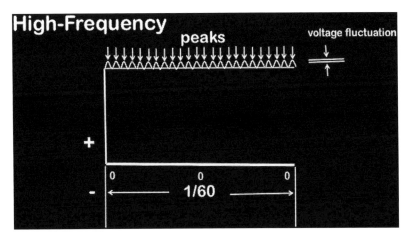

Figure 4.51 High-frequency generators result in the most X-ray pulses per second and the least voltage fluctuation, but the highest heat production.

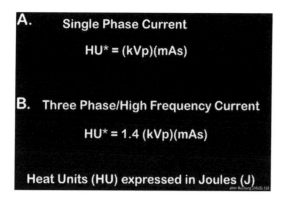

Figure 4.53 Depending on the type of current generation, two formulas are used to calculate heat units (HU).

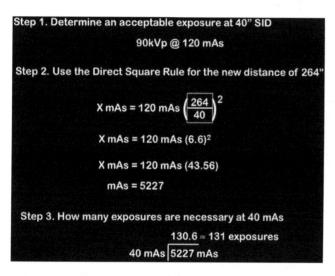

Figure 4.54 The procedure for calculating the new mAs at the longer SID using the original mAs at the shorter distance.

$$HU = 1.4 \, (kVp)(mAs)$$
$$HU = 1.4 \, (90) \, (40)$$
$$HU = 1.4 \, (3,600)$$
$$HU = 5040 \, J \approx 5 \, kJ$$

Figure 4.55 The calculation for determining the heat units (HU) for the exposure setting at the Slater Museum.

1.0 mm. If effective focal-spot size is less than 1.0 mm, for example in mammography units, it is considered to be a *fractional focal spot*. X-ray cabinet systems found in pathology departments also have fractional focal spots and may be referred to as *microradiography systems* because the resulting image would be viewed with magnification. With this latter system, because of the fractional focal spot, the object could also be elevated

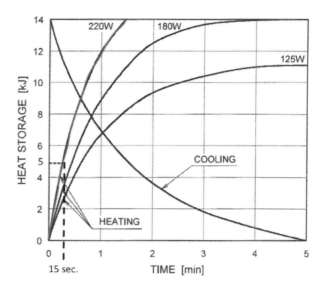

Figure 4.56 Toshiba D-124S X-ray tube utilizes the 220W curve. If the maximum heat storage is reached, it would require approximately 15 seconds for the tube to cool to "0."

Figure 4.57 A step-down transformer (arrow) employed in Gangi, Sicily to make it possible to use an X-ray tube intended for a 110-volt electrical system with the 220-volt Italian system.

fixed distances above the image receptor to create specific magnifications.

Image Receptor: Film

Any type of light-sensitive film or paper can be used to record a radiographic image (Figure 4.9E). Although film is not the recording media of choice for medical imaging in the twenty-first century, a discussion of the basic characteristics enables a more complete understanding of the factors involved in image production. First, recall there were three requirements for X-ray production: a source of electrons at the cathode; a force to

Figure 4.58 The area bombarded by the electron beam is termed the actual focal spot size. However, due to the angle of the anode face, the effective focal spot size projected out of the X-ray tube is smaller.

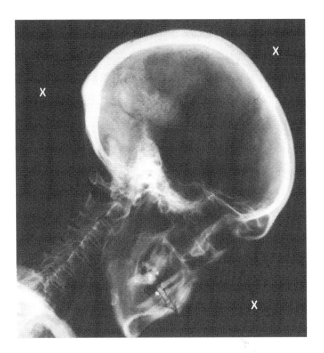

Figure 4.60 A lateral radiograph of the skull of a mummy. The area to evaluate the overall density or blackness on the film is indicated by "X."

Figure 4.59 The mA selector on the X-ray control panel at the Office of the Chief Medical Examiner for the State of Connecticut. Note the small focal spot choices are 50 and 100 mA while the large focal spot selections include 150, 200, and 300 mA.

accelerate the electrons away from the cathode; and a target or anode for the conversion of high-speed electrical energy to X-ray energy.

The source of electrons is controlled by the mA and the total number of electrons released during an exposure is determined by the mA multiplied by the duration of the exposure in seconds, referred to as mAs. The latter

contributes to the overall density or *blackness* on the processed film and is most evident in the areas outside of the object of interest (Figure 4.60). If those areas lack density and are not sufficiently black, the radiograph is considered underexposed and a minimum increase of 40–50% in the mAs is required. Conversely, if the area examined is overly dense, with it even affecting the visibility of the object, a minimum reduction in the mAs by 40–50% is necessary (Figure 4.61).

When changes in mAs are required in a non-clinical setting, it is advisable to change the exposure time rather than increase or decrease the mA. The actual mA settings or *stations* are supposed to be proportional to each other, a principle known as *linearity*. For example, the 50 mA station should be half the value of the 100 mA station. If the unit is properly calibrated, that would be the case. However, an infrequent calibration could result in a lack of linearity. Since the timer, on most units, is much more accurate, it is therefore more reliable to depend on that setting. In addition, unlike in the clinical setting, working with live patients, longer exposures on an object that has been stabilized will generally not result in motion artifacts on the radiograph (Figure 4.62).

The force determining the acceleration of the electrons and resulting penetrating ability of the X-ray quanta is the kVp (refer to property #8). In clinical radiography, each body part, such as skull or femur, has a suggested kVp setting for optimal penetration (Table 4.2). The degree of penetration determines another image quality factor previously described as *contrast*. Therefore, an

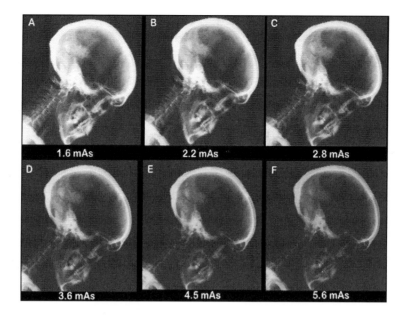

Figure 4.61 A series of lateral radiographs with minor mAs changes between exposures: A–B 38%; B–C 27%; C–D 29%; D–E 25%; and E–F 24%.

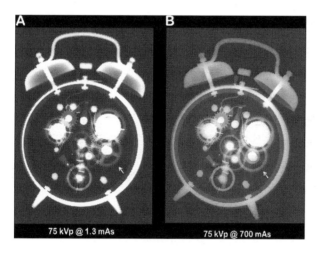

Figure 4.62 Two exposures taken of a functioning spring-operated alarm clock: the exposure with the film in the cassette-equipped intensifying screens (A) has fewer shades of gray, but because it was acquired with a very short exposure, the teeth on the gears are clearly demonstrated (arrow); the non-screen radiograph (B) has a longer scale of contrast; however, with an exposure 539 times longer, has blurred the teeth on the faster moving gear (arrow).

Table 4.2 In the Clinical Practice Setting, kVp Values Have Been Determined for Specific Body Parts/Regions and a Range of Thickness

Body Part	Position	Ave. Thickness (cm)*	kVp
Skull	PA	18–21	85
	Lat	16–18	85
Chest	PA	15–17	80
Abdomen	AP	17–21	70
Pelvis	AP	17–20	80
Femur	AP	14–17	80
Knee	AP	11–14	80
Humerus	All views	7–10	60
Elbow	AP	6–9	60
Hand	PA/Obl	3–5	50

*Increase or decrease 2 kVp/cm; After Cahoon (1961: 181–183)

image with high contrast would have few grays separating black from white, and results from the use of lower kVp settings. As the kVp is increased, increasing penetration, more shades of gray appear in the processed radiograph and the image is said to have a longer scale of contrast. On the processed radiograph, the region to assess penetration is within the object of interest. If structures within the object are clearly visualized, there is adequate penetration (Figure 4.63). However, if there is a lack of structural visualization within the object, the image is described as *underpenetrated*.

The optimal radiograph has a balance between density, determined by mAs, and penetration/contrast, controlled by kVp. However, there is a relationship between the two principal exposure factors defined by the empirically derived *15% Rule* (Bushong, 2013: 248, 10th ed.). If it is determined that a subsequent radiograph is required with fewer shades of gray (increased contrast, shorter scale of contrast), but the overall density is acceptable, the technical factors are adjusted by decreasing the kVp by 15% and doubling the mAs. Conversely, if additional images are desired with more shades of gray (lower contrast, longer scale of contrast), the kVp would be increased by 15% and the mAs decreased by 50% (Figure 4.64).

Film, specifically intended for radiography, can be divided into two broad categories, industrial and

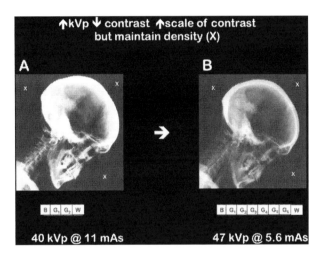

Figure 4.63 The area around the skull (X) is sufficiently dense, indicating satisfactory mAs. When evaluating the kVp selection, attention should be focused within the part of interest. In the lateral radiograph of the skull, an important aspect would be visualization of the brain (arrow). However, the posterior portion of the brain is visualized well with 63 kVp (A), but not clearly delineated at 40 kVp (B).

Figure 4.64 Application of the 15% Rule. Observing the density or overall blackness in the areas indicated by the "X" in both radiographs, we can see that they are the same. However, the image with the lower kV setting (A) has increased contrast and, correspondingly, a shorter scale of contrast than the radiograph with the 15% increase in kV (B).

medical. The former will be considered in the section dedicated to industrial radiography. All film has a specific relationship between exposure and the resulting density. Graphically, the relationship is known as a *characteristic curve* or a *Hurter and Driffield (H&D) Curve*, and the study of the relationship is termed *sensitometry* (Figure 4.65). The slope of the straight-line portion of the graph determines the *film latitude* or acceptable range of exposure. For example, a steep slope would possess a narrower latitude and fewer acceptable exposure choices. With a shallower slope, the film would be considered to have wider latitude and more acceptable variability in exposure settings. An exposure setting outside of the

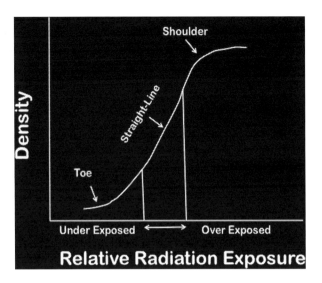

Figure 4.65 The graphic representation of the relationship between exposure and density on the processed radiograph. Known as a Characteristic Curve or Hurter and Driffield (H&D) Curve, the curve is divided into three regions: *Toe*; *Straight-Line*; and *Shoulder*. The acceptable exposure is limited to the Straight-Line section, with a lower setting resulting in underexposure and a higher setting producing overexposure.

acceptable range would be considered either under- or overexposed and the radiograph would have to be repeated.

Medical film can be further categorized as non-screen or screen film. The former is exposed solely by the action of X-ray and, relatively speaking, would require a very long exposure time. Non-screen film has a photosensitive emulsion applied to only one side of the film base. The composition of the single emulsion has an inherent higher resolution than film intended for use with intensifying screens. In order to indicate the emulsion side, a notch or series of notches are located in the upper right corner of the shorter side of the film when the emulsion side is facing up (Figure 4.66). In order to distinguish different types of non-screen film, the notch pattern varies (Figure 4.67), while film intended for use with intensifying screens has smooth non-notched edges (Figure 4.68). Radiographs produced with non-screen film have extremely wide latitude and long scale contrast with many shades of gray. Any film, even if intended for use with intensifying screens, can be used in a non-screen film holder with resulting wider latitude (Figures 4.69 and 4.70). Commercially available non-screen film holders are found in disposable *READY PACK*™ (Figure 4.71) and in the form of reusable cardboard or vinyl (Figure 4.72) film holders. The latter are loaded using a very specific sequence of steps (Figure 4.73A–B), but light-tight black plastic can also be used (Figure 4.74A–C).

Figure 4.66 Single emulsion Fuji Mammography AD-M film, with a notch cut (arrow) in the upper right corner on the shorter side of the film, when the emulsion is facing up. The emulsion side (A) also appears dull compared to the non-emulsion side (B) that looks shiny.

Figure 4.67 Each type of non-screen film has a different notch pattern. Fuji Mammography AD-M, 18 × 24 cm (A); and Fujifilm IX 20, 11.4 × 25.4 cm (B).

Figure 4.68 Radiographic film intended for use with intensifying screens has an emulsion on both sides and therefore lacks a notched side.

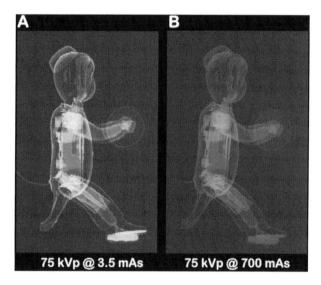

75 kVp @ 3.5 mAs 75 kVp @ 700 mAs

Figure 4.69 Two exposures: (A) screen film in a cassette with intensifying screens has increased contrast and narrow latitude, exhibiting fewer shades of gray, and (B) screen film in a non-screen holder demonstrating lower contrast, wider latitude, and more shades of gray.

Most medical radiographic film available today has been developed for use in a film holder, or *cassette*, equipped with intensifying screens. The function of the latter is to transform a high-energy X-ray quantum into many lower-energy light quanta. Each vendor has produced an intensifying screen that emits light at a very specific wavelength (Figure 4.75). Correspondingly, they manufacture film that would be most sensitive to the light emitted by those specific screens. Therefore, a mismatch of intensifying screens and film will result in a less-than-optimal image and require an adjustment in the exposure time.

The primary function of the intensifying screen is to reduce the dose of radiation required to produce an acceptable radiograph of a patient. Intensifying screens are rated based on the relative efficiency of the X-ray/light conversion termed *conversion efficiency* or CE. A system was developed, known as *relative speed index*, RSI, with values ranging from 50 to 400 RSI. Although a bit simplistic, the easiest way to understand the system is to think the 50 RSI would convert one quantum to X-ray to 50 quanta of visible light while the 400 RSI will produce 400 light quanta. The former will require a longer exposure than the latter. However, the higher-speed screen has a narrower latitude and produces higher-contrast images with less detail. In general, film intended for use in cassettes with intensifying screens has lower resolution than non-screen film because the former is exposed to the light emitted by the screens.

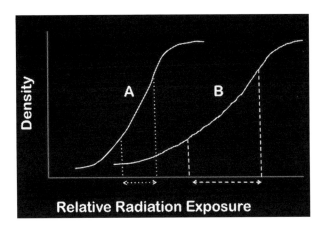

Figure 4.70 A comparison of H&D curves for screen film exposed with intensifying screens (A) and in a non-screen film holder (B). Note the lower exposure values required and narrow latitude of (A) (dotted line) compared to (B) (dashed line).

Cassettes have been manufactured with either one or two intensifying screens. The single-screen cassette is generally rated at 50 RSI and employed for the high-resolution imaging required for mammography. Due to the specialty application, mammography cassettes were generally not larger than 10×12 in (24×30 cm). The film used with this system has a photosensitive emulsion coated only on one side of the film, similar to non-screen film. To function optimally, the emulsion side of the film must be placed into the cassette facing the intensifying screen. If the non-emulsion side is placed against the screen, sufficient light might not be produced from the intensifying screen to penetrate to the emulsion side of the film, resulting in an underexposed radiograph and requiring a repeat exposure.

Other films meant for use in cassettes equipped with two intensifying screens have an emulsion on either side, so they cannot be improperly placed into the film holder. Because the cassettes were intended for a wide variety of clinical radiographic procedures, they were manufactured in a variety of sizes ranging from 8×10 in (20×25 cm) to 14×17 in (36×43 cm). Up until about the 1990s, a 14×36-in (36×91-cm) cassette and film were manufactured for X-rays of the spine or entire extremities. However, as digital image systems began to replace film as the recording media of choice, these large cassettes and then film became less available until they were finally discontinued.

Film Processing

Until about the 1960s, most radiographs were processed manually in stainless-steel tanks. Although more than 50 years have passed, manual processing hasn't changed. The most common processing configuration had one 5 gal (18.9 l) tank containing developer and another 5 gal (18.9 l) tank with fixer immersed in a much larger tank filled with circulating water maintained at a constant temperature of 68 °F (20 °C). At that temperature, film would be developed for approximately 5 minutes, fixed for 10, and washed for 30 minutes. In the darkroom, exposed film is removed from the cassette and clipped into a wire film hanger (Figure 4.76). Based on the temperature, film is first immersed into developer for a specific amount of time. One of the functions of the chemically basic developer is to change the exposed silver halide crystals, embedded in the film emulsion, into

Figure 4.71 A single sheet of screen film within a disposable Kodak X-Omat V *READY PACK*™.

Figure 4.72 Commercially available 14 × 17-in non-screen film holders made of cardboard (A) and vinyl (B).

Figure 4.73 Step 1: All flaps of the vinyl film holder are opened and the film placed into the holder. Step 2: Flap A is folded over the film, followed by Flaps B. Step 3: Flap C is folded over both B Flaps. Step 4: Flap D is folded over to completely enclose the film.

Figure 4.74 (A) A non-screen film holder can be created using the black plastic liner from a box of 14 × 17-in Agfa X-ray film (arrow A) and one of the two sheets of white cardboard (arrow B) also from the film box. (B) The cardboard is slid into the plastic envelope to provide stiffness. (C) After the film is loaded into the plastic envelope, the top is folded over and sealed with duct tape.

Figure 4.75 Vendors manufacture intensifying screens that emit light within a specific range of the spectrum and film sensitive to that emission.

Figure 4.76 A demonstration of the proper method to load a 14 × 36-in film onto a hanger for developing.

black metallic silver by donating electrons to the silver ions. During development, the film is gently agitated to bring fresh developer to the surface while removing the spent chemical. Proportionally to the surface area of the film, a specific volume of developer is *exhausted* and therefore incapable of providing electrons to reduce the metallic silver ions. Once the desired time is reached, the film is transferred into the water with continued agitation to remove the developer. During the transfer process, a certain amount of developer will remain on the surface of the film, reducing the volume in the developer tank. Therefore, fresh developer, termed *replenisher*, must be added periodically to the developer tank. If the level in the tank is permitted to drop below the top of the film when it is immersed into the developer, the area above the level of the chemical will remain undeveloped

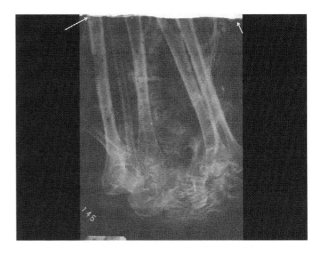

Figure 4.77 An AP projection of a Chachapoya mummy (CMA 145) that was manually processed. The level of developer was below the top of the exposed film, creating a region that was not developed (arrow).

(Figure 4.77). The easiest approach to replenishment would be to add developer to the tank whenever the chemical level drops to approximately the top of the immersed film. Instead of replenisher, water could be added to top off the tank. However, this method dilutes the developer, so the entire 5 gal (18.9 l) tank should be dumped after a total of 100 films have been processed and the tank refilled with fresh developer for the next 100 films.

After approximately 30 seconds of washing, the film is moved into the chemically acidic fixer tank with continued agitation to neutralize the developer and stop development, remove the unexposed silver from the film, and *fix* the black metallic silver to the film base. Although the fixing time should be about double the developing time, after approximately 30 seconds in the fixer, the lights can be turned on. Following fixing, the now-processed radiograph would be placed back into the water to be washed. The fixer is not as sensitive as the developer, and replenishment of the chemical can be accomplished by simply topping off the level in the tank with fresh fixer.

While an often overlooked phase of manual processing, insufficient removal of fixer will result in decreased archival capacity of radiographs. Radiographs that have been inadequately washed will have an odor of a component of fixer, acetic acid, that smells similar to vinegar. Therefore, washing in circulating water should be three times the fixing period. When washing is completed, the radiographs must dry completely before the images are filed away. Ineffectually dried radiographs will stick together. If this is the case, immersing the films in water for several minutes may help to separate the radiographs, and thorough drying may help recover the

X-rays. If stuck films are separated without this step, the emulsion will be torn off the surface of the film.

Finding a facility, even veterinary or chiropractic, that still utilizes manual processing could be difficult. However, a low-volume undertaking can be easily accomplished employing flat photographic film trays that would accommodate the desired size film (Figure 4.78). In 2012, for a study of objects at the Barnum Museum in Bridgeport, Connecticut, a temporary darkroom was set up in a basement restroom of the museum. Since the chemistry was intended for use in an automatic processor set at 90 °F (32 °C) rather than the ambient temperature of the restroom, about 68 °F (20 °C), a procedure known as *sight development* was employed. In this case, instead of development being time dependent, an X-ray safelight with a 6B Wratten filter was utilized to determine when to terminate development. A student radiographer immersed the exposed film into the developer and, periodically, interrupted the continuous agitation to view the stage of development using the safelight. When they just began to perceive an image, after approximately 60 seconds, development was terminated, and the film was transferred into the fixer (Figure 4.79). Although this is not the best method to process a film for archival purposes, as long as the radiograph is digitized shortly after acquisition, image storage should not be a problem.

One other point that must be made before leaving a discussion regarding manual processing is that care must be taken to prevent any fixer from contaminating the developer. Small quantities of the acidic fixer will neutralize the basic developer, rendering it ineffective.

Figure 4.78 (A) Manual processing using commercially available 8 × 10-in photographic trays. Note running water for wash. (B) Manual processing set-up using ordinary plastic containers.

Figure 4.79 Quinnipiac University radiography student, Milad Ziyadeh, removing the processed film from the fixer solution (A). The film was processed in the totally darkened restroom at the Barnum Museum with the aid of the safe light. The developer and fixer tray were placed on a rack set over the sink that contained a larger tray for washing the film. The processed radiograph of a telephone receiver was later digitized (B).

Once the developer has been contaminated, the entire volume of the chemical must be discarded and replaced. The problems related to the disposal of chemicals will be discussed shortly.

By the 1960s, manual processing was being replaced by automatic processing units. One of the major disadvantages of manual processing was that from the time the film first went into the developer until it was dried it was approximately 45 minutes. The earliest the radiograph could be viewed was after it had been in the fixer for a minute or so, about 7 minutes into the procedure. Because the radiograph had to be returned for the remaining fixation and wash, viewing the radiograph at this stage for interpretation was termed a *wet reading*. Mechanical or more commonly termed *automatic processors* were developed to speed up the processing steps. The first automatic processors were large, about 10 ft (3 m) long and, for several of the units, a ceiling-mounted crane apparatus was required to lift the transport roller units out of the machines for cleaning. Today, automatic processing unit can be placed on a tabletop and the entire processing time reduced to approximately 45 to 90 seconds. In order to reduce the processing time, the developer temperature has risen from 68 to 90 °F (20 to 32 °C).

Before the automatic processors were commonly found in the radiology department, a Polaroid system was introduced in the 1950s for medical imaging. This system, like Polaroid camera film, did not require immersion development but rather the packet contained a "negative sheet," a pod of paste-like material, and a "positive transfer sheet." The exposed pack was then placed in a mechanism that contained rollers that spread the paste-like material between the negative and positive sheets. The "image" was transferred to the positive sheet and as with many types of Polaroid products, the negative sheet covered with paste was discarded. The largest-size image receptor that could be manufactured for the system was 8×10 in (20×25 cm) and was primarily employed only for imaging in the operating room. Possibly due to the limited size and rapid implementation of the automatic units that would produce a dry radiograph in approximately 3 minutes, the Polaroid system became obsolete by the mid-to-late 1960s.

In the mid-1980s an old Polaroid processor, recovered from a hospital storage area at Thomas Jefferson University Hospital in Philadelphia, Pennsylvania, was employed in a study at the Mütter Museum, in that city. The museum requested a radiographic study of a mummy that was too fragile for transport to an imaging facility. Because the relative speeds of both imaging systems were comparable, the Polaroid system was employed to determine the appropriate exposure factors required for the regular clinical film/screen imaging system (Figure 4.80). Exposed films were transported to an automatic processor at a hospital (Conlogue, Schlenk, Cerrone, and Ogden, 1989).

The same processor was used to determine if a skull in a private collection was real or fake. In this situation, since the intent of the study was simply to document the

Figure 4.80 A late 1960s era Polaroid processor intended for medical use (A). Note the special cassette (arrow) loaded into the processor. A Polaroid lateral skull radiograph (B) of Soap Lady mummy from the Mütter Museum at the College of Physicians of Philadelphia in Philadelphia, Pennsylvania. Note that the image is a positive and not the familiar negative obtained with radiographic film. Polaroid images were employed in 1986 to determine the optimal technical setting with convention film/intensifying screen cassette.

nature of the skull, the Polaroid image was sufficient and an exposure made on conventional radiographic film was not necessary (Figure 4.81).

Tabletop processing was a major advance in radiography; however, this approach still had several disadvantages. Even though the new units had much smaller internal tanks (Figure 4.82) than the larger older processor (Figure 4.83), most still required wet chemistry and plumbing for attachment to a water supply. Units such as the Ecomax™ (Protec GmbH & Co. KG) tabletop film processors are available that use water tanks rather than main water for washing, allowing field deployment

Figure 4.81 A 2001 study in the home of a private collector. The Polaroid cassette (A) was placed behind the skull (B) that was sealed in a pyramid-shaped container. The radiograph was taken with a 1950s era Picker Field Army X-ray source (C) with a fabricated support system (D). On the processed image (E), the frontal sinuses and orbits indicate that the skull is genuine.

Figure 4.82 Because the Konica SRX-101A tabletop processor is intended for a lower film volume, processing tanks are smaller. The developer roller rack has been removed to reveal the size of the developer tank. The entire system is located within the darkroom.

Figure 4.83 Outside the darkroom (A), a Kodak M6B Processor intended for an optimal workflow of greater than 100 14 × 17-in films per day. (B) Inside the darkroom.

(https://protec-med.com/en/product/human-medicine/film-processor/33-ecomax.html). Like the larger units, replenishment tanks for developer and fixer, although smaller, were necessary. Not only can those requirements be messy due to leaks or spillage, but exposure to developer and fixer fumes can be hazardous and the darkroom should be vented to the outside. In addition, used fixer contains the unexposed silver halide crystals, considered by the Environmental Protection Agency (EPA) as a heavy metal, and can no longer be allowed to flow out the drain into the public water system.

Large-volume field radiographic facilities employing manual processing were established in Peru in 1998 using salvaged stainless-steel developer and fixer tanks (Conlogue, Guillén, and Salazar, 1999), and later fabricated wooden tanks lined with plastic (Conlogue and Beckett, 2013) (Figure 4.84). In all situations, the processed film was washed with running water and hung out on lines to air dry. However, a number of difficulties were encountered with these studies. Chemicals had to be transported to the site and dumping of used developer and fixer raised ethical questions. Since automatic processors had been around for nearly 50 years, it was difficult to locate film that was not intended for automatic processing and the higher development temperatures. Because medical facilities cannot use outdated film, the film used for these studies was obtained from medical clinics and film distributors without charge. In fact, the radiology laboratory for the Diagnostic Imaging Program at Quinnipiac University has frequently used

outdated film. The only consequence to this approach to reduce costs is that the unexposed base of the film, when processed, will not be clear, but will appear more gray.

In order to avoid dealing with wet processing, for a time a Polaroid system provided a 4 × 5-in (Figure 4.85A–B) and an 8 × 10-in (Figure 4.86) alternative (Conlogue and Nelson, 1999). While easier to process, these films required a longer exposure than regular X-ray film to produce an image. Unfortunately, in 2001 Polaroid Corporation declared bankruptcy and film production ceased, eliminating the alternative to wet processing. Today there is renewed production of some types of Polaroid materials, including black-and-white 8 × 10-in film; however, the website advises, "it requires special equipment, a lot of manual processing and even more technical knowhow, so if you're not a seasoned veteran, you may want to try one of our other formats first." (https://us.polaroidoriginals.com › Instant Film › 8 × 10 Film). In addition, as of 13 February 2019, a pack of 10 sheets costs US$179.99 (https://www.amazon.com/Polaroid-Originals-Instant-Film-4681/dp/B07BJG5JJF). Moreover, tighter airport security, which was one of the consequences of the terrorist attacks of September 11, 2001, made it nearly impossible to transport X-ray film internationally, eliminating the availability of free film and increasing the cost of field studies.

Regardless of how the film will be processed, some type of identification system must be used, particularly if a number of exposures are going to be taken prior to processing. One of the original approaches was to use

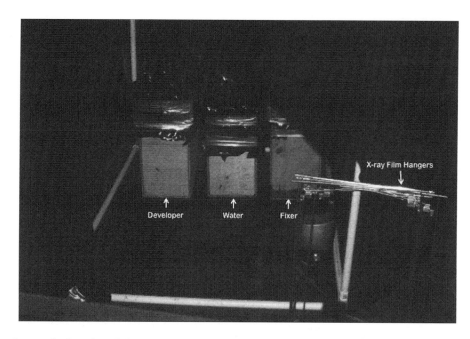

Figure 4.84 Wooden tanks lined with heavy plastic were used to hold chemicals in a portable darkroom constructed in Leymebamba, Peru in 1998. Note the 14 × 17-in film hangers resting on the side of the darkroom.

Figure 4.85 (A) A 4×5-in Polaroid Type 55 film processor. (B). In a study conducted in El Algarrobal, Peru in 1998, a lateral projection of the head and neck of a femur using 4×5-in Polaroid Type 53 photographic film. The resulting radiograph demonstrated the trabecular pattern that can be employed to assess changes due to age.

Figure 4.86 (A) An 8×10-in Polaroid cassette (arrow) placed inside of the Polaroid processing unit. (B) A lateral chest radiograph on Polaroid 8×10-in photographic film of a mummy in Benguet, Philippines. Note the wide latitude demonstrated on the image with the trachea (arrow) clearly shown.

lead numbers and letters to not only identify the patient but also indicate right or left side (Figure 4.87). By the 1950s and 1960s, cassettes were manufactured with a leaded rectangle in one corner of the device (Figure 4.88). On the processed film, this area would appear clear (Figure 4.89). The intent was to create a location to imprint patient information. The latter was handwritten or typed onto what looked like an index card. In the darkroom, the card was placed into an imprinting device known as a *flasher*. Since in the United Kingdom, the latter describes a person who indecently exposes themselves to others, the proper terminology there for the device is *actinic marker*. Initially, the exposed film was removed from the cassette and the corner that was under the lead blocker was placed into the flasher, the top of the device was depressed, and a light would flash the information from the card onto the film. Later versions eliminated the need to remove the exposed film from the cassette. The corner of the cassette was pushed into the flasher and a mechanism would slide open the

blocker in the corner and automatically flash the information onto the film (Figure 4.90). A homemade *actinic marker* or *flashing device* was built by one of the authors, Mark Viner, when working at a United Nations Mission in Sierra Leone (UNAMSIL) mortuary in Freetown, Sierra Leone (Figure 4.91A–C). He needed a method to identify or mark the exposed films in the makeshift

Figure 4.89 A radiograph of the skull and upper chest region of a Chachapoya mummy taken in 1998 at a field facility set-up in Leymebamba, Peru. Note the clear area in the corner of the image (arrow) that indicates the location of the lead blocker.

Figure 4.87 The lead number/letter identification system used by the Office of the Chief Medical Examiner for the State of Connecticut, indicating the year (A), case number (B), and the right side of the victim (C).

Figure 4.88 An open cassette demonstrating the leaded blocker in the corner (A) and a sheet of film (B).

Figure 4.90 The upper right corner of the front of the cassette indicating the area of the lead blocker (A). The backside of the cassette (B), showing the position of the lead blocker (C) and the small depression (D) that engages with the mechanism in the flasher or actinic marker to open the blocker.

Figure 4.91 (A) A homemade actinic marker or flashing device (image A) created by combining an empty plastic bottle and a torch, showing the torch or flashlight on/off switch (arrow). (Image B) Bottom of the plastic bottle removed and replaced with several layers of cleared x-ray film. (B) Front projection of the homemade actinic marker (bottle C) taken on a CR plate at a 40-inch (100-cm) SID with 72 kVP and 2.0 mAs. Note the margin of the torch (solid arrows) and the lens (dotted arrow). Due to superimposition, it is not easily possible to differentiate the internal components of the torch. (Bottle D) A side view of the device not only reveals details of the torch, the batteries (dashed arrows), and the bulb (dotted/dashed arrow), but also the margin of the torch (solid arrows) and lens (dotted arrow) seen on the front view. (C) A slip of paper (image E) slid into the layers of cleared X-ray film to demonstrate how the device was used.

darkroom. Starting out with an empty plastic bottle of dental X-ray developer, he purchased a small torch or flashlight in a local market. After cutting out about half of the bottom of the bottle, he replaced it with several layers of cleared X-ray film to create a pocket. With the cap removed, he inserted the lens of the torch into the mouth of the bottle, and with the exception of the torch switch and the window he created in the base, wrapped the device with duct tape.

On strips of paper that would fit into the window at the base of the device, he printed the name of the facility, UNAMSIL mortuary Freetown, and the case number. After some experimenting, he found that standard printing paper compensated for the fact that the torch could not be turned on and off in less than about a second with satisfactory results.

Film Limitations

A darkroom will be necessary to load and unload cassettes and process the exposed film. These two activities can actually be accomplished at two different locations.

A simple film-changing area was created in the basement of the Mütter Museum by building a light-tight enclosure around a chair (Figure 4.92). In the case of the Winged Victory of Samothrace previously discussed, the back of a Dodge van was converted into a light-tight film-changing area (Figure 4.93). Exposed films were transferred into a light-tight transport case (Figure 4.94) and at the end of the day, driven approximately one hour to the location of an automatic processor for development. The obvious disadvantage to this approach was the delay between when the exposure was taken and viewing the processed radiographed. On occasions when a radiograph needed to be repeated, not necessarily for selection of technical factors but rather a slight change in position, an entire day was lost in the process.

Creating a space to process the exposed film is a much greater undertaking, particularly in the field. A more detailed presentation for establishing a high-volume field facility is presented elsewhere (Conlogue and Beckett, 2010). For small-scale studies, the approach presented above for the Barnum Museum is by far the easiest. Automatic processing units are discussed below.

Figure 4.92 A PVC pipe frame constructed around a chair in the basement of the Mütter Museum. Two layers of black gardening plastic were placed over the frame to create the light-tight enclosure. Note the exposed film transport case (arrow) open on the chair.

Figure 4.94 A light-tight film transport case manufactured by Bar Ray.

Recent developments may affect the availability of film. As part of a federal mandate to improve healthcare delivery, in 2017 Medicare will begin reducing payments for examinations performed with *analog* (film) X-ray systems. Since most medical facilities have already transitioned to digital imaging, film is less readily available and decreased demand may eventually result in increased costs. In August 2018, a 100-sheet box of Fuji PPG 14×17-in (36×43-cm) film, one of the least expensive choices, cost US$121.18 (Parker X-Ray, East Hartford, Connecticut), about the same price as it did several years ago.

Another cost associated with film, assuming a low-volume project and a plan to purchase an automatic processing unit, is that of chemistry: US$7.50 for 10 gal (38 l) of developer; and US$3.40 for 10 gal (37 l) of fixer. Since it requires about 100 ml (0.1 l) of developer and 150 ml (0.15 l) of fixer for each film, the total cost per film would be approximately US$0.03.

If long-term or multiple studies are the objective, used tabletop automatic processors can be found on *ebay*: for example, in August 2018, a Minolta-Konica SRX-101A was available for US$725.00 or an AGFA Curix 60CP for US$795.00. However, automatic processing

Figure 4.93 A PVC pipe frame was assembled for the darkroom in the back of a Dodge van. The frame was covered with two layers of black gardening plastic to provide the light-tight enclosure. Due to the height limitation within the enclosure, the procedure required kneeling on the van floor, so a layer of foam (arrow) was taped to the floor to provide cushioning.

incurs other costs, including: replenishment tanks for the developer and fixer; the services of a plumber to connect the system to the replenishment tanks, a water supply and drainage of used developer and fixer; a source for maintenance and service for the unit; and, last but not least, a silver recovery system. The latter is necessary because local and state Environmental Protection Agency organizations regulate or limit the amount of silver halide found in the used fixer that can be released into the drainage system by automatic processors. There are two basic types of silver recovery processes: an active type utilizing electrolysis, and a passive method employing fractional precipitation (https://www.researchgate.net/.../237538834_SUSTAINABLE_RECOVERY_OF_BY-PR...).

An important, but often overlooked, aspect of using film as the recording media is digitization of image. Unlike medical applications where the primary objective is a diagnosis and storage of the image, in a majority of non-traditional applications, the resulting radiographs will be used in presentations or publication. Other advantages of digitalization include: a reduction in the sheer volume and mass of film; an ability to adjust the contrast and density of the film image; and the ability to electronically send the images over the Internet to a specialist possibly located in another country.

The most simplistic approach would be to place the film on a view box and photograph the image with a digital camera. Unfortunately, the resulting photograph is generally saved as a compressed JPEG (Joint Photographic Expert Group) file and can only be adjusted once the image is acquired using a software program such as Photoshop®. Most publishers want uncompressed images saved as TIFF (Tag Image File Format) files. For more information regarding radiographic data formats and graphic software, see Chapter 9, Section 4.

The optimal approach to digitizing an image is with a flatbed scanner equipped with a transparency adapter, such as the MICROTEK ScanMaker® 9800XL unit employing SilverFast v6.5 Irla® software (Figure 4.95). The only disadvantage of the unit is the 12×17 in (30×43 cm) bed, which is slightly smaller than the 14×17 in radiograph. Unfortunately, this unit was originally shipped with an SCSI connector that is not recognized by operating systems newer than XP. The company offers a conversion kit that changes SCSI connector to a USB, but one of the authors (AN) could not get it to work so he has a legacy XP box driving the scanner. Most flatbed scanners were designed to digitize printed material using a reflective method for acquiring the image. The transparency adapter was developed for scanning color and black-and-white photographic negatives and

Figure 4.95 A MICROTEK ScanMaker® 9800XL equipped with a transparency adapter.

permits the adjustment of contrast and density before the image is acquired at 16-bit gray scale (2^{16} or 65,536 shades of gray). The unit also provides adjustment of the resulting spatial resolution of the image from 25 to 6400 dpi (dots per inch). Most publications request that images be submitted at 300 dpi (dots per inch). At that level of resolution, a 12×17-in (30×43-cm) scan of a film results in a file size of approximately 35 megabytes, MB.

The final consideration in the digitization of film is data storage. Since these files are so large, an external hard drive is suggested as the storage device of choice. In a study of 207 Chachapoya mummies in Peru, a total of 1,080 14×17-in (36×43-cm) radiographs were taken and later digitized, requiring 38 GB of storage (Conlogue, Guillén, Salazar, and Beckett, 2011). The files were downloaded onto a single hard drive instead of the eight required DVDs.

Digital Image Receptor Systems

As previously suggested, film, as an image receptor, has a number of inherent disadvantages. A film, with perfectly selected kVp and mAs settings, could result in an unsatisfactory image due to processor problems, such as an inaccurate temperature of the developer, incorrect processing time, contamination of exhaustion of the chemistry, and/or improper developer and/or

fixer replenishment rates. In addition, films could get jammed in the processing unit. Regular cleaning and maintenance of the processing facility together with routine testing are therefore required. However, probably the more significant problem, particularly for non-medical applications, is an inaccurate selection of kVp and mAs settings. Once the exposure has been taken, there is no way to alter the density, penetration, and/or contrast visualized on the processed image.

These two factors, wet processing and an inability to post-process the radiograph to correct the appearance, led to the development of a digital image receptor to replace film. The ground-breaking work that resulted in the introduction of computed tomography, CT, in the mid-1970s significantly contributed to the realization of a digital image receptor. An in-depth discussion of CT will be presented in another chapter. There are two categories of digital imaging receptors: direct digital radiography, DR, and computed radiography, CR. With the former, the image receptor plate transmits an image to the computer/monitor within seconds of the termination of the exposure, while the image receptor plate in CR must be placed in a device termed a *reader*, where the surface is scanned then sent to the computer/monitor. Other than the image-processing method, there are several features in common with both approaches. Digital receptors have a much wider latitude than film, providing more flexibility in the selection of exposure factors, kVp and mAs (Figure 4.96). Unlike when film was the image receptor, kVp does not control the contrast to the same extent on the processed image. With digital imaging, the kVp contribution is dependent upon inherent subject contrast, the density differences between adjacent tissues. If the mAs setting is too low, too few X-ray photons will strike the image receptor. The

resulting electrical signal will have a high-noise component and when processed by the software will render a grainy image. The particular appearance is termed *quantum mottle*.

The image data, captured by the digital system, is processed mathematically by choosing a specific algorithm. In medical systems, algorithms are developed by manufactures for specific body parts/regions, such as chest, with a corresponding inherent scale of contrast. Systems intended for industrial applications employ algorithms for specific materials, such as plastic and steel. In addition, industrial systems generally provide higher-resolution images, requiring at least twice the dose as their medical counterpart. However, the most significant feature is probably the ability to change the appearance of the image once it has been processed. This is termed *post-processing*. Not only can the density and contrast be repeatedly altered, but features such as edge enhancement, image reversal, magnification, placing arrows, or other types of annotations on the image are possible.

The origins of DR can be traced directly to research in the development of computed tomography. It is similar to the system employed in digital cameras. With this digital approach, the imaging plate is either directly wired or remotely connected to a computer. If the system is mobile, a laptop computer is employed (Figure 4.97). Older systems required the plate to be connected to the X-ray source that activated the detector at the moment of exposure. However, newer units can be used with any X-ray tube. Once the exposure is taken, the image will appear on the computer monitor in a matter of a few

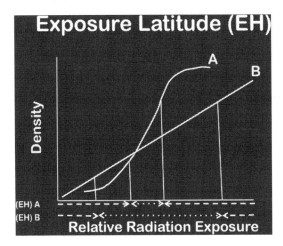

Figure 4.96 A comparison of H&D curves for screen film (A) and digital imaging receptors (B). Note the narrow latitude of A compared to B; acceptable exposure (dotted arrows); under- or overexposure (dashed arrows).

Figure 4.97 A DR system set up in the crypt under St. Bride's Church, London, England. The laptop computer (arrow) serves as control panel and location for image display.

seconds. The object under study remains on the imaging plate while the radiograph is processed and examined. Therefore, if the object was not positioned properly, it could be repositioned and another image captured immediately. With conventional radiography, the object must be moved to remove the cassette and process the film. Moving the object makes a slight alteration of the original position difficult and, even if an automatic processing unit is employed, several minutes will elapse before the next exposure can be taken. The decrease in the amount of time required to examine a particular object is a significant advantage of DR. In the clinical setting, reducing the time to complete a radiographic study enables more patients to be examined per unit of time; this is more commonly termed increasing patient *through-put*.

The disadvantages of DR can be divided into two categories; the price tag and a technical limitation. The initial cost of a DR system is approximately US$95,000 and the price to replace a damaged plate about US$60,000 or more. The risk of damaging a plate is greater when used with a portable situation. Often overlooked, but a necessary expense, is the service contract that is generally calculated at 10% of the purchase price, or in the example above, US$9,500 annually. If a damaged plate cannot be repaired, but must be replaced, a back-up plate must be considered at the time of purchase, especially if the system is intended for use in a remote location.

The technical disadvantage about to be considered is not really relevant in a clinical setting. As soon as the exposure is made, the plate transfers the data to the computer to be processed. It is not currently possible to take multiple exposures before the data is transmitted. Multiple exposures are only necessary when a single exposure cannot deliver a sufficient quantity of X-ray to produce a satisfactory image. The situation arises under very specific conditions. It would generally occur with a mobile X-ray source that has a lower output than fixed equipment or in a forensic examination when a lateral projection is required on a very large victim (Figure 4.98). In addition, the object under examination is larger than the image receptor with the ultimate intent to electronically stitch the resulting radiographs together. An example will be provided in the following section, which considers computerized radiography.

Another non-clinical drawback is the availability of a single-size DR plate, generally either 14 × 17 in (36 × 43 cm) or 17 × 17 in (43 × 43 cm). For example, in the clinical setting, an AP projection of an adult chest would utilize the entire plate. If a hand is the object to be radiographed, the area exposed would not require the entire plate, but be restricted or collimated to an area slightly larger than the object. The resulting smaller image would fill the entire monitor screen. In anthropological study, the practice has been to fill the entire surface of the plate with skeletal elements (Figure 4.99). However, if a segment of the resulting image is magnified to view a smaller component, for example the cervical spine, the enlarged image will be pixelated (Figure 4.100 and 4.101). Therefore, smaller objects must be individually radiographed to maximize resolution.

Figure 4.98 A horizontal beam lateral radiograph of a self-inflicted knife wound (arrow) required three exposures at 100 kVp; 100 mA; 2 seconds. A distance, termed an *air-gap*, of approximately 8 inches (20 cm) between the side of the victim and the image receptor plate served to reduce the quantity of scatter radiation striking the plate.

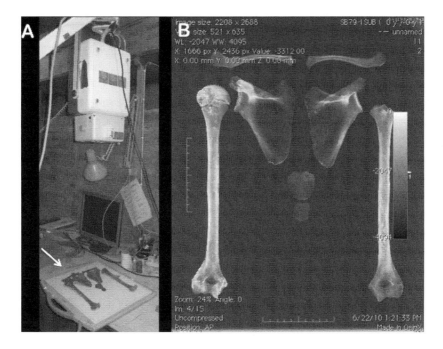

Figure 4.99 The practice in anthropological studies is to reduce the number of exposures by filling the entire imaging plate with skeletal elements (A). The resulting radiograph (B).

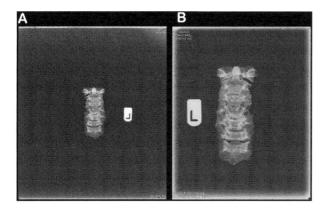

Figure 4.100 An un-collimated radiograph of a cervical spine placed in the center of the 14 × 17-in DR plate (A). A collimated radiograph of the same cervical spine; note the enlarged appearance of the image (B).

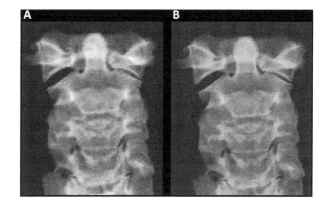

Figure 4.101 Magnification of the un-collimated (A) and collimated (B) images of the cervical spine. Note the pixelation of the non-collimated image.

CR is a more recent development than is DR. With this approach, a photostimulable phosphor plate is placed within a device that looks similar to a conventional radiograph cassette. When exposed to X-ray energy, electrons in the photostimulable phosphors are elevated to an "excitable state" (see property #7). However, unlike the electrons in the intensifying screen, the electrons in the photostimulable phosphor will remain excited until exposed to a laser beam. Once the exposure is taken, the cassette-like device is placed into a reader (Figure 4.102). Within the latter, the plate inside the cassette is scanned by a laser beam, and the resulting light energy released from the surface of the plate is captured and transformed by algorithms into an image on the computer monitor attached to the reader. Following

the image-forming scanning process, the final step is the erasure process where the plate surface is exposed to fluorescent light for approximately a minute in order to prepare the plate for the next exposure.

Prior to an algorithm processing the image data, a number of clinical-based parameters, such as patient name, date of birth, etc., must be entered into the system (Figure 4.103). Because most of the systems available are clinical and not industrial, the choice of algorithms is anatomic (Figure 4.104). Even if the subject is mummified remains, the clinical algorithms were designed for a live patient with hydrated tissues. Although an anatomic choice will seldom match the object of the study, it should be considered primarily as a starting point. Regardless, since the latitude of the digital radiograph exceeds that provided by film (Figure 4.105) and the

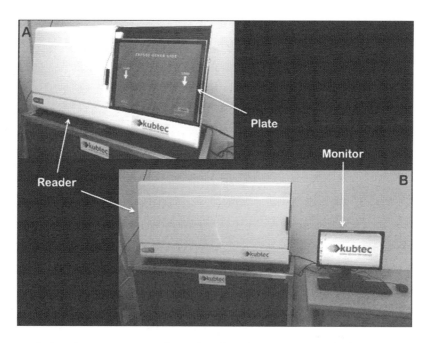

Figure 4.102 The exposed plate is put into a reader. After the plate is processed, the image appears on the computer monitor.

Figure 4.103 The KUBSCAN™ CR system patient information screen. The minimum fields necessary (arrows) were set by the vendor specifically for the Quinnipiac Diagnostic Imaging Program Laboratory. In a clinical situation, all fields may be required prior to engaging the algorithm to process the plate.

ability to post-process the image, the initial selection is not of great importance.

After the selection has been made, the image will appear on the computer monitor along with other information, including additional factors such as dose and a reference to the exposure factors. There are several vendor-specific systems that relate to exposure: Fuji and Konica identify it as *S number* (sensitivity), Agfa

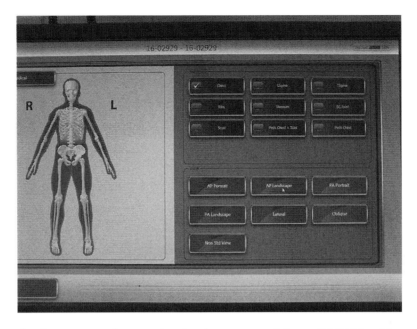

Figure 4.104 An example of anatomic selections for the chest region of the KUBSCAN™ CR system.

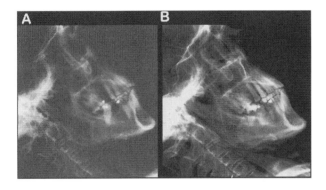

Figure 4.105 Two lateral radiographs of the facial region of a mummy: film (A) and digital (B). Note the increased latitude, more shades of gray, on the digital image.

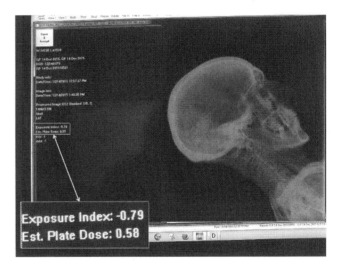

Figure 4.106 A photograph of the computer monitor. The image provided not only the acquired radiograph but also information related to the *patient* and the exposure. The Kubtec system utilizes the Exposure Index (EI) notation to indicate the relative exposure. In this case of a lateral skull of mummified remains, green lettering and a value of –0.79 indicated a satisfactory setting for a setting of 55 kVP at 2.8 mAs. Note the estimated dose to the imaging plate is also provided.

employs *LgM* (log of median), while Kodak and Kubtec use *EI* (exposure index). Although the processed image may look fine, the exposure indicator value may designate that the image is under- or overexposed. To demonstrate the process, the Kubtec EI system will serve as an example. An appropriate exposure setting is indicated as a value displayed in a green annotation (Figure 4.106). However, under- or overexposures are indicated by a red display (Figure 4.107). Also appearing below the EI value is the *est. plate dose* or the estimated dose received by the imaging plate. The value is in units designated as *Gray* and abbreviated as *Gy*. An in-depth presentation of radiation units will be presented in Chapter 9, Section 8.

Unfortunately, each vendor uses different *target* figures to indicate an appropriate exposure: for Fuji CR systems the target is a 200 *S number*; systems using Kodak EI recommend a 2,000 value; and Agfa systems recommend an LgM of 2.5. This has led to confusion even amongst experienced radiographers, especially if multiple systems are in use throughout the imaging department.

In order to reduce the confusion among users of these systems, a new measurement system has been developed: EI_T (exposure index target) and DI (deviation index). EI_T indicates the target exposure number for each procedure. DI indicates the amount of over- or

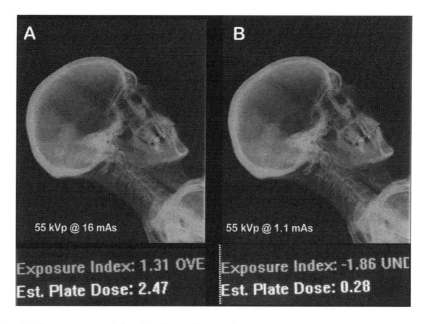

Figure 4.107 The EI value becomes a red display for under- and overexposures.

underexposure and a corrective indicator, an example of which is below:

$$-3(75\%) < -2(50\%) < -1(25\%) < \text{Target Value} >$$
$$+1(25\%) > +2(30\%) > +3(75\%)$$

A DI value of −2 or −3 would require a repeat exposure due to the production of an insufficient quantity of quanta reaching the imaging plate, a condition known as *quantum mottle*.

The exposure values demonstrate the increased latitude of the digital imaging system. Due to the manipulation of the imaging data by the algorithm, under- and overexposed images may appear satisfactory without the need to employ post-processing adjustment (Figure 4.108). A comparison of the range of acceptable exposure settings with film and CR further illustrates the relationship (Figure 4.109).

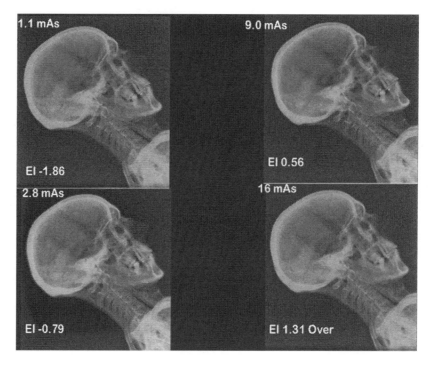

Figure 4.108 A comparison of four CR images. Although the appearance of radiographs is similar, the EI values range from under- to overexposure.

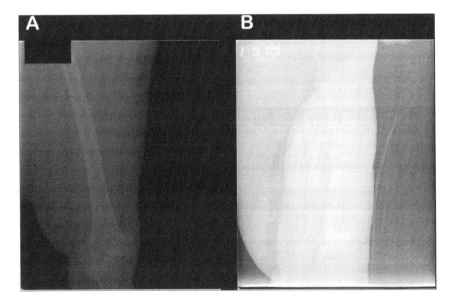

Figure 4.109 A comparison between a range of exposures recorded on film and CR not only demonstrates that CR has a wider latitude, but also the effects of a change in contrast and density only noted on film.

The time between placing the plate into the reader and the appearance of an image on the computer monitor is approximately 1.5 to 2 minutes. This longer period to visualize an image is considered a disadvantage of CR compared to DR. Another disadvantage of the CR approach is a phenomenon termed *ghosting* or *ghost image*. There are two possible explanations for the problem: the photostimulable plate was not completely erased in the reader (Figure 4.110) or an old plate that is no longer capable of complete erasure was used. The latter is not expected before approximately 5,000 exposures. A third shortcoming of CR are the moving parts in the reader required to transport the plate through the device, providing a possible source for mechanical

failure. For example, improper placement of an exposed imaging plate in the reader would jam the device and require it to be disassembled before the process could continue. To prevent this type of error at the Office of the Chief Medical Examiner, OCME, for the State of Connecticut, a plastic "bar" was added to receiving portion of the reader to prevent malalignment of the 14 × 17-in (36 × 43-cm) image receptor (Figure 4.111A–B). In an effort to simplify procedures, only the 14 × 17-in (36 × 43 cm) image receptor is employed to radiograph cases at the OCME.

A final, and to many the greatest, disadvantage is the need to move the object in order to process the CR plate, similar to the need to unload an exposed film from a cassette. In many circumstances, such as in forensics, the need to remove the plate from beneath the object in order to view it compared to the *instant* nature of the appearance of the DR image may actually increase the chance for contamination. In this situation, without moving the object, DR can be used to capture a rapid succession of images to facilitate retrieval of a foreign body, such as a bullet, using a radiopaque probe. This procedure would certainly not be possible with CR.

In addition, once the object has been moved, a repeat radiograph, due to a positioning error, is more difficult to correct. A viable solution to the problem is to create a thin, radiolucent *table* on which to put the object and permit the CR plate or cassette to be placed under. The surface can be made from modern carbon-fiber or *Bakelite*, an early plastic recovered from an old X-ray table, or Plexiglas. Depending on the weight and length of the object, 0.125-in (3-mm), 0.25-in (6-mm), or 0.5-in (13-mm) material supported on 1.0-in (25-mm)

Figure 4.110 A radiograph of a femur (A) at the Office of the Chief Medical Examiner for the State of Connecticut. The *ghost image* or *ghosting* (B) that remained on the plate after being exposed to the fluorescent light in the reader.

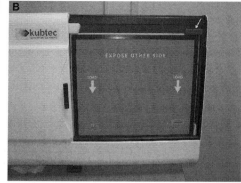

Figure 4.111 (A) The addition of a plastic *bar* (arrow) to ensure that the imaging plate will be placed properly into the reader. (B) Imaging plate properly positioned in the reader. Note the plastic bar (arrow).

legs will provide not only an adequate surface, but permit a plate or cassette to be repeatedly positioned under the object without the need to move the object (Figure 4.112A–B). There is also the added benefit for objects larger than the largest imaging receptor requiring multiple radiographs. Since the X-ray beam diverges from the source and multiple radiographs are required to image the entire object, it would not be possible to electronically *stitch* all the images together to produce a seam-less composite image. However, with an SID that allows the X-ray beam to cover the entire object and if the object is not moved between exposures, the resulting multiple radiographs could be stitched together. An easier approach to achieve a long SID is to employ a horizontal X-ray beam directed on a vertically oriented object (Figure 4.113).

CR does have several advantages over DR. The initial cost to purchase a CR system is approximately US$35,000 with an annual service contract of about

US$4,500. Two plates are generally provided with the systems and since different sizes are available, including 8 × 10 in (20 × 25 cm), 10 × 12 in (25 × 30 cm), and 14 × 17 in (36 × 43 cm), two different sizes or two of the largest size plates can be selected with the purchase. The replacement price for a 14 × 17-in (36 × 43-cm) plate is approximately US$800, much less than the US$60,000 required to replace a DR plate.

From a non-traditional imaging standpoint, a more significant advantage is the ability to take multiple exposures prior to placing the cassette into the reader. As indicated above, other than the example of the forensic case, there is another instance for delayed processing of an image receptor—that is, when imaging a large object necessitating many radiographs for complete coverage, an SID greater than 6 ft or 2 m, and requiring multiple exposures (Figure 4.114A–B). Other than using film, CR is the only available digital image receptor that will permit multiple exposures.

Figure 4.112 (A) A 62-inch (157-cm) SID was required for the X-ray beam to cover the entire mummy that was supported on a bakelite surface. The support was elevated above the floor by four 1-inch (25-mm) high legs. (B) The elevation of the support permitted a CR plate (arrow) to be placed under the mummified remains without moving the mummy.

Figure 4.113 A horizontal X-ray beam directed at an infant mummy (arrow) in a 2013 study in Quito, Ecuador (A). Two radiographs superimposed, but not stitched together (B).

Figure 4.114 (A) A PVC pipe frame (arrow A) constructed to support a 14×17-in (36×43-cm) CR plate during an imaging study of a *Centaur* skeleton (arrow B) with a 6-ft (2-m) SID. (B) A composite image produced by a total of 36 CR images stitched together.

Mammography Equipment

The first dedicated mammography unit was introduced in the late 1960s. It was still used primarily for symptomatic patients, and it wasn't until the early 1980s that widespread use of mammography for preventative screening of patients was employed. In 1992, the Mammography Quality Standards Act (MQSA) was developed by the Food and Drug Administration (FDA) and passed, making mammography the first federally regulated modality in imaging. The intent of the MQSA was to create a set of standards by which all facilities and personnel would abide to assure a minimum level of quality of care. The final regulations went into effect in 1999. While the general function of the mammography equipment is the same as general radiography, there are some design variances that improve the capabilities of the mammography machine.

Tube Design

The mammography machine incorporates a beryllium window rather than a glass window employed in general radiography. This allows for the soft characteristic radiation to emerge from the X-ray tube, guaranteeing enhanced subject contrast and enabling the visualization of subtle tissue differences. Unlike general radiography, which images a variety of anatomical structures at once (i.e. bone vs soft tissue), mammography primarily images soft tissue with limited contrast variance in the overall anatomy. The need to maintain the soft characteristic radiation allows us to capture these slight differences.

Like in radiography, the actual and effective focal spot contributes to the size of the projected area and the resolution obtained. The average focal spot size for routine mammography work is 0.3 mm and for magnification

work is 0.15 mm or smaller. Mammography achieves these smaller sizes by angling the tube as well as the target. This is referred to as the line focus principle. This principle allows for the smaller effective focal spot while maintaining the ability to dissipate the large amount of heat created. As stated earlier, the equipment is not capable of producing a sharp image of an object less than that size. In addition, instead of a tungsten-based target found in X-ray tubes used for other clinical applications, the mammography tube has a molybdenum target. The latter has a lower average energy, producing a lower kVp range than what is used in other clinical procedures. The lower kV setting results in higher contrast to differentiate tissues of similar density.

Another difference is the source to image distance (SID). In general radiography, the SID can be controlled by the technologist. In mammography, a fixed SID is used with the goal of having the smallest focal spot size with the longest SID and minimum exposure to the patient. The SID will vary from manufacturer to manufacturer.

Digital mammography machines have quickly become the new standard. The MQSA reports that less than 1% of certified units are screen-film/analog. The advantages of digital units are profound for traditional use in imaging the breast and for research of alternate objects. The ability to manipulate the technical factors (mA, s, kVp), focal spot size, and target materials allows for visualization of a wide variety of structures. While mammography is not typically the modality at the forefront in imaging specimens, it does have value and can contribute especially with small and low attenuation specimens. In addition, the units are widely available for access with over 17,000 units in the United States alone.

A Hologic™ Selenia Dimensions digital mammographic unit was used to obtain images of dry fetal skulls with the intent to demonstrate development of dentition and auditory canals. A series of radiographs were acquired including posterior-anterior (PA), both right and left lateral and oblique projections to demonstrate the mandible/maxilla, and a sub-mento vertical projection to provide an unobstructed view of the auditory canals.

Multiple attempts were made using various settings on the equipment to obtain diagnostic-quality images. It was determined that the Auto kV setting provided the best detail of the skulls. Due to the size of the skulls, the 1.8x magnification stand was used to enhance visualization of the anatomy. Of note was the thickness recorded by the machine. The images were improved when the compression paddle mechanism was at the lowest setting, indicating the smallest thickness (Figure 4.115).

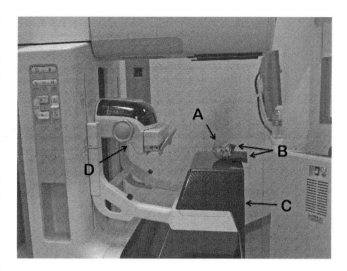

Figure 4.115 Fetal skull (A) placed in a right lateral position supported by small radiolucent foam wedges (B) on top of the 1.8 magnification stand (C) and the compression device with the motor drive (D) at the lowest setting.

Despite not having actual recorded force, this made a dramatic difference in the exposure. In addition, a saline bag utilized to add thickness to the skulls helped with the two larger but not with the smallest of the skulls (Figure 4.116). Although the mammography unit was not designed to image skeletal material, with a radiographer manipulating the hardware and software, diagnostic-quality images were acquired (Figure 4.117).

Positioning Objects for Plane Radiography

Regardless of the type of image receptor employed, the positioning of the object is an important factor in any radiographic examination. First, with the exception of a flat item such as a painting, all objects are 3D, and radiographs are 2D. Therefore, a minimum of two projections at 90° to each other are required for a 3D perspective of the internal structure of the object. Second, there may be variations in accepted positions. For mummified and skeletal remains, an anthropologist may acquire two projections at 90°; however, the positions may not be identical to those needed by a radiologist to make a diagnosis in a clinical situation. In selecting the appropriate positions for the radiograph, it should be remembered that the side *closest to the image receptor* will be less magnified, sharper, and less distorted than the side furthest away.

Positioning aids are therefore a key to acquire reproducible positions of objects under examination. The optimal radiolucent material is foam. However, different foams have very different cell structures and

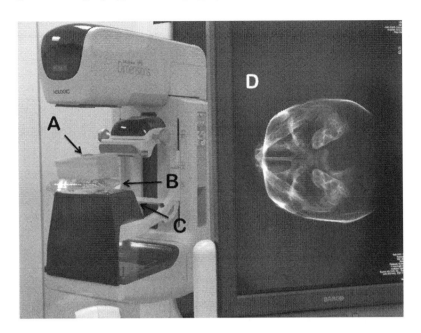

Figure 4.116 The set-up for a sub-mento vertical projection on one of the larger fetal skulls. Note (A) the skull positioned within a foam cradle; (B) a saline IV bag placed under the cradle; (C) the 1.8 magnification stand; and (D) the acquired DR image.

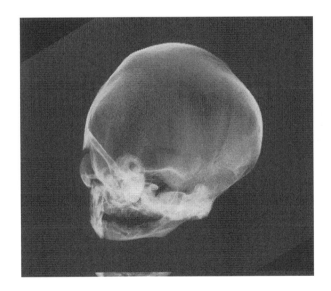

Figure 4.117 An anterior oblique projection of the right mandible, demonstrating the developing dentition acquired with the Hologic™ Selenia Dimensions digital mammographic unit.

subsequent visibility on the film. Commercially available foam cut into various shapes with specific angles, such as 45° and 30°, has been developed for the clinical setting, but is generally expensive. For non-clinical applications, foam is commonly available at stores that sell fabric or upholstery materials, but can also be costly. A low-cost alternative is to acquire packing foam from shipping containers. This foam is frequently more dense than that used to make pillows, but still radiolucent. It is usually in large sheets of various thicknesses and

sometimes somewhat difficult to remove because it has been glued into place. Nevertheless, even if it is necessary to remove it in pieces, it can be cut into the required shapes and the glued surface cut away using an electric knife (Figure 4.118). Foam, although very light-weight, can be bulky and occupy much-needed space when preparing to transport material to a field site. However, in a field-study situation, equipment can be packed with foam and, once at the site, the packing foam can be utilized as positioning aids.

For radiographs that will be reviewed by a radiologist, it is imperative to replicate clinical positions. For a study of a dry fetal skull, a "cradle" was carved out of dense foam packing material to create a device that would permit rapid and reproducible positioning (Figure 4.119). Disarticulated vertebrae present a particular challenge. Individual vertebral components must be reassembled into anatomic positions for AP and lateral projections. One method is to cut a length of foam into a column that can be inserted into the vertebral canal. Sufficient space must be established between each vertebra to replicate the disc space and flexed slightly to reproduce the curve of that section of vertebral column (Figure 4.120A–B). However, this procedure cannot be undertaken if the vertebrae are fragile. For more frail specimens, the vertebrae can be placed into a foam tube coating available at building supply stores (Figure 4.121A–C). A similar product, *pool noodles* (Figure 4.122), can be purchased at toy stores. Even something as readily available as Styrofoam picnic

Figure 4.118 An electric knife next to a piece of packing foam (A) with glue on the surface (arrow). A thin layer containing the glue sliced off the main piece of foam (B).

Figure 4.119 Fetal skull #5 from the Shapiro/Robinson placed in a foam cradle.

coolers and insulation foam boards can be broken up and used to position objects.

Disadvantages of Plane Radiography and Possible Means to Overcome Them

As previously indicated, radiographs are a 2D image of a 3D object resulting in superimposition of all the structures within the imaging plane. As a consequence, multiple images are necessary to make a clear assessment of the spatial orientation and relationship of the internal components. Taking multiple radiographs is not only a time-consuming process, but also exposes the patient, in a clinical setting, or the equipment operator and unaware individuals wandering about in a non-clinical situation, to a greater radiation dose. In photography, the flat depth of field or lack of perspective present in a photograph was overcome by the advent of stereoscopy. Within a year of Röntgen's announcement of his discovery, a number of individuals had adapted this practice to radiography. According to Cahoon (1961), two requirements are necessary for a perfect stereo-radiograph: perfect positioning and complete immobilization. He described a method to acquire a stereo pair using a linear shift of the X-ray tube without moving the object, and defined it by the following formula:

$$\text{X-Ray Tube Shift} = \frac{\text{SID}}{10\%}$$

Another approach simulates the separation between the human eyes. With this method, a 6–8° X-ray tube angulation between the two radiographs would achieve the same results. The processed images were viewed on a stereo-viewer (Figure 4.123). Both

Figure 4.120 A wedge-shaped cut piece of foam passed through the vertebral canal (A). The complete cervical spine positioned for an anterior-posterior projection (B) and a lateral (C).

Figure 4.121 (A) A section of 3/4-inch (19-mm) outer diameter foam tubing insulation with a 1/2-inch (12.7-mm) thick wall. (B) A cervical spine inserted into the split foam tubing insulation. Note the foam wedges (arrows) to prevent the foam tube from rolling. © Cervical spine positioned for a horizontal beam radiograph.

methods of producing stereoscopic images were utilized on the mummified remains of an individual with calcified mediastinal lymph nodes (Figure 4.124). An easy method to view the stereo images was to utilize an antique stereo-viewer. Once the pair of CR images was printed, the radiographs were trimmed to the required size and mounted on cardboard for viewing (Figure 4.125).

Today, stereo-radiography is primarily a footnote in the history of clinical radiography, although it may have some applications. Conlogue and Beckett (2010) describe employing stereo-imaging to determine the number of snakes within a small Egyptian cobra coffin.

In the 1930s, a technical development, known as *tomography*, was introduced in an attempt to minimize the effects of superimposition. By definition,

Figure 4.122 A *pool noodle* acquired from a toy store resembles the tube coating except it is not split longitudinally.

tomography means a coordinated motion between the X-ray source and the image receptor. This appositional movement created a layer known as the *focal plane*, parallel to the tabletop that was in focus (Figure 4.126). All structures above and below that plane or *slice* were blurred out (Figure 4.127). The initial motion was linear along the long axis of the table the patient was laying on. However, technical developments led to more complex movements including circular, elliptical, figure eight, trispiral, and the most complex, hypocycloidal. The motion pattern of the latter resembled the outline of a three-leaf clover and provided the thinnest sections (Figure 4.128). Unfortunately, there were a number of

drawbacks associated with tomography. Because the X-ray beam could not be as tightly collimated during the exposure, the patient dose was greater than that acquired by a single radiograph. In addition, tomographic studies required multiple slices or images to demonstrate an entire organ or structure, once again increasing the dose proportional to the number of radiographs required. The lack of collimation also increased the effect of scatter radiation and reduced the contrast on the processed radiograph. Another problem associated with tomography was that the blurring did make the image more challenging for interpretation. With the introduction of computed tomography in the 1970s, the use of conventional tomography began to decline.

However, once again technological innovations applied to old concepts have produced the digital equivalent of conventional tomography, known as *tomosynthesis* or high-resolution limited-angle tomography. The Food and Drug Administration (FDA) has approved the technology for breast cancer screening and it has been incorporated into mammography units (Hologic Inc.). Self-contained cabinet system tomosynthesis units, *Mozart*™ and *Parameter 3D*™ (Kubtec), have been developed for specimen radiography. Because the system was designed for specimens, there is a size restriction for the unit. However, it certainly has several potential non-traditional applications (Figure 4.129).

Another disadvantage of plane radiography is that radiographs are static images, the equivalent of snap shots. In May of 1896 in New York City, Thomas

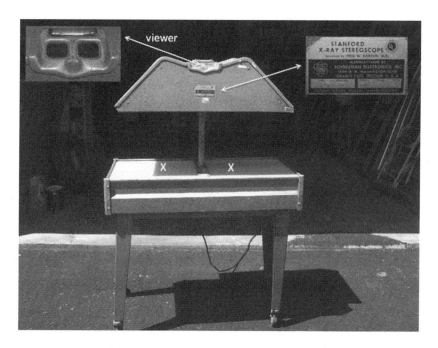

Figure 4.123 A 1960s vintage Stanford X-Ray Stereoscope. Each of a pair of stereo radiographs would be placed on the view box (X) while looking through the viewer to get the two images aligned.

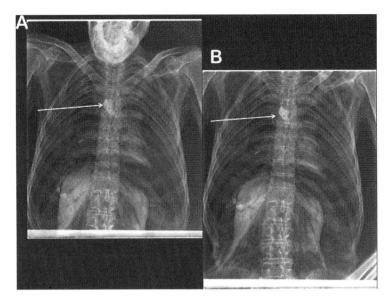

Figure 4.124 A pair of CR images acquired with linear tube shift of the remains of a mummified individual with large calcified mediastinal lymph nodes (arrow).

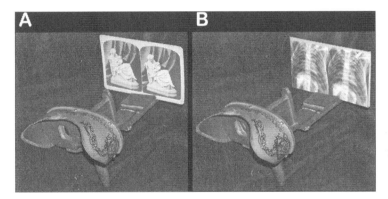

Figure 4.125 An antique stereo-viewer with a stereo card in place (A). The trimmed stereo radiographs mounted on cardboard and in place for viewing (B).

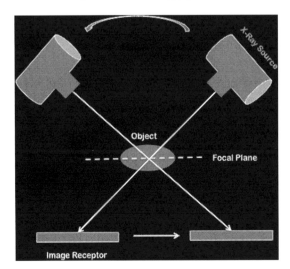

Figure 4.126 In tomography, during the X-ray exposure, the X-ray source and image receptor move in opposite directions, and the axis of rotation in the center of the object is the focal plane. Within that plane, structures are in focus; above and below the plane, structures are blurred.

Edison introduced the *Vitascope* at the Radioscopic Exhibition (Donizetti, 1967). The general public was invited into the exhibit, which was a dark chamber illuminated by two red lights. Prior to entering the room, they were asked to hide a half-dollar piece or a key under their gloves. Once inside they were told to put their hands behind the fluorescent screen and look at the bones of their hands. Later, because of the use of material that fluoresced, the name of the device was changed to a *fluoroscope* and, according to Edison, it was possible to observe dynamic motion and a photographic documentation was no longer necessary. Fluoroscopy has been an integral part of medical imaging centers and is frequently incorporated into general radiographic suites (Figure 4.130) and mobile devices known as C-arms (Figure 4.131). The latter design, on a larger scale, is found in interventional facilities (Figure 4.132). The principal advantage is real-time imaging that can be employed as a triage approach

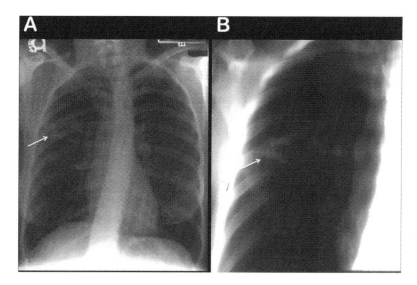

Figure 4.127 A posterior-anterior (PA) chest radiograph from the 1960s demonstrating a cavernous lesion (arrow) in the right thorax (A). A tomographic image with the focal plane through the lesion (B). Note the blurring of all the structures above and below the lesion.

Figure 4.128 A lateral radiograph of a cat's skull (A). A tomographic slice close to mid-line demonstrating the contrast filled third ventricle (arrow) surrounding the radiolucent massa intermedia (B). A more lateral section showing an air bubble (arrow) in the lateral ventricle (C). A section showing the contrast filled olfactory bulb (arrow) extending from the lateral ventricle (D).

in forensics for mass casualty situations (Viner and Lichtenstein, 2011, Viner et al., 2015) (Figure 4.133) or in an anthropological study to document the location of an endoscope (Figure 4.134). As mentioned above, DR has the potential to serve as *pseudo*-fluoroscopy in the retrieval of foreign bodies, or documenting the

position of an endoscope without the need to move the object (Viner, 2014).

Conversely, there are three principal disadvantages. First, even the mobile unit is quite heavy and not easily transportable. A second drawback, the equipment is expensive, costing many times the price of a mobile

Figure 4.129 A photograph of a fetal skull (A); a CR lateral of the skull (B); and a tomosynthesis section through the level of ramus of the mandible (C). Note the degree of enamel on the developing teeth is more clearly demonstrated in the tomosynthesis image than the CR.

Figure 4.130 The fluoroscopic X-ray tube is located under the table (A), directly opposite the image intensifier (B). Note the X-ray source (C) and the Bucky tray (D).

X-ray system. The most serious problem associated with fluoroscopy is the radiation hazard. As long as the unit is activated, X-rays are generated exposing the equipment operator and anyone within 6–9 ft (2–3 m) of the equipment. Exposure can be minimized by following the radiation protection guidelines detailed in Chapter 9, Section 8. Another approach to reducing fluoroscopic time is to utilize the services of an experienced operator,

a radiographer specifically trained in the operation of radiographic equipment.

In conclusion, taking into consideration the technological advances in hardware and the development of imaging-processing software, plane radiography using film as an image receptor may be the only viable option for field radiography in many locations around the globe. A new high-frequency X-ray tube weighing less

Figure 4.131 A 1980s vintage C-arm fluoroscopic unit: X-ray source (A); image intensifier (B); and image monitor (C).

Figure 4.132 A twenty-first century Toshiba *Ultimax*® C-arm designed for interventional radiographic procedures: X-ray source (A); image intensifier (B); and image monitor (C).

Figure 4.133 Employing a C-arm to examine fragments of human remains.

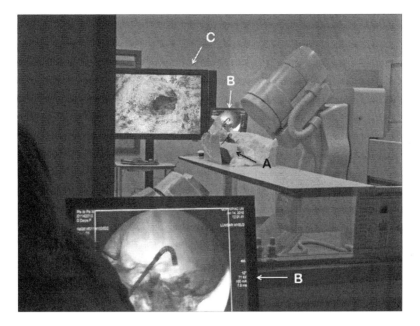

Figure 4.134 An interventional C-arm system employed to document the position of an endoscope in the skull within the box (A). The fluoroscopic image appears on monitors (B) inside and outside the fluoroscopy room, while the endoscopic image is on the monitor in the room (C).

than 22 lbs (10 kg) can certainly serve as the source for a field study; however, due to the cost and somewhat fragile nature of digital image-recording systems, the latter is impractical in many situations. The reader is directed to the Case Study volume, which demonstrates the use of film in a number of circumstances.

References

Bushberg, J.T, Seibert, J.A., Leidholdt, E.M., and Boone, J.M. (2012). *The Essential Physics of Medical Imaging* (3rd ed.). J.M. Lippincott Williams & Wilkins: Philadelphia, PA.

Bushong, S.C. (2013). *Radiologic Sciences for Technologists: Physics, Biology, and Protection* (10th ed.). Elsevier Mosby: St. Louis, MO.

Cahoon, J.B. (1961). *Formulating X-Ray Technics*. Duke University Press: Durham, NC.

Carlton, R.R., and Adler, A.M. (1992). *Principles of Radiographic Imaging: An Art and a Science*. Delmar Publishers, Inc.: Albany, NY.

Conlogue, G., and Beckett, R.G. (2010). Conventional Radiography. In R.G. Beckett and G. Conlogue (Eds), *Paleoimaging: Field Applications for Cultural Remains and Artifacts*. CRC Press: Boca Raton, FL.

Conlogue, G., and Beckett, R.G. (August, 2013). Field Paleoimaging: Applications and limitations. Paper presented at 8th World Congress on Mummy Studies, Rio de Janeiro, Brazil.

Conlogue, G., Guillén, S., and Salazar, J. (April, 1999). Field Radiography of Mummified Peruvian Remains. Poster presented at the annual meeting of the Paleopathology Association, Columbus, OH.

Conlogue, G.J., Guillén, S., Salazar, J., and Beckett, R.G. (November, 2011). A Field Radiographic and Endoscopic Study of the Mummies from Laguna de los Cóndores, Peru: A Paleopathologic Analysis. Paper presented at the IV Reunión de la Asociación de Paleoptologia en Sudamerica, Lima, Peru.

Conlogue, G., and Nelson, A. (1999). Polaroid Imaging at an Archaeological Site in Peru. *Radiologic Technology*, 70(3), 244–250.

Conlogue, G.J., Schlenk, M., Cerrone, F., and Ogden, J.A. (1989). Dr. Liedy's Soap Lady: Imaging the Past. *Radiologic Technology*, 60, 411–415.

Dibner, B. (1963). *The New Rays of Professor Röntgen*. Burndy Library: Norwalk, CT.

Donizetti, P. (1967). *Shadow and Substance: The Story of Medical Radiography*. Pergamon Press Ltd.: Oxford, England.

Eisenberg, R.L. (1992). *Radiology: An Illustrated History*. Mosby Year Book, Inc.: St. Louis, MO.

Gagliardi, R.A., and McClennan, B.L. (1996). *A History of the Radiological Sciences Diagnosis*. Radiology Centennial: Reston, VA.

Hall, F.M. (2000). Language of the Radiology Report: Primer for Residents and Wayward Radiologists. *American Journal of Radiology*, 170, 1239–1242.

Nepple, J.J., Martel, J.M., Kim, J-K, Zaltz, I., and Clohisy, J.C. (2012). Do Plain Radiographs Correlate with CT for Imaging of Cam-type Femoroacetabular Impingement? *Clinical Orthopaedics & Related Research*, 470(12), 3313–3320. Retrieved from https://link.springer.com/article/10.1007/s11999-012-2510-5

O'Rahilly, R., Müller, F., Carpenter, S., and Swenson, R. (2008). *Basic Human Anatomy: A Regional Study of Human Structure* [Chapter 5: Radiologic Anatomy]. Retrieved from https://www.dartmouth.edu/~humananatomy/part_1/chapter_5.html

Thompson, S. (1976). *The Life of Lord Kelvin* (vol. 2). American Mathematical Society Chelsea Publishing: New York.

Viner, M.D. (2014). The Use of Radiology in Mass Fatality Incidents. In B. Adams and J. Byrd (Eds), *Commingled Human Remains: Methods in Recovery, Analysis & Identification*, pp. 87–122. Academic Press.

Viner, M.D., Alminyah, A., Apostol, M., Brough, A., Develter, W. O'Donnell, C., Elliott, D., Heinze, S., Hoffman, P., Gorincour, G., Singh, M.K.C., Iino, M., Makino, Y., Moskała, A., Morgan, B., Rutty, G.N., Vallis, J., Villa, C., and Woźniak, K. (2015). Use of Radiography and Fluoroscopy in Disaster Victim Identification. *Journal of Forensic Radiology and Imaging*, 3(2), 141–145.

Viner, M.D., and Lichtenstein, J.E. (2011). Radiology in a Mass Casualty Situation. In M. Thali, M.D. Viner, and B.G. Brogdon (Eds), *Brogdon's Forensic Radiology* (2nd ed., pp. 177–178). CRC Press: Boca Raton, FL.

Contrast Media

5

GERALD J. CONLOGUE AND RONALD G. BECKETT

Contents

Objectives: To use various imaging modalities to demonstrate and possibly determine the undocumented procedures employed by anatomists several hundred years ago. In addition, to discuss the value of re-examining specimens injected with a contrast media, developed over 40 years ago to demonstrate the circulatory system and cerebral ventricles.

Prior to Röntgen's announcement in 1895, anatomists employed a number of different materials to demonstrate arteries, veins, cerebral ventricles, and airways. Since many of these substances would, centuries later, absorb or attenuate X-ray photons, radiographs of the preparations clearly demonstrate the expertise of the preparators and assist in revealing often undocumented methods. Honoré Fragonard (1732–1799) was the director of the Veterinary School in Alfort, France, founded by Louis XV in 1766. Utilizing a technique never divulged, he preserved and utilized over 3,000 specimens to teach anatomy to his students. A study of the collection in the spring of 2003 was conducted for an episode of the *Mummy Road Show* (*Mummies Inside Out*, 2003) and broadcast on the National Geographic Channel. Many specimens were smaller prosections, dissections that demonstrate specific anatomic features (Figure 5.1). The smaller size made these specimens easier to examine with radiography and endoscopy in an attempt to better understand Fragonard's methods. Red-colored arteries, visualized on the radiographs, indicated the vessels were filled with a dense, *radiopaque* material that absorbed or attenuated X-ray photons. However, his greater fame and subsequent controversy originated when he applied his technique to human cadavers. Wanting to illustrate bodies as dynamic, he placed corpses in life-like positions or cast them in biblical roles. In all he created over 700 *flayed figures* or *écorchés*, some combining humans and animals, such as the *Cavalier*, a man on a horse, symbolizing one of the *Horsemen of the Apocalypse* (Figure 5.2). Because of the fragile condition of the large *écorchés*, the most accessible and stable example, *Homme à la Mandible,* a man holding the mandible of a horse, not an ass, representing the biblical *Samson*, was

selected for a radiographic and endoscopic examination of a more complex preparation (Figure 5.3). The radiographs revealed the flayed muscles were held in place by strategically placed pins that were not visible exteriorly (Figure 5.4). In addition, as in the prosected head, arteries were visualized on the radiographs of the hip and pelvis. However, adjacent to the arteries, the veins, visibly colored blue, were *radiolucent*, not detected radiographically. Endoscopic examination provided more information regarding the vascular system. Over the years, some of the injected material seeped out of the vessels and was seen with the endoscope. The contents of the arteries remained red while the leakage from the veins seemed brown. It appeared the veins were painted blue (see Figure 5.3 panel B), but the arteries were definitely injected with a red radiopaque material. The leaking or dripping of the vascular contents suggested the material was wax, and over the intervening centuries, during periods of high ambient temperatures in the museum, the wax melted. Analysis of material recovered from a drip demonstrated that the red pigment was vermillion, containing mercuric sulfide, a radiopaque metallic salt. During the summer of 2003, a heat wave in Paris, with temperatures as high as 104 °F (40 °C), created a severe situation with the wax injections, including in the larger *écorchés* melting. A major effort was undertaken to not only save the collection, but also continue and expand the investigation undertaken for the earlier National Geographic Channel series (Degueurce et al., 2010). During this period, analysis of the injection material recovered from the human cadaver revealed not wax but mutton tallow mixed with pine resin and an essential oil. Only the large animals, such as the horse, disclosed traces of beeswax. According to Degueurce et al., the tallow mixture melts at a much lower temperature than beeswax. This characteristic, although making it easier to inject, also made it more susceptible to melting at lower ambient temperatures than the beeswax.

Another European, a generation later than Fragonard, was Allan Burns (1781–1813), a lecturer of surgery and anatomy in Glasgow, Scotland. His

Figure 5.1 (A) Prosection of the head and neck with the dura mater (solid arrows) peeled away to reveal the circulation to the brain. Note: the falx cerebri (dotted arrow) separating the right and left cerebral hemispheres in place; the carotid artery (dashed arrow). (B) A lateral Polaroid radiograph demonstrating the carotid arteries (dashed arrow). Note both the right and left carotids were seen on the radiograph due to superimposition.

Figure 5.2 Écorché of a man on a horse created by Honoré Fragonard between 1766 and 1771.

Figure 5.3 (A) A view of the rider with the chest musculature flayed (solid arrows) and the chest opened to reveal the heart (dotted arrow). (B) The prominent superficial vein on the face (dashed arrows).

collection included over 400 specimens of prosected organs, limbs, and whole corpses. After his death, one of his favorite students, Granville Sharp Pattison (1791–1851), left Scotland for the United States and brought part of the Burns Collection with him. Pattison, who began dissecting in Glasgow at the age of 16, arrived in Philadelphia in 1818 where he lectured privately in anatomy. In 1829 he brought the Burns Collection to the University of Maryland where he became chair of anatomy, physiology, and surgery. Today, the anatomic collection is still housed at the university and provided the focus of another episode of the *Mummy Road Show* (*Medical Mummies,* 2003). Among the specimens was a prosected neonate (Figure 5.5A). Burns, like other anatomists, sought out fetuses, neonates, and infants to dissect for a number of reasons. Because of the small size and lack of adipose tissue, these specimens were

optimal for preservation and prosection. Due to the limited size of the Polaroid film, 8 × 10 in (20 × 25 cm), it took a total of nine exposures to image the entire specimen (Figure 5.6). Compared to Fragonard's *écorchés,* the material injected into the arteries was considerably more radiopaque. The abrupt ending of the major vessels associated with the heart indicated the material was permitted to solidify before the vessels were cut, during the dissection (Figure 5.7). In addition, the filling of the artery on the lateral aspect of the surface of the skull confirmed the injection was completed before the proximal portions of the vessels were severed. The Polaroid radiograph of the legs provided another bit of information regarding the substance injected (Figure 5.8). Spaces or breaks in the column of material within the arteries indicated contraction during the cooling process.

Figure 5.4 (A) Polaroid radiograph of the right hip demonstrated that a pin (dashed/dotted arrow), hidden from view, was employed to maintain the flayed appearance of the muscle. In addition, the external iliac (solid arrow) and femoral (dotted arrow) arteries were visualized indicating injection with radiopaque material. (B) The image of pelvis revealed not only the symphysis pubis (dashed arrow), but also the external iliac (solid arrows) and femoral (dotted arrow) arteries.

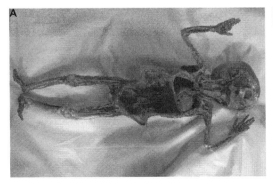
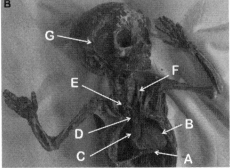

Figure 5.5 (Panel A) The dried mummified prosected neonate prepared by Allan Burns in the collection at the University of Maryland. (Panel B) A close-up image of the upper half of the prosected neonate. Note the diaphragm (A); left ventricle (B); right atrium (C); superior vena cava (D); point where the superior vena cava was cut (E); left common carotid artery (F); and a superficial artery (G).

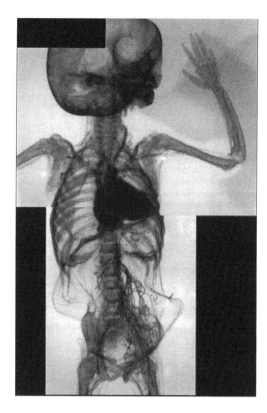

Figure 5.6 Three of the nine Polaroid radiographs necessary to completely image the specimen.

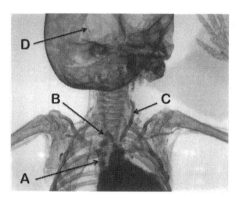

Figure 5.7 A Polaroid image of the vessels associated with the superior aspects of the heart: superior vena cava (A); the right brachiocephalic (B) and left common carotid (C) arteries. Note: the presence of the superficial artery (D) confirmed the arterial system was injected and allowed to solidify before the major vessels were severed.

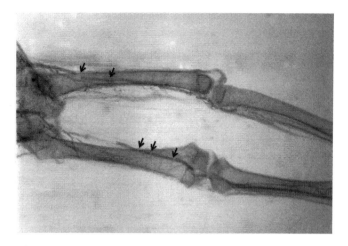

Figure 5.8 The Polaroid radiograph of legs demonstrating spaces or breaks in the column of filling in the arteries indicates that the material contracted as it cooled.

Although the identity of many anatomists who created other prosections has been lost in time, surviving specimens demonstrating the circulatory system attest to their knowledge of anatomy and preparatory skills. Imaging studies of two prosected neonates, presented in more detail in Case Study 7: Contrast Media Injections (*Case Studies for Advances in Paleoimaging and Other Non-Clinical Applications*, Beckett and Conlogue (Eds.), CRC Press, 2020), provided more insights into preparatory techniques and the material injected. The first specimen was in the hands of a private individual until 2015, when it was donated to the Mütter Museum of the College of Physicians in Philadelphia, Pennsylvania (Figure 5.9). Only an anecdotal history of the remains was available at the time of the donation. About 1850, according to family lore, the body of an infant was discovered by a shopkeeper in Beauharnois, Quebec, Canada at the bottom of a molasses barrel that had been in his shop for several months. A few doors away, a physician, John Hall Gernon, a graduate of McGill Medical College in Montreal, was notified of the finding. He washed off the molasses and was permitted to dissect the body. The cadaver was included with the rest of his possessions when he and his family moved to Lafayette, Indiana. The next move was to Kankakee, Illinois where

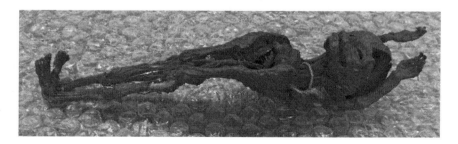

Figure 5.9 The neonatal prosection donated to the Mütter Museum at the College of Physicians in Philadelphia, Pennsylvania in 2015.

Figure 5.10 AP radiograph of the prosected neonate. The position, with the arms extended on either side of the head, minimized damage to the specimen during transportation. The left side of the calvarium was removed (A) to provide a view of the interior of the skull. Filled with the radiopaque material injected into the circulatory system, the heart (B) was rotated to provide a clearer prospective of where the umbilical vein/ductus venosus (C) entered the right atrium and the posterior aspect of the left atrium.

his son, also a physician, relocated. Finally, in 2000 the remains were shipped to the third generation of physicians in Lakewood, Washington. After the death of the last owner in 2010, his wife sought to donate the remains, which finally reached the Mütter Museum.

Imaging certainly provided a more detailed explanation as to the origins of the preparation. The AP (anterior-posterior) (Figure 5.10) and lateral (Figure 5.11) plane CR (computed radiography) images demonstrated that the circulatory system had been injected with radiopaque material that extended into the upper and lower extremities. Unless the body had been injected shortly after death, vascular filling would not have been so complete. The arms were not only extended on either side of the head, but rotated so that the hands were presented in an AP position, not a natural location. The latter would certainly have minimized damage to the upper extremities during transport. The heart was rotated anteriorly and superiorly so as to enable a better perspective of where the umbilical vein/ductus venosus entered the right atrium and the posterior aspect of the left atrium. In addition, the heart was completely filled with the material, suggesting the injection was through the umbilical vein and confirming the introduction of material shortly after death. The left side of the calvarium was removed to provide a view of the interior of the skull. A close examination of the vasculature of the legs revealed a similarity with the Burns' specimen (Figure 5.12). Although the injected material extended into the feet, numerous interruptions in the solid column indicated contraction of the injected material during the cooling process.

Other imaging modalities also contributed to the understanding of the preparation of this prosection. The 3D MDCT (multi-detector computed tomography) reconstruction demonstrated a ligature that was not

Figure 5.11 (A) Lateral projection of the prosected neonate clearly demonstrating the modified position of the heart (dashed arrow) and the aorta (dotted arrow). (B) In the enlarged portion of the lateral projection, note the breaks (solid arrows) in the column of material filling the aorta.

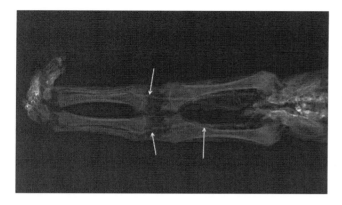

Figure 5.12 An enlargement of the radiograph of the legs demonstrates that the injection reached the feet. However, breaks in the column of injected material (solid arrows) indicate contraction during the cooling process.

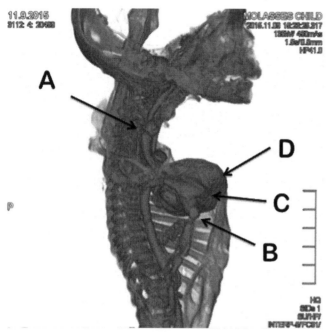

Figure 5.13 A 3D reconstruction utilizing a combination of two 3D algorithms to accentuate particular features such as the ligature on the superior vena cava (A) to ensure no leakage from the vessels after it was cut distal to the tie. Note the ductus venosus (B) entering into the right atrium (C) The muscular-walled right ventricle (D) was easily differentiated from the thin-walled right atrium filled with injected material.

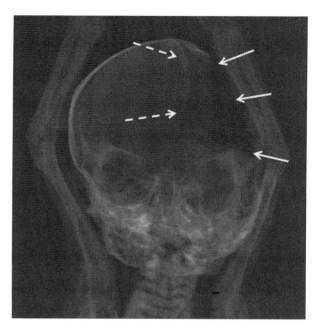

Figure 5.14 The plane AP radiograph of the skull not only documents the *window* into the calvarium (solid arrows) to enable visualization of the interior of the skull, but also reveals the falx cerebri (dashed arrows) separating the left and right cerebral hemispheres.

visible on the plane radiographs or on visual inspection (Figure 5.13). The tied-off vessel suggested that, following the injection, the vena cava was cut distal to the ligature to prevent leakage during the dissection. Although the plane AP radiograph of the skull clearly demonstrated the falx cerebri, the extension of the dura mater between the right and left cerebral hemispheres, there did not appear to be any vessel-filled portions of brain remaining (Figure 5.14). However, tomosynthesis

images of the skull clarified the initial impression (Figure 5.15A–C). Visualization of both vertebral and both internal carotid arteries suggested good filling of the cerebral circulation. Following solidification of the injected material, the major vessels supplying the brain were severed and the brain was very carefully removed, but avoiding removal of the falx cerebri. The ability to remove the brain but leave the falx cerebri intact suggested a dissection by a very skilled individual.

The second prosection, a neonate identified as 1090.55, in the collection of the Mütter Museum, was obviously intended for anatomic demonstration and similar to what was seen in the Burns' Collection (Figure 5.16). The visual presentation was certainly impressive. However, the AP plane digital radiographs not only confirmed the radiopaque nature of the injection material, but also the extent of the filling (Figure 5.17). A sagittal MDCT image of the head revealed a nearly completely filled vascular system and the location of the brain suggested the cadaver was in a supine position during the dehydration process (Figure 5.18). Unlike Fragonard's specimens, both the arterial and venous systems appeared to be filled with equally radiopaque material (Figure 5.19). In contrast to the previously described specimen recently added to the Mütter Collection, the umbilical vein was not present and more organs remained in the cadaver (Figure 5.19).

Material within the vascular system of anatomic preparations was not always intended for demonstration

Figure 5.15 (A) A tomosynthesis slice revealing the two vertebral arteries (dashed arrows) after entering the foramen magnum at the base of the skull. (B) A more anterior slice showing the basilar artery (dashed arrow) formed by the joining of the two vertebral arteries. (C) More anterior than the previous slice exposes the point where the right internal carotid artery was cut (dashed arrow) and what appears to be the cut end of the left middle cerebral artery (solid arrow).

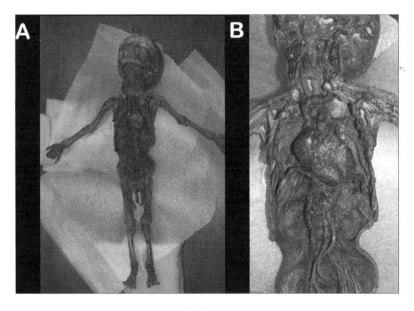

Figure 5.16 (A) The Mütter Museum prosection identified as 1090.55 was in a typical anatomic presentation position. (B) A close-up of the chest and abdomen with clearly demonstrated arteries and veins.

purposes, but the radiopaque appearance contributed to understanding preservation methods. Three European mummified women in the collection of the Anatomy Museum in Modena, Italy, provided excellent examples and the focus of another *Mummy Road Show* episode (*Involuntary Mummies*, 2003). The Museum was founded 1815 by Duke Francesco IV and continued collecting specimens until the 1970s. The precise

circumstances that led to the preservation of the women were not documented; however, it was known that the Duke controlled the local prisons and claimed possession of prisoners' bodies and unclaimed individuals. Following Napoleon's return from Egypt in 1801 and the subsequent Egyptomania, the Duke made it known that he wanted to improve on the mummification process. All three women look similar: very emaciated,

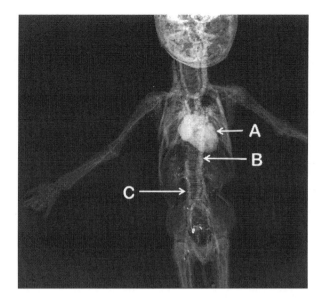

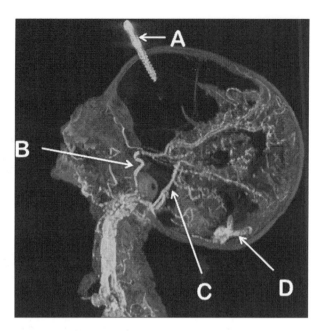

Figure 5.17 AP plane radiograph of Mütter Museum specimen 1090.55 demonstrating the completely filled arterial and venous systems. Note the heart (A), abdominal aorta (B), and the inferior vena cava (C).

glass eyes, dark-brown shiny skin with long dark-brown or black hair.

By the time the first woman was intended for mummification in 1834, arsenic was employed in embalming (Figure 5.20). Polaroid radiographs of the skull confirmed the presence of porcelain or glass eyes and possible brain remnants in the base of the skull. An unusual finding was the visualization of many strands of hair formed into a wig and fastened to the skull by a row of

Figure 5.18 The sagittal MDCT section of specimen 1090.55 showing the extent of the injection and the posterior position of the dehydrated brain. Note the screw employed to hang the prosection (A); internal carotid artery (B); basilar artery (C); and segment of the venous sinus (D).

tacks not seen on visual inspection (Figures 5.21 and Figure 5.22). Subsequent analysis of the hair revealed high concentrations of cinnabar, the ore of mercury, employed as a preservative. Recall that this was also responsible for the red color in the vermillion used by Fragonard's radiopaque arterial injection material. On the AP and lateral chest images, there appeared to be a

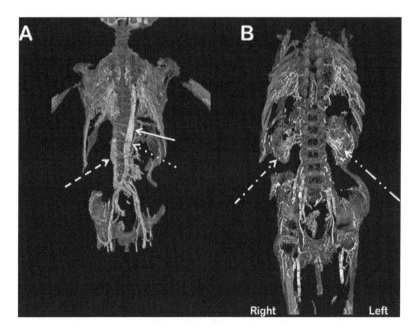

Figure 5.19 (A) Both the aorta (solid arrow) and the inferior vena cava (dashed arrow) appeared to be equally radiopaque. In addition, a break in the column was noted (dotted arrow). (B) The extent of the filling and skill of dissection was illustrated by visualization of the vascular supply to the right and left kidneys (dashed/dotted arrows).

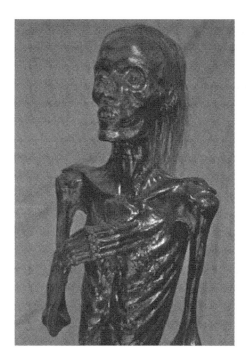

Figure 5.20 One of the three mummified women in the collection of the Anatomy Museum in Modena, Italy.

Figure 5.21 Two overlapping Polaroid images to visualize the lateral skull of the mummified woman prepared in 1834. Note: the porcelain or glass eyes (A); remnants of the brain resting in the base of the skull (B); many strands of radiopaque hair (C) in the form of a wig fastened to the skull by the tacks (D).

collection of radiopaque material in the aortic valve and a coating of the interior of the left ventricle (Figure 5.23). The findings suggested the material was injected in the opposition to the direction of arterial flow with a small quantity seeping beyond the valve into the chamber of the heart. In addition, the position of the radiopaque material noted in the thoracic aorta seen on the lateral projection indicated the body was in a supine position as the cadaver dried.

The images of the third mummy, prepared in 1841 and known as *Bellona*, the beautiful one (Figure 5.24), showed a very different appearance of the injected

Figure 5.22 An AP Polaroid radiograph demonstrating the radiopaque strands of hair forming a wig (arrows) held in place by tacks not seen on visual inspection.

material with a much greater radiopaque composition. The lateral projection of the skull demonstrated comparable porcelain or glass eyes and the brain remnants in an almost identical position as those in the cadaver prepared in 1834. However, the very dense radiopaque material appeared to have completely filled the arterial system (Figure 5.25). The AP image of the upper thorax confirmed the filling of the aorta, left side of the heart, including the ventricle and atrium, and left pulmonary veins (Figure 5.26). Similarly, AP radiographs of the pelvis revealed excellent filling of the arteries, but no radiopaque material was evident in any of the veins (Figure 5.27). Analysis of the skin indicated the presence of arsenic, lead, and mercury, suggesting the metallic elements were employed in the embalming process and injected solely into the arterial system. Unlike in the procedures carried out by Fragonard and Burns, these individuals were not preparations intended to demonstrate circulatory anatomy; however, the embalming solution proved to be an excellent radiographic contrast media.

Other preparation methods involved injecting materials followed by immersion in corrosive liquids to remove all of the surrounding structures and tissues. With the development of plastics in the middle of the last century, this technique became less complex and provided a method to document the *hollow* structures, normally filled with air or fluid, such as blood or urine, and demonstrate structural associations. The technique proved an excellent method to remove soft tissue (Figure 5.28), but the corrosive nature frequently precipitated calcium from bone (Figure 5.29A–B). In addition, the narrow latitude of the film precluded demonstrating both plastic-filled vasculature and bone. However, with wide latitude

Figure 5.23 (A) AP of the thorax revealed an accumulation of radiopaque material in the location of the aortic valve (solid arrow). Note the outline of the left ventricle (dotted arrows) and two radiopaque collections (dashed arrows) in the thoracic aorta. (B) The lateral radiograph not only confirmed the position of the aortic valve (solid arrow) and the left ventricle (dotted arrows), but also demonstrated the orientation of the deposits of radiopaque material in the thoracic aorta (dashed arrows), suggesting the cadaver was in a supine position during the drying process.

Figure 5.24 A close-up photograph of the face of the mummy, known as *Bellona*, the beautiful one, prepared in 1841. Note the porcelain or glass eye and the glossy appearance of the skin.

Figure 5.25 The composite lateral skull radiograph consisting of four Polaroid images clearly reveal the porcelain or glass eyes (A) and the collapsed brain (B) similar to that seen in the previous mummy. However, the arterial system is completely filled with radiopaque material: note the vertebral artery (C).

of digital radiography, both plastic-injected vessels and bone can be visualized within a commercially available injected fetal pig. Both the arterial and venous injections were seen on the plane digital radiograph acquired in a radiographic system, Kubtec KUB™ 250, intended for imaging neonates (Figure 5.30). The tomosynthesis unit, Kubtec Parameter™ 3D cabinet system, produced not only a higher contrast image, but also a method to eliminate the superimposition of the ribs (Figure 5.31A–B). The 3D MDCT reconstructions provided a mechanism to do a virtual dissection in order to better understand the relationship of the vasculature prior to the actual dissection (Figure 5.32A–B).

In 1977, Gunther von Hagens, a German anatomist, developed the process of plastination, which replaces water and fat with silicone resins or epoxy polymers. Today, von Hagens' *Body Worlds* and other imitators' traveling exhibits worldwide are presenting anatomy to global audiences. Ronn Wade, director of the Anatomical Services at the University of Maryland School of Medicine and curator of the Burns Collection, has employed plastination for decades to prepare prosections for medical students.

Figure 5.26 Polaroid radiograph of the thorax of the mummy prepared in 1841 known as *Bellona*. Note: the aorta (A); left pulmonary vein (B); chambers of the left side of the heart (C); left axillary artery (D); and left common carotid artery (E).

Figure 5.27 Three Polaroid radiographs of the pelvis of the mummy prepared in 1841. Note the very distinct arteries filled with the radiopaque material, but no visualization of the venous circulation.

Shortly after Röntgen's announcement, many scientists, in a variety of disciplines, experimented with X-ray. In 1913, Pierre Goby published his radiographic studies of many organisms, including plants and invertebrates. He laid each on a glass plate covered with a photographic emulsion, exposed them to X-ray, developed, and enlarged the resulting image by standard photographic processes. Because the images were enlarged, he termed the procedure *microradiography*. One of his studies involved earthworms. Knowing that earthworms process soil and that rich soil has high calcium content, he theorized that he could detect the condition of soil with a radiographic study. Since calcium is denser than the invertebrates' tissue, earthworms with

Figure 5.28 A 1972 triple injection of the kidney of a cat, with the renal artery injected with red (solid arrow), the renal vein with blue (dashed arrow), and the ureter with yellow (dotted arrow). The soft tissue was dissolved with commercially purchased bleach. Over the past 40 years the red and blue have faded.

higher amounts of calcium in their gut indicated richer soil. Inadvertently, this may have been the first contrast medium study.

As previously indicated, contrast medium was developed to enable visualization of *hollow spaces* normally filled with fluid (blood vessel, cerebral ventricles, urinary system), air (lungs), or a combination of both (gastrointestinal track), on radiographs. The history and development of contrast medium in the clinical setting can be found in Eisenberg (1992) and Gagliardi and McClennan (1996); however, this chapter considers enhancing the visualization of hollow spaces in specimen imaging. Once again, before the discussion of materials and techniques can be addressed, the basic concepts of contrast medium must be considered. To be effective, a contrast medium–filled structure must stand out on the radiograph from the surrounding tissue and bone densities in the image. Therefore, contrast medium should represent the extremes in density, and consequently these are divided in two general categories: negative, having a very low density and appearing black or nearly black on a radiograph; or positive, possessing a high density, attenuating many X-ray photons and seeming white or approaching white on the image.

Air or other gasses represent negative or radiolucent contrast medium. In the clinical setting, the best example is having a patient take a deep breath, filling their lungs with air, for a chest X-ray. Although it might be employed to expand vessels post mortem, the possibility of rupturing the structure and flowing into the surrounding tissues generally precludes it as the contrast medium of choice for specimens.

Figure 5.29 (A) A 1972 injection of both common carotid arteries of a cat. In order to remove all the soft tissue, the prolonged immersion in commercial bleach began to precipitate calcium, resulting in the continued flaking of the surface of the bones. (B) A dog injected bilaterally through the carotid arteries with the Vinylite™ and then soft tissue removed using commercially available bleach. The mandible was removed to demonstrate arterial circulation to the tongue.

Figure 5.30 A plane lateral direct digital radiograph of the abdomen obtained with a KUB 250 X-ray system of a commercially prepared fetal pig with arteries and veins injected with colored vinyl. Note the clearly visualized aorta (A) and the ductus venosus (B).

Positive contrast medium for clinical radiographic applications can be basically divided into two categories: iodine- and barium-based. The former is employed primarily as an injectable solution, and the later for ingestion. Unfortunately, once an organism has died, the injectable iodinated medium will not remain in the blood vessel or any other hollow structure, but will diffuse through structure walls into adjacent tissue, virtually vanishing on subsequent radiographs. Depending on the concentration of iodine in the medium, this process can take from 20 minutes to an hour. On the other hand, because of the particulate nature, barium compounds, intended for clinical use, will stay within the hollow structures as long as they remain intact. However, any medium that remains in a liquid state will leak once the vessel or structure is cut, precluding dissection and subsequent sectioning of the specimen.

A barium-gelatin compound, developed in the mid-1960s for use in specimen radiography, has proven very successful (Conlogue et al., 1978). The basis for the preparation is Micropaque®, Demancy & Co. Ltd, London, a fine-particle (0.1–0.4 μ) barium sulfate powder. In arterial injections, the small particulate size permits the barium to reach arterioles. In clinical use, mixed with water, Micropaque® frequently flocculated or fell out of suspension in the large bowel, making it difficult for the patient to expel. Because of that, it was removed from clinical applications. For specimen radiography, in order to maintain the powder in suspension, mucilage acacia was added. To eliminate the other problem, permitting dissection, gelatin was added to the mixture. When protein, the basis of gelatin, is treated with a 10 % buffered formalin, the protein is *fixed*, therefore preventing the medium from returning to a liquid state. In addition, the texture of the fixed compound resembles Jello® and remains within the structure not only when dissected, but also when subjected to sectioning.

The first step in creating the contrast medium requires preparation of a supersaturate sugar solution. To a liter of distilled water, brought close to boiling, 850 gm of dextrose is slowly added with constant stirring. Once all the sugar has been dissolved, the solution should be allowed to cool to room temperature and can be stored in a refrigerator. When ready to continue with the preparation, if any of the dextrose has crystallized, the solution can be gently heated until re-dissolved. Next, mucilago acacia is prepared from the stock supersaturated sugar solution in the following proportion: 10 gm solution : 1.0 gm gum arabic. Because it is somewhat difficult to get the gum to dissolve in the solution, a minimum of 40 gm of solution may be necessary. While heating the solution and with constant stirring, add the gum

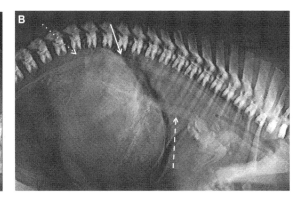

Figure 5.31 (A) An image acquired with the Parameter™ tomosynthesis unit with all the slices stacked to produce a single composite image. The higher-contrast image provided a more distinct view of the aorta (solid arrow) and ductus venosus (dashed arrow). (B) An individual slice from the tomosynthesis stack eliminating the ribs to provide an unobstructed view not only of the aorta (solid arrow) and the ductus venosus (dashed arrow), but also the branches off the aorta to the spine (dotted arrow).

Figure 5.32 (A) A 3D MDCT reconstruction with the window level adjusted to remove the skin. The aorta (solid arrow) and ductus venosus (dashed arrow) are just becoming visualized. (B) Further adjustment of the window level and cutting away of the right ribs to reveal the aorta (solid arrow) and the inferior vena cava (dashed arrow).

slowly. If the gum clumps, break the masses up before adding more. In a blender, combine 10 gm of mucilage of acacia with 15 gm of gelatin, 150 gm of the fine barium powder and 200 ml of hot, but not boiling, water. Blend at a medium speed for a minimum of 15 minutes. Once blended, if the contrast medium is not going to be stored but rather used immediately, the actual injection should be delayed at least an hour to allow air bubbles, introduced during blending, to rise to the surface. The elimination of bubbles is best accomplished by pouring the blended solution into a container with a lid loosely in place and immersing into a 37 °C water bath, periodically tapping the container to encourage air bubbles to rise to the surface.

If the blended solution is to be stored, it should be poured into sterilized containers with lids. Each container should hold a sufficient amount of contrast medium for a single injection, secured with a lid and refrigerated. Do not freeze. Because mucilage acacia is a great culture media, the solution will be susceptible to mold formation over time even if refrigerated. If mold does form on the surface of the contrast medium, the entire quantity must be discarded because the mold will alter the properties of the injected solution.

Prior to injection, the container should be removed from refrigeration. With the lid loosely in place, the container should be immersed in a 37 °C water bath as described above. If the lid is removed, prolonged heating can result in evaporation of the water component, thickening the contrast media and preventing filling of small vessels. Heating for 10 to 15 minutes, with periodic tapping, should be sufficient to produce complete liquefaction at uniform temperature with most of the air bubbles at or near the surface of the solution.

Once the heating process has been completed, the container should be removed from the water bath, lid removed and, once again, tapped a few more times to enable trapped bubbles to rise to the surface. In addition, to exclude bubbles when drawing up the solution for injection, it should be aspirated from the bottom of the container and not the surface. The actual injection should be through appropriate-size, clear polyethylene tubing that has been flushed with 37 °C water to prevent thickening of the contrast media. Hand injection done slowly should provide satisfactory results; however, a mechanical injector set at very low pressures can also be used.

Specimen preparation is the most important factor for a successful injection. In the past, live animals were frequently the subjects. Prior to euthanasia, an anticoagulant, such as heparin, was administered into the circulatory system in order to prevent blood clotting (Figures 5.33, 5.34, and 5.35). If anticoagulants have not been introduced, natural death generally comes about as blood pressure drops resulting in blood being pumped out of the arterial side, but without enough pressure to return it, causing pooling in the venous components and lividity. In all cases, injection into the circulatory system of entire animals should be done as

Figure 5.33 A contrast media injection of a cat through the carotid artery following the administration of an anticoagulant. (A) Ventral-dorsal, VD, projection of the cat skull following decapitation. (B) A repeat of the VD projection after the brain had been removed from the skull.

Figure 5.34 (A) The lateral projection of the cat's head prior to the removal of the brain. (B) The lateral radiograph of the brain following removal of the skull. (C) A photograph of the right side of the brain demonstrating the contrast filled arteries.

Figure 5.35 Cat brain microCT 10 mm–thick coronal (A) and sagittal (B) sections demonstrating arterial filling now visible on the plane radiographs.

soon after death as possible. If demonstration of the entire circulatory system is the objective, the polyethylene catheter should be inserted into the aortic arch and tied into place (Figure 5.36). The other approach is to select one of the femoral arteries, insert the catheter, advance it about half the distance to the aortic arch, and tie it in place slightly above where it enters the artery (Figure 5.37). In either case, catheters can be placed into both femoral veins to permit drainage. According to Conlogue et al., 1978, arterial volume, including arterioles, is approximately 30 % of total blood volume; therefore, estimating a 25 % volume should be sufficient.

Unless an anticoagulant has been administered, satisfactory venous injections of an entire animal are difficult to achieve. Generally, regional venous injections

Figure 5.36 AP (A) and lateral (B) radiographs of an aortic approach on an arterial injection of an armadillo.

Figure 5.37 AP (A) and lateral (B) radiographs of the femoral artery injection route of an opossum.

prove more acceptable. For example, if the venous circulation of the head is the objective, the catheter would be inserted into either the right or the left internal jugular vein. A drainage catheter would be introduced into the internal jugular vein on the opposite side. The size or diameter of the catheter should be only slightly less than that of the vessel to permit clots to flow following the slow injection of normal saline solution into one of the catheters.

If an isolated anatomic component, such as a severed lower head, is the object of the intended injection, the approach has to be slightly modified. If the body part was removed shortly after death, a majority of the blood may be drained, improving the chances for a good injection. As a first step, the major artery to the body section must be catheterized. Severed arteries have a tendency to contract, possibly making isolation difficult. The catheter must be advanced into the vessel as far as possible and tied into place. However, because the section was severed, leakage must be anticipated and numerous hemostats must be at the ready to clamp off vessels (Figures 5.38, 5.39, 5.40, 5.41, and 5.42). Other examples of injections will be discussed in Case Study 7: Contrast Media Injections.

Figure 5.38 The barium-gelatin contrast media was injected through the polyethylene tubing inserted into the right common carotid artery (dotted arrow) in the horse's neck. Note the white contrast media leaking from the severed arteries (solid arrows) that were not ligated.

Figure 5.39 DV (A) and lateral (B) radiographs revealed good filling from the right carotid, but since a similar injection had not been done on the opposite side, only partial filling was achieved via the circle of Willis.

Figure 5.40 (A) 3D demonstration of the arterial circulation with the "basket" algorithm. (B) The addition of the semi-transparent algorithm revealed the relative position of the brain (solid arrow) and spinal cord (dashed arrow) to the arterial circulation.

Figure 5.41 A mid-sagittal MR section through the horse head.

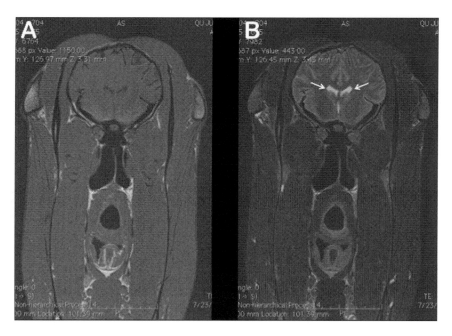

Figure 5.42 Coronal T1 (A) and T2 (B) sections of the injected horse head. On the T2 section, note the high signal from the cerebro-spinal fluid in the lateral ventricles (arrows) not seen on the T1 image. The barium gelatin contrast media is not visualized.

Whenever possible, arterial and venous injections should be done under fluoroscopy to determine when a sufficient volume has been delivered and to detect any possible extravasation of contrast medium. This approach also helps determine the appropriate volume for subsequent injections when fluoroscopy might not be available. If cerebral ventricles are the objective of the investigation, fluoroscopy is an essential component of the protocol (Figure 5.43A–C).

At the end of the injection, cooling is the key. For small specimens, immersion in liquid nitrogen will instantly solidify the contrast media. However, refrigeration for 24 hours will provide sufficient cooling for small and large specimens. Once the cooling process has been achieved, the next stage is fixation of the gelatin component of the contrast media with 10 % buffered formalin. For entire animals or even sections, the initial step in the process is skinning. Once the hide has been removed from the animal, a mid-sagittal incision is made from the manubrium of the sternum to the symphysis pubis. This is followed by bilateral transverse incisions along the base of the last rib extending to the spine. Burr holes can be drilled into the skull, but a more effective method to expose the brain is to remove the top of the calvarium (Figures 5.44, 5.45, and 5.46A). The entire animal must be immersed in 10 % buffered formalin. The quantity of preservative should be at least five times the volume of the animal. Once the animal is immersed in formalin, the dura mater may expand, sealing off the burr holes, preventing the preservative to flow around the brain

and therefore prohibiting proper fixation of the tissue and the contrast medium. The specimen should remain in the formalin for at least two to three weeks prior to dissection.

Thus far, the contrast medium that has been considered will only function on the modalities that utilize radiography. However, beginning in the mid-1980s, another modality, magnetic resonance (MR) imaging, once again altered the potential of medical imaging. As in Chapter 8: Magnetic Resonance Imaging, the modality primarily images mobile hydrogen, and the MR contrast media, which is primarily gadolinium, is paramagnetic. The following is a description of a new contrast media developed by a team from the Department of Anatomy, Kirksville College of Osteopathic Medicine, at A.T. Still University in Kirksville, Missouri.

A Multimodality Contrast Media—Bruce A. Young, Solomon Segal, James Adams, and Kyler Douglas

We sought to develop a simple, inexpensive contrast agent that could be utilized across imaging platforms for non-clinical applications. Restricting our work to non-clinical applications meant that we could safely ignore issues of nephrotoxicity, or other concerns that influence clinical imaging. The substrate for the contrast agent was a combination of 100 ml tap water, 2.8 gm gelatine (Knox), and 25.5 gm gelatin (Jello®). The

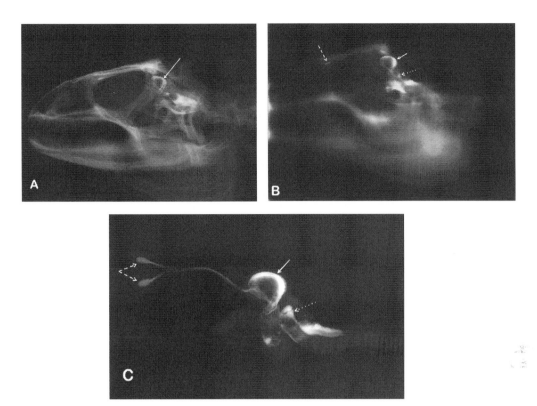

Figure 5.43 (A) Lateral projection of the iguana skull showing the contrast media filled cerebral ventricles (arrow). (B) A midline conventional tomographic section of the iguana skull demonstrating the lateral ventricle (solid arrow), ventricular cavity within the olfactory bulb (dashed arrow), and fourth ventricle (dotted arrow). (C) Lateral radiograph of the removed iguana brain demonstrating the contrast media filled cerebral ventricles on Kodak Type R single emulsion film. Note the lateral ventricles superimposed (solid arrow); extension of the ventricles into the olfactory bulbs (dashed arrows); and the fourth ventricle (dotted arrow).

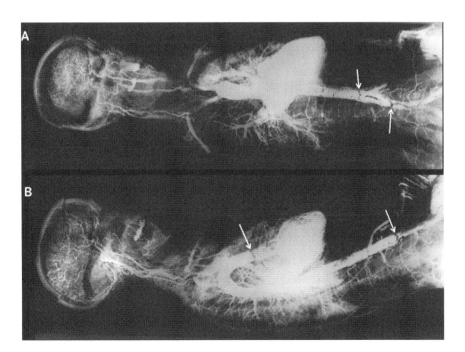

Figure 5.44 AP (A) and lateral (B) radiographs recorded using a 14×36-inch (35×91-cm) film in a cassette of the adult cadaver injected through the femoral artery in 1972. After over 20 years, the contrast media has remained intact with some *cracking* noted in the aortic arch and abdominal aorta. Several of the cracks are indicated by arrows.

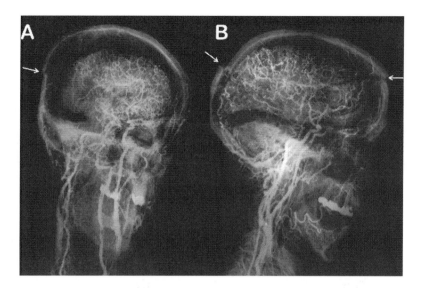

Figure 5.45 AP (A) and lateral (B) computed radiography, CR, images of the contrast media–injected cadaver: note the cut made (arrows) in the calvarium to permit the preservative to reach the surface of the brain. The extensive filling of the brain on a plane radiograph makes the evaluation of specific vascular components difficult.

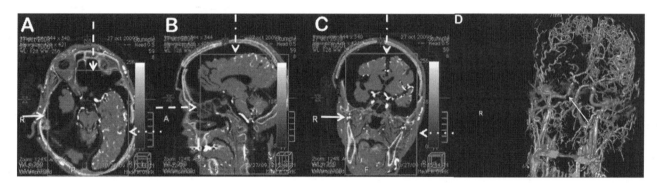

Figure 5.46 Utilizing the orthogonal, axial (A), sagittal (B), and coronal (C), the *clipping* application permitted removal of imaging data from the right (solid arrow) and left (dotted arrow) aspects, along with anterior (dashed arrow) and superior (dashed/dotted arrow) planes. In this case, removal from the posterior aspect was not necessary. (D) After employing the clipping application, the 3D reconstruction of the circulation in the head and neck revealing the apparent clot (arrow) in the right internal carotid artery.

materials for this substrate are readily available and inexpensive; the water should be heated (but need not be boiled), and the gelatine added first. This substrate sets firmly with cooling and can be fixed (we used 10 % neutral-buffered formaldehyde) to facilitate subsequent dissection.

Once the substrate was prepared, we added 7.9 mmol (10 ml) of iopamidol (Isovue 0.788 mmol/ml, Bracco Diagnostics Inc.), and 1.25 mmol (2.5 ml) of gadolinium (Optimark 0.5 mmol/ml, Liebel-Flarsheim Company LLC, Mallinckrodt Pharmaceuticals). Isovue and Optimark are (relatively) expensive prescription contrast agents; but since they are dispensed in single-use volumes, we have found that "leftover" amounts of both can be obtained (for non-clinical use) from medical imaging centers.

We first performed a phantom study by filling 10 ml plastic syringes, which were then placed in a refrigerator to harden. The phantom study was intended to determine the best concentration of gadolinium, so 10 syringes were filled in concentrations ranging from 0.1 mmol to 1.0 mmol in 0.1 mmol. After the agent had set, the end of the syringe was cut off and the 10 cores removed. A second set of 10 identical gelatin cores were fixed in 10% neutral-buffered formalin for 48 hours. These phantom series were imaged in the Northeast Regional Medical Center Department of Radiology and Gutensohn Clinic in Kirksville, MO. A CT phantom study (Philips Ingenuity CT scanner) was conducted (oblique coronal scan, 120 kV, 16 mAs, field of view [FOV] = 26.4 × 26.4 cm, slice width = 1.00 mm) followed by an MRI phantom study (Philips Achieva

Figure 5.47 Cores used for the initial phantom study showing the resulting images from the CT (A), the radiograph (B), and the MRI (C). In all three images, the top series of cores have been fixed, while the bottom series is fresh; the cores are numbered from 1 to 10, indicating increasing concentrations of gadolinium.

Figure 5.48 A 2-ml capsule of the contrast agent was placed into the abdominal cavity of a water monitor lizard, *Varanus salvator* ((A), (C), and (E)) or the oral cavity of a boa constrictor, *Boa constrictor* ((B), (D), and (F)). The capsule (white arrow) was clearly evident with radiographs ((A), (B)), CT ((C), (F)), and MRI ((D), (E)). Images were isolated and color-filtered using Osirix (Pixmeo).

1.5T MR scanner) of oblique coronal T1-weighted scan (TR/TE = 15.00/5.21, FOV = 25.0 × 25.0 cm, slice width = 10.00 mm). Lastly, a radiographic phantom study was conducted in a Quantum Medical Imaging Scanner (40 kVp, 150 mA, 0.750 mAs, 2 cm). The results (Figure 5.47) demonstrated that this contrast agent was slightly modified, though still of utility, following fixation, and that the initial series of gadolinium was too high. A second phantom series (not illustrated) was performed and enabled us to determine the optimal concentration of gadolinium at 0.125 mmol/ml of substrate.

Once the final concentrations of the Isovue and gadolinium were set, the efficacy of this concentration agent was examined by filling small (2.0 ml) gelatin capsules with the agent and implanting the capsules into two previously euthanized specimens; a capsule was placed in the oral cavity of a boa constrictor (*Boa constrictor*), and within the abdominal viscera of a water monitor lizard (*Varanus salvator*). CT images were

taken with the same Philips Ingenuity CT scanner (boa head—oblique coronal scan, 100 kV, 239 mAs, field of view = 26.4 × 26.4 cm, slice width = 0.90 mm; monitor abdomen—oblique coronal scan, 100 kV, 241 mAs, field of view = 26.4 × 26.4 cm, slice width = 0.90 mm). MRIs were taken with the same Philips Achieva 1.5T MR scanner (boa head—oblique axial T1 weighted image, TR/TE = 30.6/14.8, FOV = 12.0 × 12.0 cm, slice thickness = 3.0 mm/−1.0 mm, number of signals acquired = 2, bandwidth = 7.8 kHz; monitor abdomen—oblique axial T1 weighted image, TR/TE = 30.4/14.5, FOV = 12.0 × 12.0 cm, slice thickness = 3.0 mm/−1.0 mm, number of signals acquired = 2, bandwidth = 7.8 kHz). Radiographs with the Quantum Medical Imaging Scanner (set for an adult arm scan, 60 kVp, 150s mA, 8.0 mAs, 14 cm). As seen in Figure 5.48, the capsules are clearly evident in both locations, by all three modalities.

Previous studies (see above) have documented that gelatin-based contrast agents have the ability to fill arterial trees down to the level of the capillary beds. To accomplish this, the vascular tree is first cleared by perfusion with heparinized saline, then the (still warm) contrast agent is introduced. There are a variety of clot-dissolving compounds, but these are generally inadequate to completely clear the vascular

Figure 5.49 The contrast agent is capable of clearly demonstrating relatively small vessels; here a small artery has been injected (post mortem) in the neck of a preserved specimen of *Boa constrictor.*

tree. We did not attempt a complete vascular perfusion with this contrast medium, but did introduce it to a small vessel within the neck of the *Boa constrictor,* where even the small volumes could be detected by CT (Figure 5.49).

The gelatin/gelatine substrate of this contrast medium, once set, is valuable for dissection. This contrast agent should withstand basic histological processing (depending on the protocol used, the addition of gum arabic at 0.02 gm per ml of contrast agent may be advised), thus allowing the marker to be used for subsequent histological 3D reconstruction.

Acknowledgments

The authors are indebted to the staffs and administrations of the Northeast Regional Medical Center (Kirksville, MO) and the Kirksville Family Medicine Clinic (Kirksville, MO) for their cooperation and technical assistance with this project.

References

Conlogue, G.J., Ogden, J.A., and Kier, E.L. 1978. Preparation Technique and a New Contrast Medium for Radiography of Biological Specimens. *Radiologic Technology.* 49:737–743.

Degueurce, C., vo Duy, S., Bleton, J., Hugon, P., Cadot, L., Tchapla, A., and Adds, P. 2010. The Celebrated Écorchés of Honoré Fragonard, Part 2: Details of the Technique Used by Fragonard. *Clinical Anatomy.* Apr, 23(3):258–264.

Goby, P. 1913. A New Application of Roentgen Rays, Microradiography. *Journal of the Röntgen Society.* 9(36): 92, 373–375.

Eisenberg, R.L. 1992. *Radiology: An Illustrated History,* pp. 457–451. St. Louis, MO: Mosby Year Book, Inc.

Gagliardi, R.A. and McClennan, B.L. 1996. *A History of the Radiological Sciences Diagnosis,* pp. 179–184, 271–276. Reston, VA: Radiology Centennial.

Schlesinger, M.J. 1957. New radiopaque mass for vascular injection. *Laboratory Investigation.* 6:1–11.

The Mummy Road Show. Episode 302: *Medical Mummies.* Engle Brothers Media Inc., New York. The National Geographic Channel. Premier: September 2003.

The Mummy Road Show. Episode 304: *Involuntary Mummies.* Engle Brothers Media Inc., New York, New York. The National Geographic Channel. Premier: September 2003.

The Mummy Road Show. Episode 305: *Mummies Inside Out.* Engle Brothers Media Inc., New York, New York. The National Geographic Channel. Premier: September 2003.

Industrial Radiography

ROBERT LOMBARDO AND GERALD J. CONLOGUE

6

Contents

The intent of this chapter is to provide an overview of non-clinical applications of radiograph. A more thorough presentation can be found in Martz et al. (2016). Industrial radiography is more generally known as non-destructive testing or NDT. The term emphasizes that an object will not be adversely affected when inspected using radiation. In the military, the term is slightly modified and more commonly designated as non-destructive evaluation or NDE and non-destructive inspection or NDI. Unlike clinical radiography, where the focus is a patient's body containing a narrow range of densities including a variety of hydrated tissues, bone, and air, NDT must consider imaging a wide variety of materials ranging from thin plastics to thick steel. In addition, diagnostic radiography of patient only utilizes radiation of extra-nuclear origin, whereas NDT also employs isotopes where radiation originates from the nucleus. A more in-depth discussion of the two types of radiation origins will be provided shortly.

The extensive role NDT plays in our everyday lives is often overlooked (Table 6.1). The main purpose for industrial radiography is to inspect and evaluate materials in order to assure structural integrity. Examples of the types of defects include the detection of corrosion, bad welds, stress fractures, discontinuities, or flaws. It plays an extremely vital role especially in the aircraft industry, both commercial and military, where there are structural high-stress factors on wings and engine parts. NDT also plays an important role in munitions manufacturing and explosive ordinance disposal teams (bomb squads, bomb disposal).

Radiation Sources

The type of radiation utilized in NDT is dependent upon the object size, composition, and thickness of material under examination. As previously described, the penetrating power of the radiation is designated by the electron volts (eV). In clinical radiography and some NDT applications, the penetrating power is expressed as thousands of electron volts or keV, and the maximum or peak kilovoltage is indicated as kVp. Once the penetration required has been determined, the total quantity of radiation needed to produce the image on the image receptor is determined by two factors: milliamperage (mA) multiplied by the total exposure time expressed in seconds (s) or mAs. In clinical radiation therapy and other NDT applications, the penetrating power is expressed in millions of electron volts or MeV. In NDT, the total quantity of exposure is expressed as seconds (s), minutes (min), or even hours (hr).

The method to generate extra-nuclear forms of radiation was previously discussed in Chapter 4, Plane Radiography Digital Radiography, Mammography, Tomosyntheses, and Fluoroscopy, and generally will provide, in the clinical setting, penetrating power of 120 kVp and in NDT up to 350 kVp. When higher penetrating powers are needed, radiation that originates from the nucleus of the atom is required. Before the discussion goes further, a bit of a review of nuclear structure is necessary. For our purposes, the nucleus contains two particles: a positively charged proton and a neutron with a neutral charge. The latter is also slightly *larger* than the former.

An element is determined by the number of protons. Therefore, a nucleus that contains one proton is always hydrogen with the chemical symbol *H*. However, an element with the same number of protons but a different number of neutrons is defined as an isotope. Elemental hydrogen has no neutron present in the nucleus, but there is a form of hydrogen with one neutron, known as deuterium, and another with two neutrons, tritium. Since all are forms of hydrogen, *H*, there is a convention to identify the specific form. The total number of protons and neutrons is indicated by a superscript number positioned to the right of the chemical symbol (Table 6.2). NDT employs two isotopes of elements, iridium (Ir^{192}) and cobalt (Co^{60}).

Table 6.1 A Sample of Items Examined Using NDT

Categories	Items
Automotive	Engines and engine parts, rims, seat belts, airbag deployment mechanisms
Aircraft	Engine components, wings, landing gears, overhead compartments, even toilet bowls in the aircraft lavatory
Military	Aircraft, ships, explosives, detonators, weapons, and components
Household and Commercial products	Appliance parts, switches
Transportation	Train wheels, highway bridges, power plants, refineries

Table 6.2 Three Forms of Hydrogen

# Protons	# Neutrons	Symbol	Term
1	0	H^1	Elemental Hydrogen
1	1	H^2	Deuterium
1	1	H^3	Tritium

With an understanding of basic nuclear structure, the process of radiation originating from the nucleus can be considered. Nuclear radiation is the result of the process of transformation of unstable nuclei to a more stable form. During this process, there is spontaneous random emission of ionizing radiation consisting of nuclear particles and gamma radiation. The number of nuclei in a specific sample undergoing transformation per unit time is defined as activity. The transformation or decay occurs at constant intervals and is measured using the term physical half-life. The latter is defined as the time it takes for the specific sample to lose half of its initial activity. The half-life of Ir^{192} is 73.83 days and that of Co^{60} is 5.26 years.

The nuclei of both the isotopes of iridium and cobalt go through a similar transformation process. Recall the neutron is slightly *larger* than the proton. Within the nucleus of those isotopes, a neutron transforms into proton and emits the residual energy difference between the two particles as a beta (β) particle and gamma radiation, high-energy electromagnetic radiation. In both forms, the beta radiation can be filtered out using aluminum, leaving the Ir^{192} emitting 0.31, 0.47, and 0.60 MeV gamma radiation and Co^{60} emitting 1.33 and 1.17 MeV gamma radiation. Therefore, Co^{60} is about twice as penetrating as Ir^{192}.

Three sources of radiation are available: X-ray generator, isotopes, and a linear accelerator.

X-ray generators: The X-ray sources used in industrial settings are identical in basic construction to the sources employed in the clinical setting, with the exception of the penetrating power. With an NDT source capable of 80–450 kVp, as the penetrating ability increases there must be a greater awareness of radiation-protection precautions. Where 6 ft (1.8 m) might be a safe distance when using 55 kVp to radiograph

skeletal remains, 100 ft (30.5 m) would be required with a 200 kVp exposure of a 1-in (2.54-cm) steel plate.

Isotopes: In situations where an extremely large object such as a steel plate needs to be examined, radio-isotopes can provide the solution. They are portable and do not require an electrical supply; therefore, they can be used in the field where X-ray sources cannot go. However, there are several problems associated with this approach. The possession and use of isotopes are regulated by the Nuclear Regulatory Commission and require licensing. Isotopes are extremely dangerous to handle and cannot just be removed from the container and placed in front of an object for an exposure. The isotope must be stored in a radiation-protected transportable container and placed in the exposed position remotely. When being deployed for an exposure, the isotope is cranked out to its location from a safe distance away (Figure 6.1). The exposure areas must be roped off up to 100 ft (30.5 m) or more in all directions for safety. The exposure time can be 30 minutes to an hour or more. Once the exposure is made, the isotope must be cranked back into its container and the area is measured with a radiation meter to confirm its safe placement back into its storage container.

LINAC system: The major difference between linear particle accelerators, commonly known as a LINAC systems (linear accelerators), and X-ray generators is that the electron acceleration across the X-ray tube is limited by the voltage supply available. However, the LINAC, depending on its design, is capable of accelerating not only electrons but also ions close to the speed of light. Based on this higher acceleration, LINAC systems are available with penetrating abilities ranging from 5 to 10 MeV.

Therefore, a LINAC system can be used for NDT radiographic examination. In medical institutions, the same type of system is used in radiation therapy termed teletherapy. These units are not mobile and have a high capacity to penetrate thick metal objects used in industrial applications, ranging from applications such as the inspection of brake pads to imaging entire tractor-trailer trucks.

Figure 6.1 A 1-inch (2.5-cm) thick steel plate radiographed at 200 kVp, 4.5 mA, 1.5 minutes (A). A second radiograph increasing the exposure time to 2.0 minutes (B). The plate was put through the reader twice without additional exposures: note the *ghosting* (C).

Image Receptor

NDT still utilizes both film and digital recording media. Since image receptors and associated topics were discussed extensively in Chapter 4: Plane Radiography (this volume), only the more salient points will be presented here.

As indicated above, film is still employed in NDT and differs from what was commonly used in general clinical radiography. In the latter situation, in order to minimize the patient dose but still produce an image of diagnostic quality, resolution was sacrificed. Resolution and not dose is the primary objective with NDT. Therefore, the film intended for industrial application differed from the product intended for clinic application. Industrial films have more of the image-forming crystals, silver halide, in a thicker layer coating the film base. Therefore, the film may require longer exposure time, which might extend for many seconds or minutes, instead of the fraction of a second to expose a patient's chest in a clinical facility. Following the exposure, the film will complete the transit through an automatic processing unit in 90 to 180 seconds. The exposed NDT film can require 5 to 12 minutes to exit the processing unit.

Similarly, the basic concepts of the two categories of digital image receptors, direct digital radiography (DR) and computed radiography (CR), have been previously considered, but the more relevant aspects of NDT will be discussed in this section. Spatial resolution is the primary concern with NDT digital image receptor systems. Clinical CR and DR image receptors have a maximum spatial resolution of 100 ʊm, whereas in NDT there are CR systems available with 30 ʊm and DR plates with 5 ʊm spatial resolution. Beside the higher resolution, the clinical digital image receptor systems were designed for a 50–140 kVp range. However, image receptors intended for NDT must be selected for specific energy ranges of 20–150 kV versus 40 kV–15 MV relative to the intended use. If the lower kVp range image receptor is used with the higher setting, it may not be possible to easily erase the plate (Figure 6.1).

Advantages and Disadvantages of CR and DR

Computed radiography uses image phosphor plates, similar in appearance to standard film cassettes and easily transportable. One CR system, including the reader and computer, can serve many X-ray rooms, while a DR system is incorporated into the room it's used in. Portable DR systems are available, but due to the incorporated electronics they are heavier than the CR plates. In addition, the image receptor can be very costly to replace: US\$800 for a CR plate and US\$60,000 for the DR panel. Aside from being less expensive, certain CR systems, such as Fuji imaging panels, can be removed from the cassette-like holder and placed into a flexible sleeve.

Reference

Harry E. Martz, Clint M. Logan, Daniel J. Schneberk, and Peter J. Shull. *X-Ray Imaging: Fundamentals, Industrial Techniques and Applications*. 2016. CRC Press Taylor & Francis Group.

Computed Tomography (CT), Multi-Detector Computed Tomography (MDCT), Micro-CT, and Cone Beam Computed Tomography (CBCT)

7

GERALD J. CONLOGUE, ANDREW J. NELSON, AND ALAN G. LURIE

Contents

Computed Tomography—Gerald J. Conlogue

The term *tomography* means a coordinated motion between the X-ray source and the image receptor. In the case of computed tomography (CT), the image receptors consist of detectors that capture the X-ray photons transmitted through the patient or object, convert the photon energy to an electronic signal, and, finally, transmit the signal to the computer. Undoubtedly, CT was the most significant advancement in radiography since Röntgen's announcement in 1895. Prior to the introduction of CT as a modality, the only methods to image the brain were indirectly through invasive cerebral angiography (Figure 7.1), pneumoencephalography (Figure 7.2), and ventriculography (Figure 7.3). The latter two procedures required the introduction of either air or radiopaque contrast media into the cerebral ventricles. Displacement of the normal vascular or ventricular pattern indicated a space-occupying lesion on the 2D images. With the advent of CT, the brain could actually be visualized, completely eliminating the need for invasive cerebral ventricular studies.

The CT modality is based on the principle of differential attenuation. If tissue attenuation profiles can be collected from 180° around an object, these profiles can be mathematically superimposed to produce a single axial image of the object under examination. Godfrey Hounsfield has been credited with the development of

the equipment and Allan Cormack with the mathematical manipulations required to reconstruct the image. Interestingly, Hounsfield conducted his research while employed by EMI (Electric and Musical Industries) Limited, a company that also manufactured phonograph records and electronics. In fact, the rock and roll legend, The Beatles, recorded under the EMI label. In recognition of their achievements, both Hounsfield and Cormack were jointly awarded the 1979 Nobel Prize in Physiology and Medicine.

Introduced clinically in the mid-1970s, CT eliminated a number of problems associated with plane radiography. Primarily, superimposition, only partially suppressed by conventional tomography, was completely eliminated by this new modality. Because the X-ray beam, employed in CT, was extremely collimated, with maximum reduction of scatter radiation, tissues with similar levels of attenuation, such as gray and white matter of the brain, could be differentiated. In addition, this innovation transformed radiography from being simply qualitative, with black, white, and gray tones recorded on film, to a quantitative modality capable of tissue characterization based on X-ray photon-attenuation characteristics.

In the basic configuration of a computed tomographic unit, the X-ray source and several detectors in a single row are located within a circular or donut-shaped structure termed the *gantry* (Figure 7.4). The diameter of the latter will be the size-limiting factor of objects that

Figure 7.1 An approach in early cerebral angiography required the needle to be directly inserted into the carotid artery (A). Note the hub of the needle (arrow). The pattern of the cerebral arteries supplied by the left internal carotid on anterior-posterior (B) and lateral (C) projections were examined to determine if abnormal structures were present diverting the vessels.

Figure 7.2 Pneumoencephalography employed air to demonstrate the cerebral ventricles. Because air rises, the patient was rotated in various positions to demonstrate various portions of the ventricles. (A) An AP projection revealing the right (solid arrow) and left (dashed arrow) lateral ventricles; (B) the *brow-up* lateral projection with the lateral ventricles somewhat superimposed, but clearly demonstrating the third (dotted arrow), and fourth ventricles (dashed/dotted arrow).

Figure 7.3 A lateral skull following injection of contrast media into the cerebral ventricles during ventriculography: 3rd ventricle (A); cerebral aqueduct (B); and 4th ventricle (C).

can be examined (Figure 7.5). The object, the patient in the clinical situation, is placed on the table, more appropriately termed the *couch*. In this configuration, the couch is advanced into the center of the gantry and the X-ray tube and detector rotate to collect a single slice of data. This process is referred to as slice-by-slice acquisition.

In early CT scanners, rotation was restricted to less than 360° to prevent electric cables, connected to the X-ray tube and detectors, from tangling. Before the next slice could be acquired, the X-ray tube and detector returned to their original position and the couch advanced, in a process termed *indexing*, a specific

distance to prepare for the next exposure. Slice thickness was determined by restricting the X-ray beam to a specified width. Tony Santos, clinical coordinator at Naugatuck Community College in Waterbury, Connecticut, has been a radiographer working in CT for over 30 years. He recalled the thinnest section possible back then was 3 mm; however, it was not selected because it resulted in poor signal due to the high noise level. The common thicknesses he remembered using were 5, 8 and 10 mm. If contiguous slices were desired, the couch would index a distance equal to the slice thickness (Figure 7.6). For certain examinations, the couch index was greater than the slice width. In this

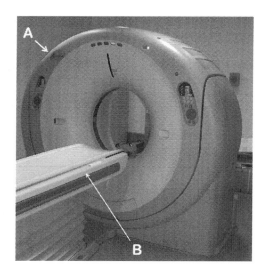

Figure 7.4 The typical configuration of a CT unit showing the rounded, donut-shaped structure (A), the gantry, containing the X-ray source and detectors, and the couch (B).

Figure 7.6 With contiguous slices, the couch index distance is equal to the slice thickness. (A) represents the first slice and (B) the second slice.

Figure 7.5 The diameter of the opening in the gantry is the size-limiting factor for objects that can be examined.

Figure 7.7 When the table index is greater than the slice thickness, a gap will exist between the slices (A) and (B).

situation, gaps would exist in between slices; however, the total X-ray dose to the patient would be reduced and the examination was completed in a shorter time (Figure 7.7). Santos also remembered that, during this period, the table index was almost always greater than the slice thickness, especially in abdomen and pelvis examinations. It probably wasn't until around 1990 that it was common to have table index equal to slice thickness. In a third approach, the couch would index less than the slice width, resulting in overlapping anatomic sections (Figure 7.8). The latter was performed in regions, such as the liver, where subsequent breath-hold for each slice may result in the organ being in a different position for each slice acquisition. However, overlapping slices increased the radiation dose to the patient.

From its introduction over forty years ago, various configurations of the hardware, termed *geometry*, have

been introduced. Each new geometry was identified as a particular *generation*. A more in-depth presentation of the early development of CT can be found in Bushong (2013). Early in this period, all data acquisition was slice-by-slice in the axial plane, therefore the common name for the modality was *computed axial tomography* or *CAT* scan. If coronal or sagittal reconstructions were desired, all the acquired slices had to be stacked and an algorithm was used to *reformat* the raw data into the desired plane, because at least several seconds elapsed between the acquisition of each slice and, due to voluntary or involuntary motion, the anatomic structure may not be in exactly the same position for each slice. Therefore *mis-registration artifacts* were frequently noted in the coronal (Figure 7.9) and sagittal reformats (Figure 7.10). On the 3D reconstructions, this mis-registration was more exaggerated and produced a characteristic *stair-step artifact* along the margins or edges of structures (Figure 7.11).

Figure 7.8 With overlapping slices, the table index is less than the slice thickness. (A) is the first slice and (B) is the second.

By the mid-1990s, volume acquisition scanners were introduced. In order to make this possible, several hardware innovations were required. Slip ring technology overcame the wiring limitations that restricted the X-ray source and detector movement to less than 360° within the gantry, and permitted continuous unrestricted rotation. Combining this circular motion with continuous movement of the couch through the gantry resulted in the collection of a volume of data instead of individual slices. Multiple parallel rows of detectors were also necessary to allow larger volumes of data to be collected during each rotation (Figure 7.12). Because of the latter, the modality is commonly referred to as either multi-detector computed tomography, *MDCT*, or multi-slice computed tomography, *MSCT*. The modality has also been referred to as *spiral scanning*; however, according to Bushong (2013), a spiral is a circular motion with a changing diameter, whereas a helix maintains the diameter throughout the motion. Therefore, the term *helical scanning* is more appropriate. With this hardware

arrangement, slice thickness was not determined by collimation of the X-ray beam, but rather by the configuration of rows of detectors that have been activated. In addition to the CT hardware innovations, concomitant computer hardware and software advances made it possible to not only handle the huge volume of data continuously streaming in from the detectors, but also create slices in various planes from the volume of data.

Although there may be old slice-by-slice acquisition units still available, this chapter will focus on volumetric acquisition equipment. Similarly to the other chapters, the following discussion will not provide an in-depth review of the physics involved with X-ray production, basic computer principles involved with image reconstruction, or a historic perspective of specific equipment innovations. For those topics and more, the readers are referred to Seeram (2009). However, the details presented are intended to provide a basic understanding of hardware configurations and build the complete set of instructions, termed a *protocol*, to optimize the factors involved in the raw data acquisition and subsequent data manipulation.

There have been numerous publications regarding MDCT related to topics such as scanning mummified remains; however, many omit important factors from the materials and methods sections of the paper that are relevant to either completely understand or replicate the specific protocol. This is perhaps due to the fact that the author or authors may not have been the individual who operated the unit, and are unaware of the significance of the omission. A 2010 study of 12 Chachapoya mummies illustrates the point (Friedrich et al. 2010). The following technical factors were included:

thorax and abdomen: standard resolution; collimation: 64×0.625; 120 kV/50 mAs; matrix: 512; (a) slice thickness: 3 mm/increment: 1.5 mm; filter B; (b) slice thickness: 1.5 mm/increment: 0.5 mm; filter C.

Figure 7.9 Axial image of the skull with the location (dashed line) of the desired coronal slice (A) Reformatted coronal section (B) Note the pixelation along the curve of the skull (arrow) created by stacking the axial images.

Figure 7.10 The axial image of the pelvis indicating the location (arrows) of the reformatted abdominal sagittal section (A) The lack of resolution (B) is due to a combination of peristalsis and breathing motion that occurs during the acquisition of all of the axial sections.

Figure 7.11 A 3D reconstruction of a skull. Note the stair-step artifact along the bone margins, such as the rim of both orbits. A fracture (arrow) is noted on the floor of the orbit.

Although a great deal of information was provided, unfortunately, the field of view, *FOV*, was not included. The FOV is significant because it determines the size of the image-forming pixels in the X–Y plane, a topic considered in depth below. However, relevant to the 3D reconstruction, the slice thickness was included along with an "increment" measurement. With the increment less than the slice thickness, it indicates overlapping of slices that improved the resolution on 3D reconstructions.

Therefore, the following discussion will not only consider all factors included in establishing a protocol, such as directing the acquisition and subsequent raw data manipulation, but also explain the rational for each selection. This information is important because most individuals who operate the equipment are radiographers who were trained to perform carefully prescribed scanning studies of live patients. However, the clinical approach is inappropriate here for two primary reasons. First, clinical protocols were developed for living patients with hydrated tissues. Second, the primary focus of clinical scanning is to reduce the dose as much as possible while maintaining a level of resolution that will ensure an accurate diagnosis. Comparing a low-dose clinical protocol to one specifically formulated for mummified remains

Figure 7.12 With the cowling removed from a Toshiba Aquilion® 64-slice unit, it is possible to see the X-ray source (A) and the rows of multiple detectors (B).

Figure 7.13 A magnified portion of an axial image of the thoracic spine demonstrating calcified mediastinal nodes (arrow) acquired with a low-dose chest algorithm (A) and one specifically designed disregarding dose and enhancing resolution. (B) The low-dose approach consists of a thicker slice that contributes to the lower resolution.

clearly demonstrates the lack of resolution in the former (Figure 7.13).

In non-traditional applications, the opposite is the case; maximum resolution is necessary with little regard for dose. However, dose and heat generated within the X-ray tube are directly related. Recall, from the discussion in the plane radiography chapter (Chapter 4), that there is a direct relationship between kVp and mAs with regards to heat production. Therefore, in non-clinical applications, dose is not important, but efforts

to reduce heat load and therefore to minimize impact on the life of the x-ray tube should be given careful consideration.

In the clinical setting, a CT study is generally guided by signs and symptoms presented by the patient, suggesting that there are specific pathologic conditions that need to be confirmed or ruled out. However, in non-clinical studies, such as forensic or bioarchaeological research, with the exception of what may have been revealed on prior plane radiographs, the CT scan is likely to reveal new and unexpected features. Therefore, it is desirable to have MDCT images acquired at the highest resolution possible.

The following discussion will begin with those factors associated with raw data acquisition:

kVp

The primary role of kVp in MDCT is to provide sufficient penetration of the object under examination to ensure adequate X-ray photons reach the detectors. As with other digital imaging modalities, contrast and density are determined by algorithms and post-processing adjustments and not by the kVp selected. Consequently, there is only a limited range of kV settings. For example, with the Toshiba *Aquilion*® system at the Diagnostic Imaging Laboratory at Quinnipiac University on the North Haven Campus, Connecticut, the choices are 80, 100, 120, and 135 kV, while a Philips *Brilliance*® unit offers a selection of 90, 120, and 140 kV. If an insufficient kVp setting is selected, the software will not be able to assemble an accurate representation of the object because it is not being penetrated completely by the X-ray beam from all angles. This misrepresentation is termed an *aliasing artifact* and appears as streak artifact within the image. This artifact is generally encountered in a clinical context with an obese patient while attempting to minimize the dose delivered during the examination. Improved newer detector material requires fewer photons to form an image than those employed several decades ago, so lower kVp settings can be used. However, if a large number of specimens is going to be scanned in a short period of time, a lower kVp setting will decrease the overall heat load on the X-ray tube.

As long as aliasing is avoided, unlike plane radiography, kVp has no effect on the appearance of the image. To demonstrate this point, several different kVp settings were used to image the thoracic region of a mummy and the resulting sectional images were compared (Figure 7.14). Therefore, as a starting point, 100 kVp is suggested for mummified remains; however, 135 kVp would be necessary for fossils.

Figure 7.14 A comparison of axial sections through the thoracic spine of a mummy at different kVp setting: 80 (A); 100 (B); 120 (C); 135 (D). Note that there is little difference in resolution among the images.

mA

Unlike the discussion in previous chapters regarding plane and digital radiography, the "mA" and "s," are going to be considered separately. As formerly described, the mA determines the quantity of electrons that will be available for acceleration across the X-ray tube and subsequent production of X-ray photons. This is also referred to as X-ray *flux*. Since the detectors transform the X-ray photons to an electrical signal, a sufficient quantity of photons must reach the detectors to generate a strong signal with a low noise component, more specifically a high signal-to-noise ratio (SNR), to produce a quality image. Therefore, mA is the primary factor regulating the SNR. In the clinical setting, an obese patient will require a higher mA setting than a thin individual or an insufficient quantity of X-ray would result in a low SNR and a noisy or poor-quality image.

Generally, a wide range of mA settings is available, for example, the *Aquilion®* unit provides the following choices of 50, 100, 150, 200, 250, 300, 350, and 400, while the *Brilliance®* offers a selection of 15, 30, 50, 110, 125, 150, 175, 200, 350, and 265. Since mummified tissues are easily penetrated, fewer photons are required to create a satisfactory image. To illustrate the point, a comparison of two mA settings, 50 and 350, demonstrated no significant difference in resolution that could be seen on the resulting images (Figure 7.15). However, when examining fossils, the maximum setting of 400 mA was required in order to prevent aliasing artifacts.

In the last decade, in an effort to reduce radiation doses, MDCT units permit the mA to be automatically adjusted during the data acquisition process. This is achieved by a procedure termed *automatic mA*

modulation or *automatic tube current modulation* (ATCM). During the initial phase of a CT study, two preliminary exposures, termed *scout, scanogram (scano),* or *localizer* views are taken. Recall the X-ray tube, located in the gantry, rotates 360° around the couch that the object is resting on. The scout exposures are taken with the X-ray tube and detectors in a stationary position. For the first scout, the X-ray tube is directly above the table, considered "0" azimuth and corresponds, with regards to a patient, to anterior-posterior, AP, projection (Figure 7.16). For the second scout, the X-ray tube rotates 90° to generate an exposure across the couch and produce an image similar to a lateral project (Figure 7.17). When set for modulation, the computer calculates the quantity of radiation necessary to produce the satisfactory AP and lateral scout images. If the object on the couch was a living patient lying on their back for a study of the chest, less radiation would have been required for the AP than for the lateral scout. From those calculations, the computer will modulate the quantity of mA to ensure that only the minimum amount will be used as the X-ray tube rotates around the object. Once again, the principal advantage is to reduce the dose to the patient. In addition, lower mA settings will also reduce the heat load on the X-ray tube.

If modulation is selected, there are several choices, based on the level of dose, in selecting a specific mA. Toshiba provides three choices qualitatively indicated as *high quality, standard,* and *low dose*. Quantitatively, each selection is designated by the "standard deviation" (SD) by which the exposure is permitted to vary: SD 4.0 (high quality); SD 6.0 (standard), and SD 8.0 (low dose). The lower the SD, the higher the dose and the

Figure 7.15 A comparison of 50 mA (A) and 350 mA (B) demonstrating no significant difference in resolution in a formalin-preserved human injected with contrast media.

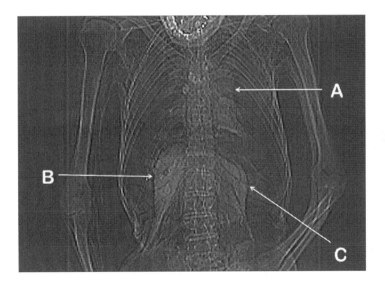

Figure 7.16 AP scanogram of a mummified adult. Note the lungs (A), liver (B), and spleen (C).

lesser the noise. Noise is defined as the variation about the mean, therefore less noise indicates less variation and a smaller SD. On the images, noise can be seen as non-uniform density, more of a speckled appearance. A series of scans, using all three levels of modulation, was conducted to determine if modulation affected resolution when imaging mummified remains. The resulting images demonstrated no difference in image resolution between high quality and low dose. However, the results can be attributed to the dehydrated nature of the remains (Figure 7.18A–B).

Since dose is not a concern in non-traditional applications, objects, such as dry skulls or mummified remains, lack sufficient differences in density for the mA to vary greatly during tube rotation. As a result, it is suggested that the modulation option be disregarded and not engaged. For most non-traditional applications with the exception of fossils, an initial mA selection of 300 should provide a sufficient quantity of radiation, with a higher S/R ratio, to reach the detectors and produce a quality image.

Exposure Time

That brings us to the "s" or time component of mAs. In MDCT, the exposure time is determined by two factors: the rotation time and the rate at which the table travels through the gantry. The former, a key feature in all

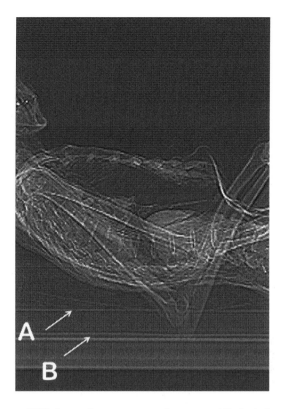

Figure 7.17 Lateral scanogram of a mummified adult resting on a foam pad (A) on the top of the couch (B).

MDCT units, is the time required for the X-ray source and detectors to make one complete revolution within the gantry. For the *Aquilion®* unit, the minimum rotation time is 0.32 seconds. Recall that these units are intended for clinical use. Fast rotation times are necessary in studies such as circulatory dynamics. Shorter duration exposures reduce the possibility of involuntary movement, such as peristalsis, and when integrated with a heart monitor, cardiac motion (termed *cardiac gating*). Reduced time also permits larger volumes of tissue to be collected in a shorter period of time, for example, during a single breath-hold by the patient. If the volume collection can be completed in a single breath-hold, involuntary motion can also be minimized. However, faster

rotation times would require increased mA settings. The other factor, table speed, is not only directly related to the volume of tissue acquired but also to image resolution. The relationship between rotation time and table speed is defined by the term *pitch*, to be discussed later. The *Aquilion®* system offers the following rotation times: 0.32, 0.5, 0.75, 1.0, 1.5, 2.0, and 3.0 seconds.

If the object under examination is not alive, there are several advantages to using a longer rotation time. First, the longer the rotation time, the lower the amount of X-ray (mA) necessary to produce a satisfactory image and a reduction in the heat generated by the system that is good for the life of the X-ray tube. This point leads to the second advantage: more objects can be examined in a shorter period of time. When patients are the focus of the imaging facility, it is possible to complete a study every 15–20 minutes with fast rotation settings, allowing the X-ray tube to cool down sufficiently between exposures as patients are exchanged. However, if the study consists of 20 skulls, it is possible to scan a skull every 5 minutes with slower rotation settings and numerous short change-outs between scans.

Detector Width

In MDCT, the detector width is provided by the first numerical value in its specification. For example, 0.5 × 64 indicates a 0.5 mm width and 64 detectors will be activated for the scan. One rotation of the X-ray source and detectors will provide a volume of 32 mm. In a system indicated by 0.625 × 64, such as the GE system, the detector width is 0.625 mm and a volume acquisition of 40 mm following one rotation.

The smallest detector width will provide the highest resolution. Once the raw data have been collected, it is not possible to reconstruct slices or sections that are smaller than the initial size. In addition, the quality of the 3D reconstructions will be improved with the smaller initial detector size.

Figure 7.18 (A) Employing three different standard deviations with the modulated mA demonstrated no noticeable difference in resolution. (B) Magnified section demonstrating no noticeable difference in resolution.

Figure 7.19 Three detector array configurations: (A) Siemens 4-Channel Asymmetric or Adaptive Array with the narrowest detector in the central position and increasingly wider detectors on the outside. (B) A General Electric (GE) 16-Channel Hybrid Array consisting of two detector widths with the narrowest in the center flanked by the wider detectors. (C) A GE 4-Channel Uniform Array with all detectors the same width.

Number of Detectors

Multiple detector rows enable larger volumes of tissue to be collected in one breath-hold in the clinical setting. When non-clinical materials are the subject of the study, the detector width is more important than the number of detector rows or channels available. However, if 64 detectors are available, they all should be employed. In the case of an asymmetric (adaptive) detector array, the central detectors are the narrowest and should be the only channels activated for the examination (Figure 7.19).

Detectors can be combined or coupled. For example, a specific protocol may employ 0.5 × 64, while another may be set for 1.0 × 32. In both cases, all 64 detectors are being used; however, in the second example, two 0.5 mm detectors are coupled together and work as a single 1.0 mm unit, a function known as *binning*, which allows for a reduction in mA, or an increase in detector sensitivity with static technique settings. However, binning will increase partial volume effect and therefore reduce resolution. Situations will be described later when coupling detectors are discussed. In the clinical setting, if detail is not as important, selecting a 1.0 mm detector would require a lower dose for the same area.

$$\text{Pitch} = \frac{\text{Couch movement (mm)/Rotation}}{\text{Slice Thickness (mm)}}$$

Figure 7.20 The formula for pitch calculation.

Figure 7.21 With a pitch greater than 1.0, the coils of data collected by consecutive slices, (A) and (B), are further apart.

Remember, when living patients are the subject of the study, dose is an important consideration.

Pitch and Helical Pitch

Pitch (Figure 7.20) can be a difficult concept to grasp; however, the following is an attempt to present a simplified explanation. Consider a helical CT unit with a single row of detectors. As described above, the volume is collected by a combination of two motions: first the X-ray tube and detectors spinning inside of the gantry and, second, at the same time, the couch moving through the gantry. The result is the collection of a helical data set. If the rates of the two are equal, the pitch is expressed as 1.0. If the couch is moving through the gantry at a higher rate, the pitch will be greater than 1.0. Conversely, if the couch movement rate is slower, the pitch will be less than 1.0. At this point, in most courses that train radiographers to understand the concept, a *Slinky*™ will appear to demonstrate changes in pitch. Unfortunately, this is not possible with a book, but a couple of figures might suffice. As the pitch increases, the coils will be farther apart (Figure 7.21). When the pitch is 1.0, the coils are touching (Figure 7.22). Regrettably, the *Slinky*™ will not work to demonstrate a pitch of less than 1.0. In this case, with the couch moving slowly, the coils overlap (Figure 7.23). This latter situation will provide the most accurate representation of the data, but will result in the highest dose to the patient.

The situation becomes more complex when multiple rows of detectors are involved, as in the case of MDCT, resulting in a modification of the calculation

Figure 7.22 With a pitch of 1.0, there is no space between consecutive slices (A) and (B).

Figure 7.23 With a pitch of less than 1.0, the data collected by consecutive slices (A) and (B) overlap.

and the introduction of another term, *helical pitch* (HP) or *pitch factor* (PF) (Figure 7.24), employed to describe the process. Because HP is based on slice thickness, the result is a two-digit number, such as 41, 53, and 95, for the Toshiba *Aquilion®*. Unless you see the three settings, it would not be possible to know that 41 provided the smallest pitch. However, PF considers the beam in the calculation, resulting in values, such as 0.6, 0.8 and 1.6, that more closely resemble the pitch calculation for a single row of detectors.

Regardless of the number of rows of detectors, the process to reconstruct the images is identical. Once acquisition has been completed, imagine that the data are located on the coils and not in the space between them. However, axial slices that need to be generated are from a data set where no true axial data exist. The computer will employ an algorithm to perform *interpolation* to create not only axial slices, but sections in any plane, termed *multi-planar reformats* (MPR), including *oblique reformats* (Figure 7.25) and *curved-linear*

A

HP = <u>Table movement (mm)/Rotation</u>
<u>Slice Thickness</u>

B

PF = <u>Table movement (mm)/Rotation</u>
<u>Beam width (mm)</u>

Figure 7.24 Two calculations *Helical Pitch* (A) and *Pitch Factor* (B) are different methods to express the concept of pitch with an MDCT system.

or *curved MPR*. With the latter, using one of the conventional MPRs, such as the axial, sagittal, or coronal, a particular structure is traced using the cursor and, on the remaining quadrant of the screen, the tracing is reconstructed into a linear structure (Figure 7.26A–B).

For mummified remains, a visual inspection did not appear to provide a noticeable difference with changes in the HP settings available on the *Aquilion®* unit (Figure 7.27).

Field of View (FOV)

The reconstructed image is displayed on an image matrix. The matrix is formed by a 2D array of picture elements termed *pixels* projected onto an x/y coordinate system. CT images generally consist of a standardized matrix size of 512 × 512 pixels (Figure 7.28). From the perspective of the inside of the gantry, the x-axis runs in the left/right direction and the y-axis is along the anterior/posterior axis (Figure 7.29). The matrix dimension will remain constant; however, by adjusting the area under examination, termed the FOV, the pixel size can be altered. The thickness of the slice creates the 3D aspect for the volume element termed a *voxel*. The thickness therefore represents the z-axis in the 3D coordinate system (Figure 7.30). The z-axis runs parallel to the movement of the couch and represents superior/inferior orientation.

With the Toshiba *Aquilion®* unit, the FOV is divided into *calibrated* (CFOV) and *display* (DFOV). The former represents pre-selected field sizes, while the latter provides the opportunity to fine tune or reduce the final areas selected (Figure 7.31). Other systems employ the term *scanning field of view* (SFOV) instead of CFOV. Five CFOV settings are available for the *Aquilion®*: 180 mm (small–small), 240 mm (small), 320 mm (medium), 400 mm (large), and 500 mm (large–large). The CFOV

Figure 7.25 An axial section of an excised hyoid bone (A) indicated the position of the oblique or off-axis section (arrow). The 1.0-mm thick oblique MPR generated from the axial section (B) The arrow indicates the site of a fracture on the distal greater horn of the hyoid.

Figure 7.26 (A) An axial section through the skull of an Egyptian child mummy revealing scrambled cranial elements. The arrows indicate the beginning and end of the line drawn with the cursor over the mandibular components. (B) The resulting curve-linear reconstruction of the mandible and portion of the left posterior maxilla.

is the diameter across the center of the gantry, termed *isocenter* (Figure 7.32). Anything within that CFOV is included in the raw data acquired. The DFOV is the region, established by the operator, that will be reconstructed from the raw data set. If the DFOV exceeds the CFOV, the resulting images quality may be compromised.

Pixel size is calculated by dividing the CFOV by the matrix size, 512. For example, if a 500 mm CFOV is selected, the X and Y pixel sizes will be 500 mm/512 or 0.98 mm. The smaller the CFOV, the higher the resolution on the resulting reconstruction. Therefore, selecting the 320 mm CFOV would result in a 0.63 mm pixel. Most

important, from a resolution prospective, is to select a CFOV that is equal or nearly equal to the slice thickness. In this case, the voxel is termed *isotropic* and renders the optimal MPRs and 3D reconstructions. Reformatting *stacks* the original reconstruction process and permits viewing from different orientations. The easiest approach to understanding this concept is to relate it to the orthogonal planes commonly viewed in the clinical situation: axial sections are the initial reconstruction process. Scrolling along the z-axis would allow viewing of all the axial sections (Figure 7.33A–B). Similarly, a coronal reformat places the z/x axis in the viewing plane and requires scrolling in the y-axis to examine the stack

Figure 7.27 A comparison of the lowest, 41, and highest, 95, helical pitch resulted in no noticeable difference in resolution.

Matrix = 512 x 512 Pixels

Figure 7.28 The imaging matrix consists of 512 pixels along the x- and y-axes.

of images (Figure 7.34). Correspondingly, with a sagittal reformat, the z/y axis is placed into the viewing plane, and scrolling along the x-axis permits other sections to be seen (Figure 7.35A–B).

The effect of non-isotropic voxels is clearly evident in basic orthogonal reconstructions (Figure 7.36). Since the axial plane represents the 512×512 matrix with equal dimensions along the x/y axis, the reconstruction will provide the most satisfactory images. However, with the larger value of the z-axis, the coronal and sagittal reformats will be unsatisfactory as the voxels are no longer isotropic, but are instead rectangular (Figure 7.37). The difference between isotropic and non-isotropic voxels is even more dramatically demonstrated with 3D reconstructions (Figure 7.38).

Non-orthogonal reformats such as oblique and curve-linear reconstructions also rely on stacking the original data set but are much more complex. The oblique or off-axis orientation is easier to diagram (Figure 7.39). Since the orientation of structures within a body or object is rarely in an orthogonal plane, the

Figure 7.29 From the perspective of inside the gantry, the x-axis of the matrix is oriented from left to right, while the y-axis represents anterior to posterior.

oblique reformat can be invaluable (Figure 7.40). A curve-linear reformat is much more difficult to diagram, but easily demonstrated. Any of the orthogonal planes, axial, coronal, or sagittal can be selected to formulate the curve-linear reconstruction. However, without this algorithm it would not be possible to demonstrate curved structures, such as the teeth in a mandible, in a single image. Particularly in this last example, without isotropic voxels, the reconstruction would be less than satisfactory.

Several examples will illustrate the importance of isotropic voxels in non-clinical applications. For the Toshiba system, isotropic voxels would be reconstructed using 0.5-mm slice thickness, selecting the 240-mm

Figure 7.30 The volume element or *voxel* is the addition of the slice thickness along the z-axis added to the matrix composed of the x- and y-axes.

Figure 7.32 A diagrammatic representation of three CFOV settings relative to the *isocenter* of the gantry.

Algorithms

CFOV, which yields 0.47-mm pixels (Figure 7.41). In addition, at 1.0-mm slice thickness and a 500-mm CFOV would result in 0.98-mm pixels (Figure 7.42). With a general electric (GE) unit that offers a 0.625-mm slice thickness, the 320-mm FOV will produce isotropic voxels.

It is important to note that the kV settings must be calibrated for the various CFOV selections (Figure 7.43). Calibrations can only be accomplished by a service engineer. Failure to do so can result in *ring artifact* (Figure 7.44).

Once the raw data have been acquired, they can be adjusted by various operations to improve, modify, or manipulate the resulting image.

The area selected as CFOV will activate only the detectors under that portion of the object to be scanned. The selected detectors will then send the acquired raw data to the computer, where they are processed by specific mathematical operations or *algorithms*. Each algorithm manipulates the data to produce a certain effect seen on the reconstructed image. Algorithms, also termed *filters* or *filter convolutions* (*FCs*), can be divided into two general categories: first to establish of the initial appearance of the image and, second, to correct problems that are inherent to the physics of the system. The first category offers a number of combinations that vary the degree of edge enhancement or smoothing (Figure 7.45A–B). Simply put, the former would be used if the emphasis was skeletal structures, while the latter would be employed for studies of organs, such as the liver or brain.

The other category of corrective algorithms requires a bit more physics regarding the absorption of

Figure 7.31 The initial representation of the CFOV is indicated by the rectangle enclosing the object of the scan, in this case pottery shards (A) The DFOV provides the opportunity to reduce the size of the CFOV (B).

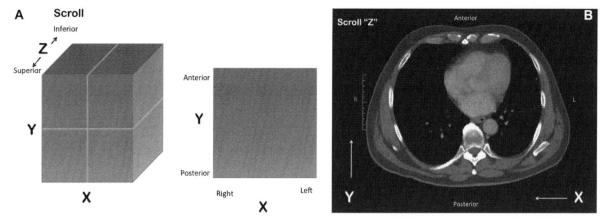

Figure 7.33 (A) Displaying an axial section places the x/y axis in the viewing plane. Visualizing all the axial images requires scrolling in the z-plane. (B) An axial image of a chest.

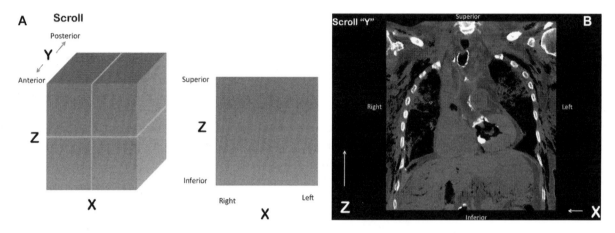

Figure 7.34 (A) A coronal reformate places the z/x axis into the viewing plane and requires scrolling through the y-axis to examine the entire stack of images. (B) A coronal reformate of a chest image.

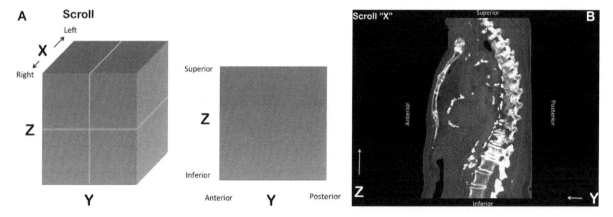

Figure 7.35 (A) A sagittal section places the z/y axis in the viewing plane and requires scrolling along the x-axis to view the stack. (B) A sagittal section of a chest.

the X-ray beam and basics on how the data were collected. The X-ray beam is composed of photons that vary in energy or penetrating power. The maximum energy of a photon is determined by the kVp set on the control panel. Remember the "p" indicates the peak kilovoltage selected. Very few photons will possess that

level of penetrating ability. The average energy of the beam is approximately 30 % of the kVp selected (Figure 7.46). A more complete description of the X-ray generation process can be found in Bushong (2013). As the beam encounters material of different densities, more low energy photons will be absorbed by structures such

Figure 7.36 With a non-isotropic voxel, the pixels are represented by equal X and Y lengths, but the length of Z, the slice thickness, is different. (A) axial; (B) coronal; (C) sagittal.

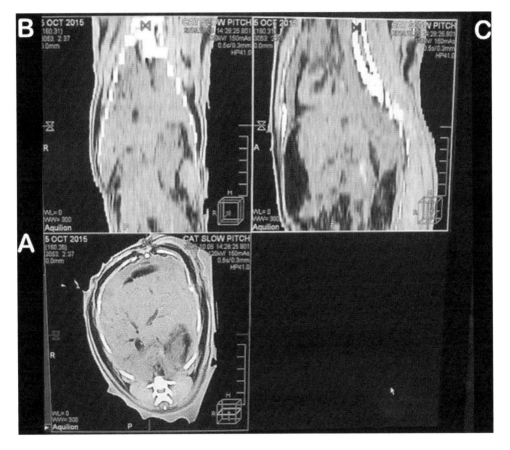

Figure 7.37 Orthogonal axial (A), coronal (B), and sagittal (C) sections of the abdomen of a formalin-embalmed cat. Since the voxels were non-isotropic, only the axial images were satisfactory.

as dense cortical bone. Therefore, the remnant of the beam emerging from the bone will have a higher average energy due to the loss of the low energy component. The beam is said to have been *hardened* by this process and will now more readily penetrate soft tissue structures that reside next to the bone and are subjected to the remnant beam. This phenomenon is known as *beam hardening effect* and is most clearly seen in regions of

the body surrounded by dense bony structures, such as on an axial scan of the cerebral hemispheres of the brain. Beam hardening is not generally encountered in the non-clinical setting, but will be discussed more when specific examples demonstrate the phenomenon (beam hardening is commonly encountered in micro-CT and will be discussed later in that section of this chapter). A different artifact occurs when very dense

Figure 7.38 3D reconstructions of an embalmed cat using isotropic (A) and non-isotropic (B) voxels.

Figure 7.39 A representation of an oblique or off-axis orientation (dashed arrow).

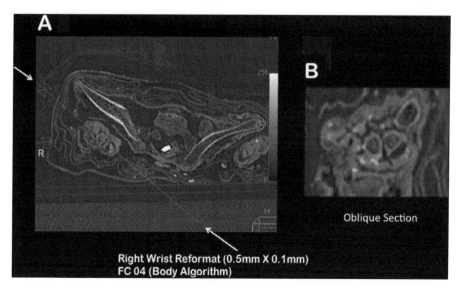

Figure 7.40 The location of an oblique section (arrows) through the right wrist of an axial section of an Egyptian child mummy (A) The oblique reformat demonstrating three calcified carpal bones in the wrist (B).

Figure 7.41 A comparison of axial sections through the liver and thoracic spine of an artificially mummified individual. (A) A 0.5 mm thick section with a 500 mm CFOV resulting in a 0.98 × 0.98 × 0.5 mm voxel. (B) A 0.5 mm thick section with a 240 mm CFOV resulting in a 0.47 × 0.47 × 0.5 mm voxel. Note the increased resolution on (B).

Figure 7.42 A comparison of axial sections through the liver and thoracic spine of an artificially mummified individual. (A) A 1.0 mm thick section with a 500 mm CFOV resulting in a 0.98 × 0.98 × 1.0 mm voxel. (B) A 0.5 mm thick section with a 240 mm CFOV resulting in a 0.47 × 0.47 × 0.5 mm voxel. Both images were generated from nearly isotropic voxels; however, (B) represents a thinner section.

Figure 7.43 The kV must be calibrated for each CFOV. For the 80 kV setting (A), only the small (S) or 240 mm CFOV was calibrated, unlike the 120 kV setting (B), where all but the small-small (SS) or 180 mm CFOV were calibrated.

objects, such as fillings in teeth or prosthetic metallic implants, are included in the FOV, resulting in streak artifacts on the reconstructed images (Barrett and Keat, 2004) (Figure 7.47A–B).

Algorithms are available that will reduce beam hardening and suppress streak artifact, but they may be identified using vendor-specific terminology. For example, with the Toshiba Aquilion®, a *BHC* FC will provide a beam hardening correction, while *Boost3D*® will suppresses streak artifact. In addition, the system also has *QDS*, quantum denoising software, to reduce image noise, and 3D adaptive filtering processes. However, since noise can be reduced by increasing signal, achieved by increasing the mA, and thus is not a consideration, QDS is not generally employed in non-clinical applications.

Figure 7.44 A ring artifact resulting from the selection of a CFOV that had not been calibrated for the kV selected. Note the pattern of the artifact in the axial image (A) and the relative position of the artifact in the coronal (B), sagittal (C), and 3D reconstruction (D).

Unfortunately, application of a particular correction algorithm, such as BHC, in a non-clinical situation may have adverse effects on image resolution. The algorithm that incorporates BHC includes edge smoothing rather than edge enhancement, resulting in decreased streak artifact, but also reduced bone resolution (Figure 7.48). In addition, when large or numerous metallic artifacts, such as fillings, are present, the streak artifact reduction component of the algorithm may have little or no effect (Figures 7.49 and 7.50). But, unlike in the clinical setting, more positioning options exist. For example, consider the skull of an individual who died in 1886 and had numerous bilateral gold fillings in premolars and molars. If it was a live patient with similar dental work being positioned for a study of the skull, the individual would have been placed supine on the couch with the head resting into a specially designed attachment to facilitate positioning and minimize movement. Since

streak artifact is generated at right angles to the X-ray tube/detector motion, the resulting 3D skull reconstructions exhibit streak artifacts projecting at right angles to the teeth. The artifact was minimized by orienting the long axis of the skull parallel to the circular motion of the X-ray source and detectors; an orientation not possible with a live patient's head (Figures 7.51 and 7.52). Aside from improving the esthetics of the 3D image, the data set acquired with the sagittal plane of the skull parallel to the axis of rotation would have been better suited for a 3D printed model.

Algorithms are selected prospectively by incorporating them into the protocol, while filters, to alter the degree of smoothing or edge sharpness, can be applied as a post-processing operation or retrospectively to alter the appearance of the image. More regarding filters in a bit. The Toshiba *Aquilion®* will permit four axial data sets to be reconstructed from the same scan data with

Figure 7.45 (A) The selection of bone algorithms or FCs available on the Toshiba *Aquilion*® system. Note each varies in the degree of edge sharpness. (B) An axial section of a dried femur processed with a bone algorithm, FC81, resulting in edge enhancement while (C) applied an algorithm, FC23, intended for a head to demonstrate a brain with edge smoothing.

Figure 7.46 As discussed in Chapter 4, the graphic representation of the X-ray beam is known as the *Characteristic Curve*. The x-axis represents the energy of the photons expressed in *keV* while the y-axis indicates the *number of photons* related to specific energies. The curved portion (A) is the *Bremsstrahlung* component of the beam, termed the continuous spectrum, and extends from "0" to the kilovoltage (kV) that has been selected and therefore designated as kVp. The discrete peak (B) represents the number of photons generated at the *characteristic X-ray* or energy of the target material. The average energy of the beam (C) is about 30–40% of the selected kVp.

a different algorithm applied to each (Figure 7.53). In addition, there is a *multiview* category that will enable the selection of coronal and sagittal sections with greater slice thickness than the axial data set (Figure 7.54). This last feature was designed for radiologists in order to reduce the amount of time required to scroll through a stack of sections. However, each axial series will automatically generate coronal and sagittal image stacks at the same thickness. Therefore, to reduce the size of the data sets that will be saved, the multiview feature is never activated in non-clinical situations. The final category under reconstruction details of the protocol is volume, which will be considered shortly.

Since the data were collected as a volume instead of the original approach of slice-by-slice acquisition, 3D renderings are easily created. Although not as

important as MPR images in making clinical diagnoses, they have several uses in non-traditional applications; more regarding the various uses shortly. There are several factors that must be considered in the volume acquisition portion of the protocol for non-clinical applications. First, the algorithm with the highest level of edge enhancement must be selected for the volumetric reconstruction (Figure 7.55). Selecting this algorithm will accentuate the difference in densities of adjacent materials. The next two items, image thickness and reconstruction interval, are critical based on desired application (Figure 7.56). The former indicates the detector width employed to collect the data, for example 0.5 mm. If 0.5 mm is also selected for the reconstruction interval, it signifies no overlapping of slices, and therefore this is considered a contiguous stack of slices. This approach would be required if the data were to be used to create a printed 3D model of the object (Figure 7.57). Currently, a DICOM data set must be converted to STL (*Stereolithography*), OBJ (object file), or other similar formats before a 3D printer will accept the data. However, if an optimal visual 3D reconstruction is the goal, non-contiguous or overlapping slices are a necessity (Figure 7.58). A consideration before selecting the amount of overlapping is the size of the file that will be generated. If a small object, such as a dried fetal skull, generated 255 contiguous axial slices, with a 0.1 mm reconstruction interval, a volume with a total of 1271 axial images would be produced. A larger subject, for example a chest of an adult mummy, would produce 701 contiguous axial images, but with a 0.3 mm reconstruction interval, a volume consisting of 1167 axial images would be produced. If instead of 0.3 mm, the reconstruction interval was set to 0.1 mm, a total of 3494 axial images would be generated, resulting in a huge file size.

Possibly the more important question, does a 0.1 reconstruction interval improve resolution compared to

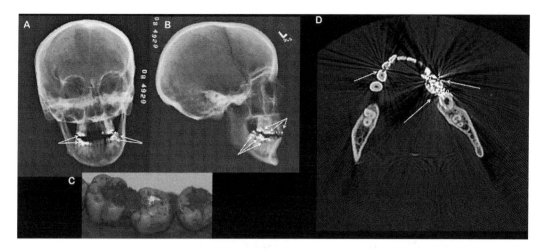

Figure 7.47 Anterior-posterior (A) and lateral projections (B) of the skull with numerous gold fillings, several indicated by arrow. (C) A photograph of several molars with gold fillings clearly visible. Axial image of the mandible (D) where the rays of the streak artifacts can be traced back to the gold fillings (arrows).

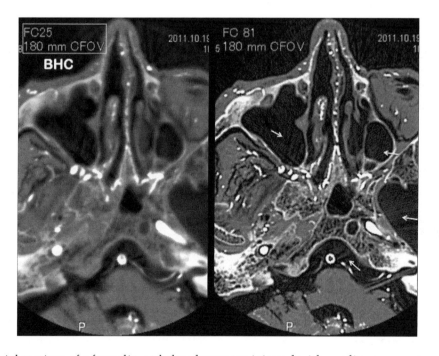

Figure 7.48 Two axial sections of a formalin-embalmed mummy injected with a radiopaque contrast media introduced into the arterial system, acquired with a 180 mm CFOV (A) An algorithm, FC 25, with beam hardening correction (BHC) (A); and an algorithm, FC 81, without beam hardening correction, but with maximum edge enhancement (B) Image (A) with the BHC incorporates softening of edges with the manipulation of the raw data. Image (B) provides the higher resolution, but artifacts (arrows) are more prominent.

a setting of 0.3 mm? A comparison of two curvilinear reconstructions of a dried fetal skull does not appear to demonstrate a significant difference (Figures 7.59 and 7.60). Therefore, in order to reduce file size, a 0.3 mm reconstruction overlap is suggested.

Windowing

Windowing, a feature of all digital imaging modalities, provides a method to vary the contrast and density of

the displayed image. With MDCT this process is based on Hounsfield Units (*HU*) or the older term *CT numbers*. Recall that the modality is based on differential attenuation and it is the ability to calculate HU that provides the quantitative characteristic of the modality. It is far beyond the scope of this presentation to demonstrate the derivation of the equations employed to arrive at the HU; for that, the reader is again directed to Seeram (2009) and Bushong (2013). However, hopefully, a more simplistic explanation will suffice. First, for each pixel a

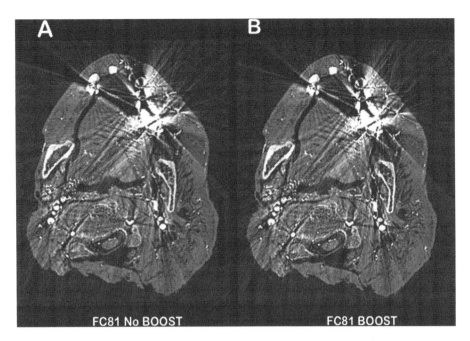

Figure 7.49 Axial sections of a formalin-embalmed human head with contrast media injected post mortem. In both cases, a high resolution bone algorithm (FC 81) was applied to the raw data. However, one (A) represents the reconstruction without the streak artifact reduction component (Boost3D) and the other (B) with the component applied.

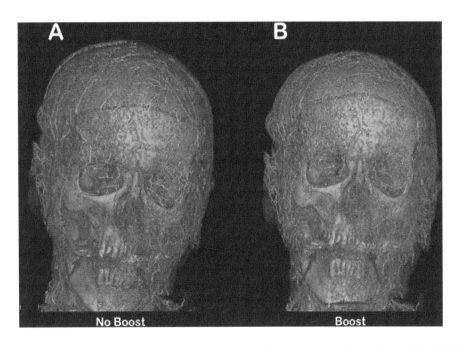

Figure 7.50 3D reconstructions of the embalmed human adult. The pattern on the surface of the skull represents superficial arteries filled with the radiopaque contrast media. The streak artifact is visible on both reconstructions (arrows). Although the *Boost3D* was supposed to remove more of the artifact on 3D reconstruction, a comparison between the algorithm without (A) and with the component (B) appears similar.

comparison is made between the quantity of X-ray photons that exits the X-ray tube and those that reach the detectors under the patient or object. This calculation provides the linear attenuation coefficient, *LAC*. The LAC is dependent on the atomic number and density of the object being scanned, and the penetrating ability of the X-ray beam that is determined by the kV selected,

another reason for limited kV choices. In addition, remember that kV must be calibrated for each CFOV, because the latter determines the size of the pixel and the LAC is calculated for each pixel in the image matrix.

Once the LAC has been derived for that pixel, the value is standardized to the LAC of water at the specific kV setting, with the resulting value designated as

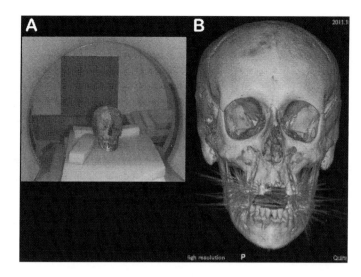

Figure 7.51 The skull positioned similarly to that of a live patient with the sagittal plane perpendicular to the axis of X-ray source/detector rotation (A) The resulting 3D reconstruction with streak artifact radiating out of the mouth (B)

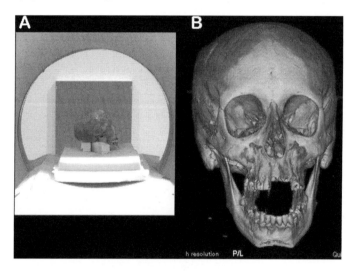

Figure 7.52 The skull positioned with the sagittal plane parallel to the axis of X-ray source/detector rotation (A) The resulting 3D reconstruction eliminated the streak artifact from projecting out of the mouth (B)

Figure 7.53 The Toshiba *Aqulion*® permits four axial imaging sets each with a different algorithm to be reconstructed from a single data acquisition.

Figure 7.54 Multiview (solid arrow) will permit up to two sets of axial sections to be reconstructed as coronal (dashed arrow) and/or sagittal (dotted arrow) sections of differing thickness than the corresponding axial section series.

Figure 7.55 The *Aquilion*® allows two volume reconstructions from the initial data acquisition. The first selection is the algorithm (arrow) used to process the data.

the HU. There can be only a single HU value for each pixel. Thick sections pose a potential problem because they may contain several densities. For example, in the most extreme case, cancellous bone contains both dense bone and air. Bone is very dense, resulting in a high HU, whereby air attenuates very little X-ray, generating a very low HU. However, since only a single HU can be assigned to any given pixel, an average value will be assigned which may not actually represent the materials within the voxel. This condition is known as partial volume effect (PVE) or partial volume averaging (PVA) and can be minimized by selecting thin sections.

Finally, back to windowing. The process can be divided into two components: *window width* and *window levels*. The window width is the range of HU that will be displayed as shades of gray in the image. The HU to the left of the window width, *WW*, will be displayed as black, and those to the right of the WW will appear as white. The modality is identified as an 8-bit system

Figure 7.56 The detail section choices under the volume reconstruction includes the algorithm selection (A), along with the image thickness (B) and the reconstruction interval (C).

Figure 7.57 A contiguous data set of a dried fetal skull converted to an STL file and used to print a model of the skull: The model being constructed on the 3D printer (A) The completed 3D model of a fetal skull (B).

indicating that there are 2^8 or 256 shades of gray to be distributed across the WW.

There are two important points regarding the window level, *WL*: the WL is always in the center of the WW; and the WL should represent the HU of the tissue or structure of interest (Figure 7.61). In the clinical setting, decades of experience have provided tables with HU for various tissues (Table 7.1). For example, recall the unit allows four possible axial data sets to be displayed. If the patient's orbits are the focus of the study, algorithms for

soft tissue, brain, and bone can each be assigned to individual axial data set reconstruction. However, this is not the case for non-traditional objects ranging from skeletal remains to fossils, where multiple algorithms have not been found to be required.

Data Manipulation

This is an excellent point to begin the discussion of the types of operations that are possible once optimal

Figure 7.58 A 3D reconstruction of a dried fetal skull created using a volume data set with 0.1 mm reconstruction overlap.

raw data have been collected. Since there are differences between software packages provided by each vendor, only a brief discussion of what is available on the Toshiba *Aquilion*® will be discussed. A more in-depth presentation can be found in Chapter 9, Section 4. The point of emphasis is that the units were developed for clinical applications and the specific pre-programmed image manipulation operations serve only as a starting point. Extensive experimentation with each software package is necessary to achieve the optimal results.

Most clinical MDCT units have two workstations or *consoles.* The one used to select the protocol and direct the scanning operations is termed the *operating console.* Once the raw data have been collected and processed according to specification in the protocol, they are sent to be viewed on the *display console* (Figure 7.62). As previously indicated, the analysis and manipulation of the data at this stage can be extremely time consuming. On a clinical scanner, there may not be sufficient free time available to carry out a thorough examination of the data or to complete lengthy procedures such as 3D reconstructions. Frequently, after what may be thought as the completion of a session, additional questions are raised and another session of data analysis is required. Not only may it be difficult to reschedule time on the display console of the clinical scanner, but the data may no longer be on the scanner. The data storage space on the scanning computer is limited. Once data have been collected, they are usually transferred to a *picture archiving and communication system, PACS.* Depending on the number of cases at the clinical site, data may only be available for a few weeks or a month before they are deleted to create space for recent studies. Because of the lack of information, such as patient identification number and billing data, non-clinical cases are usually not transferred to the PACS of the imaging center. It is therefore advisable to download data from the scanning computer onto a CD, DVD, thumb drive, or portable hard-drive. Although each manufacturer may utilize a *proprietary language* within their systems, all data are exported in a format known as *digital imaging and communications in medicine,* commonly referred to as

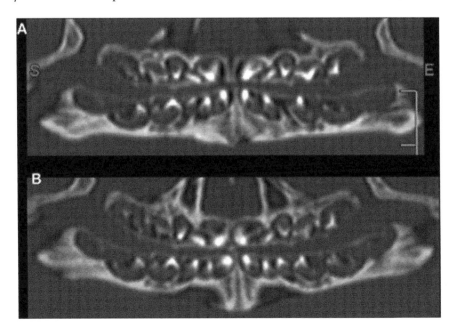

Figure 7.59 Curvilinear reconstruction of the maxilla and mandible of a dried fetal skull employing contiguous 0.5 mm thick sections (A) and overlapping of section intervals by 0.4 mm (B).

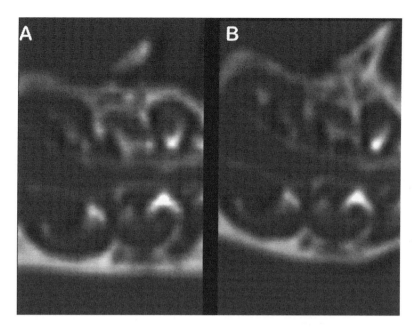

Figure 7.60 Magnified images of curvilinear reconstruction of the maxilla and mandible of a dried fetal skull employing contiguous 0.5 mm thick sections (A) and overlapping of section intervals by 0.4 mm (B).

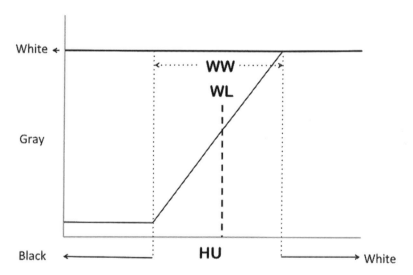

Figure 7.61 A diagrammatic representation of the concept of window width (WW) and window level (WL). Hounsfield Units (HU) are along the x-axis and the display, consisting of black, 256 shades of gray, and white, is along the y-axis. The window width (dotted lines) comprises the HU that will be displayed as shades of gray. HU values to the left of the WW will appear black while all the HU to the right of the WW will be assigned white. The window level (dashed line) is in the center of the window width and should represent the HU of the tissue/structure of interest.

DICOM. The DICOM format is basically a TIFF file with a header for metadata containing information about the patient, etc., and is never separate from the image. Frequently, DICOM readers are downloaded with files exported from PACS; however, DICOM image views are also available free of charge for PC or MAC platforms from the Internet. For the latter, there are both a free version, *OsiriX Lite®*, that will accommodate smaller file sizes and have limited image manipulation capabilities,

and a paid version, *OsiriX MD®*, that offers advanced post-processing techniques and a complete integration with any PACS. Similarly to many versions of software that perform the same functions, each have a somewhat different appearance and require a steep learning curve to operate (Figure 7.63A–C).

This section will briefly review a number of the post-processing functions and analysis tools that are available on most advanced software programs.

Table 7.1 WWs and WLs Expressed in HU for Various Regions of the Body

Region	Tissue	Window Width (HU)	Window Level (HU)
Brain	Posterior Fossa	100	40
	Brain	80	40
Chest	Soft Tissue	400	40
	Lung	1000	−400
Abdomen	Liver, Spleen, etc.	400	50
Cervical Spine	Soft Tissue	500	60
	Bone	1600	300
Thoracic Spine	Soft Tissue	500	60
	Bone	1600	300
Orbit	Soft Tissue	400	30
	Brain	100	40
	Bone	3000	500
Bone	Temporal	3000	500
	Spine	1600	300

After Bushong (2000: 58)

Figure 7.62 Two consoles, an operating or scan (A) and directing (B), were provided with the Toshiba Aquilion® multi-detector computed tomography unit.

Figure 7.63 (A) Multiplanar images as seen on the directing console screen of the Toshiba Aquillion® unit. (B) After a data set has been selected (arrow) with the OsiriX® software, the personal computer screen will display a stack of axial images. © With the OsiriX® software, a "3D MPR" must be selected from a pull down menu in order to display the same screen that would automatically come up on the Aquilion® system.

Figure 7.64 From the prospective of looking through the gantry toward the couch, the Daily Quantity Control Phantom (A) mounted on the end of the couch: the four plastic cylinders (B) mounted inside the water-filled chamber of the phantom, and the air-filled cylinder (C).

Region-of-Interest

The last topic considered concerning data acquisition was windowing and represents a convenient point to begin the discussion of data manipulation. In order to establish the proper settings, first the WL and then the WW, the HU for the components of the subject to be examined, must be determined. This procedure is accomplished by collecting either *region-of-interest (ROI)* data or pixel values. The ROI permits quantification of

pixel values for a specific region. At least three values are generated for each ROI: the area, *A*, that comprises the region sampled; the mean value, *M*, for the pixels in the sample area; and the standard deviation, *SD*, for the total number of pixels sampled.

However, prior to the collection of these data, it is important to scan a calibration phantom to establish baseline values. The Toshiba phantom is similar to those produced by other vendors and consists of small plastic cylinders of known varying densities arranged in a pattern within a larger cylinder filled with water. In addition, a small chamber is filled with air (Figure 7.64). The densities in the test areas simulate bone, oral contrast media, tissue, and fat, while the air in the small chamber and distilled water, filling the phantom, are not simulations (Figure 7.65). As previously indicated, the ROI provides three calculations: the area sampled, the mean HU value, and the standard deviation of the HU values for the region sampled (Figure 7.66). Although recommended as a daily practice in the clinical setting, scanning of the phantom is frequently overlooked. Nevertheless, in non-traditional applications, where WL and WW must be determined, HU are an important component of the data set and it is recommended that the phantom be scanned before and after the study or studies have been conducted. At the very least, it is recommended that a water calibrator be included in each scan to check the values produced by air and water. Although distilled water is the intended calibration material, one of the authors (AN) always includes a bag of saline on the scanner bed. However, a

Figure 7.65 The image of the phantom with ROIs for each of the test cylinders and the water within the larger cylinders (A) The daily report form with the acceptance limits for each of the test areas (B).

Figure 7.66 The ROI of the "air" chamber and the three calculated values: the size of area sampled (A); the mean HU value within the sample area (B); and the standard deviation of the HU values for the region sampled (C).

bottle of distilled water can generally be acquired from any pharmacy.

Returning to the discussion of ROI, other than the actual mean pixel HU obtained, the SD is also important. A small SD indicates homogeneity of the material within the ROI (Figure 7.67, Table 7.2). When the SD is high, there are three possibilities: the ROI is too large; the ROI has not been carefully placed to include only the material of interest, resulting in partial volume effect; or the structure of interest may be composed of mixed materials of differing densities. Particularly, with small structures within large objects, such as dehydrated tissues within mummified remains, employing solely ROIs to determine structural densities can be difficult, because of partial volume effect (Figure 7.68). If the ROI cannot be reduced in size (Figure 7.69), individual pixel values (Figure 7.70) provide a more accurate method to determine HU for specific structures. Because numerous pixel values need to be acquired to ensure an accurate representation, this is a much more laborious procedure.

Now that we have HU values for mummified tissue (Table 7.2), it is possible to demonstrate how WW alters image contrast and density. Using a mummified individual with an axial section at the level of the liver, two different WL and WW were selected. For the first, a WL of 200 and a WW of 2000 were chosen (Figure 7.71). With these settings, HU values from −800 to +1200 were displayed as shades of gray. In the second series of images, the designated WL was 300 and the WW equaled 3500 (Figure 7.72). In this case, HU values of −1450 to +2050 were assigned shades of gray. Comparing the two images, the wider window displays a longer scale of contrast with more shades of gray and less black (Figure 7.73).

Figure 7.67 Four ROI data sets were collected in this coronal section of a mummy, identified as G/F, dating to the late nineteenth or early twentieth century. Numbers 1 and 4 were from around the heart, while 2 and 3 were within the liver. Note the small standard deviations for the ROIs in the liver. Number 1 has a small deviation, but the standard deviation in 4 is rather large. The latter indicates the ROI was either too large for the area and/or not carefully placed over a since structure.

Table 7.2 HU Values for Various Structures with Mummy G/F Acquired at 100kV

A. A number of structures demonstrated low standard deviations

Brain White Matter n=6	Brain Gray Matter n=6	Heart n=33	Liver n=14	Clot n=12	Costal-Cartilage n=6
149±50	−525±55	285±46	318±43	304±102	373±36

B. Structures with high standard deviations

Cortical Bone n=3	Calcified Node n=2	Rib n=5	Vertebral Body n=9	Intervertebral Disk n=18
2056±899	2774±631	−490±220	−554±360	343±133

Note: A number of structures (A) demonstrated low standard deviations, however, another group (B) presented high standard deviations suggesting several possibilities: the ROIs were too large; were not well placed; or the structures contained mixed materials.

Figure 7.68 ROIs of remnant brain material within the posterior fossa of mummy G/F. The high standard deviation values suggest material of different densities within the 9.2 mm² area.

Very dense objects, such as fossils, present another challenge in establishing WL and WW. A number of clinical MDCT units are not capable of a sufficient HU scale to demonstrate fossilized structures enclosed within the matrix. The typical range of HU values would not reveal the fossilized structures (Figure 7.74). Arbitrarily, the WL and WW can be adjusted to produce an esthetically pleasing image (Figure 7.75). However, the previously described, more analytical approach can certainly be applied to the examination of fossils. Because the densities of the materials under examination are so different, a technique used in the clinical setting dating back to the 1980s appears to be appropriate. During that period, CT was used to measure bone densities of patients' spines,

known as *quantitative CT (QCT)*. Between the patient and the couch was placed a small curved device containing samples of varying concentrations of calcium and phosphorus. During the image analysis phase of the procedure, ROIs were taken within the vertebral bodies of the spine and compared to the ROIs of the samples. With a fossil, six known reference minerals were placed close to the fossil (Figure 7.76). Following the acquisition of the raw data, a coronal reconstruction through the fossil and the known materials permitted the collection of HU values (Figure 7.77). However, similar to the previously described examination of mummified material, accurate HU values require multiple ROIs. In an examination of a fossil, identified as *Dimorphodon*,

Figure 7.69 An axial section at the base of the skull of a mummified perinatal, prosected individual that have the arterial system injected with a material for demonstration purposes. Three ROI measurements were collected to determine the density of the injected material: 1 and 2 were for the internal carotids and 3 for the basilar arteries. Note the SD values exceed the M in all cases.

Figure 7.70 Utilizing the same axial section, but with OsiriX® software, three individual pixels (P) values were obtained from the right carotid (A), basilar (B), and left carotid (C) arteries. Note the similar values. Because these were pixel values, the "x" and "y" location of each pixel within the matrix was provided.

ROIs were acquired in both the axial (Figure 7.78) and coronal planes (Figure 7.79).

As previously noted, it may not be possible to perform all the manipulations on the unit where the raw data was acquired. In this case, the data *DICOM* was downloaded onto a DVD and loaded onto an Apple MAC™ laptop computer with OSIRIX™ software downloaded from the Internet to provide manipulation of DICOM data. Although, as with different software programs the applications may appear dissimilar, the analysis will provide valid results (Figure 7.80).

Measurement

Because magnification has been totally eliminated from CT and subsequently MDCT, it is possible to acquire accurate measurements directly from all multi-planar images by selecting the *Measure* tool (Figure 7.81). The challenge is to ensure that the object being measured is entirely within a single plane. Since few objects would be entirely within the orthogonal plane of the original data acquisition, generally oblique (Figure 7.82) or off-axis sections would be required (Figure 7.83).

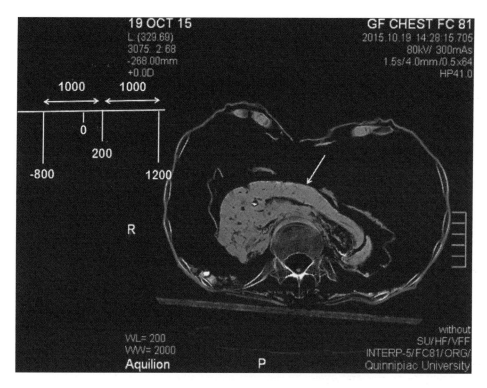

Figure 7.71 An axial section of a mummified individual at the level of the liver (arrow) with a WL of 200 and WW of 2000. HU values from –800 to 1200 were displayed as shades of gray.

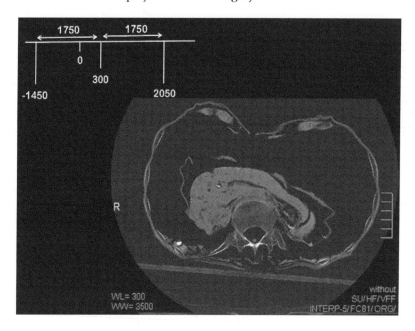

Figure 7.72 Another image of a mummified individual at the same axial position with a WL of 300 and WW of 3500. HU values from –1450 to 2050 were displayed as shades of gray.

A paleoimaging example of this process would be the measurement of long-bone length of a flexed mummy, where each bone will be in a different off-axis plane.

Filters

As previously described, filters that either enhance or smooth edges can be employed retrospectively to the acquired data during reconstruction. The Toshiba *Aquilion*® unit provides six levels of edge adjustment, ranging from *Smoothing* to *Sharp* +++ (Figure 7.84). Because the process utilizes the raw data, the appearance of the images acquired prospectively will not be permanently changed; however, additional filtered images can be saved. From a non-clinical prospective, comparing smoothing to the highest degree

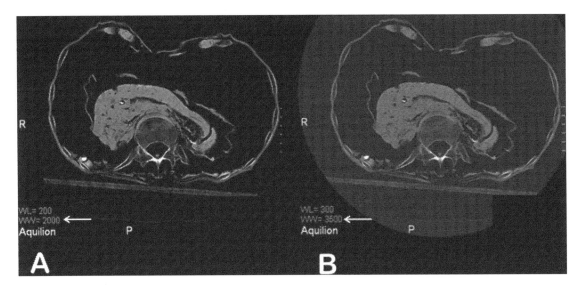

Figure 7.73 A comparison of two different window widths (arrows) (A) demonstrates that a wider window setting (B) provides a longer scale of contrast with more gray shades and less black.

Figure 7.74 Axial (A) and sagittal (B) sections of a fossilized structure. The WL, 450, and WW, 4500, were insufficient to demonstrate the underlying fossil.

of sharpness, smoothing results in a loss of detail (Figures 7.85, 7.86, and 7.87).

Slice Thickness

Slice thickness can be altered from the initial protocol selection (Figure 7.88) by post-processing at the visualization work station. However, remember that it is not possible to reduce the original acquisition thickness. Collecting a thin slice with isotropic voxels will provide

the highest resolution (Figure 7.89). By stacking a number of thin slices together, it is possible to achieve the desired thickness that most clearly demonstrates the structures of interest (Figure 7.90).

Maximum Intensity Projections and Minimal Intensity Projections

The *maximum intensity projections*, *MIP*, create a volume that displays only pixels with maximum HU

Figure 7.75 Arbitrarily, the WL and WW were adjusted until the fossil was clearly visualized, resulting in a WL of 4238 HU and a WW of 4473 HU. Note HU values can only be whole numbers.

Figure 7.76 The AP scanogram image prior to the scan showing the position of the fossil (A) and six samples (B) of known minerals placed close to the fossil.

Figure 7.77 A coronal section through the fossil and the six known minerals and their corresponding ROI values. Note that even with the 450 WL and 4500 WW, it was possible to acquire HU values.

values (Figures 7.91 and 7.92) along a line projected through the volume perpendicular to the slice being viewed. The thickness of the volume (the number of slices included) is determined interactively. In the clinical setting, a MIP application would be employed to demonstrate vessels filled with high HU value contrast media. According to Seeram (2009), since MIP uses less than 10 % of the data in 3D space, it can be used to display a rapid sequence of images. MIPs can also be used to generate images that are very similar in appearance to plain film radiographs.

Minimal intensity projections, min-IP, conversely generate a volume that reveals pixels with minimum HU values (Figure 7.93). Clinically, min-IP would be employed to visualize low-density structures, such as large bowel and airways extending into the lungs, while minimizing high-density structures, such as bone.

3D Image Manipulation/3D Algorithms

The first step in the 3D image manipulation process is the selection of an algorithm to visualize the data set. Similarly to the previously described multi-planar algorithms, windowing based on HU values for human

Figure 7.78 An axial section of a Dimorphodon fossil with eight ROI measurements.

Figure 7.79 A coronal section of a Dimorphodon fossil with six ROI measurements.

Figure 7.80 The same fossil of Dimorphodon from which ROI data was collected with the *Aquilion*® system, re-examined using OSIRIX® software to collect ROI (A) and pixel (B) data on a MAC™ platform.

tissues is applied to the 3D reconstructions. Unlike the gray scale assigned to the multi-planar images, the 3D reconstructions can apply look-up tables to map colors to regions of specific HU values. The Toshiba *Aquilion*® provides 32 pre-set choices of algorithms to construct a 3D image. Icons indicate tissue types or structures intended for demonstration (Figure 7.94).

Establishing Thresholds

The 3D algorithms, particularly for non-clinical applications, should represent a starting point for manipulation of the colors assigned to a specific color palette or even with regard to the gray scale image. Once the pre-set has been selected, the *Manual Adjust* should be

Figure 7.81 Selection of the *Measure* tool (arrow) will permit various types of measurements.

Figure 7.82 Oblique sections can be created by selecting the *Oblique* tool (arrow).

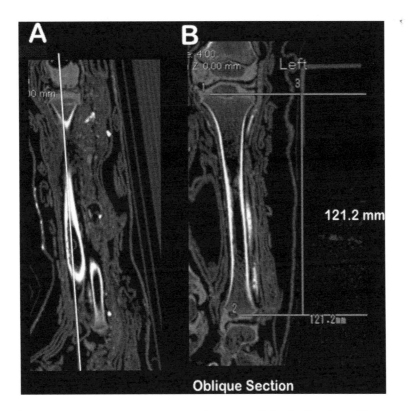

Figure 7.83 In order to determine an approximate age at the time of death, diaphyseal lengths of the long bone were measured. The left tibia was measured by first placing an oblique section along the long axis of the bone (dashed line) (A) A direct measurement was acquired from the generated coronal section (B).

Figure 7.84 Filters are one of the post-processing procedures that can be selected (A) The Toshiba *Aquilion*® unit offered six choices from Smoothing to Sharp+++ (B).

Figure 7.85 A comparison of the original image constructed from the raw data (A) and smoothing (B).

clicked open to view the WL and WW assigned to each color. However, several icons represent monochromatic color selections intended for high HU structures such as metallic prostheses (Figure 7.95). They are well suited for contrast media–injected specimens. An example is a cadaver injected in 1972 with a barium-gelatin contrast media; the latter will be described in Chapter 5: Contrast Media (this volume). The initial 3D reconstruction automatically selected a WL of 1000 and a WW of 200, extending from 900 to 1100. The 3D reconstruction revealed a fine network of vessels covering the skulls (Figure 7.96). Unfortunately, the bones concealed the

vasculature of the brain. In order to eliminate the skull, the WL was increased to 2705 and the WW reduced to 94, extending from 2658 to 2752 (Figure 7.97). With the exception of the teeth (A), the resulting image eliminated the bony structures and provided visualization of a highly vascularized left cerebral hemisphere (B), but decreased the visualization of vascular supply to the right hemisphere (C) (Figure 7.98).

The bone algorithm (see Figure 7.94) is also monochromatic and unsuitable for creating a 3D reconstruction of mummified remains where tissue is present (Figure 7.99). Selection of an algorithm with a more

Figure 7.86 A comparison of the original image constructed from the raw data (A) and enhancement (B).

Figure 7.87 A comparison of the smoothing filter (A) and Sharp+++ (B).

extensive color palette that can be manually adjusted providing more satisfactory results. A *mummy algorithm* was created by beginning with a pre-set algorithm that had a color palette with five colors: pale yellow, orange, red, beige, and white. By adjusting the threshold for each color, a more esthetically pleasing 3D reconstruction was developed (Figure 7.100A–B).

Formalin-preserved wet specimens, such as fetal pigs, required a different color plate. For instance, one was selected with four colors: pink, red, pale yellow, and white. The palette was modified to compress the pink, red, and pale yellow into very narrow range with few HU. The WL was selected to focus on the skeleton and WW was chosen to combine the three colors to create a

nearly translucent appearance to the skin and muscles, enabling the underlying bones to be seen (Figure 7.101). Without modifying the color palette, the specimen was *virtually dissected* by sliding the WL from 309 to 518. Because the WL is in the center of the WW, moving to the right eliminated the soft tissue to reveal the intact skeletal elements (Figure 7.102).

The Toshiba *Aquilion*® also permits several 3D algorithms to be combined. An example of this combination is a forensic ballistics study that utilized adult pig carcasses. Each carcass was shot several times with a 9-mm pistol. The objective was to track the trajectory and assess tissue damage. The bone algorithm was selected to produce white opaque skeletal elements and

Figure 7.88 With an initial 0.5 mm slice thickness acquisition, the system permits reconstructed slice thickness from 1.0 to 20 mm.

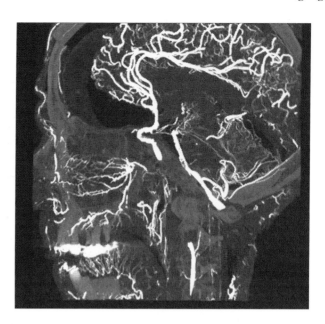

Figure 7.90 The sagittal slice thickness was extended to 10 mm by stacking 20 of the isotropic slices.

Figure 7.89 A sagittal section created with a 240-mm DFOV and 0.5 mm slice thickness of a contrast media injected head of a cadaver.

Figure 7.91 The location of MIP and min-IP on the drop-down menu.

combined with the lung algorithm (see Figure 7.94) to create somewhat translucent blue lungs (Figure 7.103). Similarly, a contrast media injection into the arteries of a severed horse head utilized two algorithms. In order to demonstrate the contrast-injected arterial system, the monochromatic *lumbar cage* or *spine fixation*

hardware algorithm (see Figure 7.95) was selected (Figure 7.104). To provide an orientation of the arteries to other anatomic structures, such as the spinal cord and the brain, once again the lung algorithm was added (Figure 7.105).

Figure 7.92 A coronal section of a mummy's head reconstructed from the raw data (A) and after the MIP was applied (B).

Figure 7.93 A coronal section of a mummy's head reconstructed from the raw data (A) and after the min-IP was applied (B).

Because an independent workstation, although connected to the imaging facility's PACS, is free standing and does not affect patient workflow through the MDCT unit, many are loaded with software, such as Vitrea® (Vital Imaging), that has a larger selection of 3D algorithms. The ballistic study with the pig carcasses provides an excellent example. While the combined bone and lung algorithms (Figure 7.103) clearly demonstrated the trajectories of the bullets and tissue damage in the chest area, this was less than satisfactory for the pelvic wound. The projectile not only smashed the

femur, but also made it nearly impossible to differentiate bullet fragments from bone. The Vitrea™ software provided a pre-set combined bone and metal 3D algorithm that made it very easy to differentiate the two materials (Figure 7.106).

Although 3D reconstructions are esthetically pleasing and useful, there is a reason why the multiplanar reformats are the primary source for a clinical diagnosis. Without careful manipulation and a thorough understanding of the limitations of the 3D reconstruction, the results may be less than a

Figure 7.94 The screen on the directing monitor provides icons for the initial preset 3D image reconstruction grouped according to tissue types, such as lungs, or the structures intended for examination, such as C.O.W. (circle of Willis) (arrow).

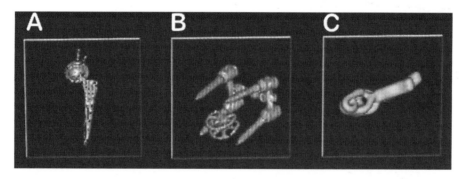

Figure 7.95 Three monochromatic 3D reconstruction icons: prosthetic implant (A); lumbar cage or spine fixation hardware (B); and aneurysm clip or surgical staple (C).

completely accurate representation. While an algorithm with maximum edge enhancement may have been employed to create the MPR images, when a 3D algorithm is applied to the same data set, edge smoothing is incorporated into the reconstruction. An example of the problem was demonstrated by a hyoid bone fractured as the result of manual strangulation. The bone was not clearly visualized on the pre-mortem radiographs. The hyoid was removed, preserved and, several weeks later, microradiographs were acquired with a digital cabinet system, revealing the fracture (Figure 7.107). In an attempt to obtain a 3D rendering that could be rotated and angled, an MDCT was acquired. While the small size of the bone resulted

in decreased resolution, the fracture was seen on a 1.0-mm thick lateral oblique reformat through the greater horn of the hyoid (Figure 7.108). Less satisfactory results were obtained on the 3D reconstruction (Figure 7.109): the fracture was clearly visible, but a combination of tissue remnants that were not cleaned from the bone and edge smoothing, inherent to the 3D algorithm, resulted in a distracting *melted wax* appearance. The latter was even more pronounced on small specimens, as demonstrated on a dry fetal skull aged at 16–18 weeks of gestation (Figure 7.110).

The other major disadvantage with 3D reconstructions results from areas of anatomy that may not be included in the final displayed data set. The problem

Figure 7.96 Once the Manual Adjust has been opened, it revealed the initial WL was 1000 and the WW extended from 900–1100 (A) The resulting 3D reconstruction demonstrated not only the network of vasculature but also the skull (B).

Figure 7.97 The WL was increased to 2075 to eliminate the superficial fine vessels and the bone of the skull.

is most frequently encountered with materials that are thin and/or lack sufficient density to be included in the threshold values for the reconstruction. A set of mummified remains provides an excellent example. Digital radiographs of the left shoulder and mandible clearly demonstrated the acromion-clavicular articulation and head of the humerus. However, the same area was excluded in the 3D reconstruction (Figure 7.111). Similarly, a number of openings appeared to be present in the 3D reconstruction of the mummy's skull

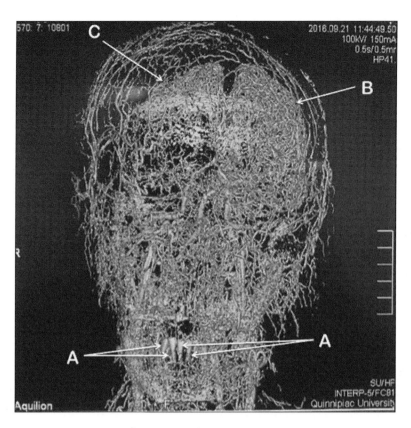

Figure 7.98 The resulting image at the higher WL. Note the teeth (A), and the left (B) and right (C) hemispheres of the brains.

Figure 7.99 Selection of the 3D bone algorithm also results in a monochromatic image of the mummified remains of an individual.

(Figure 7.112). The problem occurred because the radiographer had no experience scanning mummified remains. Following the same routine procedure repeated on numerous occasions with clinical cases, she only applied the bone algorithm and did not adjust the resulting WL. Subsequently, thin areas of bone were excluded in the final reconstruction. The solution, for objects with a thin material component, is first to the engage the 3D algorithm, such as bone. Once the image appears on the monitor, the level must be adjusted to *fill in the holes* (Figure 7.113). It may also be possible to do manual segmentation of the slices to include the required material and exclude the unwanted components.

It is also important to consider who is looking at the images. The clinical radiologist is trained to look at multi-planar reformats, particularly axial images, to make a clinical diagnosis. However, for an anthropologist, who is used to looking at bones in 3D, the 3D reconstructions are more than just esthetics; rather, they are the presentation to which they can relate. This clearly depends on one's training and on how one processes the object. Such discussions are inevitably a negotiation, and in the paleoimaging context it is important that both perspectives be recognized as being valid.

Figure 7.100 (A) Manual manipulation of a 3D algorithm with a more extensive color palette provided more esthetically pleasing 3D images. (B) The manually adjusted color palette with the WL set at –216 HU in the narrow red color band. The WW includes only a little of the pale yellow and ensures that the bones will be white.

Figure 7.101 Once the color palette was selected, the WL was adjusted to focus on the bone colored white. For the WW, three colors were compressed into narrow ranges of HU (A) The WL was set to focus on the bone and the WW was reduced to 618. The three colors at the lower end of the WW were compressed to create a (B) translucent appearance of the skin and muscles to reveal the bones.

Figure 7.102 A virtual dissection of the fetal pig was accomplished by sliding the WL from 309 to 518 (A) Because the WL is in the center of the WW, moving to the right removed the soft tissue to reveal the developing skeleton (B) Note an unexpected finding: the aorta (solid arrow), inferior vena cava (dashed arrow), umbilical vessels (dashed/dotted arrows), and highly vascularized liver (dotted arrow) were all visible due to the circulatory system having been injected with vinyl.

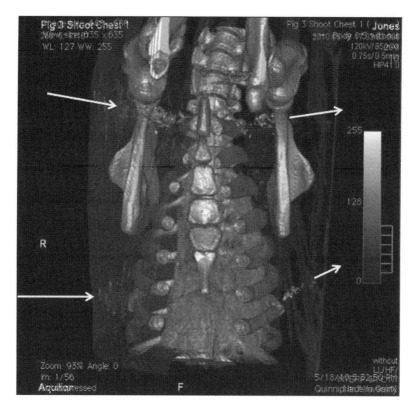

Figure 7.103 A 3D anterior-posterior projection of the chest demonstrating the trajectories of two 9-mm bullets (arrows). Two superimposed algorithms were employed to demonstrate the bone and the lungs.

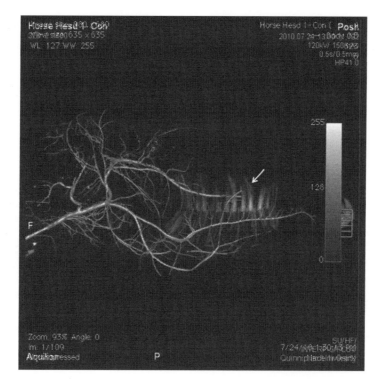

Figure 7.104 The monochromatic *lumbar cage* or *spine fixation hardware* algorithm was employed to demonstrate the contrast injected arterial system. However, the teeth, with a density similar to the contrast media, were also visualized (arrow).

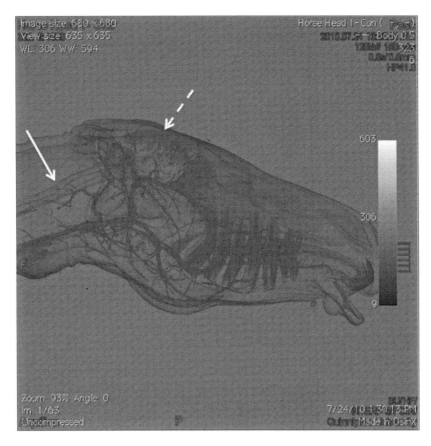

Figure 7.105 The lung algorithm was added to produce translucent outlines of not only the head of the horse, but also anatomic structures such as the spinal cord (solid arrow) and brain (dashed arrow).

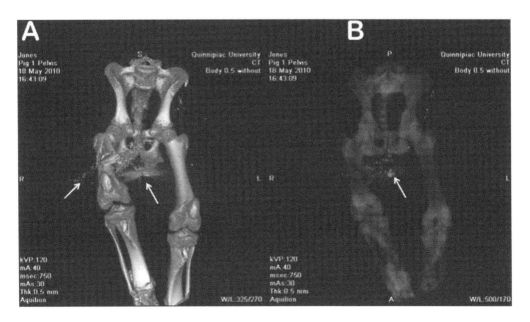

Figure 7.106 A 3D bone algorithm made it difficult to distinguish between bullet and bone fragments (arrows) (A) The Vitrea™ 3D software combined bone and metal algorithms, the bone appeared somewhat translucent while the projectile and associated fragments were bright blue (solid arrow) (B).

Figure 7.107 The microradiographs acquired with the digital cabinet system at Kubtec provided the highest contrast and resolution of the fracture (arrow) even at increased magnification.

Figure 7.108 A 1.0 mm thick lateral oblique reformatted image of the hyoid revealed the fracture (arrow).

Having thoroughly considered the application of 3D algorithms, there are a number of benefits to including 3D in all MDCT imaging studies:

- The full complexity of a 3D structure cannot be appreciated on 2D multi-planar reformats.
- 3D models can be segmented and exported for manipulation by other programs, such as animation, or for 3D printing.
- To enable visualization of surface details of bones or objects that might be difficult to discern on 2D slices, for example periosteal plaque formation or delicate porosity.

Figure 7.109 The 3D reconstruction of the hyoid data set. The fracture (A) was well defined on the distal aspect of the greater horn (B) However, an inherent consequence of the reconstruction process was edge smoothing that produced a "melted wax" appearance noted on the posterior margin of the lesser horn (C) and tissue associated with the medial, posterior aspect of the left greater horn (D).

Clipping

Another 3D processing function is *Clipping* (Figure 7.114), a method employing planar images to remove volume data. An MDCT scan of a dry fetal skull illustrates the process (Figure 7.115). The skull, between 32 and 38 weeks of gestation, was part of the Shapiro/Robinson Collection in the Cushing Center at the Yale Medical School Library in New Haven, Connecticut. A volume was removed from the apex of the skull by dragging the *clipping bar* displayed on the coronal MPR and simultaneously seen on the sagittal image (Figure 7.116). The resulting image clearly demonstrates internal structures. Similarly, a volume was eliminated from the left lateral aspect of the skull by advancing the clipping bar on the sagittal MPR (Figure 7.117).

An example demonstrating the use of the clipping tool to provide an unobstructed view of internal structures was the study of a giltwood seated Buddha on a wooden stand that dates to the Edo period in Japan (1615–1868) (Snow personal communication, April 19, 2017). A more complete description of the study is presented in Case Study 5 (*Case Studies for Advances in Paleoimaging and Other Non-Clinical Applications*, Beckett, Conlogue, Nelson (Eds.), CRC Press, Boca Raton, 2020). On the MPR images, posterior to the inlay eyes, was a carved wooden piece that appeared to be held in place by pins (Figure 7.118). An initial 3D reconstruction was accomplished by combining two 3D algorithms (Figure 7.119). Once the pins were clearly seen on the 3D reconstruction, the clipping function was employed (Figure 7.120A–B). With the clipped 3D image revealing an unobstructed view of the pins and supported carved wooden block, another 3D algorithm was selected that maximized the visualization (Figure 7.121).

Figure 7.110 A 3D reconstruction of a dry fetal skull approximately 16--8 weeks gestation. Note the ill-defined margins and the *melted wax* appearance.

Figure 7.111 A positive digital radiograph of the region including the left shoulder and mandible clearly demonstrating the clavicle (dashed arrow), head of the humerus (dotted arrow), and body of the left mandible (solid arrow) (A) On the 3D reconstruction only the denser mandible is seen, while the acromion-clavicular articulation and head of the humerus were not visualized (B).

Cutting

The *Cutting* function (Figure 7.122) allows a ROI to be drawn with the cursor. The operation will allow the area inside the ROI to be either *included* or *excluded* from the revised reconstruction. Optimally, the procedure is best suited when there are a number of scattered densities around the object (Figure 7.123). Cutting could also be employed to remove the supporting material an object is resting on (Figure 7.124). However, drawing a line close to an object or around a large dense structure may be somewhat difficult.

Segmentation

Segmentation is the process of breaking a digital image into individual components (segments) that are defined

Figure 7.112 The 3D reconstruction of the mummy's skull including the shoulder region. Note the *missing* acromion-clavicular articulation and head of the humerus in the shoulder area (solid arrow) and openings in the skull (black arrows).

on the basis of density, connectivity, size, shape, texture, and other properties. Once identified, the segments can be selected, eliminated, added, subtracted, etc. The first step is to select *Segmentation* and then *Seed* (Figure 7.125). The latter is placed over the object to be eliminated and will automatically include all the pixels with the same HU values (Figure 7.126A–C). Once deleted, the selected object will be removed from the

current 3D reconstruction. However, it remains in the raw data set. This function is best applied to large uniform objects. If used for smaller, scattered densities, it can become a long tedious process (Figure 7.127).

Fly-Through

Software is available to demonstrate hollow tubes such as airways, *virtual bronchoscopy*, and the large intestine, *virtual colonoscopy*. Unfortunately, the package was not available for the *Aquilion®* unit. However, *Vitrea® 3D Fly-Through* was loaded onto an independent workstation. Although the learning curve was greater than for many of the software applications, it provided stunning results. Two applications were explored, both involving the trachea down to the bifurcation of the right and left mainstem bronchi. The easiest was carried out on a 200-pound (91 kg) pig carcass that was a subject in a ballistics study (Figure 7.128). The other, more difficult, was attempted on the mummified remains of an adult. The problem appeared to be a collapse of the mummy's trachea.

Micro-CT—Andrew J. Nelson

Micro-CT Scanning

The increasing availability of micro-CT (a.k.a. X-ray microtomographic, micro-computed tomographic, μCT)

Figure 7.113 The initial 3D reconstruction of a dried fetal skull utilizing the pre-set bone algorithm appears to have *holes* (arrow) where the thin bone was below the threshold HU value (A) By lowering the WL and not changing the WW, the holes *were filled in* (B).

Figure 7.114 The *Clipping* function on the Toshiba *Aquilion*® Tool 1 menu.

scanners has had a profound effect on the field of paleo-imaging. Now, paleoimagers can non-destructively enter the microscopic (or close to) realm, which was previously accessible only through the destructive preparation of thin sections. Furthermore, micro-CT scans are volumetric representations of the objects, as opposed to thin sections' inherently 2D character. Applications range from the investigation of the internal structure of individual teeth of Miocene hominoids (Gantt et al. 2006), to the reconstruction of the skull of a *Homo habilis* fossil (Benazzi et al. 2014), to the assessment of the condition of archaeological artifacts in compacted soil (McBride and Mercer 2012), to the investigation of the mode of manufacture of medieval prayer beads (Ellis et al. 2017). In the hands of a skillful operator, these scans can also be turned into works of art (see http://www.nhm.ac.uk/our-science/departments-and-staff/core-research-labs/imaging-and-analysis-centre/tosca.html for a few examples from the Natural History Museum in London, UK).

Definition

The term "micro-CT" (as a synonym of "X-ray computerized microtomography") is defined as a Medical Subject Headings (MeSH) term by the US National Library of Medicine, and by PubMed as "tomography

Figure 7.115 A 3D reconstruction of a dried fetal skull, between 32–38 weeks gestation, from the Shapiro/Robinson Collection in the Cushing Center at the Yale Medical School Library in New Haven, Connecticut. Note, the WL was lowered to include very thin regions of the developing skull.

Figure 7.116 The final position of the *clipping bar* seen on the coronal (A) and sagittal (B) MPR images. The 3D reconstruction rotated, following the clipping procedure, to provide an interior prospective of the base of the skull (C).

Figure 7.117 Employing the axial MPR, the clipping bar removed a section of the left aspect of the skull (A) Following the clipping, the 3D reconstruction rotated to permit the interior of the skull to be examined (B).

Figure 7.118 The axial (A), coronal (B), and sagittal (C) images demonstrated inlay eyes (solid arrows), a carved wooden piece (dashed arrows) posterior to the eyes and supported by pins (dotted arrows).

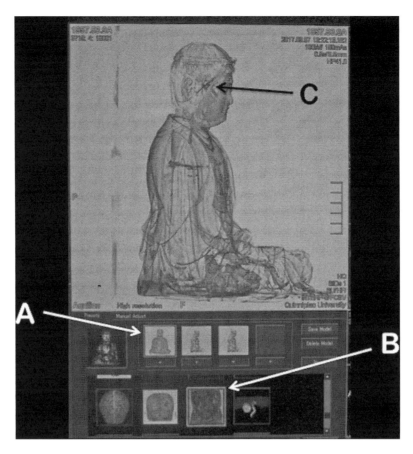

Figure 7.119 A 3D reconstruction was produced by combining the monochromatic lung algorithm (A), providing a somewhat translucent figure, and a multicolored organ algorithm (B) with the WL adjusted to assign the pins a red color (C).

Figure 7.120 Using the coronal MPR, the first clip removed the top of the skull (A) The second clip eliminated the volume on the right side of the face (B) Another clip was used to take away the left side of the face (C) The final clip removed the posterior aspect of the head (D).

with resolution in the micrometer range" (www.ncbi.nlm.nih.gov/mesh/?term=micro-CT). In general usage, micro-CT is generally defined as an X-ray unit with a small focal spot paired with a high-resolution detector that can produce a volumetric scan with voxel (3D pixel) sizes in the 1 μm to 50 μm range (e.g. Stock 2009;

Ritman 2011). Ritman (2011) has specified a sequence of terms defining levels of resolution, ranging from nano-CT (0.1–1.0 μm voxels), to micro-CT (1–50 μm voxels), to mini-CT (50–200 μm voxels). Note that some micro-CT units (such as the GE Locus Ultra) have voxel sizes in the mini-CT range (150 μm for the Locus

Figure 7.121 Following the clipping to remove the sides, top, and back of the head, a 3D algorithm was selected with sufficient colors in the palette and a WL and WW adjustment to demonstrate the pins (dotted arrows) supporting the carved wooden block (solid arrow).

Ultra—http://www.preclinicalimaging.ca/equipment.php). Clinical CT scanners are sometimes referred to as macro-CT. Figure 7.129 shows a side-by-side comparison of a clinical and a micro-CT scan of the cranium of an anencephalic mummified fetus (Nelson et al. 2018).

History

The first published micro-CT scan was presented by Elliott and Dover (1982), showing a single tomographic slice of the shell of a snail. In this case, the apparatus was described as "a microscope system based on the principles of computerized axial tomography" (Elliott and Dover 1982: 211). The tomographic slice had a pixel size of 12 μm². Initial development of micro-CT scanners was slow, as even such figures as Godfrey Hounsfield and the Royal Society thought that such instruments were impractical, so funding for development was difficult to obtain (Elliott et al. 2008). It was not until 1989, when Feldkamp et al. (1989) published the first application of

Figure 7.122 The *Cutting* function on the Toshiba *Aquilion®* Tool 1 menu.

micro-CT to the analysis of bone trabeculae, that the field started to take off as the clinical research applications became clear. The first commercial unit, the Scanco μCT 20, appeared in the mid-1990s from a spinoff company formed by members of the Institut für Biomedizinische Technik in Zurich (Rügsegger et al. 1995; www.scanco.ch/en/company/history.html). Since that time, the number of manufacturers and models has exploded. However, it is fair to say that the availability of such units for paleoimaging is still limited, either by availability of units or by purchase and operational costs. See Table 7.3 for a sample (certainly not exhaustive) of micro-CT facilities that routinely do paleoimaging research.

Types of Micro-CT Scanners

Micro-CT scanners come in several sizes and shapes. The three broad divisions are preclinical, bench top, and industrial. Preclinical scanners are designed for use with small animals (e.g. rats and mice) that are typically used in biomedical research done in advance of human clinical trials. Scanning may be done *in vivo* or *in vitro*. The *in vivo* units are typically configured to favor rapid scan acquisitions and reduced radiation dose to the animals over spatial resolution (Holdsworth and Thornton 2002). These scanners often resemble small versions of clinical scanners. Bench-top units designed specifically for *in vitro* imaging are referred

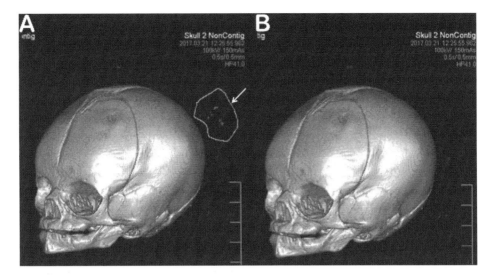

Figure 7.123 Cutting provided a method to eliminate scattered densities around an object. Once the function was selected, it allowed an ROI to be drawn around the items. In this case, the densities within the ROI, indicated by the arrow, were excluded (A) The image following removal of the densities posterior to the skull (B).

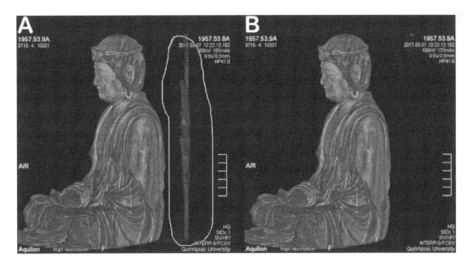

Figure 7.124 The cutting ROI was drawn around the dense material behind the Buddha (A) The image of the statuette following removal of the material (B).

to as specimen scanners. Industrial micro-CT units are designed for use in manufacturing for part inspection and analysis, materials characterization, and metrology (Figure 7.130). Industrial units typically have a higher range of kVp than clinical and preclinical scanners, and so are valuable in paleoimaging applications involving particularly dense specimens such as fossils, ceramic, or metal artifacts. Industrial micro-CT scanners can also typically handle larger objects than preclinical or bench-top micro-CT scanners.

Some preclinical *in vivo* micro-CT scanners resemble clinical scanners, with source and detector mounted on a slip-ring device that rotates around the animal, while the animal lies on the scanner bed (like the clinical patient). Clinical and preclinical *in vivo* scanners are referred to as fan-beam scanners, as the cone-shaped

beam that emerges from the source is collimated to a narrow fan-shaped beam to match the detector on the other side of the ring. In this case, the total volume is acquired as a sequence of individual slices that are then concatenated to create the digital volume (this is a bit of a simplification, as helical, multi-detector CT scanners have more complex image reconstruction algorithms). Most bench-top and industrial scanners are true cone-beam scanners, where the source and detector are fixed, there is no beam collimation, and the specimen or part sits on a turntable between the source and detector and rotates as the scan is acquired. In this case, the volume is acquired as a sequence of X-ray projection images (2D TIFFs) of the entire specimen, which are then processed to create the digital volume. Most systems (cone-beam and fan-beam systems) utilize some

Figure 7.125 The *Segmentation* function is located from the Tool 1 menu (A) Once selected, choose the *Seed* option (B).

Figure 7.126 The uniformly dense material (arrow) beneath the foam sponge supporting the Buddha was the target for elimination (A) The *seed* was placed (arrow) on the object to be excluded (B) Automatically, all the pixels with the same HU values were included. Once deleted, the object is removed from the data set of the current 3D reconstruction (C).

variant of the back-projection algorithm (e.g. filtered, convoluted) published by Feldkamp et al. in 1984 (commonly known as the FDK algorithm). This algorithm was first proposed in 1917 by Johann Radon but the subject of image reconstruction "is steadily evolving and gives rise to a seemingly never ceasing flow of new algorithms" (Turbell 2001—note that this quote is now more than 15 years old, and the never-ceasing flow has not yet ceased). The resulting volume has isotropic voxels (which is not always the case in clinical CT—see the CT section).

There is a class of clinical CT scanners that occupies the "mini-CT" part of the resolution spectrum defined by Ritman (2011) that also has a cone-beam configuration. These are referred to as C-arm and dental Cone Beam CT (CBCT) scanners. In this case, the detector is a square flat panel that is positioned opposite the source on either side of a rotational unit that rotates around the patient/object (Orth et al. 2008; Scarfe and Farman 2008). These are typically used in interventional radiography, angiography, and dental exams, and their voxel size resolution runs

Figure 7.127 On the dried fetal skull, there were a number of small scattered dense objects posterior to the skull (A) A *seed* was placed over one of the objects. However, because the objects were separate, only the one was removed. In this situation *Cutting* would have been a better approach (B).

Figure 7.128 An image of the workstation monitor demonstrating the fly-through process. The viewing location within the trachea of the pig is indicated in the sagittal (A), coronal (B), and axial (C) projections. The forward (D) and reverse (E) perspectives from the viewing location are provided.

between about 70 μm and 200 μm (Nemtoi et al. 2013). Application of these units in the field of paleoimaging is not common, but the best-known example is probably the child mummy from the Rosicrucian Museum in California, which was scanned at the Stanford-NASA Biocomputational Center, at Stanford University (Cheng et al. 2006).

Several synchrotrons now include tomography beamlines that are being used in paleoimaging applications. A synchrotron is a large facility, the center of which is a linear accelerator that generates high-energy electrons. These flow into a booster ring that increases the energy by orders of magnitude. The electrons are then introduced into a circular or elliptical storage ring, where they can be further accelerated. Bending magnets force the electrons on a circular path, and as the path bends to follow the ring, photons are emitted (synchrotron radiation) and directed down individual beamlines, each specialized to take advantage of a specific part of the electromagnetic spectrum and to undertake a specific kind of analysis (Balerna and Mobilio 2015). There are many applications of

Figure 7.129 Mid-sagittal slice of the cranium of an anencephalic fetal mummy from Ancient Egypt. The clinical scan—slice thickness 0.625 mm (A) The micro-CT scan—voxel size 63.8 μm (B) Specimen EA 493, Maidstone Museum, Maidstone, UK—Samantha Harris, Collections Manager. Clinical CT data courtesy of M. Garrad, KIMS Hospital, Maidstone. Micro-CT data courtesy of Andrew Ramsey and Michael Hadland, Nikon Metrology, Tring UK.

Table 7.3 A Sampling of Micro-CT Facilities Routinely Used for Paleoimaging

Facility	Institution	Micro-CT unit	Web Site
Center for Nanoscale Systems	Harvard University, Cambridge, MA	Nikon HMX ST 225	https://cns.fas.harvard.edu/micro-CT
Microfocus X- ray Computed Tomography (CT) Facility	University of the Witwatersrand, Johannesburg, SA	Nikon XTH 225/320	https://www.wits.ac.za/micro-CT
Imaging and Analysis Centre	Natural History Museum, London, UK	Nikon HMX ST 225	http://www.nhm.ac.uk/our-science/ departments-and-staff/core-research-labs/imaging-and-analysis-centre.html
Center for Quantitative Imaging	Pennsylvania State University, University Park, PA	GE v\|tome\|x L300 multi-scale nano/ micro-CT system	http://wvvw.energy.psu.edu/ cqi/?q=instrumentation.html
The University of Texas High- Resolution X- ray Computed Tomography Facility	The University of Texas, Austin, TX		http://www.ctlab.geo.utexas.edu/
The University of Chicago PaleoCT Lab	The University of Chicago, Chicago, IL	GE/Phoenix v\|tome\|x s 240	http://luo-lab.uchicago.edu/paleoCT.html
Sustainable Archaeology	The University of Western Ontario, London, ON, Canada	Nikon HMX ST 225	http://sustainablearchaeology.org/ facility-equipment.html#micro-CT

synchrotron radiation to the analysis of paleontological and archaeological objects, including X-ray fluorescence, and X-ray diffraction (see Bergmann et al. 2012; Quartieri 2015), but the application of interest here is X-ray tomography. From the perspective of tomography, synchrotron radiation's most important properties are its very high flux, its tunable monochromatic X-ray beam, its narrow collimation, and its high spatial resolution. Synchrotron tomographs are generally executed with voxel sizes between 1 μm and 10 μm, although sub-micron sizes have been achieved (Stock 2009; Ding et al. 2018).

Resolution

Spatial resolution is defined as the smallest separation distance needed to differentiate two discrete objects (typically disks) in a slice image (Stock 2009). Thus, small voxel sizes are required to visualize very small features, and so voxel size is often (if not accurately—see Brüllmann and Schulze 2015) used interchangeably with spatial resolution. However, there are other variables that affect spatial resolution. First, "effective voxel size" is determined by the pixel size of the detector panel and by the geometric magnification of the object onto

Figure 7.130 The Nikon Metris XT H 225 ST micro-CT scanner housed at Museum of Ontario Archaeology Ancient Imaging Lab. Photo credit: Andrew J. Nelson.

the panel. There are many factors other than voxel size that affect the actual spatial resolution of any scan. A key determinant of resolution is the focal spot size at the source of the cone beam; to maximize spatial resolution, the spot size should be smaller than the pixel size. In micro-CT scanners, spot size is typically less than 5 µm, but the spot size increases with beam energy (Rueckel et al. 2014). Other factors affecting resolution include noise, the contrast in the image, scattering, the movement of the object, the number of projections taken (and intervening angles), and reconstruction algorithms (Stock 2009; Brüllmann and Schulze 2015).

Logically, the voxel size should match the smallest discernible feature in a scan. However, features such as cracks that are smaller than the effective voxel size can be resolved, but they must be of high contrast (Breunig et al. 1993; Bull et al. 2013) and map across several contiguous voxels.

Clinical CT Compared to Micro-CT

Clinical and micro-CT scanners are designed following different principles that reflect their mode of use. First, in preclinical and clinical scanners, the minimization of radiation dose to the patient is the central concern in design and operation, rather than spatial resolution. In specimen and industrial scanners, radiation dose is typically not a concern, so scans can have much higher energy and generally run for longer times. This allows for higher quality scans. It must be acknowledged that X-radiation is ionizing radiation and has the potential

to damage samples, particularly organic ones. However, recent work has demonstrated that typical lab-based micro-CT analytical levels of exposure do not inflict apparent damage to samples of wood (Kozachuk et al. 2016) or DNA (Paredes et al. 2012; Ziegler et al. 2013; Fehren-Schmits et al. 2016; Immel et al. 2016). The very high flux of synchrotron radiation does have the potential to alter biological objects: it can for instance change the color of teeth (Richards et al. 2012) and damage DNA (Immel et al. 2016). In this case, the user should carefully consider the cost of damage against the benefit of the images and take measures to minimize the risks.

In the clinical CT section of this chapter, there is an extensive discussion on the different pre-set algorithms and how these algorithms contain processes that manipulate the raw data as it is gathered and reconstructed. These pre-set algorithms ensure that patient examinations are gathered in a systematic and repeatable way. This is also the case for preclinical micro-CT scanners, but industrial micro-CT scanners are designed to allow the examination of a wide range of objects/parts and so give the operator much greater control over both image acquisition and reconstruction. For instance, the Nikon XT H 225 ST unit (with which the author is familiar) has a continuously variable range of kVp from 0 to 225 kVp and (in standard configuration) a maximum current of 1000 µA (maximum power of 225 watts). The target material can be changed from tungsten to molybdenum to copper to silver and a range of filters of different metals and thicknesses can be introduced to modify the X-ray beam. During set-up for acquisition, the exposure

length, panel gain, pixel binning, number of projections, number of frames to average per projection, and several other factors can all be adjusted. During reconstruction, factors such as beam hardening, data filtration, calibration (to a known value such as the linear attenuation coefficient for water, or aluminum, or some other substance), and others can be adjusted. Thus, there are no pre-set standard protocols, although the user can establish such protocols, as is done in industry, where repeated inspection tasks and strict quality control are required. However, in paleoimaging, it is rare for two objects/artifacts to be exactly the same, so the acquisition and reconstruction settings must constantly be adjusted. This flexibility is both a boon and a bane; the myriad adjustments can be tweaked for the best possible scan quality, but the process requires an expert operator who is familiar with the principles of X-ray imaging and with the effects of each adjustment. There is a very steep learning curve involved in mastering a micro-CT system.

Another difference between micro-CT and clinical CT is the sheer volume of data produced. A typical clinical CT sub-millimeter slice thickness scan of a mummy, when captured from head to toe, will produce 2500 to 3000 slices, and the resulting DICOM stack will be around 2 to 3 GB in size (in DICOM format). However, a micro-CT scan using the Nikon system can produce a volume as large as 20+ GB in size. The size of the volume does not depend on the resolution of the image, but on the square area of the detector panel that is occupied by the projection of the object and therefore included in the reconstructed volume, and the number of individual slices. Scans obtained on a synchrotron can produce TIFF stacks that range from 40 to 50+ GB. That magnitude of data stretches network transmission capabilities, hard drive read/write speeds, and computer (RAM) and graphics card capabilities.

A corollary of the differences in voxel size, spatial resolution, detector size, data management, and spot size is the fact that clinical and micro-CT systems deal with very different ranges in the size of the sample that they can accommodate. A clinical CT scanner can scan something of the size and shape of a human body, while a micro-CT scanner scans much smaller objects. Some bench-top specimen scanners are restricted to objects the size of a small bone or tooth, while preclinical scanners are optimized for objects the size and shape of a mouse or rat, and larger cabinet industrial units can accommodate objects ranging in size from a few mm in diameter to the size of a human skull. Because of the geometric magnification inherent in the cone-beam cabinet system, smaller objects will be visualized with smaller voxels (higher resolution), while larger objects are

visualized with larger voxels. In the case of the author's Nikon system, objects a few mm across can be visualized at ca. 3–5 μm voxels (noting that the spot size of the reflecting target is 3 μm up to 7 watts), while an object the size of a human skull is visualized at ca. 120 μm voxels. Synchrotron beamlines can accommodate objects of varying sizes depending on the beamline configuration, but tomography lines tend to be restricted to small-sized objects in order to maximize spatial resolution.

Clinical and preclinical micro-CT scanners are calibrated to generate a gray scale in HU. The HU values (linear attenuation coefficients) for air and distilled water are −1000 and 0, respectively (Kalender 2011). Industrial CT scanners show the attenuation at particular pixels in gray scale values. The range of available gray values depends on whether the file is 8 bit (0–256 shades) or 16 bit (0–65,536 shades). There is no inherent calibration, as the range of materials that might be scanned is so variable, but the scans can be calibrated to a specific phantom with a known linear attenuation coefficient (e.g. water, aluminum). In the typical industrial CT calibration, the CT number assigned to water is 1000, and to air it is 0 (and aluminum is 2700), offset from the clinical DICOM scale by 1000 units (Johns et al. 1993).

While on the topic of DICOM files, it is worth noting that industrial micro-CT scanner files are reconstructed as a volume rather than as a stack of DICOM files (which are 12- or 16-bit TIFF files with the additional DICOM header containing information about the patient, the physicians, the scanner, the technique, and other information embedded in each image). The specific format of these volumes is dependent on the software used for the volume reconstruction (e.g. .VOL for VG Studio, .VFF for GE MicroView). The data can be exported in many different formats, such as RAW for a volume and DICOM, TIFF, or JPEG for image stacks. However, even if exported to the DICOM format, the DICOM header will contain the information necessary for software to read the file (pixel size, numbers of rows, and columns), but other metadata such as scanner, imaging parameters, and so on will not be recorded.

Finally, slice orientation nomenclature varies between clinical CT and non-preclinical micro-CT scans, as the objects being scanned do not have the anatomical characteristics of a human body and they may be positioned in a scanner in a variety of ways. While the term "axial" may be meaningful for some objects (depending on the position in which they were scanned), the terms "sagittal" and "coronal" have no meaning for something like a ceramic vessel. Different software packages handle this in different ways. For example, VG Studio (https://www.volumegraphics.com/en/products/vgstudio.html) labels the views "top" (axial), "front" and

"right," while ORS[si] and Dragonfly (http://theobjects.com/) use the labels "XY" (axial) and "XZ" "YZ."

Image Artifacts in Micro-CT

Several image artifacts were discussed in the CT section, including ring, aliasing, streak, stair-step, and misregistration artifacts. These are also all artifacts that can affect micro-CT, although stair-step artifacts are reduced with the smaller voxel sizes.

- Ring artifacts are the product of detector noise or bad pixels in the detector (Boas and Fleischmann 2012). They are seen as rings on the axial slice and as a columnar artifact on the other slices (at the center of rotation). Detector calibration is the best way to eliminate these artifacts, but extended shading corrections before acquisition is also important.
- Streak artifacts caused by photon scatter within the object are very common in paleoimaging projects, as they frequently contain high-density elements within lower-density matrices (e.g. a metal hinge in a wooden bead—Figure 7.131) (Stock 2009). These artifacts can be reduced by adding filters and increasing the mean beam energy, although that risks a reduction in contrast and image quality for the lower-density

matrix. Streak artifacts also occur if one tries to scan two or more highly attenuating objects (especially metal objects) at the same time (Figure 7.132). These artifacts can be avoided by scanning such objects one at a time. A variety of metal artifact reduction (MAR) techniques is being implemented by clinical CT-scan manufacturers (Katsura et al. 2017).

- Beam hardening is an artifact caused by filtration or scattering of the X-ray beam by the object itself (Stock 2009; Boas and Fleischmann 2012). This phenomenon manifests itself in a variety of ways, including the streak artifacts mentioned above, but also in the form of "cupping artifacts." The cupping describes the form of a line graph that demonstrates the variation in gray scale values across an artifact, with the highest values (image intensity) being on the outer edges of the object. This phenomenon is most commonly seen in high-density objects, such as metals or ceramics. In this case, the lower energy part of the X-ray beam is being filtered (attenuated) by the object itself. The filtration of the lower energy X-rays "hardens" the beam, raising its average energy level. Most hardening of the beam takes place at the thickest part of the object, making it appear to be less dense than the outer parts of the object where

Figure 7.131 Streak artifacts (arrows) caused by a metal hinge and clasp in a boxwood medieval prayer bead, AGO ID 29365, Thompson Collection at the Art Gallery of Ontario, Toronto, Ontario, Canada. It was scanned on the Nikon unit in Figure 7.130. Bead scanned at the request of Alexandra Suda and Lisa Ellis of the AGO by Andrew J. Nelson. See Ellis et al. (2017) for details.

Figure 7.132 Streak artifacts, several indicated by arrows, caused by scanning a number of high-attenuation objects (in this case Allen wrenches). Scan done on the Nikon unit in Figure 7.130 by Andrew J. Nelson.

the beam is not being hardened to the same degree. This phenomenon can be dealt with by pre-hardening the beam using filters and/or by using post-processing algorithms. See Edey (2014) for an excellent discussion of the latter. The monochromatic beam generated by synchrotrons generally means that beam hardening is not an issue for those scans.

- Mis-registration artifacts caused by object movement are seen when the object being scanned is not properly mounted during the long scans that are characteristic of industrial or specimen micro-CT scans. The development of proper mounts for an object that sits on a rotating stage is an art in and of itself. The mount should not interfere with the scan or introduce artifacts. See du (Plessis et al. 2017) for the creative sculpting of green florist's foam for a mount for a chameleon. The proper mounting of objects that will not move during a scan is a bit of a black art that requires time, experience, and great patience.

- Cone-beam artifacts are caused when peripheral parts of an object are incompletely exposed to the diverging cone-shaped X-ray beam. These present as V-shaped artifacts on the periphery of the scan field (Scarfe and Farman 2008). These artifacts can be reduced by increasing the source-to-object distance, ensuring that the entire object is fully contained within the X-ray beam.

- Noise is a common concern in micro-CT scans. Noise can arise from electrical sources or from an inadequate number of photons hitting the receptor (Schulze et al. 2011). Noise can be reduced by increasing current, increasing the length of exposure for each projection, increasing the number of projections captured, or increasing the number of frames averaged for each projection. With the exception of varying the current, the rest of the variables increase the length of the scan. Thus, the operator must balance image quality with the length of time invested in each scan.

There are many other artifacts that are introduced from a variety of sources. The interested reader is directed to Stock (2009: Chapter 5), Ramsey (2011), (Schulze et al. 2011), and Boaz and Fleischmann (2012) for more information.

Current and Future Developments

There are a number of important research developments in the micro-CT field which could have great impact in the paleoimaging field.

- Dual energy scanning. Different materials have different linear attenuation coefficients at different energy levels. This fact can be used to identify or characterize specific materials in

CT scans, but requires registered scans taken at two different energy levels. This technique is typically used in preclinical scanning to assist in image segmentation (e.g. the vasculature from the rest of the soft tissue) (see Granton 2008) and has recently made its way into commercial clinical CT scanners (see Johnson et al. 2007; Marin et al. 2014). Dual energy techniques are also used to reduce metal artifacts (Katsura et al. 2017). We have experience using this technique to aid in the segmentation of the skull of a mummy from overlying resin (Friedman et al. 2012), and Bewes et al. (2016) have used the technique on mummified cats, but to the best of our knowledge, this technique has not been widely applied in the field of micro-CT paleoimaging (but see Wanek et al. 2011).

The identification of specific elements is possible using dual energy scanning with the kVp settings chosen to lie on either side of the element's K-edge value. This application was actually anticipated by Elliot and Dover in their 1982 paper. Cooper et al. (2012) have demonstrated this application in bone, mapping strontium using the tunable monochromatic beam of a synchrotron. This is an area ripe for development. Possible micro-CT applications include the identification of fabric and tempers in ceramics and of diagenetic elements in bone, as well as the identification of specific pathological lesions.

- Helical scanning. Sheppard et al. (2014) and Dierick et al. (2014) reported on the development of the first implementations of helical scanning capability for laboratory micro-CT units. Helical CT allows the scanning of long specimens without the need for the merging of volumes in the post-processing phase. More importantly, it solves a central problem of cone-beam imaging: that is, that only the central plane is sampled exactly. In a typical cone-beam image, regions away from the central plane demonstrate distortion caused by the divergent beam angle. Helical scanning resolves this issue. This technology is now entering the commercial realm (see https://www.fei.com/product/micro-CT/HeliScan/). Van den Bulcke et al. (2016) report on the analysis of a wooden flute using a helical scan. The fetal cranium shown in Figure 1 was scanned on a Nikon XTH 320 scanner in helical mode at the Tring facility in the UK.

- Stock (2009) outlined three other analytical areas where the field of micro-CT is evolving: phase-contrast imaging, X-ray fluorescence (XRF), and scatter micro-CT (SAXS). These areas have not been widely applied yet in paleoimaging, although isolated examples do exist (e.g. phase-contrast imaging has been used on a synchrotron to identify fossil inclusions in amber; Lak et al. 2008—see also Bergmann et al. 2012, Quartieri 2015, and Bertrand et al. 2016).

Conclusions

Micro-CT scanning offers non-destructive access to high-resolution images of the inner structures and composition of fossils and artifacts of interest to paleontologists, archaeologists, historians, and museum curators. While this is based on the same principles as clinical CT, system configuration, operation, and imaging, artifacts encountered require an additional knowledge base to be effectively exploited. The use of micro-CT in paleoimaging is spreading rapidly and the different kinds of applications are multiplying exponentially, with new developments bringing new capabilities practically every day. This is an exciting time to be a paleoimager.

Cone-Beam Computed Tomography (CBCT)—Alan Lurie

Cone-beam technology was first introduced in the European market in 1996 by QR s.r.l. (NewTom 9000) and subsequently into the US market in 2001. In fact, CBCT is a large-scale version of micro-CT, as it employs the same physical principles on a macro scale. CBCT uses a divergent, cone-beam X-ray beam to acquire a single volumetric data set that can be broken down into up to some 600 base images. All of the voxels that generate the data set are isotropic and measure as low as 80 μm at the highest resolution. CBCT has the highest spatial resolution of any volumetric clinical imaging modality, which makes it superior for detailed study of mineralized structures. It does not have high-contrast resolution, and thus it is not very useful in the study of soft tissue.

FOV, in CBCT imaging, is determined at the time of acquisition and can range from 180 mm × 180 mm, which generally includes the entire craniofacial and upper cervical spine, to 40 mm × 40 mm, which includes a field of approximately 3–4 teeth and supporting alveolar structures. These FOVs vary considerably from one manufacturer to another. Acquisition parameters for

these FOVs will employ minimal voxel dimensions of 80 μm–120 μm for the various FOVs. Voxels are isotropic in all CBCT imaging.

Dental CBCT units and post-processing software programs have special curved-surface reconstruction programs that allow a variety of multi-planar, panoramic and 3D reconstructions of the DICOM data set. There are also programs for ROI, pixel intensity measurements, corrected cross-sectional image displays, linear and special measurements, and other functions useful to dentistry and mineralized tissue analysis, which are available for use with the CBCT DICOM data set. These capabilities become extremely useful when a detailed analysis of the dentition of the specimen is needed.

Recommendations

When possible, radiographers who are familiar with non-traditional applications of clinical procedures should be sought. Individual who have only clinical experience will not have the in-depth knowledge of the equipment and know-how to modify clinical protocols. Prior to any CT study, conventional or digital radiographs should be taken of the object or specimen. To be of any value, two projections at 90° to each other must be obtained. In clinical terms, these images represent a triage process that serves several functions. The initial information relates to the condition and is important to determine the stability and feasibility of moving the object. Once that has been established and the object is skeletal or mummified remains, initial impressions regarding the age at the time of death and presence of pathology can be established. The latter is also important to determine target regions within the remains for advance imaging studies. For objects, such as the wooden Buddha described earlier, the protocol employed should include settings to create isotropic voxels. When incorporating 3D reconstructions, the selection of a clinical algorithm should represent a starting point, followed by manipulation of threshold values on the color pallet. If fossils or similar materials are the subject, a standard, such as a number of mineral samples, should be included to serve as a density standard for comparison.

References

Balerna, A. and Mobilio, S. 2015. Introduction to synchrotron radiation. In S. Mobilio, F. Boscerini, and C. Megeghini (eds), *Synchrotron Radiation* 3–28. Heidelberg: Springer.

Barrett, J.F. and Keat, N. 2004. Artifacts in CT: Recognition and avoidance. *Radiographics* 11: 1679–1691.

Benazzi, S., Gruppioni, G., Strait, D.S., and Hublin, J.J. 2014. Technical note: Virtual reconstruction of KNM-ER 1813 *Homo habilis* cranium. *American Journal of Physical Anthropology* 153: 154–160.

Bergmann, U., Manning, P.L., and Wogelius, R.A. 2012. Chemical mapping of paleontological and archaeological artifacts with synchrotron X-rays. *Annual Reviews of Analytical Chemistry* 5: 361–389.

Bertrand, L., Bernard, S., Marone, F., and Bergmann, W. 2016. Emerging approaches in synchrotron studies of materials from cultural and natural history collections. *Topics in Current Chemistry* 374(1): 1–39.

Bewes, J.M., Morphett, A., Pate, D., Henneberg, M., Low, A.J., Jruse, L., Craig, B., Hindson, A., and Adams, E. 2016. Imaging ancient and mummified specimens: Dual-energy CT with effective atomic number imaging of two ancient Egyptian cat mummies. *Journal of Archaeological Science* 8: 173–177.

Boas, F.E. and Fleischmann, D. 2012. CT artifacts: Causes and reduction techniques. *Imaging in Medicine* 4: 229–240.

Breunig, T.M., Stock, S.R., Guveniler, A., Elliott, J.C., Anderson, P., and Davis, G.R. 1993. Damage in aligned-fibre SiC/Al quantified using a laboratory X-ray tomographic microscope. *Composites* 24(3): 209–213.

Brüllmann, D., and Schulze, R.K.W. 2015. Spatial resolution in CBCT machines for dental/maxillofacial applications—what do we know today? *Dentomaxillofacial Radiology* 44, 20140204.

Bull, D.J., Helfen, L., Sinclair, I., Spearing, S.M., and Baumbach, T. 2013. A comparison of multi-scale 3D X-ray tomographic inspection techniques for assessing carbon fibre composite impact damage. *Composites Science and Technology* 75: 55–61.

Bushong, S.C. 2000. *Computed Tomography*, 58. New York: McGraw Hill.

Bushong, S.C. 2013. *Radiologic Sciences for Technologists: Physics, Biology, and Protection*, 10th ed., 439–442. St. Louis, MI: Elsevier.

Cheng, R., Brown, W.P., Fahrig, R., and Reinhard, C. 2006. An Egyptian child mummy. *Science* 303: 1730.

Cooper, D.M.L., Chjapman, L.D., Carter, Y., Wu, Y., Panahifar, A., Britz, H.M., Bewer, B., Duke, M.J.M., and Doschak, M. 2012. 3D mapping of strontium in bone by dual energy K-edge subtraction imaging. *Physics in Medicine and Biology* 57: 5777–5786.

Dierick, M., Van Loo, D., Masschaele, B., Van del Bulcke, J., Van Acker, J., Cnudde, V., and Van Hoorebeke, L. 2014. Recent micro-CT scanner developments at UGCT. *Nuclear Instruments and Methods in Physics Research B* 324: 35–40.

Ding, Y., Vanselow, D.J., Takovlev, M.A., Katz, S.R., Lind, A.Y, Clark, D.P, and Cheng, K.C. 2018. Three-dimensional histology of whole zebrafish by sub-micron synchrotron X-ray micro-tomography. bioRxiv 392381; doi: https://doi.org/10.1101/39238.

du Plessis, A., Broeckhoven, C., Guelpa, A., and Gerhard le Roux, S. 2017. Laboratory X-ray micro-computed tomography: A user guideline for biological samples. *GigaScience* 6: 1–11.

Edey, D.R. 2014. *Micro-Computed Tomography Semi-Empirical Beam Hardening Correction: Method and Application to Meteorites*. MSc Thesis, School of Graduate and Postgraduate Studies, Western University. Electronic Thesis and Dissertation Repository. 2000. http://ir.lib.uwo.ca/etd/2000.

Elliott, J.C., Davis, G.R., and Dover, S.D. 2008. X-ray microtomography, past and present. In S.R. Stock (ed.), *Developments in X-Ray Tomography VI*, Proceedings of SPIE, 7078, 707803: 0277-786.

Elliott, J.C. and Dover, S.D. 1982. X-ray microtomography. *Journal of Microscopy* 126(2): 211–213.

Ellis, L., Suda, A., Martin, R.M., Moffatt, E., Poulin, J., and Nelson, A.J. 2017. The virtual deconstruction of a prayer bead in the Thomson Collection at the Art Gallery of Ontario with micro-CT scanning and advanced 3D analysis software. In E. Wetter and F. Scholten (eds), *Prayer-Nuts, Private Devotion and Early Modern Art Collecting* 209–217. Riggisberg: Abegg-Siftung.

Fehren-Schmits, L., Kapp, J., Ziegler, K.L., Harkin, K.M., Aronson, G.P., and Conlogue, G. 2016. An investigation into the effects of X-ray on the recovery of ancient DNA from skeletal remains. *Journal of Archaeological Science* 76: 1–8.

Feldkamp, L.A., Davis, L.C., and Kress, J.W. 1984. Practical cone-beam algorithm. *Journal of the Optical Society of America A* 6: 612–619.

Feldkamp, L.A., Goldstein, S.A., Parfitt, M., Jesion, G., and Kleerekoper, M. 1989. The direct examination of three-dimensional bone architecture by computer tomography. *Journal of Bone and Mineral Research* 4: 3–11.

Friedman, S.N., Nguyen, N., Nelson, A.J., Granton, P.V., MacDonald, D.B., Hibbert, R., Holdsworth, D.W., and Cunningham, I.A. 2012. Computed tomography (CT) bone segmentation of an ancient Egyptian mummy: A comparison of automated and semiautomated threshold and dual-energy techniques. *Journal of Computer Assisted Tomography* 36: 616–622.

Friedrich, C.M., Nemec, S., Czerny, C., Fischer, H., Plischke, S., Gahleitner, A., Viola, T.B., Imhof, H., Seidler, H., and Guillen, S. 2010. The story of 12 Chachapoyan mummies through multidetector computed tomography. *European Journal of Radiology* 76: 143–150.

Gantt, D.G., Kappleman, J., Ketcham, R.A., Alder, M.E. & Deahl, T.H. 2006. Three-dimensional reconstruction of enamel thickness and volume in humans and hominoids. *European Journal of Oral Sciences* 114 (Suppl. 1): 360–364.

Granton, P.V. 2008. *Micro-CT Material Interpretation by Segmentation and Multi-Energy Data Acquisition*. MSc Thesis, Faculty of Graduate Studies, University of Western Ontario.

Holdsworth, D.W. and Thornton, M.M. 2002. Micro-CT in small animal and specimen imaging. *Trends in Biotechnology* 20(8): S34–S39.

Immel, A., Le Cabec, A., Bonazzi, M., and Krause, J. 2016. Effect of X-ray irradiation on ancient DNA in sub-fossil bones—Guidelines for safe X-ray imaging. *Nature Scientific Reports* 6:32969. doi:19.1038/srep32969

Johns, R.A., Steude, J.S., Castanier, L.M., and Roberts, P.V. 1993. Nondestructive measurements of fracture aperture in crystalline rock cores using X-ray computed tomography. *Journal of Geophysical Research* 98(B2): 1889–1900.

Johnson, T.R.C., Grauβ, B., Sedlmair, M., Brasruck, M., Bruder, H., Morhard, D., Fink,C., Wecjbach, M., Lenhard, M., Schmidt, B., Flohr, T., Reiser, M.F., and Becker, C.R. 2007. Material differentiation by dual energy CT: Initial experience. *European Radiology* 17: 1510–1517.

Kalender, W. 2011. Fast and dynamic micro-CT imaging in pre-clinical research. Presentation, Workshop on FMT-XCT, Munich, Germany. November 24, 2011.

Katsura, M., Sato, J., Akahane, M., and Abe, O. 2017. Current and novel techniques for metal artifact reduction at CT: Practical guide for radiologists. *RadioGraphics* 38: 450–461.

Kozachuk, M.S., Martin, R.R., Nelson, A.J., Hudson, R.H.E., Macfie, S.M., Biesinger, M.C., Walzak, M.J., Ellis, L., Suda, A., and Heginbotham, A. 2016. Possible radiation-induced damage to the molecular structure of wooden artifacts due to micro-computed tomography, handheld X-ray fluorescence, and X-ray photoelectron spectroscopic techniques. *Journal of Conservation and Museum Studies* 14(1): 1–6.

Lak, M., Niéraudeau, A., Nel, A., Cloetens, P., Perrichot, V., and Tafforeau, P. 2008. Phase contrast X-ray synchrotron imaging: opening access to fossil inclusions in opaque amber. *Microscopy and Microanalysis* 14: 251–259.

Marin, D., Boll, D.T., Mileto, A., and Nelson, R.C. 2014. State of the art: Dual energy CT of the abdomen. *Radiology* 271(2): 327–342.

McBride, R.A. and Mercer, G.D. 2012. Assessing damage to archaeological artefacts in compacted soil using microcomputed tomography scanning. *Archaeological Prospection* 19: 7–19.

Nelson, A.J., Harris, S., Saleem, S., Sheikholeslami, C., Garrad, M., Price, C., Ramsey, A., Hadland, M., Gibson, G., Ikram, S., Willmore, K., Han, V., Razvi, H., Dautant, A., and Wade, A.D. 2018. "Maidstone EA 493—A mummified anencephalic fetus from Ancient Egypt. Extraordinary World Congress on Mummy Studies, Santa Cruz, Tenerife, May 2018.

Nemtoi, A., Czink, C., Haba, D., and Gahleitner, A. 2013. Cone beam CT: A current overview of devices. *DentoMaxilloFacial Radiology* 42(8): 20120443.

Orth, R.C., Wallace, M.J., and Kuo, M.D. 2008. C-arm cone-beam CT: General principles and technical considerations for use in interventional radiography. *Journal of Vascular and Interventional Radiology* 19: 814–821.

Paredes, U.M., Prys-Jones, R., Adams, M., Groombridge, J., Kundu, S., Agapow, P.-M., and Abel, R. 2012. Micro-CT X-rays do not fragment DNA in preserved bird skins. *Journal of Zoological Systematics and Evolutionary Research* 50(3):247–250.

Quartieri, S. 2015. Synchrotron radiation in art, archaeology and cultural heritage. In S. Mobilio, F. Boscerini, and C. Megeghini (eds), *Synchrotron Radiation*, 677–695. Heidelberg: Springer.

Ramsey, A. 2011. The rules of X-Ray micro CT (and when to break them). *Quality Magazine*. http://www.quality-mag.com/articles/90176-the-rules-of-x-ray-micro-ct-and-when-to-break-them (accessed July 22, 2017).

Richards, G.S. Jabbour, R.S., Horton, C.F., Ibarra, C.L., and MacDowell, A.A. 2012. Color changes in modern and fossil teeth induced by synchrotron microtomography. *American Journal of Physical Anthropology* 149: 172–180.

Ritman, E.L. 2011. Current status of developments and applications of micro-CT. *Annual Review of Biomedical Engineering* 13: 531–552.

Rueckel, J., Stockmar, M., Pfeiffer, F., and Herzen, J. 2014. Spatial resolution characterization of an X-ray microCT system. *Applied Radiation and Isotopes* 94: 230–234.

Rügsegger, P., Koller, B., and Müller, R. 1995. A microtomographic system for the non-destructive evaluation of bone architecture. *Calcified Tissue International* 58: 24–29.

Scarfe, W.C., and Farman, A.G. 2008. What is cone-beam CT and how does it work? *The Dental Clinics of North America* 52: 707–730.

Schulz, R., Heil, U., Groß, D., Bruellmann, D.D., Dranischinkow, E., Schwanecke, U., and Schoemer, E. 2011. Artefacts in CBCT: A review. *Dentilomaxillofacial Radiology* 40: 265–273.

Seeram, E. 2009. *Computed Tomography: Physical Principles, Clinical Applications, and Quality Control*, 3rd ed. St. Louis, MI: Saunders/Elsevier.

Sheppard, A., Latham, S., Middleton, J., Kingston, A., Myers, G., Varslot, T., Fogden, A., Sawkins, T., Cruikshank, R., Saadatfar, M., Francois, N., Arns, C., and Senden, T. 2014. Techniques in helical scanning, dynamic imaging and image segmentation for improved quantitative analysis with X-ray micro-CT. *Nuclear Instruments and Methods in Physics Research B* 324: 49–56.

Snow, C. 2017. Personal communication, phone conversation, May.

Stock, S.R. 2009. *MicroComputed Tomography: Methodology and Applications*. Boca Raton, FL: CRC Press.

Turbell, H. 2001. *Cone-Beam Reconstruction Using Filtered Backprojection*. Linköpings Studies in Science and Technology Dissertation No. 672.

Van den Bulcke, J.V., Van Loo, D., Dierick, M., Masschaele, B., Van Hoorebeke, L., and Van Acker, J. 2016. Nondestructive research on wooden musical instruments: From macro- to microscale imaging with lab-based X-ray CT systems. *Journal of Cultural Heritage*. doi:10.1016/j.culher.2016.01.010.

Wanek, J., Székely, G., and Rühli, F. 2011. X-ray absorption-based imaging and its limitations in the differentiation of ancient mummified tissue. *Skeletal Radiology* 40: 595–601.

Ziegler, K.L., Conlogue, G., Beckett, R., Blyth, T., Aronson, G.P., and Fehren-Schmitz, L. 2013. An investigation into effects of X-ray on the recovery of DNA from skeletal remains. *American Journal of Physical Anthropology* 150(S56): 299.

Magnetic Resonance Imaging (MRI)

JOHN POSH AND GERALD J. CONLOGUE

8

Contents

Unlike radiography, which is based on the differential absorption of the radiation transmitted through a patient, MRI or simply MR detects the quantity and behavior of mobile hydrogen protons within the patient. Although hydrogen is found in a number of compounds within the body, in many instances it is locked into a crystalline structure and is not sufficiently mobile to be useful. However, the hydrogen within water and lipid molecules is quite mobile and is the primary source of the MR image.

A more complete description of the physical basis of MRI can be found in Westbrook and Talbot (2018). For the purpose of this text, a more generalized, less technical overview will be presented that presupposes no prior knowledge of MRI.

Hydrogen is an unusual atom. In its most abundant form, it has a nucleus containing only a single positively charged proton. In a magnetic field, the proton will spin on its axis, or precess. The rate of precession is proportional to the intensity of the magnetic field.

Before we go further into the imaging process, a review of the basic laws of magnetism is necessary. All magnets have north and south poles. Poles with like charges or lines of force repel, whereas unlike poles or lines of force attract. The attraction or repulsion between two magnets is directly proportional to the intensity of the magnetic field and inversely proportional to the square of the distance between them; this is also known as the inverse square law as it applies to magnetism.

Materials can be classified according to their reaction to magnets. Ferromagnetic material, such as iron, is strongly attracted to magnets. Diamagnetic materials, such as gold, aluminum, and most body tissues save for dense cortical bone, are weakly repelled. Paramagnetic material, such as gadolinium, is weakly attracted. Nonmagnetic materials, such as glass, ceramic, and wood, are not affected at all by magnets. In the clinical world, these distinctions are important for a variety of reasons such as image quality, safety, and understanding pathological processes. When discussing paleoforensic imaging, a strong understanding of how materials

affect the magnetic fields is essential for proper image planning as the specimens to be imaged are frequently treated or exposed to substances that can alter their imaging properties.

The magnetic field that we experience when walking about on the Earth is relatively low and equivalent to about 0.5 gauss (G). A "gauss" is a unit of measure frequently used for weak magnetic-field measurement in medical imaging. It is strong enough that a ferromagnetic compass needle can indicate the direction of the magnetic north pole; however, it is not of sufficient strength for imaging purposes. The unit of magnetism employed for the stronger fields used for imaging purposes is the tesla (T), named after Nikola Tesla, who did extensive research with electricity and magnetic fields. One tesla equals 10,000 G. For high-field MRI, the magnetic field strength is 1.5 to 3 T, or roughly 30,000 to 60,000 times stronger than the Earth's geomagnetic field.

Now back to the H^1 protons. Normally, these protons are randomly aligned throughout the body (Figure 8.1). When a strong external magnetic field is applied (B_O), the protons are forced into alignment with the overwhelmingly more powerful external field. They tend to align either parallel (low energy) or antiparallel (high energy) to the field (Figure 8.2). Since nature favors a lower energy state, there will be a greater number of parallel protons. Parallel and antiparallel protons have equal magnitude and opposite value, so pairs cancel each other out (Figure 8.3). This imbalance leaves a remainder of protons available for imaging, and aligned with B_O, but out of phase (Figure 8.4). In a 1.5 T magnetic field, approximately 7 out of every 1×10^5 hydrogen protons will remain. That may not seem like many, but since humans are made up of 70–80 % water and water contains 1×10^{23} hydrogen atoms per cubic centimeter, there are literally trillions of individual hydrogen protons available for imaging, though the overall number is dependent on the tissue type and the strength of the magnetic field.

When external radiofrequency (RF) energy (B_1) is transmitted into the sample, several things will happen.

Figure 8.1 Randomly aligned hydrogen protons within the body.

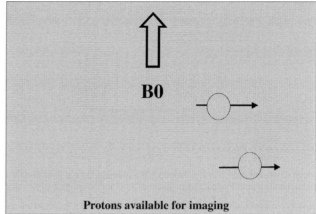

Figure 8.3 After the antiparallels cancel out the parallels, the remaining protons are available for imaging.

Figure 8.2 When a strong external magnetic field (B0) is applied, the protons tend to align antiparallel or parallel.

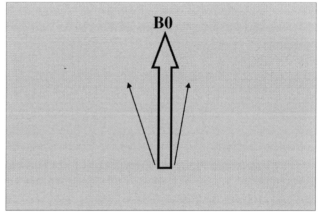

Figure 8.4 The parallel protons will align with B0, but will be out of phase.

First, all the remaining protons will be gathered together from their naturally out-of-phase precessions and placed in step (phase) with each other. Once organized in this fashion, they are aggregately termed the net magnetic vector (NMV). Second, the NMV will be pushed from a low-energy longitudinal alignment to a higher-energy transverse alignment (Figure 8.5). They will remain in this state as long as external RF energy is applied.

Once the external RF energy is terminated, the NMV will begin to lose the absorbed energy (Figure 8.6) and simultaneously go through two separate processes. First, the NMV will begin to recover from the excited transverse state to the preferred longitudinal state. As it does so, it gives up its accumulated energy to the surrounding tissue lattice. This process is called *T1 recovery* or *spin lattice*. *T1 time* is defined as the time it takes to recover 63 % of the longitudinal magnetization (Figure 8.7). The second process that affects the NMV involves the individual protons within its bulk. Once the external RF energy is terminated, the individual protons

begin to dephase and lose step with one another. This process is driven by the interaction and exchange of energy between the individual protons and is called *T2 decay*. T2 decay is defined as the time it takes for 37 % of the transverse magnetization to be lost (Figure 8.8). The rate at which either or both these processes occur can be influenced by the strength of the magnetic field, temperature of the specimen, biological state of the imaged tissue, and presence of any foreign material that could alter the local magnetic field.

During the T1 and T2 processes, the NMV, an aggregate of multiple small magnetic fields, is precessing on its axis. This magnetic field, though small, is precessing at 8–127 MHz (million cycles per second) depending on field strength, 0.2–3.0 T respectively. According to Faraday's laws of induction, a magnetic field of changing intensity perpendicular to a wire will induce a voltage along the length of that wire. MRI exploits the fact by placing a special wire conductor, called a *coil*, perpendicular to the precessing NMV. There are coils of many shapes and sizes, and it is best to choose the smallest

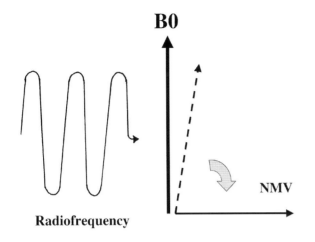

Figure 8.5 The RF will be absorbed and in doing so push the NMV into the higher-energy transverse alignment.

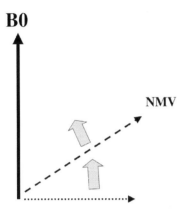

Figure 8.6 Once the RF is terminated, the protons begin to lose the absorbed energy and return to B0, the longitudinal magnetization.

coil possible for the body part to be imaged. Since the amount of voltage induced depends on both the strength and rate of change of the magnetic field, we can see that even a weak magnetic field is capable of inducing a measurable current when precessing between 8 and 127 million times per second. The induced current, similar to the NMV itself, is not a single entity but is composed of the sum of its parts and is of the same frequency as the precession of the NMV. Careful analysis of the signal will yield valuable information about the protons that created it. As discussed earlier, the rate at which T1 and T2 occur is dependent on the nature of the tissues. By manipulating the excitation and relaxation process, we can, in essence, interrogate the protons and extract valuable information regarding the quantity and binding characteristics of water molecules.

The information gained through this manipulation, though valuable, is limited to two dimensions: frequency and amplitude. To create an image, we need to add information regarding the precise location of each component of the signal within the sample. This is done

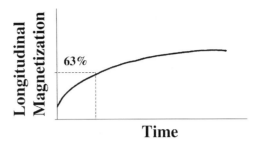

Figure 8.7 The T1 recovery process signifies the loss of energy to the surrounding tissue. The process is defined as the amount of time it takes to recover 63 % of the longitudinal magnetization.

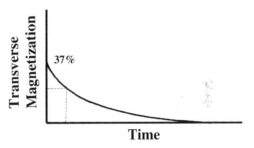

Figure 8.8 The T2 is defined as the time it takes for 37 % of the transverse magnetization to be lost.

through a process called *spatial localization*. Although a detailed understanding of spatial localization is not necessary for this text, the basic concept should be mentioned.

The entire basis of clinical MRI is that protons will precess in a magnetic field. The rate of precession is extremely precise, and for hydrogen it is equal to 42.57 MHz per tesla. We can vary the rate of precession by varying the magnetic field, and by doing so we can vary the frequency of the signal induced in the coil. If, in addition to the main magnetic field, we apply changeable magnetic fields in the X, Y, and Z planes, we then have the ability to alter the precession in any direction we choose. These additional components are called *gradient coils* and are really nothing more than electromagnets arranged around the bore (tunnel) of the main magnet. Though very complex in application, the concept is simple. Apply a changing electromagnetic field by altering power to the gradient in any one direction, and you will alter the precession of the individual protons along that axis. Record the values and repeat the process in another plane. By repeating this process thousands of times per second, we can not only determine the T1 and T2 properties of the imaged tissues, but also their precise anatomical location within the sample. The T1 and T2 properties are important because they tell us the type of tissue and its general state of health. The location

is important because it allows us to image not in a single slice, like early CT scanners, but rather across a large volume of tissue that the computer can segment into slices for easy viewing. The added benefit of MRI is that since the image is created not by the attenuation of an x-ray beam but rather by the concentration and distribution of water molecules, the image is extremely sensitive to subtle tissue changes that would otherwise be lost to other modalities.

The disadvantage of this increased sensitivity is that it comes with a much more complex series of user-defined parameters for obtaining images. Whereas X-ray is limited to a few basics and CT has a few more, MRI has a significantly higher number of user-selectable parameters that create hundreds of thousands of possible combinations. With MRI in widespread clinical use since the mid- to late 1980s, the parameters are well understood for clinical human imaging. In the end, we are really trying to obtain an image that is optimized for either the T1 properties of a tissue, the T2 properties of the tissue, or the overall density of protons contained in the tissue. We do this by manipulating the parameters within long-established guidelines.

The basic schematic diagram of how the excitation and relaxation processes are con- trolled along with the functions of the gradients is called a *pulse sequence.* Though complex in application, the pulse sequence is nothing more than a preset series of events that the computer uses to produce an image. The pulse sequence has several components that are controllable by the operator, and a few of these basic parameters are applicable here.

The few parameters we will mention in this text will be those with the greatest impact on the images we wish to obtain. *TE (echo time)* is defined as the time between the RF excitation pulse and the time we sample the resultant signal. The longer the TE, the less the signal available, because of the rapid rate of the T1 and T2 processes. *TR (repetition time)* is defined as the time from one excitation pulse to the next, or how long we wait before repeating the entire process. By altering these values, we can formulate an image with the tissue characteristics we desire to see (Table 8.1). These two parameters have a great impact on the signal characteristics of the resultant image. For example, fat will be bright and water will be dark or vice versa.

The other parameters we set have little impact on the signal characteristics, but they play a critical role in the overall quality of the image. When discussing image quality, we are discussing a trade-off between image resolution, or detail, and signal-to-noise ratio (SNR) or just signal. An image can have a very high resolution but a low SNR. Such an image will be of little value because,

Table 8.1 Signal Characteristics of Tissues with Spin Echo T1 and T2 Imaging

Hyper-intense on T1	Hyper-intense on T2
Fat	Water
Sub-acute blood	CSF
Melanin	Sub-acute hematoma
Myelin	Inflammation
Highly Proteinaceous fluids	Highly proteinaceous fluids
Cholesterol	Most lesions
Gadolinium enhancement	

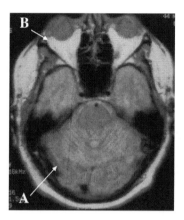

Figure 8.9 A T1-weighted image at the level of the cerebellum (A). Note the high signal from the retro-orbital fat (B).

although we have great detail, there is not enough signal to see it. The opposite is also true. A high-SNR image with low resolution, though pretty, will not provide sufficient detail to visualize the intended structures. The key parameters needed to balance SNR and resolution are field of view (FOV), slice thickness, and image matrix. In short, the more protons included in each portion of the image, the greater the SNR. Thick slices and large FOVs accomplish this nicely. Image resolution is more a factor of the displayed image. The more tiny pieces an image is divided into (pixels), the better the detail. But if the pieces are too small or if the images were collected with a small FOV and thin slices, there may not be enough signal to fill the pixels and the resultant image will be very noisy.

Finally, images can be classified as T1- or T2-weighted depending on which process contributed more to the final image. With a T1-weighted image, fat has a higher signal than water (Figure 8.9). High signal appears hyper-intense (bright) on the displayed image, lower signals are generated as shades of gray, and no signal, such as received from air or cortical bone, is black. T1 images provide excellent anatomical detail. On the other hand, a T2-weighted image provides a higher signal from water and a lower signal from fat (Figure 8.10). T2 images are advantageous for demonstrating pathological processes,

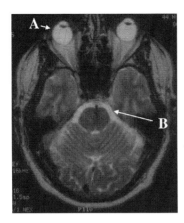

Figure 8.10 A T2-weighted image at approximately the same level. In this case, the high signal is from the aqueous fluid in the eye (A) and the cerebrospinal fluid (B) anterior and lateral to the pons.

such as edema, that have high "water" content and also for detailing fluid in areas where it does not belong, such as with trauma or penetrating injuries. Through careful manipulation of the technical parameters, a skilled operator, experienced in scanning non-living specimens, can create images to enhance or feature almost any disease process, injury, or anatomy.

Because MR primarily provides information on the location of mobile hydrogen within a body, it would seem of little value in the examination of mummified remains. Notman et al. (1986) published a report following the examination of a mummy with MR looking for residual moisture. They stated, "... It appears MRI is unsuitable for the paleopathologic investigation of dehydrated structures." At the time they were correct, as early attempts to utilize MRI to image mummies and mummy tissues realized little success. Three notable exceptions are a modern mummy created in the ancient Egyptian method in 1994 at the University of Maryland by Bob Brier and Ronn Wade (Quigley 1998), a dog mummified to document and analyze the desiccation process by Notman and Aufderheide (1995), and brain tissue removed from the preserved skull of an Indian Bog Mummy and embedded in agar (Notman 1983).

Since that time, we have, on several occasions, been successful in incorporating MRI into the imaging workup protocol for the evaluation of mummified remains. With mummified tissues, it is sometimes necessary to override the standard auto-tuning process (prescan) and tune the system manually. It is also helpful in some cases to add an isolated source of mobile protons to "load" the coil. This can be accomplished by placing saline IV bags or water bottles in the coil with the body part to be imaged. The mobile protons in the water trick the system into "thinking" that the tissue within the coil

is hydrated. Once the system tunes in appropriately, the operator can fine-tune the scanner and obtain satisfactory images even with the bags removed.

Additional readings related to MRI and paleoimaging can be found in the following sources

Aufderheide, A. C. 2003. *The Scientific Study of Mummies*. Cambridge, UK: Cambridge University Press.

Beckett, R., J. Posh, C. Czaplinski, G. Conlogue, L. Quarino, J. Kishbaugh, and A. Bonner. 2008. Moving toward field application of percutaneous needle biopsy in mummified remains using a non-gravity-dependent needle scrape/aspiration technique with CT and endoscopic guidance—A preliminary study. Paper presented at the 35th annual meeting of the Paleopathology Association, April 8–9, Columbus, OH.

Bushong, S. C. 2008. *Radiologic Science for Technologist*, 9th edition, 428. St Louis, MO: Elsevier Mosby.

Cockburn, A., E. Cockburn, and T. Reyman (Ed.). 1998. *Mummies, Disease and Ancient Cultures*, 2nd edition. Cambridge, UK: Cambridge University Press.

Conlogue, G., J. Jones, R. Beckett, M. Biesinger, L. Engel, and M. Smith. 2005. Imaging the legend of Marie O'Day. Paper presented at the 32nd Annual North American Paleopathology Association Meeting, April, Milwaukee, WI.

Cox, J. E., C. Chiles, C. M. McManus, S. L. Aquino, and R. H. Choplin. 1999. Transthoracic needle aspiration biopsy: Variables that affect risk of pneumothorax. *Radiology*, 212: 165–168.

Eiseberg, R. L. 1992. *Radiology an Illustrated History*, p. 430. St. Louis, MO: Mosby-Year Book, Inc.

Fauber, T. L. 2009. Exposure variability and image quality in computed radiography. *Radiologic Technology*, 80(3): 209–215.

Hiss, S. S. 1983. *Understanding Radiography*, 2nd ed., p. 302. Springfield, IL: Charles C., Thomas.

Larscheid, R. C., P. E. Thorpe, and W J. Scott. 1998. Percutaneous transthoracic needle aspiration biopsy: A comprehensive review of its current role in the diagnosis and treatment of lung tumors. *Chest*, 114: 704–709.

Lombardo, R. 2008. Personal communication. (contact author)

Ruhli, F. J., H. Jmg, and T. Boni. 2002. CT guided biopsy: A new diagnostic method for paleo pathological research. Technical note. *American Journal of Physical Anthropology*, 117(3): 272–275.

Seeram, E. 1985a. *X-Ray Imaging Equipment*, 162. Springfield, IL: Charles C Thomas.

Seeram, E. 1985b. *X-Ray Imaging Equipment*, 164. Springfield, IL: Charles C Thomas.

Seeram, E. 2001. *Computed Tomography Physical Principles, Clinical Applications and Quality Control*, 3rd edition. Philadelphia, PA: WB Saunders Company.

Webster, J. G. (Ed.). 1988. *Encyclopedia of Medical Devices and Instrumentation*, 834. New York: Wiley.

Westbrook, C. and Talbot, J., 2018. *MRI in Practice*, 5th edition, 1–17. London: Black-Well Science.

Wolbarst, A. B. 1993. *Physics of Radiology*, 321. Norwalk, CT: Appleton & Lange.

References

Notman, D. N. H. and A. C. Aufderheide. 1995. Experimental mummification and computed imaging. In Proceedings of the First World Congress on Mummy Studies, February, 1992, Vol. 2, 821–828. Santa Cruz, Tenerife, Canary Islands: Archeological and Ethnographical Museum of Tenerife.

Notman, D. N. H., J. Tashjian, A. C. Aufderheide, O. W. Cass, O. C. Shane III, T. H. Berquist, and E. Gedgaudas. 1986. Modern imaging and endoscopic biopsy techniques in Egyptian mummies. *American Journal of Roentgenology*, 146: 93–96.

Notman, D. N. H. 1983. Use of nuclear magnetic resonance imaging of archeological specimens. *Paleopathology Newsletter*, 43: 9–12.

Quigley, C. 1998. *Modern Mummies*, 115–119. Jefferson, NC: Macfarland & Company, Inc.

Development of Study Strategies

<div style="text-align: right; font-size: 2em;">9</div>

Introduction

In order to conduct a paleoimaging study, there are many factors to consider. In this chapter we discuss a variety of associated issues pertaining to paleoimaging study development and implementation. The chapter is presented in section format with topics including ethical considerations, determining imaging needs and associated costs, and establishing and managing workflow. There are also sections discussing data management and storage, data interpretation strategies, the integration of bioarchaeology and bioarchaeology of care models in paleoimaging, along with concerns regarding field safety and health challenges associated with studies, and information regarding radiation protection.

Clearly each of these sections could become full texts in themselves and we encourage the reader to delve deeper into these topics as you consider developing an imaging study. Each of these topics has an impact on imaging studies, regardless of where the study is being conducted. The issues and concerns presented pertain to museums, industrial settings, as well as to research conducted in remote field locations. We think that you will find the information provided useful and that it will assist the reader in putting information from previous chapters together in a manner that will allow the reader to design and implement a successful imaging research plan.

Section 1
Ethical Considerations

RONALD G. BECKETT AND ANDREW J. NELSON

9

Contents

Section Rationale

Clearly, ethics must be considered in the development of a study strategy when dealing with ancient artifacts or cultural human remains. When considering imaging methodologies as applied in non-traditional settings, it is important for research teams to ask some very fundamental questions. One of the most basic of these is why the study is being done. To the bioarchaeologist, "human remains are a repository of a person's life history and collectively tell the story of the population that individual belonged to. Skeletal data are thus critical to our understanding of the adaptive history of our species" (Larsen & Walker 2005: 113). In cases where artwork, ceramics, or other inanimate objects are the focus of a study, the primary question of "why?" may be apparent where the major ethical questions surround the proper care of the object and obtaining the necessary permissions for the analysis. When the subjects of a study are human remains, the question of ethics requires more critical consideration. The consideration of collecting imaging data from cultural artifacts certainly requires informed decision-making measures. In this section, we provide some background on the issue of ethics and focus our discussion on the ethics associated with developing imaging studies on mummified and skeletal human remains.

Ethics Defined

Ethics are defined as the discipline dealing with what is good and bad and with moral duty and obligation. In simple terms, ethics are a set of moral principles or a theory or system of moral values (Beauchamp and Childress 2001).

It is important to make the distinction between the constructs of morals and ethics. Morals describe one's personal values regarding right and wrong. Thus, morals can vary greatly among individuals within a given group. Ethics, on the other hand, are often presented as a system of what is right or wrong as it applies to questions of correct behavior within a relatively narrow area of activity. Professional ethics then are statements of proper and responsible behavior within a particular field, such as anthropology or medicine. With that said, individual morals can run contrary to what a profession considers ethical practice.

Establishing a common set of ethical principles to the analysis of human remains is not without its challenges. One of the interesting characteristics of the study of human remains in mummy science studies is that the quality, interpretation, and meaning of the data collected require cross-professional collaboration. Each of these professions bring their own set of ethical principles and study practices to bear on a shared research project. Fortunately, many disciplines associated with the examination of human remains hold many ethical values in common. A broader challenge is the fact that ethical norms are culturally contingent. A code of acceptable behavior that might pertain in one country may not in another. These challenges highlight the need to consider these issues carefully and thoughtfully.

Highlights for Cross-Disciplinary Codes of Ethics

Several interacting disciplines are involved in the scientific study of human remains. Some of these disciplines are anthropology, archaeology, bioarchaeology, medicine,

and forensics. Each of these has its own ethical standards of practice. Codes of ethics are public statements that define the "norms and beliefs" of an organization leading to acceptable behavior as defined by those norms. These codes may be regulatory or aspirational (Wood and Rimmer 2003). It is beyond the scope of this text to present each of these statements of ethical standards in their entirety, and the reader is encouraged to familiarize themselves with the ethical principles of related disciplines. Here we will highlight general characteristics of ethical standards as reported by various professional organizations. The ethical focus of each organization is related to their specific professional norms and responsibilities, yet the similarities can be easily drawn. Awareness of the ethical "personality" of collaborators will certainly result in a more efficient study strategy and reduce unnecessary "debate" in the field.

The American Anthropological Association (AAA) presents its "core principles" in a statement titled "Principles of Professional Responsibility" (see Table 9.1.1). In this statement, the AAA recognizes the importance of understanding the complexities of anthropological study and the need for interactive collaboration with other professionals. Further, the AAA describes the need for sensitivity to not only the researchers but also the involved communities. The AAA presents these principles as general statements that can be applied in any given situation. The principles also provide a structure for communicating ethical precepts in anthropology to students, other colleagues, and outside audiences, including sponsors, funding agencies, and institutional review boards or other review committees.

The basic principles of the AAA include: 1) Do no harm, 2) Be open and honest regarding your work, 3) Obtain informed consent and necessary permissions, 4) Weigh competing ethical obligations due collaborators and affected parties, 5) Make your results accessible, 6) Protect and preserve your records, and 7) Maintain respectful and ethical professional relationships. When designing an imaging study project focused on human remains in an anthropological setting, it is imperative that these guiding principles inform not only the imaging professionals, but any students involved as well.

The Archaeological Institute of America (AIA) brings additional ethical considerations into the discussion (see Table 9.1.1). The AIA code of ethics includes aspects of research that imaging professionals may encounter while in the field. The AIA code directs its membership to conduct themselves in the highest professional manner by working with or under the supervision of qualified personnel. As with the AAA, the AIA states that research results should be shared and made public. Further, participants should refuse to participate in the trade of undocumented antiquities and inform appropriate local authorities if threats to archaeological sites are observed.

The Society for American Archaeology (SAA), in their document "Principles of Archaeological Ethics" (see Table 9.1.1), adds to both the AAA and the AIA by stating that archaeological professionals have a responsibility of stewardship of the archaeological record. The SAA also states that the promotion of archaeological methods and discoveries should be presented to the public through outreach programs/presentations as

Table 9.1.1 Selected Ethics Statements of Professional Anthropological/Archaeological and Medical Organizations (websites current as of February 10, 2019)

Organization	Web Site
American Anthropological Association	http://ethics.americananthro.org/catego.ry/statement/
American Association of Physical Anthropologists	http://physanth.org/about/committees/ethics/aapa-code-ethics-and-other-ethics-resources/
American Medical Association	https://www.ama-assn.org/sites/ama-assn.org/files/corn/media-browser/principles-of-medical-ethics.pdf
Archaeological Institute of America	https://www.archaeological.org/news/advocacy/130
British Association for Biological Anthropology and Osteology	http://www.babao.org.uk/publications/ethics-and-standards/
Canadian Association for Physical Anthropology	https://capa-acap.net/ethics-physical-anthropology-O
Guidance for the Care of Human Remains in Museums—2005. Department for Culture, Media, and Sport (UK).	http://webarchive.nationalarchives.gov.uk/+/http://www.culture.gov.uk/images/publications/GuidanceHumanRemains 11Oct.pdf
Society for American Archaeology	https://www.saa.org/career-practice/ethics-in-professional-archaeology
Society of Forensic Anthropologists	http://www.sofainc.org/code-of-ethics
World Archaeological Congress—The Vermillion Accord on Human Remains	http://worldarch.org/code-of-ethics/

well as to professional communities through publications. The statement reminds the professional that the information derived is not a personal possession but rather something to be treated in accordance with the principle of stewardship. Of particular importance to imaging professionals is the principle of creating a safe educational and workplace environment. Field safety for imaging studies with specific attention to radiation safety and protection will be discussed in Sections 7 and 8 of this chapter.

Medical professionals are often included in studies that involve the mummified or skeletal human remains. Medical specialists such as radiologists, pulmonologists, and cardiologists, to name a few, are called upon to offer their expertise in terms of diagnosis. Other medical professionals such as physical, occupational, and respiratory therapists are also called upon to assist with understanding the pathophysiological impact on the human condition in bioarchaeology of care studies. Each of these disciplines brings with it its own code of ethics directed toward the treatment of living patients and the care they receive. The basic principles of ethics adopted by the various professional organizations are crafted after the American Medical Association (AMA) principles of medical ethics (see Table 9.1.1). The AMA principles describe the ethical behavior with regards to interactions with patients and professionals, legal aspects of medical care, access to care, honesty and integrity, and respect of the rights of patients. One aspect of medical ethics that impacts the imaging study strategy is that of informed consent (cf. Lonfat et al. 2015). As an ethical doctrine, informed consent is a process of communication whereby a patient is enabled to make an informed and voluntary decision about accepting or declining medical care. Informed consent has become integral to contemporary medical ethics and medical practice.

When considering the logical concern for ethical decision making where the research involves mummified human remains or skeletal material, it is important for medical specialists and imaging professionals to understand the complexities of conducting such research. The factors and concerns involved in research on ancient human remains are quite different from those in clinical practice. It is important to note that there are clearly ethical standards that cross the clinical-anthropological contexts such as "do no harm." However, when developing a study strategy, researchers less familiar with anthropological, archaeological, and bioarchaeological frameworks must adopt and adhere to the current ethical standards of these professions.

Given that informed consent is not possible when the "patient" is a mummified human, the concept of "implied consent" becomes the ethical standard. Implied consent is an assumption of permission to do something that is inferred from an individual's actions or inability to act. An example among the living may be someone who collapses on a public street. Paramedics are called and care is rendered without informed consent. It is assumed that the individual would want to have medical interventions, thus, consent is implied. This concept of implied consent is used to address the ethical choices made when the subject is the remains of someone from an ancient culture. Examples of ethical choices regarding implied consent may be to study the remains respectfully with a reasonable degree of methodology or, in the case of exhumation from tombs, make decisions based on the protection of the remains from looting. Keep in mind that "consent" in bioanthropological studies may include a much broader range of players when considering the local, regional, and national communities of interest. Consultations and permissions are critical and must be considered when developing an imaging study strategy.

When considering consent for the study of remains, all stakeholders must be a contributing voice to the discussion of what should be done, and further, to what degree.

Finally, the Society of Forensic Anthropologists (SOFA) holds additional considerations with regards to the ethics of working with human remains. Among these are that the study of remains must be carried out with respect for human dignity in an environment of cooperation with other professionals (see also the Vermillion Accord for an emphasis on respect—Table 9.1.1). A researcher must not conduct analysis outside of their area of expertise or qualifications. An important consideration that translates to the study of mummified human remains is that the methods, interpretations, and opinions must be supported by the evidence and the facts of the case. These findings must be reported in an impartial and non-judgmental manner, maintaining respect for the human remains and authority, which includes all aspects of recovery, analysis, data collection, research, teaching, and proper disposition in accordance with applicable country, province, state, and local laws.

Authors have grappled with the need for ethical guidelines for mummy science research and have employed many of the concepts from codes of ethics of various disciplines in their efforts. This is clearly an ongoing discussion with various aspects of research on human remains being debated, including the ethics of excavation and exhibition, ancient DNA analysis, and the application of newer technologies or methods. The basic constructs being debated revolve around two major concepts, that of "doing harm" and the related concept of "consent."

Considering "doing harm" in the field of mummy science is, at best, conceptualized within the view point of the researcher. Harm can be both physical and related to personal identity, body integrity, and personal identity (Lonfat et al. 2015: 1178). In dealing with ancient remains, researchers feel that it is their duty to help understand the significance of past peoples and cultures as they relate to humankind's journey (cf. Bahn 1984; Larsen and Walker 2005). There is certainly merit to this view, considering that many of these past cultures have left no written record of their traditions and norms. Thus, the respectful study of such remains is seen as an obligation on the part of scientists to give a voice to those who cannot speak for themselves. Through research, a sense of personal identity is returned to the remains even in the most basic research questions such as sex determination, age at death, dental condition, and so on.

Physical harm is a bit more challenging to think through and involves philosophical questions regarding the nature of life itself. Is posthumous harm (e.g. tissue sampling) in fact physical harm to the individual? Does an individual cease to be one upon death? Aside from such debates, a wealth of information can be derived from invasive tissue sampling. The importance here is that ethics dictate that if tissue samples are to be taken to address a critical aspect of the research goals, then the smallest sample possible should be taken (minimally invasive). There will continue to be a debate among scholars as to whether or not samples should be taken at all (see Moissidou et al. 2015). Some argue that as members of the human species, we have an inherent interest in the continued progress of that species. Therefore, scientific, goal-driven sampling for histology or DNA has the potential to better humankind through the greater depth of understanding of, for example, the characteristic changes in a disease over time. Based on the assumption that humans strive to better their species, minimal consent for study is implied on the part of the remains in possession of competent researchers (Lonfat et al. 2015).

Ethics in Practice

When developing an imaging strategy, it is useful to consider the construct of ethics as a two-factor concept: pre-research ethical considerations and active-research ethical considerations.

Pre-Research Environment

Pre-research ethical guidelines are applied during the planning stages of a project. While the imaging professional may not be directly involved with the process of planning the project, they must assure themselves that ethical preparation has in fact been conducted. If it has not been conducted, imaging professionals should involve themselves in the process. Pre-research guidelines include the development of focused research questions and objectives. Rigorous development of the research focus helps to establish the validity of the proposed study, helps determine if there is evidence of a duplication of efforts, and establishes an ethical approach to planning the study. Building on the research questions and objectives, researchers must establish a need to conduct such a study. Researchers must ask, how will the data from the proposed study add to our understanding of past cultures? Have there been earlier studies that provide sufficient information to answer the questions the proposed work is trying to answer? If there is an established defendable need, careful consideration regarding the concerns of the various stakeholders should take place prior to further planning. These stakeholders may include but are not limited to the research team, science community, cultural descendants of the remains, museums, local communities and government, as well as any public concerns. Development of a study strategy must respect and consider existing rules and laws regarding the study of cultural remains. Pre-research planning must assure that appropriate authorizations and permissions can be obtained and, if they can, that they are in fact obtained for the projected study. These authorizations must conform to local, regional, national, and international rules and laws. Documentation of such authorizations/permissions should be available during the active-research stage and should also be provided to any funding support organizations. In the planning stage, research methods and team members must be appropriate for the proposed research. The researchers must possess relevant expertise to address the objectives of the study. In the case of imaging personnel and medical experts who may assist in data interpretation, experience in the study of mummified human remains is critical. It is important that, during the planning stage, researchers know and can document the circumstances surrounding the material, as well as the site of the discovery. There can be situations where research on material of uncertain provenance implies participating in illegal or unethical activities. It is possible that the remains are or have been part of an illegal economy (cf. the AIA code of ethics—see above). Further, the remains may have been acquired in a manner that involved encroachment on the rights of individuals or groups. It is the responsibility of the researchers to assure that there is a known and proper provenance of the remains considered for the proposed study. Finally, the pre-research stage should also assure

that there is adequate coordination with other ongoing or planned projects. Collaboration can only add to the knowledge attained and allow a refinement of research objectives and the potential of dovetailing with other projects. Such collaboration can reduce the duplication of efforts. If the pre-research ethical considerations have been satisfactorily addressed, active-research considerations come into play.

Active-Research Environment

The active-research environment dictates the need for additional ethical practices to be considered and applied during the actual application of various modalities. There are some general ethical guidelines drawn from a variety of sources that apply to the study strategy and active-research approach. These sources include but are not limited to anthropological, medical, forensic, and other professional ethical concepts or codes. Researchers must approach each study with the concept of "do no harm" in the forefront of considerations of their activities. Universal guidelines in the active-research stage include a genuine respect for the deceased as well as for the descendants of the deceased. This respect transcends political and governmental boundaries. Many cultures have different traditions, requirements, or attitudes toward human remains. It is important to respect the cultural context or contexts associated with the study at hand. Researchers must realize the precious nature of the human remains that they are working with and respect not only the cultural aspects of the material, but also its rarity. This is of course an argument for non-destructive research approaches whenever possible in line with the "do no harm" concept. It is important to maintain respect for other groups that may be associated with the remains and whom the remains may represent. Among these may be ethnic, religious, or national groups. Studies on remains that represent a group requires the researchers to gain insight into the history of that group and enter into a dialogue with current members. In keeping with the potential sensitivities or historical factors, researchers may need to modify their approach and even be willing to abort the project. During the active-research stage it is critical to respect the ethical concerns of other disciplines. For example, museum scientists may have reason to withdraw from a project because of public pressures regarding the study of human remains. Any and all concerns and research decisions should be a cooperative venture. With respect to other researchers, the team must take an inclusive stance realizing that the research, the rarity of the remains, and the knowledge attained belong to everyone. When feasible, other researchers with legitimate objectives should be allowed access. It is important to note that this practice may run counter to institutional goals as well as funding rules and regulations.

Specific to developing an imaging study, decision-making processes regarding which modalities are to be employed need to be guided within an ethical framework. In other words, just because we can do something such as advanced imaging (CT, MR), should we? A logical discussion regarding the added value of such imaging strategy should include all involved.

Objectives for Developing Imaging Study Strategy

What is right and wrong in an imaging study design then may be framed in a series of questions to be asked at the onset of any research project. These questions help to establish the research hypotheses and ultimately the specific objectives for a study. Examples of what researchers may ask themselves when approaching the study design involving human remains include (but are not limited to) the following: 1) Considering the available imaging modalities associated with a study. What information can reasonably be expected to be derived? 2) Will the information/data collected have the potential to develop knowledge? 3) Is there a way to involve the local community in the imaging efforts? 4) If the data collected suggests that advanced imaging studies such as CT and/or MR scanning or sample collection via biopsy would provide additional information, what would be the value of that information regarding the understanding of past cultures? 5) Should all of the remains be subjected to advanced imaging or are more portable and basic imaging methods adequate to answer the questions? 6) How is a pre-determined system of triage to be applied as it relates to advanced imaging decisions? 7) If advanced imaging or procedures are suggested, will the remains need to be transported? 8) What then is the risk/benefit consideration of the potential new information? 9) Are there methods that can be applied that have lower risks? 10) How will the information or knowledge derived be disseminated to the scientific community as well as other communities of interest?

Finally, the imaging professional must consider how the results of the study are disseminated to interested audiences. As discussed above, knowledge mobilization is a key responsibility of the ethical researcher. However, the push to make data publicly available is not without concern, particularly with regard to intellectual property (Watanabe 2018), and especially in the case of images or 3D models of human remains (Ulguim 2018). This is an active area of scholarship that is working hard to keep up with the rapidly evolving gaming and clinical digital

imaging industries. The display of human remains, and/or images thereof, in museum contexts, is another area where there is active and thoughtful debate taking place in the discipline. See Day (2014) and Swain et al. (2013).

Summary

Developing an imaging study strategy can be quite complex. There is a tendency for imaging personnel to focus on the technical aspects of selecting and mobilizing imaging technology. It has been the intent of this initial section to demonstrate that ethical aspects of the study of human remains require much detailed attention. Working alongside professionals from varied disciplines requires that the imager be aware of the various "world views" with respect to the ethical study of human remains. The interested reader is encouraged to delve into the considerable literature on this topic, beginning with the references presented at the end of this section.

Perhaps the most important ethical consideration for imaging personnel is that of preparation. Conducting imaging research in non-traditional settings requires that the imaging professional be competent and adaptable. Non-traditional settings, such as working with objects of antiquity and cultural human remains, dictate the need for critical thinking, adaptability, and flexibility. These characteristics not only relate to the imaging challenges but also to the multi-professional work environment. The imager is a valuable team member and must be prepared to contribute to the overall goals and objectives of the research project. This requires forethought, self-education, and planning for a given upcoming project. The imager must know details about the historical or cultural context if they are to make useful contributions.

As a team member, the imager must be prepared physically for the tasks at hand. Many research projects take place in remote or even hostile environments. Proper preparation for work in varied environments helps keep the team on task and can influence the progression of research activities. The imager must be prepared to adapt the technology to fit the task. This is discussed in greater detail in other parts of this text as well as in the "Case Studies" companion book.

Ethical preparation is crucial to the outcomes of a given research project. The preliminary planning stages are as important as the on-site active research itself.

Rigorous attention to the ethical aspects discussed in this section will greatly enhance the potential of conducting research that will have meaning and contribute to our further understanding of past peoples.

Finally, the imaging professional must be aware that while we seek to identify universals in ethical practice, varying national and cultural contexts make this quest very difficult (Larsen and Walker 2005). For instance, work on human remains that might be ethically and morally responsible in Peru, the UK, or continental Europe may not be so considered in North America, Australia, New Zealand, or Israel (Larsen and Walker 2005). Thus, the key tenets of "do no harm," be respectful, consult broadly, and mobilize the resulting knowledge guide our actions from the conception of a project to its completion.

References

Bahn, P.G. 1984. Do not disturb? Archaeology and the rights of the dead. *Oxford Journal of Archaeology* 3(1): 127–139.

Beauchamp, T.L. and Childress, J.F. 2001. *Principles of Biomedical Ethics*, 5th edition. Oxford University Press: Oxford.

Day, J. 2014. "Thinking makes it so": Reflections on the ethics of displaying Egyptian mummies. *Papers on Anthropology* XXIII(1): 29–44.

Larsen, C.S. and Walker, P.L. 2005. The ethics of bioarchaeology. In T.R. Turner (ed.), *Biological Anthropology and Ethics: From Repatriation to Genetic Identity*, 111–119. State University of New York: Albany, NY.

Lonfat, B.M.M., Kaufman, I.M., and Rühli, F. 2015. A code of ethics for evidence-based research with ancient human remains. *The Anatomical Record* 298: 1175–1181.

Moissidou, D., Day, J., Shin, D.H., and Bianucci, R. Invasive versus non-invasive methods applied to mummy research: will this controversy ever be solved? *BioMed Research International*, 2015, Article ID 192829.

Swain, H., Jackson, J., Morris, J, Redknap, M., Walker, E., Davies, M., and Wones, E. 2013. *Guidance for the Care of Human Remains in Museums*. Department for Culture, Media and Sport: UK. https://pdfcrowd.com/url_to_pdf/?footer_text=%u&use_print_media=1

Ulguim, P. 2018. Models and metadata: The ethics of sharing bioarchaeological 3D models online. *Archaeologies: Journal of the World Archaeological Congress* 14(2): 189–228.

Watanabe, M.E. 2018. Digitizing specimens—Legal issues abound. *Bioscience* 68(9): 728.

Wood, G. and Rimmer, M. 2003. Codes of ethics: What are they really and what should they be? *International Journal of Value-Based Management* 16: 181–195.

Section 2
Determining Imaging Needs

<div style="text-align: right;">9</div>

GERALD J. CONLOGUE, RONALD G. BECKETT,
AND MARK VINER

Contents

Being prepared to obtain the most useful imaging data for a given study requires careful consideration of a variety of factors. Further, such planning requires an honest assessment of the limitations of the various imaging modalities. In order to determine the specific imaging needs of a study, a series of questions must first be addressed. The imaging professional must consider factors such as material characteristics, size, availability of imaging past data, and positioning limitations, to name a few.

Has the Object(s) Been Radiographed in the Past?

It is important to know if the objects of a study have had previous imaging studies conducted. Most important is to know what modalities were used and what the characteristics of those modalities were in terms of resolution, positioning, and limitations. Among the modalities we include here are plane radiography (film or digital), multi-detector computed tomography (MDCT), and endoscopy.

There are several reasons why past radiographic studies are important and an attempt should be made to locate the images. First, the radiographs can provide a tremendous amount of information and help determine the best future approach. For example, a plane film examination of an object can aid in the determination of whether an MDCT scan will provide additional information. Second, imaging technology, driven by hardware and software, has continued to develop rapidly. Film, the preliminary recording media for nearly a century, has been replaced in the clinical setting by digital media. The latter has inherent wider latitude and can demonstrate a greater range of densities on an image than its predecessor. In addition, the contrast and density on a digital image can be adjusted following acquisition, which is not possible with a radiograph recorded on film. Therefore, if the previous study was acquired using film, the study should be repeated using a digital format.

Another example would be a computed tomography (CT) study carried out in the 1990s using an old slice-by-slice acquisition unit. Generally, those systems produced excellent axial section images. The coronal and sagittal sections created by the software, however, were less optimal and usually produced unsatisfactory 3D images. Because today's MDCT systems acquire data as a volume, the software can provide not only excellent

sections in any plane, but equally excellent 3D reconstructions. Finally, studies conducted years apart can be used to track the state of conservation of objects, such as mummies, where internal components may shift over time.

Endoscopy may have been conducted in previous work. It is imperative that duplication of efforts is avoided given the invasive nature of endoscopic study. With that said, newer endoscopic technologies have been developed that may justify reapplication of this method. Two major factors should be considered when making a decision to reimage an object using endoscopy: 1) Will an up-to-date endoscopic system provide higher resolution images enhancing the ability to interpret data? Will newer technology applications such as 3D endoscopy provide useful data? 2) Will the endoscopic method help determine changes in the spatial relationships of structures within objects or help document evidence of degradation that may inform conservation efforts?

What Is the Composition of the Object(s)?

When determining imaging needs, imaging professionals need to consider the various characteristics of objects that can be imaged in non-traditional settings. Clinical imaging is typically focused on living subjects where target densities are somewhat predictable. The density of the object in the non-traditional setting must be considered in order to determine the imaging approach required. The non-traditional setting may challenge the researcher to obtain radiographic data from low-density objects, such as bone, ceramics, clay, or thin-metal or high-density objects such as stone, thick metal, or densely packed dirt as seen in concretions.

The composition of an item determines the density required for the X-ray to penetrate the object. The technical factor that determines the penetrating ability of the beam is the peak kilovoltage or kVp. As the density of the material under examination increases, the kVp required to produce an acceptable image increases. Most clinical and mobile X-ray units generate a maximum of 90–100 kVp. Therefore, dense material, such as thick compact dirt or concretions, will require equipment intended for industrial applications that have 110–250 kVp ranges. Clinical MDCT scanners can typically generate X-ray beams that range between 80 and 140 kVp.

The density of the object may or may not influence the application of endoscopy. Clearly, if the object is of high density and solid with no air-filled areas, endoscopy could not be employed. Body cavities and the interior of ceramics and other artifacts often provide accessible pathways for endoscopic insertion.

Table 9.2.1 Typical Sizes of Standard Imaging Receptors

A	< 8×10 in (18×24 cm)
B	> 8×10-in (18×24 cm) BUT < 10×12 in (24×30 cm)
C	> 10×12 in (24×30 cm) BUT < 14×17 in (35×43 cm)
D	> 14×17 in (35×43 cm)

What Is the Size of the Object(s)?

The size of the object determines the size of the X-ray film/digital receptor used to acquire the images. The typical sizes of receptors that are clinically available are shown in Table 9.2.1. Objects larger than 14×17 in (35×43 cm) will need to be radiographed using a tiling strategy (see Case Study 1: Large Objects). A PVC pipe frame or similar imaging plate support system would need to be constructed to cover an area larger than the object.

For MDCT scanners, the limiting factor is the diameter of the circular-shaped opening in the gantry that the object must pass through for the imaging study. This diameter is generally about 28 in (71 cm).

What Is the Required Orientation of the Object(s)?

When determining the imaging needs of a particular study, it is important to know if the object(s) can be laid on a horizontal surface and rotated to achieve orthogonal projections, or if it is limited to being radiographed in a vertical position. Since radiographs are a 2D image of a 3D object, at least two projections at 90° to each other, or orthogonal, are necessary to provide the spatial orientation of internal structures. For objects that cannot be laid flat on a horizontal surface and then rotated to acquire the necessary orthogonal projection, the X-ray system must be set up for a horizontal beam. If a group of objects requiring both vertical and horizontal beams is to be examined, the objects should be divided into two groups completing one orientation before reconfiguring the X-ray tube support system. Switching the X-ray tube orientation can require several minutes to achieve, and minimizing the number of times the operation is performed saves a considerable amount of time. The other approach is to use two X-ray sources, each set up for a particular orientation.

What Are the Study Objectives?

The research goals and objectives must be clearly understood as they will dictate the instrumentation and imaging needs of a given study with regards to the resolution

requirements. Resolution can be broadly divided into two categories, standard resolution and high resolution. The resolution requirements will determine the type of film/digital receptor used. High-resolution radiography requires a mammography or industrial receptor system, while standard-resolution work can utilize typical clinical receptors. MDCT resolution is determined by a combination of slice thickness and display-field-of-view, DFOV (see Chapter 7: Computed Tomography, this volume). High-resolution CT scanning will require the use of cone-beam clinical or micro-CT scanners.

Are There Mobility Limitations?

An important question to be answered is that of the overall condition of the object(s) to be studied. It is important to note if the object(s) is stable enough to be transported or if it is too fragile to be moved. This determination usually requires initial on-site imaging in order to determine the stability of internal features not seen on external observations. Transporting an object that is externally stable but internally fragile may change the spatial orientation during transport, resulting in the potential for misinterpretation of the imaging data collected. The stability of an object must be considered as a factor in triage decisions regarding the use of advanced imaging found at hospitals or imaging facilities.

Objects that are not fragile and in stable condition can be transported to an imaging facility with the modality/modalities necessary to achieve the study objectives. For fragile or unstable objects, minimal manipulation requires a mobile imaging approach with the equipment being brought to the location where the objects are stored. If objects cannot be moved, an attempt to attain maximal information complementary methodologies, such as endoscopy, can be employed on site. It is a good practice to image the object(s) to determine stability characteristics prior to transporting it and to repeat the imaging upon return of the object to determine what, if any, impact the transportation process had on the object.

How Many Objects Are Included in the Project?

A combination of the required resolution, mobility, and the number of objects is important in determining the most appropriate modality and the time required to complete the study. However, groups of 10 or more objects, even if in stable condition, may require an initial phase with the equipment transported to the object storage location. During this first phase, plane digital radiography would be used to triage the objects in order to prioritize the material most suitable to be transported to an imaging facility with necessary advanced modality, such as MDCT.

With a larger number of objects, for example 14 adult human mummies, not only should the stability of the object be considered in the triage decision, but a research team decision regarding what additional information could be attained and which of the 14 mummies would have best possibility of yielding that information must be discussed. The questions then become 1) Is it stable? 2) Will there be safety in transport? 3) Is there an available facility? 4) If stable, what are the objectives for advanced imaging? 5) What are the risk/benefit considerations? 6) What is the economic feasibility of a large number of advanced imaging studies? These questions need to be addressed within the context of the study location. The answers will vary greatly if the study is in a modern metropolitan setting versus a remote rural research environment.

What Are the Characteristics of the Location of the Study?

The location of the study dictates the imaging needs and aids the researcher in proper preparation decisions to ensure that the objectives of the study can be achieved. Research locations can vary dramatically and range from an urban setting, such as the Mütter Museum in Philadelphia, Pennsylvania, to a very isolated location, such as the fringe highlands of Papua New Guinea. There is a continuum of possibilities with regards to location, which may include suburban settings, such as a private collector's home in suburban Virginia, and a rural setting as found in El Algarrobal, Peru.

The more isolated the location, the more important it is that everything that will be needed for the study has been included in the material transported to the location. In suburban or urban sites, items, such as extension cords, power strips, and foam needed as a positioning aid, can be acquired at stores or outlets near the work location.

What Utilities Are Required by the Imaging System and What is Available?

Knowing the power requirements of the instrumentation is obviously an important factor influencing an assessment of imaging needs. The available electrical power supply at the location should be determined prior

to embarking on a research expedition. In addition, and dependent on the location and study needs, the water supply should be assessed.

Since 110–120 volts is the standard voltage in the United States and other countries, such as Canada and Mexico, the only consideration is a location that has sufficient outlets for all the electrical requirements. For locations in countries where the standard voltage is 220–240 volts (e.g. Europe, much of South America, Australasia, and parts of Africa and Asia) parts a step-down transformer may be required for equipment that does not have an internal switch. In remote locations lacking electricity, a generator will be required to provide the electricity to operate the X-ray source and other equipment, such as a digital image recording system. The equipment manufacturer of all the items transported should be consulted regarding the electrical needs, but 3000–5000 watts ought to be sufficient. It should be noted that some modern generator systems incorporate a surge protection device, which may not be compatible with some X-ray systems that draw a high current for sub-second exposures. For this reason, a compatibility check is recommended.

For some instrumentation, battery operation may be possible. This is the case for smaller imaging instrumentation such as endoscopic and XRF equipment and for some X-ray generators. Of course, ample battery back-up supplies need to be considered along with the accessibility to an electrical supply that can charge rechargeable units. In very remote settings, a portable solar panel array may serve this function.

An assessment of available water should be conducted. Water availability, like electricity, varies from setting to setting. There may be an abundant supply, as found in urban settings such as the Barnum Museum, Bridgeport, Connecticut; a limited supply in remote locations such as Leymebamba, Peru, or complete unavailability as at the Step Pyramid, Saqqara, Egypt.

The only occasion when water enters into consideration is when manual development is included in the imaging plan. In order to completely wash a 14×17-in (35×43-cm) film, 5 gal (19 l) of water are required. When fewer, smaller-size objects that would fit on 10×12 in (24×30 cm) or smaller film are involved, the radiographs could be processed in photographic film trays. The water supply in a rest room would be sufficient to wash the films and generally the room could be made light-tight by duct taping black plastic over the closed door (see Chapter 4: Plane Radiography, Digital Radiography, Mammography, Tomosyntheses, and Fluoroscopy). A radiographic safe light can be plugged into an available outlet in the rest room to provide light for the developing process. With a limited water supply

in a remote area, more elaborate preplanning must be undertaken. A complete discussion can be found in Chapter 4: Plane Radiography, Digital Radiography, Mammography, Tomosyntheses, and Fluoroscopy.

What Are the Characteristics of the Proposed Work Area? Radiation Safety Plan

If radiographs are acquired outside of a clinical imaging facility, a radiation safety risk assessment must be undertaken and a radiation protection plan must be included in the developmental phases of the project. This will require an estimation of the likely number of exposures for each day of the project together with the likely exposure factors and knowledge of the location, likely construction materials of walls, floors, and ceilings, and knowledge of adjacent spaces and their likely hours of occupation by team members or the public. A floor plan of the proposed work area must be used to determine the placement of radiographic equipment for the study, together with any necessary protective equipment or the size and location of any "exclusion zones" into which personnel must not enter while the X-ray examinations are taking place. Information provided must also include factors such as occupancy and movement patterns through the proposed area and adjacent spaces.

What Are the Availability and Access Limitations to the Objects?

In order to predict the amount of time required to complete the project, the availability of the designated workspace should be known during the planning phase. During planning it must be determined if the object(s) will be available only during working hours, after working hours, weekdays, weekends, or, in contrast, if there will be unlimited availability. In addition, if special identification for individuals is required for access to the work-space, the process must be clearly defined, and documents obtained prior to beginning the study. In some cases, additional personnel, such as security, may be a factor in both availability and access concerns.

What Funding May Be Available for the Project?

Once the above queries have been addressed, specific levels of funding available for each aspect of the study can be considered. Funding may come from a variety of

sources, and the imaging needs as well as the location of the study will dictate the amount of funding required. With little or no funding designated for a project, it would be necessary to find a volunteer radiographer and/or a student radiographer to operate donated equipment. Partial funding may provide for certain aspects of a project but not all of its fiscal needs. In contrast, external granting organizations, such as The National Geographic Society, may approve research applications that will cover the entire costs of a project.

What Is the Availability of Radiographic and Related Technologies for a Study?

It is important to assess available imaging resources as one determines the imaging needs of a study. There are a variety of possibilities to gain access to the imaging technology required if the researchers do not have access to the instrumentation. Contacting a local radiography or diagnostic imaging program may provide both equipment and personnel for a project. Many private freestanding imaging centers may be willing to help with the caveat that they derive some public-relations benefit for their generosity. Also, a university or museum may have imaging facilities that may be used. Rental of equipment is a possibility as is the loan of equipment from manufacturers.

Imaging Needs Determination Applied, an Example

Considering the imaging needs questions discussed, here is a brief example of an imaging challenge and the probable solution:

> *The Challenge:* Under 10 (quantity), low- to medium-density objects (kVp), all under 10 in (25 cm) (size) long at the Barnum Museum, Bridgeport, Connecticut (location). The objects are stable and can be manipulated into various positions. The building is supplied with 110 volt electricity and has access to running water in the rest rooms, but there is no funding.
>
> *The Solution:* Use 10 × 12-in (24 × 30-cm) film in a non-screen film holder to be developed in photographic trays in the rest room. The developer and fixer can be transported to the museum. The portable X-ray source that weighs less than 20 pounds (9 kg) will be supported by a tubing system that will provide a 40-in (100-cm) SID to the floor.

Determining Costs

As indicated above, there are two basic approaches to access radiographic equipment: purchase and rental/leasing. The purchase option may appear to be straightforward; however, in the twenty-first century it is a bit more complex than simply buying a particular X-ray unit. For plane radiograph, both an X-ray source and image recording system are necessary. The former is probably the least complex. There are both new and reconditioned X-ray tubes available. The newer units are all equipped with high-frequency generators to convert the existing electrical supply, 110–120 volts in the United States and 220–240 volts in most of the rest of the world, to the kilovolt range required for X-ray production. Over the past 20 years, these tubes have become smaller and are now down to about 19.4 lbs (8.8 kg). However, the newest development is a battery-operated X-ray source, XTEND® 150 (Kubtec Scientific) weighing only 12 lbs. (5.5 kg). Regardless of whether the X-ray source is old or new, it is important to also include the service agreement, which is approximately 10 % of the purchase price.

The image recording system may require a more complicated decision-making process. For certain, the choice should be a digital system, but then the selection is between a direct digital radiography, DR, or computed radiography, CR, system. A more complete description of the systems is presented in Chapter 4: Plane Radiography, Digital Radiography, Mammography, Tomosyntheses, and Fluoroscopy. Only 10 years ago, the former cost twice as much as the latter. During that period, due to a number of circumstances, the DR costs have dropped significantly; however, cost shouldn't be the only deciding factor. For example, if the DR plate is damaged, everything comes to a halt until and other plate is purchased. With the CR approach, the system usually includes two plates and the plates are not as susceptible to damage as in the DR system. However, the principal disadvantage with the CR system is the size of the reader. Regardless of which system is selected, once again the service contract, about 10 % of the purchase price, is a necessary requirement.

Due to the rate of technical advances, both software and hardware, more advanced systems, including higher resolution and image manipulation, will certainly be available shortly after purchasing the equipment. An alternative is to rent/lease the equipment. Generally, rentals are for a shorter period than the leasing option. Beside avoiding the large initial cost of purchase and added service contract fee, the expense incurred is only for the time the equipment is being used. In addition, usually the most technically advanced equipment, for example the demonstration units, will be available. In

both Case Study: Skeletal Remains and Case Study: Mummified Remains are examples of the cost of renting equipment.

Additional Considerations

Although not under the heading of "Determining Needs," a plan must be developed during this stage of the project in order to maximize the information retrieved from the imaging study. The two major considerations during this phase are as follows: 1) How is the data going to be stored? Data management and storage will be discussed in Section 4 of this chapter, and 2) Who will be included in the interpretation of the data? Interpretation strategies will be discussed in Section 5 of this chapter.

Section 3
Workflow (Throughput)—Systems Design for Field Research

9

GERALD J. CONLOGUE, RONALD G. BECKETT,
AND MARK VINER

Contents

Workflow or throughput only becomes a factor if there are a large number of objects that must be examined in a short period of time. However, if time is not a consideration, then the study can proceed at a pace determined by all the participants. For those studies that must be completed in the shortest period, there are a number of key elements that must be addressed:

1. Assemble an appropriately skilled team to acquire the images.
2. Prepare and queue up the objects.
3. Agree to a plan of the radiographic projections to be acquired on each object.
4. Develop a logical sequence to acquire the images, minimizing unnecessary movement and duplication of effort, and automating settings where possible.
5. Audit and evaluate the methodology and make changes where appropriate.

The team that is responsible for acquiring the images should consist of at least one radiographer who has experience in non-clinical radiography. This individual should be involved in the developmental stages of the project, but more appropriately on site during the study. Since these individuals are most knowledgeable about the operation of the equipment, they should be able to troubleshoot problems that may develop. Reducing down time is an important component of increasing workflow. In addition to the radiographer, one, or preferably two other individuals should be included in the image acquisition team. Optimally, they should also be radiographers or student radiographers and have at least basic knowledge of radiographic principles.

One person should take responsibility for maintaining a complete radiographic record (examples provided in the appendices). This should include photographic documentation of each object as it is radiographed. At the time this aspect may not seem to be as important as the actual image acquisition. However, once the study has been completed and the analysis begins, reviewing the procedure is important for an accurate description of the *Materials and Methods* section of a publication. With a less than precise description, it might not be possible for someone else to replicate the results. In addition, if less than satisfactory results were obtained, for example due to poor positioning of the object, a review of the photographs may assist in correcting the problem. The other person will assist the radiographer in positioning the object, helping to move objects in and out of the radiographic study area, and provide an additional *set of eyes* in order to minimize possible accidents, such as ensuring that no one is in the radiographic exposure area.

Adequate preparation and queuing of the objects is essential for ensuring a smooth, efficient workflow. The exchange of objects with as little delay as possible will guarantee the study will be completed in the least amount of time. In order to achieve this goal, the objects should be selected long in advance of the study date. It is certainly possible, at the last minute, to include another object, but there should not be an instance where the image acquisition team is just sitting around. Objects should be prepared for imaging according to the agreed protocol. This may mean removing objects from boxes or protective wrappings or separating elements and laying them out in a particular order or pattern. In some cases, elements can be laid out prior to X-ray on radiolucent trays or thin polyethylene foam, but in other cases the positioning of elements will need to be undertaken by the radiographer immediately prior to the radiograph.

A precise series of the radiographs required should be established at the outset. Progressing logically through the sequence of images for each object will speed up the examination time. Further, knowing the series and sequence of images to be acquired allows for the development of an ergonomic method of moving

the items from one position to the next. If the X-ray machine has a programmable control console, the average exposure for each radiograph in the sequence can be pre-programmed to minimize examination time.

In the early stages of the process, there may be a temptation to try and undertake image analysis during the radiography examination. This can cause major delays if an inordinate amount of time is spent in examining the radiograph. With the exception of a totally unanticipated finding, if the objectives have clearly stated the type of information sought, a quick review of the radiograph should be sufficient to move onto the next image. At the end of the day, all the radiographs should be reviewed and at that time it can be determined whether additional projections are required. Waiting until the end of the day for an overall review of the images also provides an opportunity to consider the possibility of an unexpected finding reoccurring in a number of objects and repeating an additional projection in a group of objects.

At the commencement of imaging, throughput will often be slower than anticipated or hoped for. However, time spent upon developing the imaging methodology during these first cases will reap benefits later in the process. The radiography team should be constantly evaluating and re-evaluating the method, making minor changes here and there to improve the time taken for each examination. Where hundreds of objects are to be examined, saving a minute of examination time on each one can deliver significant time savings.

Considerations When Multiple Imaging Methods Are Employed

Imaging projects often involve more than a single modality. In addition to radiography, on-site imaging may include endoscopy, XRF analysis, as well as archaeology and anthropological researchers. In order to maximize the efficiency of the data collection phase, a systems approach to bioarchaeology studies may be employed.

Systems theory, as applied to mummy studies, focuses on the arrangement of and relations between the varied parts of the project that connect them into a whole. With this construct as a backdrop, each part interacts with the others in a manner designed by spatial relationships and assigned tasks to maximize the efficiency and efficacy of the project, which is encumbered by time constraints. Applied system theory is best applied to the large sample size projects and can enhance the interpretation of the data collected. Although planning is important in the systems approach, it is also intended to be fluid.

The systems approach is dynamic in that the system, though structured, allows for frequent recalibration of the relationships among its parts. This approach then is organic in nature and is feedback-driven in real time. The system allows for communication fluidity with all parts focused on common research goals. There is a focus on cross-discipline respect for the knowledge, inputs, and tasks of the various players. The systems approach is in contrast to a standard multi-disciplinary approach where compartmentalization dictates that each player does their part independently of the whole and reports to a central entity. A schematic depiction of this contrast is shown in Figure 9.3.1.

For the systems approach to be most functional, it is important that the researchers be informed regarding the characteristics of the research space that will be afforded them. Room dimensions and access points can help researchers plan for efficient workflow to maximize throughput. This planning should include a plan for subject staging and space for subject triage should the data dictate additional images or greater scrutiny. It is advisable to get photographs of the space, which can be assessed in the planning stages to determine how to adapt instrumentation to the constraints of the physical layout.

The systems approach begins with a clear understanding of the research stations required. Knowing how much space each station needs and an approximation of how much time will be required at each individual station is key. Some of the stations may be fixed, while others may be fluid. Still others may be both fixed, and, when necessary, fluid. An example of the needs of representative stations may be as follows:

Station 1 (for the purposes of this example) is a paleoimaging station for computed or digital radiography. The space required would be determined by both the technology and the size of the objects under investigation. Station 1 would be the entry point to the workflow as the data derived will inform the potential targets for subsequent stations. Station 1 would typically be a fixed station with the staging area feeding into it.

Station 2 would be an endoscopy station. A preliminary reading of the data collected at station 1 would help the endoscopist focus on targets of interest within the object. The endoscopy station would also conduct its standard survey analysis of internal structures. Station 2 would be a fixed area with enough space to accommodate the object of study. Ideally, the

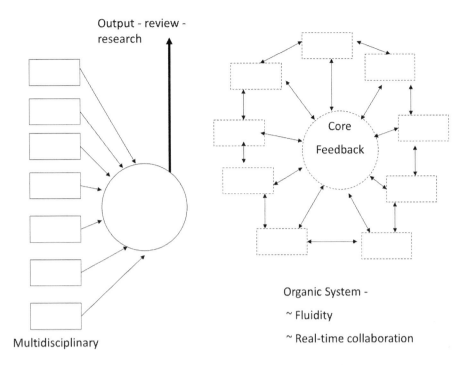

Figure 9.3.1 Schematic depiction of the standard multi-disciplinary as compared to the organic systems approach.

object(s) would be transported to station 2 on some sort of rolling table. While station 2 is in a fixed location, endoscopy instrumentation is portable and allows for fluid movement among stations, enhancing the efficiency and efficacy of the project.

Station 3 would be an archaeo/osteometric station. This is a fixed location with enough space to allow not only for the researcher to examine the object(s) under study, but to also for the placement of the varied instruments to be arranged for easy access.

Station 4 would be the documentarian station. As described earlier in this section, the importance of photographic documentation is critical to the project. Photography and videography are generally fluid tasks with the individual moving among the various stations. The individual can be called to any station at any time. With that said, it is important that the documentarian has sufficient space for equipment handling, battery recharging, and data entry as well as other record-keeping tasks.

Additional stations would be added as the modalities indicate (e.g. XRF would be a fluid station). Figure 9.3.2 presents an example of stations in a given physical location.

One of the key characteristics of the organic systems approach is that it is intended to encourage interaction

and feedback. In concept, it is much like human homeostatic mechanisms with feedback loops allowing the team to maximize resources and enhance on-site analysis and recalibration of efforts. Figure 9.3.3 demonstrates the interactive possibilities and fluid nature of the organic systems model.

There are several key considerations regarding the organic systems model. The radiography station must adhere to the radiation protection guidelines presented in Section 8 of this chapter. Specifically, the radiography station must have an exclusion zone of 3 meters in all directions from the tube. It is imperative that a following form with check boxes travel with each object from station to station. In this way, mixing up objects can be avoided and it is possible to ensure that all stations have been visited.

The organic systems approach is grounded in the domain of cybernetics where systems are used in the emerging "sciences of complexity," also called "complex adaptive systems," studying self-organization and heterogeneous networks of interacting actors.

While the concept is not new to fields such as anthropology, the approach as applied in non-traditional imaging is not so much focused on larger interactive systems, but rather on the attainment of valued data with real-time interpretations leading to informed decisions.

The significance of the systems approach is that it encourages in-depth preliminary analysis of the data with "many eyes" reviewing the information from

Physical schematic

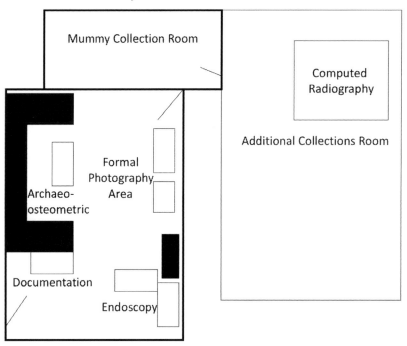

Figure 9.3.2 Station positioning.

Organic system schematic

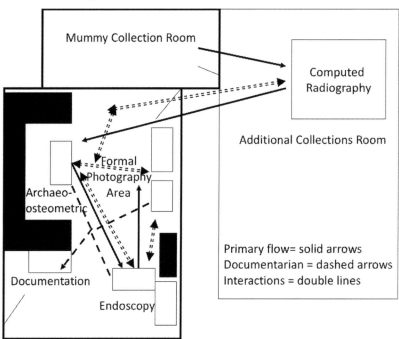

Figure 9.3.3 Interactive fluid nature of the organic systems model.

varied perspectives in real time. Further, the data can be helpful in selecting those objects for triage needing additional or advanced study. The systems approach offers great potential for enhancing the efficacy and efficiency of large population studies in the field or within museum collections. Finally, the systems approach allows for fluid on-site interaction maximizing the value and expertise from varied disciplines and encouraging diagnosis and decision making by consensus.

Section 4
Radiographic Data Formats, Graphic Software, and Online Data Repositories

9

ANDREW J. NELSON

Contents

Introduction

The objective of this section is to provide a brief overview of the most common file formats in use in paleoimaging research, particularly radiography, and some of the most common software packages that are used to manipulate those files. A fulsome treatment of these subjects would be the subject of an entire volume of its own, so this section is only a brief overview of this field. The interested reader will find much more detail in resources such as Brown and Shepherd (1995) and Russ and Neal (2016). This section will be organized as follows: basic 2D image formats and 3D image formats, software, and finally online data repositories.

Common 2D Image Formats

There is a wide array of 2D image formats used in photography, microscopy, and radiology, to name only three broad areas. These formats can be divided into *lossless* and *lossy* formats, that is, images that retain all the original information captured at the time of creation versus those that have undergone some sort of compression to reduce file size. This compression increases the number of images that can be stored on a hard drive or transmitted over the internet, but it also leads (depending on the specific compression algorithm) to degradation of the image through loss of contrast, reduction in resolution, and other factors (Russ and Neal 2016). Images stored in lossy formats (JPEG, GIF, etc.) are good for visualization, publication, and printing, but they are not the preferred format for measurement and other analyses (Wiggins et al. 2001). This review will be restricted to the formats most commonly used in the radiographic realm.

RAW—RAW files are files that contain the original data from a digital image sensor, commonly a digital camera, that has not been subject to any compression or other modification process. 2D RAW files have a header that contains encoded information about the sensor and its state when the image was acquired (Verhoven 2010). In the case of a digital camera, that would include date, time, camera model, shutter speed, and so on. Image-related information includes the dimensions of the image, number of bits/pixel, colour scheme, and colour values per pixel (Salmon 2011). The bit depth or color range of a RAW file will depend on the sensor that captured the image. Unfortunately, there is no industry standard for RAW file format, so conversion software must constantly be updated (Verhoven 2010). RAW files are generally processed into raster/bitmap format for visualization and manipulation.

TIFF—TIF (Tagged Image File Format) files either are not compressed or use a lossless compression algorithm (Wiggins et al. 2001) that looks for repeating patterns or sequences in the image (Tan 2006). Each TIFF file has a header that includes image metadata, followed by the pixel information that makes up the image. The amount of compression, if applied, is not

as much as in lossy formats and the addition of the header and 16-bit data mean that TIFF files are quite big relative to other formats (e.g. JPEG). Most photography cameras digital sensors capture 24-bit images, so saving files in TIFF format represents a loss of bit depth as well as the loss of the RAW information tags (Verhoven 2010), so the RAW format is preferred over TIFF by photographers, while the more standardized TIFF format would appear to be the preferred format in the radiographic world.

JPEG—JPG (Joint Photographic Experts Group) is a lossy image format that can allow the user to apply a range of compression to an image, ranging from 10:1 (high quality) to 20:1 (low quality) (Russ and Neal 2016). Lossy compression algorithms are predicated on the fact that most sensors can capture more information than can be detected by the human eye. Compression algorithms utilize strategies to reduce the size of the image without apparently affecting its quality (Graham et al. 2005, Tan 2006). However, if the image is to be analyzed by software that can take advantage of the full range of gray scale, resolution, or other image details, then lossy compression will compromise the utility of the image.

Professional photographers make use of the International Press Telecommunications Council (IPTC) protocol to encode and manage metadata for their photos. This metadata includes administrative information such as date and time, owner, and contact information; content information such as title, captions, and keywords; and rights information such as copyright. Google uses this metadata to find images that match users' search terms. See https://iptc.org/standards/photo-metadata/photo-metadata/ for detailed information. Software, such as Adobe Photoshop Lightroom and ACDSee Pro, allows the user to manage the metadata and to use it to catalogue their images. In the biological sciences, the Open Microscopy Environment (OME) plays a similar role in an environment with myriad different file types (Eliceiri et al. 2012). Paleoimagers are encouraged to add metadata to their images to ensure the ongoing integrity and utility of these important data sets. Standardized ontologies for metadata do not currently exist, but they could facilitate data mining in the increasingly open-data environment in which we work (Staab and Studer 2009, Brink et al. 2017, Davies et al. 2017).

3D Image Formats

There are many different kinds of 3D images, ranging from surface models, which generally consist of a mesh, to volume files such as those produced by a micro-CT scanner. There is a wide array of formats for surface models, including STL, PLY, and OBJ to name only three. STL (Stereolithography Language) is the most widely used, but others such as PLY and OBJ have larger numbers of vertices and they can include information on texture (Davies et al. 2017). 3D volumes created within the medical or research context are stored either as single volume files, in some variant of RAW data format, or as stacks of slices (individual 2D images) in either TIFF or DICOM data formats. These files can vary greatly in size from a few hundred MB for clinical scans to 40+ GB for micro-CT scans. They require very sophisticated software as well as powerful computers to manipulate the data in three dimensions. As is the case with 2D images, there is a variety of file formats, but the most common will be touched on here.

RAW data files contain the unprocessed binary information for each voxel in a 3D volume. There is no standardized format for 3D RAW voxel files, so they are generally given either a header or a small separate file containing the information that instructs the software on how to read the raw data. (Larobina and Murino 2014). Clinical CT scans are rarely saved in RAW format. See Chapter 7: Computed Tomography (CT), Multi-Detector Computed Tomography (MDCT), Micro-CT, and Cone Beam Computed Tomography (CBCT) for a discussion of the data processing that goes on at the time of scanning and is then saved in DICOM form for subsequent analysis.

Image Stacks

DICOM—The DICOM format is the heart of every clinical imaging department, as the vast majority of medical devices store their data in DICOM format. The DICOM format was developed by the American College of Radiology in conjunction with the National Electrical Manufacturers Association (NEMA) in the early 1990s (Wiggins et al. 2001, Graham et al. 2005) but did not really become the accepted standard for medical imaging until the end of the 1990s (Larobina and Murino 2014). The underlying goal was to ensure that patient data could never be separated from their images, so DICOM files have headers that contain demographic data for the patient and physician as well as technical data regarding the medical device and the settings used in obtaining the data (Graham et al. 2005, Larobina and Murino 2014). The DICOM standard is maintained by NEMA, and the most current edition of the evolving standard is available on their web page https://www.dicomstandard.org/current/. However, each manufacturer uses a slight variant on the standard. For instance,

bit depth can vary from 12 to 16 bits and file extensions vary as well. The standard extension for DICOM files is .DCM, but one can also see .DC3, .DIC, .IMA, or no extension.

A researcher who receives data obtained from a clinical imaging device (e.g. a CT scanner) is generally presented with a CD or DVD that has the data in DICOM format as well as a simple slice viewer application. Different manufacturers store the individual DICOM slice in different ways. The DICOMDIR file is the critical file that contains the road map to allow applications to find and reconstruct the slices in the correct order.

Industrial or research imaging devices (e.g. micro-CT scanners) typically create vendor-specific RAW files, from which TIFF stacks (and DICOM stacks) can be extracted. The TIFF stacks can be imported into almost any third-party volumetric image analysis program.

Software

There is a truly dizzying array of software packages available for visualizing radiographic data. The price range is similarly dizzying, running from freely downloadable to above $40,000. The reader is referred to online sources such as PC Magazine (www.ppcmag.com) for reviews of photo editing software that can allow the processing of 2D images. The following discussion of software packages will focus on software used to analyze radiographic data and is not intended to be exhaustive. Rather, it represents a sampling of available products with which the author has some familiarity.

As mentioned above, data from scans done on clinical CT scanners is generally made available to the user on a CD/DVD that also has a simple DICOM slice viewer. A simple web search using the terms "DICOM slice viewer" will return hundreds of slice viewing applications, many of them free. Most of these viewers permit basic visualization of individual slices with windowing/leveling and linear measurement capabilities, but few other analytical tools. ImageJ is one of the most powerful slice viewers available and it also has volume capabilities (https://imagej.nih.gov/ij/). ImageJ is the product of the original efforts of Wayne Rasband with the support of the National Institutes of Health and it was first released in 1987 (Schneider et al. 2012). It now consists of a sophisticated ecosystem of the base application and third party–developed macros and plugins (Schindelin et al. 2015). ImageJ was developed on a Java platform, which allows it to run on Windows, Mac, and Linux computers. ImageJ is freely downloadable, and its source code is also available; users are encouraged

to develop specific functions that are then shared with the larger community. This ecosystem contains a huge array of functions as well as image-processing and segmentation tools. Moreover, it is linked to the Open Microscope Environment initiative discussed above, in particular interfacing with the OME's Bio-Formats software tool that allows it to read more than 150 different image formats (https://www.openmicroscopy.org/bio-formats/), including DICOM and TIFF stacks. Fiji, a "batteries-included" version of ImageJ (https://fiji.sc/), is bundled with plugins in order to facilitate scientific image analysis.

There is also a wide array of software packages designed to work with radiological data in 3D format. These include packages designed for the medical community as well as the broader research and industrial communities. It is in this realm that package costs can exceed $40,000, depending on the visualization and analytical capabilities of the program.

There are a few freely downloadable applications that can work with radiological data in 3D. One, 3D Slicer, is similar to ImageJ in that it has been supported by the National Institutes of Health (https://www.slicer.org/) and is open source. 3D Slicer runs on Windows, Mac, and Linux operating systems and, like ImageJ, has the capacity to work with user-developed plugins, greatly extending the functionality of the base program. 3D Slicer is primarily built to support the analysis of medical images, such as DICOM data, but it has the ability to import stacks of slices in most 2D image formats.

Drishti was developed by Ajay Limaye at Australia National Museum's Vizlab (Limaye 2012 and http://anusf.anu.edu.au/Vizlab/drishti/index.shtml). Drishti is described as a "volume exploration and presentation tool" for X-ray tomography, electron microscopy, and other data (Limaye 2012), and it is capable of producing some striking segmented models derived from CT and micro-CT scans (see http://anusf.anu.edu.au/Vizlab/drishti/gallery.shtml).

Microview is a "general purpose 2D and 3D viewer" that was originally developed as the analytical software to accompany GE micro-CT scanners, but is now maintained by Parallax Innovations (http://www.parallax-innovations.com/microview.html). Microview runs on Windows, Linus, and Mac, and offers powerful segmentation and quantification tools.

Dragonfly is a sophisticated visualization and analytical program that is available with a non-commercial (free) license (https://www.theobjects.com/dragonfly/). Dragonfly evolved from the clinical visualization product ORS Visual (https://www.theobjects.com/orsvisual/index.html) and has been developed for the wider research community. In addition to a wide array of

segmentation tools, Dragonfly includes a machine-learning segmentation training module (Piche et al. 2017).

In the non-open-source world, there are many choices, differentiated by their capabilities and cost. Mimics (https://www.materialise.com/en/medical/software/mimics) is focused on the medical and biomedical community, so it is very strong in anatomical segmentation, planning of surgical procedures, and production of finite element array modeling of bone structural properties. VGStudio (https://www.volumegraphics.com/en/products/vgstudio.html) is optimized for the industrial/non-medical research community. VG is available as a basic platform, to which the purchaser can add numerous modules that have specific processing capabilities. Finally, Aviso-Amira (http://www.fei.com/software/avizo3d/) seeks to appeal to the broader research community, both academic and industrial.

As discussed above, this listing of software packages is by no means exhaustive. Rather, it offers a sampling of options, and seeks to highlight the potential that exists. Interested users are encouraged to visit the web sites, and to consult with sales representatives and the user community before making a final decision on which package to work with.

3D Image Repositories

Collections of digital data sets, particularly of 3D models created by laser scanning, structured white-light scanning, CT scanning, and/or micro-CT scanning, allow the researcher to move from case study or small-scale research projects to larger comparative projects. For instance, a recent study (Wade and Nelson 2013) utilized a collection of CT scans of Egyptian mummies assembled as part of the IMPACT database (see below, Nelson and Wade 2015) to demonstrate long-term trends in mummification practices in Ancient Egypt, as well as to challenge the traditional Herodotean characterization of the mummification ritual. Such a collection permits a much better understanding of variability, and how that variability might have been patterned across time and space. These collections of data reduce the need to handle the physical specimens (Niven and Richards 2017), allow new observations to be made and/or new measurements to be taken (Errickson 2017), facilitate collaborations such as diagnosis by consensus (Beckett 2017), and give potentially limitless access to valuable specimens or fossils that would otherwise be available to the few researchers with the resources and connections to travel to collections (e.g. the online availability of the fossil hypodigm of Homo naledi cf. Berger et al. 2015). While artificial intelligence (AI) has not yet made

significant inroads in paleontology or bioarchaeology (but see Navega et al. 2018), the work being done in the area of AI-assisted diagnosis in clinical radiology (e.g. Brink et al. 2017, Fazal et al. 2018) suggests that there is tremendous potential for data mining of paleoimaging data and image segmentation (Piché and Marsh 2017). Finally, online accessible collections enhance the sustainability of archaeological/paleontological data (Ahmed et al. 2014) and the entire field of paleoimaging.

The largest and most diverse web archive for 3D museum data is MorphoSource (Boyer et al. 2017). MorphoSource began in 2009 at the University of Helsinki but now resides at Duke University. The MorphoSource web site (accessed March 11, 2019) has data for 20,085 specimens represented by 62,717 data sets (occupying 27 TB of storage), and it has 7,788 registered users (https://www.morphosource.org/About/home). MorphoSource includes data from CT, micro-CT, MRI, and surface meshes. A search of Google Scholar (March 11, 2019) using the search term "morphosource" yields a remarkable 356 hits. MorphoSource is clearly transforming research in the field of comparative morphology.

Obstacles

While the benefits of data sharing are clear, there are also obstacles to be overcome. The range of specialized file formats discussed above, combined with the very large size of some of the files/sets of files, means that the common database structures that can handle text, photos, and so on cannot be used for 3D digital models (Decker and Ford 2017). The database architecture used in the world of clinical imaging is called a PACS—picture archive and communication system (see Huang 2010 for an authoritative and exhaustive discussion of PACS). However, while a PACS allows physicians access to a variety of imaging data, it is specially designed to work with DICOM format files and has a primary focus on the protection of patient privacy rather than fostering open access. The PACS architecture also does not allow for a hierarchical structure of folders and subfolders, as it is primarily organized on the patient's name. This stricture makes it very difficult to organize data in a PACS environment.

One of the most significant obstacles to data sharing is intellectual property. For instance, if a mummy or fossil is brought from a museum to a hospital or lab for scanning, who owns the data—the museum? (as the mummy/fossil is part of their collection). Or the hospital/lab? (as it was their equipment that made the scan possible—or the researcher who commissioned the scan, as they envisioned the project and will interpret the data?) The recent analysis of the 300 most popular

paleontology papers in 2017 (Lewis 2019) showed that 122 of those papers described 3D objects, 59 of those collected 3D imaging data, but of those, only 31 % shared their data online. This demonstrates a clear reluctance on the part of many scholars to share data. The most cited reason to not share data was to embargo it for future studies by the author (Lewis 2019). In the United States, medical scans cannot be copyrighted, as they do not have creative input (Watanabe 2018), so it is important that expectations and protocols regarding data sharing be clear from the start. An important part of the discussion of intellectual property is whether the user of an online repository can download the actual data set, or whether the data resides on the repository server and the user interacts with it there (a so-called thin client model) (see the discussion of IMPACT below).

There are ethical issues to be considered when considering digital representations of human remains. Medical data is typically anonymized before any sharing takes place. While we generally do not have an identity for bioarchaeological remains, when we do (e.g. Richard the III, King Tutankhamun), that identity is a crucially important part of the individual's context. Many archaeological and bioarchaeological professional associations have ethics guidelines for the treatment and display of human remains, but these guidelines rarely include a discussion of digital models. Thus, "sharing should be done in a manner sympathetic to, and respecting of, the legal rights of the deceased and the communities involved" (Márquez-Grant and Errickson 2017; Ulguim 2018: 217).

Digital models are only as good as the metadata that accompanies them. This metadata includes information such as mode and settings for the capture of the 3D model, details of the archaeological or paleontological context, the location where fossils or human remains are housed, archaeological or geological age, and so on.

Finally, the need for adequate resources to maintain online repositories is a significant concern. MorphoSource is supported by funds from Duke University and the National Science Foundation. It has a staff of five developers. There are two analysts, one product manager, and two developers (https://www.morphosource.org/About/home). Their need for both hardware and human resources is significant, as they plan on adding 10 TB of data per year. Thus, it is crucial to have appropriate resources to maintain this product.

IMPACT

Our database of radiographic studies of mummies is called IMPACT—Internet-based Mummy PACs Technology (Nelson and Wade 2015). We have contributions from 31 institutions comprising 101 human and 25 animal mummies. In setting up the data base, we found that individuals and institutions were often reluctant to share data without a formal agreement (one individual threatened a law suit if their data made it into the database). Thus, we developed a Contributor License Agreement (CLA) wherein the contributing institution retains copyright, but grants a licence to the University of Western Ontario (represented by the author) to house, maintain, and manage access to the data set(s). We opted for the commercial PACS/visualization product ORS Visual Web (http://www.theobjects.com/orsvisual/web.html) as the data interface, which is based on a thin-client PACS. The user logs into the IMPACT web site and manipulates the data sets using the tools available in the ORS visualization application, but the original data set is not transferred to the user. Access to the database is granted on the basis of an application, which is then vetted by an oversight committee. This is a different model to MorphoSource, where the user registers on the site and downloads the data sets to their own computer (there are varying options for accessibility—some require the approval of the data author) (Boyer et al. 2017).

We have struggled with two of the obstacles raised above. The first is the availability of metadata as many of the data sets came to us without any contextual information. The second is resources. The project was originally funded by a National Endowments for the Humanities and Social Sciences and Humanities Research Council of Canada joint *Digging into Data* grant (A.J. Nelson and R. Thompson co-PIs). The grant covered the cost of the computing and software infrastructure needed to get the database up and going and some initial human resources support in the form of a post-doctoral fellowship. However, there is no provision for ongoing gathering of metadata and maintenance of the data files, which is currently being done by a dedicated group of work study undergraduate and graduate students. To date, the database has been central to one doctoral dissertation, one master's thesis, nine refereed publications, and numerous conference presentations.

Another challenging area has been the actual format of the DICOM files. DICOM is supposed to be an industry-wide standard, but the reality is that each vendor has a slight variant in terms of how files are stored (ranging from logical to pathological) to the file extensions. The earliest scans we have were acquired in 1999, so the collection follows the development of the field of clinical CT scanning. In addition, the populating of DICOM fields on a per-scan basis is very idiosyncratic. Finally, how a mummy is actually scanned—head to toe, in segments, etc.—is highly variable. It is our plan

to develop recommendations about the mechanics of scanning a mummy.

Conclusions

MorphoSource and IMPACT can be seen as lying along a continuum of online repositories of 3D data sets, and they have taken somewhat different approaches to the process of gathering, storing, and making the data sets available. Some other examples are listed below. These efforts represent the move of paleontology and bioarchaeology into the world of informatics and collaborative sharing of data in an effort to go beyond case studies to broad-based comparative research. In addition to the basic logic of this move, granting agencies and journals are increasingly calling on researchers to make their data broadly and openly available (Edmunds et al. 2017; Niven and Richards 2017; Lewis 2019). We are at the very early edge of this process, and standards, principles and accessibility have yet to be negotiated beyond specific databases. This is the challenge that lies before us, and it is one with which we must engage for the field of paleoimaging to truly move into the twenty-first century. I look forward to seeing the process unfold.

A Sampling of Online Repositories of Paleoimaging Data

MorphoSource: https://www.morphosource.org/About/home

IMPACT: http://impactdb.uwo.ca/IMPACTdb/Index.html

Digitized Diseases: http://www.digitiseddiseases.org/alpha/

Digitized Diseases is an open-access resource featuring examples of pathological lesions on human bones that have been digitized using 3D laser scanning, CT, and radiography.

Virtual Zooarchaeology of the Arctic https://vzap.iri.isu.edu/ViewPage.aspx?id=230&rebuild=true

VZAP is a virtual comparative collection of 3D images of faunal material to act as a reference collection for archaeological projects working in the arctic.

tDar is a repository of archaeological data in the form of text files, 2D images, and some 3D files (OBJ remote sensing files). https://www.tdar.org/about/

Archaeology Data Services is a digital repository for reports, databases, spreadsheets, and some geophysical data. https://archaeologydataservice.ac.uk/about.xhtml

References

Ahmed, N., Carter, M., and Ferris, N. 2014. Sustainable archaeology through progressive assembly 3D digitization. *World Archaeology*, 46(1): 137–154.

Beckett, R.G. 2017. Digital data recording and interpretational standards in mummy science. *International Journal of Paleopathology*, 19: 135–141.

Berger, L. et al. 2015. *Homo naledi*, a new species of the genus *Homo* from the Dinaledi Chamber, South Africa. *eLife*, 4: e09560.

Boyer, D.M., Gunnell, G.F., Kaufman, S., and McGeary, T.M. 2017. MorphoSource: Archiving and sharing 3D digital specimen data. *The Paleontological Society Papers*, 22: 157–181.

Brink, J.A., Arenson, R.L., Grist, T.M., Lewin, J.S., and Enzmann, D. 2017. Bits and bytes: the future of radiology lies in informatics and information technology. *European Radiology*, 27: 3647–3651.

Brown, C.W. and Shepherd, B.J. 1995. *Graphics File Formats. Reference and Guide*. Manning: Greenwich.

Davies, T.G., Rahman, I.A., Lautenschlager, S., Cunningham, J.A., Asher, R.J., Barnett, P.M., and Donoghue, P.C.J. 2017. Open data and digital morphology. *Proceedings of the Royal Society B*, PubMed: 28420170194.

Decker, S. and Ford, J. 2017. Management of 3D image data. In D. Errickson and T.Thompson eds., *Human Remains: Another Dimension*, 185–191. Academic Press: London.

Edmunds, S.C, Li, P., Hunter, C.I., Ziao, S.Z., Davidson, R.L., Nogoy, N., and Goodman, L. 2017. Experiences in integrated data and research object publishing using GigaDB. *International Journal on Digital Libraries*, 18(2): 99–111.

Eliceiri, K.W., Berthold, M.R., Goldberg, I.G., Ibàñez, L., Manjunath, B.S., Martone, M.E., and Carpenter, A.E. 2012. Biological imaging software tools. *Nature Methods*, 9(7): 697–710.

Errickson, D. 2017. Shedding light on skeletal remains: The use of structured light scanning for 3D archiving. In D. Errickson and T. Thompson eds., *Human Remains: Another Dimension*, 93–101. Academic Press: London.

Fazal, M.I., Patel, M.E., Tye, J., and Gupta, Y. 2018. The past, present and future role of artificial intelligence in imaging. *European Journal of Radiology*, 105: 246–250.

Graham, R.N.J., Perris, R.W., and Scarsbrook, A.F. 2005. DICOM demystified: A review of digital file formats and their use in radiological practice. *Clinical Radiology*, 60: 1133–1140.

Huang, H.K. 2010. *PACS and Imaging Informatics; Basic Principles and Applications*, 2nd edition. Wiley Blackwell: Hoboken, NJ.

Larobina, M. and Murino, L. 2014. Medical image file formats. *Journal of Digital Imaging*, 27: 200–206.

Lewis, D. 2019. The fight for control over virtual fossils. *Nature*, 567: 20–23.

Limaye, A. 2012. Drishti: a volume exploration and presentation tool. Proceedings SPIE 8506, Developments in X-Ray Tomography VIII, 85060X.

Márquez-Grant, N. and Errickson, D. 2017. Ethical considerations: An added dimension. In D. Errickson and T. Thompson eds., *Human Remains: Another Dimension*, 194–204. Elsevier, San Diego, CA.

Navega, D., Coelho, J.D., Cunha, E., and Curate, F. 2018. DXAGE: A new method for age at death estimation based on femoral bone mineral density and artificial neural networks. *Journal of Forensic Science*, 63(2): 497–503.

Nelson, A.J. and Wade, A.D. 2015. IMPACT: Development of a radiological mummy database. *Anatomical Record*, 298: 941–948.

Niven, K. and Richards, J.D. 2017. The storage and long-term preservation of 3D data. In D. Errickson and T. Thompson eds., *Human Remains: Another Dimension*, 175–184. Academic Press: London.

Piche, N., Bouchard, I., and Marsh, M. 2017. Dragonfly segmentation trainer—A general and user-friendly machine learning image segmentation solution. *Microscopy and Microanalysis*, 23(Suppl 1): 132–133.

Russ, J.C. and Neal, F.B. 2016. *The Image Processing Handbook*, 7th edition. CRC Press: Boca Raton, FL.

Salmon, D. 2011. *The Computer Graphics Manual*, Vol. 2. Springer: London.

Schindelin, J.S., Rueden, C.T., Hiner, M.C., and Eliceiri, K.W. 2015. The ImageJ ecosystem: An open platform for biomedical image analysis. *Molecular Reproduction & Development*, 82: 518–529.

Schneider, C.A., Rasband, W.S. Eliceiri, K.W. 2012. NIH Image to ImageJ: 25 years of image analysis. *Nature Methods*, 9: 671–675.

Staab, S. and Studer, R. 2009. *Handbook on Ontologies*, 2nd edition. Springer: Heidelberg.

Tan, L.K. 2006. Image file formats. *Biomedical Imaging and Intervention Journal*, 2(1): e6.

Ulguim, P. 2018. Models and metadata: The ethics of sharing bioarchaeological 3D models online. *Archaeologies: Journal of the World Archaeological Congress*, 14: 189.

Verhoven, G.J.J. 2010. It's all about the format—Unleashing the power of RAW aerial photography. *International Journal of Remote Sensing*, 31(8): 2009–2042.

Wade, A.D. and Nelson, A.J. 2013. Evisceration and excerebration in the Egyptian mummification tradition. *Journal of Archaeological Science*, 40: 4198–4206.

Watanabe, M.E. 2018. Digitizing specimens—Legal issues abound. *BioScience*, 68(9): 728.

Wiggins III, R.H., Davidson, C., Harnsberger, H.R., Lauman, J.R., and Goede, P.A. 2001. Image file formats: Past, present, and future. *RadioGraphics*, 21: 789–798.

Section 5
Interpretation Strategies

9

GERALD J. CONLOGUE, SAHAR N. SALEEM,
AND PÉTER ZÁDORI

Contents

A key component of the diagnosis by consensus approach is to integrate the image interpretation by radiologists along with the impressions of anthropologists, pathologists, and other specialists. The radiologist, with years of experience of interpreting shapes in varying shades of gray to make a diagnosis, can provide invaluable insights to the entire process. However, these physicians have been trained on living individuals with hydrated organs in relatively specific positions. In addition, their patients generally provided verbal information and had supporting clinical data, such as hematological evaluations prior to the imaging study. The following statements are from radiologists who have accepted the challenge of offering interpretations of mummified remains imaging studies. They have detailed their approach and included some of the challenges.

Péter Zádori, PhD, MD is a consultant radiologist at Moritz Kaposi Teaching Hospital, the Dr. József Baka Diagnostic, Radiation Oncology, Research and Teaching Center, and at the Medicopus Nonprofit Ltd. in Kaposvár, Hungary, specializing in CT, MRI, and PET/CT, PET/MRI multimodality imaging. He has been involved with paleoradiology for over a decade and in 2015 defended his PhD thesis, *Special application of computed tomographic imaging in the field of human paleoradiology*, at the University of Pécs.

Dr. Zádori generated a summary comparing the radiographic examination of clinical patients to mummified remains (Table 9.5.1), and a graphic demonstrating workflow and management of paleoradiological images in a clinical imaging facility (Figure 9.5.1). In addition, he described his experiences and approach as follows:

"Organizing the paleoradiological examinations can be a difficult task if we have only access to clinical CT scanners. Besides the transportation problems, scheduling the examinations is a great challenge, as the examinations should not be performed during the in- or outpatient examinations' time period. On the other hand, these examinations should be performed with the radiologist, radiographer and the anthropologists/paleopathologists involved being on spot. With achieving this human resource background, it is possible to look through the initial CT images together and decide whether further scans, different parameters or reconstructions would be needed to visualize the regions of interest.

The site of the paleoradiological examinations is usually far away from the initial excavation sites or from the museum facilities, so the transport of the remains can be a very complicated and challenging procedure. In our practice the cooperating anthropologic institutions take the responsibility of the transportation providing continuous supervision. Continuous supervision is needed to prevent the possible damage of the remains. Protection of the remains has to be a major issue of every member of the multidisciplinary team.

Due to the difficulties of the transportation of the remains and the heavy scanners, the use of mobile CT scanners might be a compromise. These scanners have minimal installation requirements, and can prevent the possible damage due to transportation, introducing the concept "not the archaeological remains travel."

During the examinations, general CT concepts should be considered, but certain fields such as paying attention to prevent the motion caused by the table feed of the scanned, sometimes very light, weight remains, is extremely important, because it can result in poor image quality. On the other hand, paleoradiology should not lag behind the clinical imaging procedures, and should keep the pace with the continuously developing clinical imaging concepts and methods. As new imaging techniques are introduced, we have to be innovative and find the potential use of them. Such a technique is Dual Energy Computed Tomography, where the gained different density profiles of the remains and artefacts can be used to differentiate and analyse them in an up-to-date way. These dual-energy CT images can be reconstructed to achieve virtual monochromatic images, obtaining optimal contrast with reducing the beam

Table 9.5.1 A Comparison between Clinical Patients and Mummified Remains with Respect to Imaging Approach

Clinical Patients	Mummified Remains
Some form of history is available	Historical context at most
In a clinical setting	Possibly a remote location
Standardized projections	Acquire what is possible
Minimize the radiation dose	Radiation dose is not a factor
Multiple modalities available	May only have plane radiographs
Preset algorithms available	No preset algorithms available
Patients body free of artifacts	Body may be covered in artifacts

hardening artefacts. This technique has already been used in paleoimaging on mummies, bony remains, soil and fabric samples, and embalming residues.

During the evaluation of the images, it is necessary to know all the available background information (excavation documentation, photos, results of the detailed prior anthropological-paleopathological investigations, etc.) on the analogy of the patient history in a clinical setup. We could also call this group of information 'paleopathological history.' After paleoradiological evaluation and writing the paleoradiological report, multidisciplinary consultation is needed to reach a consensual view, where the results of different anthropological, paleopathological, and various diagnostic procedures are reflected together.

Archiving the obtained digital images can also be challenging. In our practice the obtained images are archived in DICOM (digital imaging and communications in medicine) format on the institutional server and we also provide them on CD/DVD to the cooperating institution. As the imaging parameters cannot be changed on the archived images, the raw data set of the scans should be

archived as well, bearing in mind that we are dealing with several gigabytes of data per examination (in clinical CT imaging, raw data is generally not archived).

Another concept is teleradiology that should also be adopted in paleoradiology. Using the IT background and features of the clinical imaging approach, the obtained digital images can be electronically transported for evaluation, post processing, consultation and archiving as these processes can differ in time and space.

As a final aim, the information gathered should also be assessed in a database format, in order to achieve an easy access to the background information, the radiological parameters and the results."

Sahar N. Saleem, MBBCH, MSc, MD is professor of radiology and head of the Neuroradiology Unit in the Radiology Department at the Kasr Al Ainy Faculty of Medicine, Cairo University in Cairo Egypt. She is specialist in advanced imaging technology and has extensive experience in Paleoradiology. In 2016, along with Zahi Hawass, she co-authored *Scanning the Pharaohs: Ct Imaging of the New Kingdom Royal Mummies*. When asked to describe the differences in interpreting images of mummified remains from a living patient, she provided the following response:

> Accurate diagnosis of bony lesions in a mummified remain is based on the appropriate interpretation of radiological findings like in a living person. This includes identification of the paleo-radiological patterns of the bony lesion: lytic or sclerotic, as well as to distinguish the suspected bony lesion from normal anatomical variants. If pathology is suspected, the paleo-radiologist provides a differential diagnosis then suggests a final diagnosis with a broad category of bone or joint dieases (Hawass and Saleem, 2016; Chhem and Brothwell, 2008)

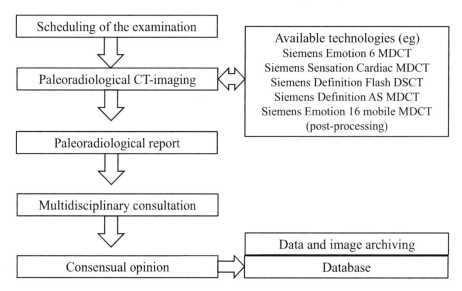

Figure 9.5.1 Workflow and management of paleoradiological imaging.

Taphonomic changes are the events and processes that affect the remains of the organism after it dies and include burial condition in sediment, decomposition of the body transportation, and any postmortem trauma or violation. (Haglund and Sorg, 1997; Pokines and Symes, 2013). However, taphonomic changes, desiccation, and any implemented mummification procedure have critical implications on interpretations of radiological scans of ancient remains. These changes can provide misleading results if interpreted as though they were living people (Villa and Lynnerup, 2012; Hawass and Saleem, 2016).

An example is imaging of bog bodies, corpses dating to the Iron Age that were found intact in bogs of Northern Europe when these were excavated several thousand years later. The cold anaerobic environment of the bogs preserved the soft tissues of the bodies, but the bones were demineralized. When X-rayed, the bog bones were very poorly visualized. Applying CT scanning using protocols made for live patients may result in the bog bones not being visualized at all. This is due to the large offset between the Hounsfield units associated with visualizing bones in live patients versus the Hounsfield range for the demineralized bog bones (Villa and Lynnerup, 2012).

The paleoradiologist has to differentiate between ante-and postmortem changes. Antemortem fracture usually shows sign of healing callus with either a good alignment or malunion. In perimortem fracture, the callus has not been formed yet but the fracture appearance fits with known clinical mechanisms such as spiral, greenstick, depressed fractures, etc. The fracture mechanism can be suggested by proper analysis of its site, pattern, and direction of the fracture line. In postmortem fracture, there is no callus formation, usually with many small bony fragments with sharp margins that do not fit with trauma patterns described in the clinical context (Hawass and Saleem, 2016; Chhem and Brothwell, 2008).

Desiccation is dryness of tissues caused by removal of water as part of natural mummification by burial in hot deserts or as an effect of adding Natron salt in artificial Ancient Egyptian mummification style. In Ancient Egyptian artificial mummification, most organs were removed from the cranium, thorax, and abdomen and the cavities were filled with air, packages, resin, and desiccated soft tissues (Saleem and Hawass, 2013).

Radiographic examination of recently dead cadavers treated with modern embalming procedures showed that the image quality was greatly reduced by beam-hardening artifacts, and that the attenuation between soft tissues was reduced as compared with living people (Chew et al., 2006). Desiccated tissues attenuate X-rays to a greater extent than they do in the living human. The radiographic contrast between the desiccated soft tissue and air is greater than under normal clinical conditions (David, 2008).

Interpretation of radiographs and CT scans of mummified tissues as though they were living people can lead to false diagnoses. The following are some examples:

- The desiccated paravertebral ligaments may also appear denser and more prominent than in a living person because of increased contrast difference between ligaments and adjacent air in mummies. In nine Royal Ancient Egyptian mummies, the dry anterior longitudinal ligaments appeared as smooth thin dense linear structures along the anterior and lateral aspects of the vertebral bodies and the intervertebral discs. These features must not be misinterpreted as paravertebral ossification of ankylosing spondylitis; normal sacro-iliac joint excluded this pathological diagnosis (Saleem and Hawass, 2014).

- Desiccated cartilage in joints may appear denser in mummies than in living humans and, consequently, the joint may appear narrower. A thin layer of resin in the joints may give a false appearance of arthritis on X-ray film. Absence of associated degenerative (osteophytes, sclerosis) or erosive changes helps to exclude the diagnosis of arthritis in mummies.

- The desiccated intervertebral discs with deposition of Natron may appear denser in Ancient Egyptian mummies than in living humans. This should not be misdiagnosed as ochronosis, a tyrosine metabolism inborn error that causes dense intervertebral discs (David, 2008).

- The X-ray of King Tutankhamun's (1334–1324 BC) head showed a dense spot overlying the thin skull base. Findings were interpreted as a subdural hematoma as a result of a blow to the head that murdered the king (Bob Brier, 1998). CT examination of the king's head related the findings to cranial mummification with no evidence of head trauma and thus ruled out the murder theory (Hawass and Saleem, 2016).

- The CT appearance of dense visceral packs within the mummified torsos of royals of the New Kingdom of Ancient Egypt could be falsely interpreted as tumors if they were living people (Hawass and Saleem, 2016).

A proposed scheme for paleoradiological method of diagnosis:

- Obtain the best available radiographic projection or proper CT technique.
- Systemic analysis of the mummy.

- Identify the possible lesion.
- Determine if the lesions are a real disease or caused by taphonomic changes, desiccation, or artificial mummification.
- Exclude a normal anatomical variant.
- If a paleo-pathologic disease is suspected, apply the radiographic patterns used in clinical conditions.
- Provide a differential diagnosis.
- The final diagnosis should be a broad category.

Ramón González, MD, is an assistant clinical professor of radiology and biomedical imaging at Yale University, School of Medicine, in New Haven, Connecticut. He has practiced clinical radiology for 35 years, specializing in CT and ultrasound body imaging. Since 2008 he has reviewed plane radiographs and CT images of over 100 mummies for the Bioanthropology Research Institute at Quinnipiac University in Hamden, Connecticut. On 15 May 2017, Dr. González responded to three questions regarding paleoradiography of mummified remains.

1. How does evaluating radiographs of mummified remains differ from live patients?

 "The evaluation of skeletal and intrinsic anatomy is the same in both cases. However, the lack of soft tissue due to desiccation results in changes in organ positions, margins and specific densities. Possible taphonomic changes can also account for unusual location of structures. The analysis of calcification of structures basically falls into the area of clinical training of radiologists and is an important factor in etiological consideration. A differential diagnosis approach is important when looking at structural pattern recognition. Since it is not a clinical case, it is possible to speculate without consequences. If several radiologists do not agree, it is not a problem. In fact, it is an advantage in a teaching institute situation and should be presented in more of a Grand Rounds approach with specialists from other disciplines present, such as pathology."

2. How does not being provided projections that are standard for the clinical situation influence interpretation?

 "Plane film can be a problem particularly if only one projection is acquired. It is reminiscent of the adage, "one view is no view." When evaluating an image, a radiologist is also skilled in factoring in rotation of structures particularly in non-standard projection radiographs, so it is possible to make preliminary observations. If the images are digital loaded onto a PACS system with all of the inherent software capabilities such as window/level manipulation, it makes a tremendous difference. However, if a particularly interesting observation is noted on the single radiograph and MDCT with multiplanar (MPR) and 3D images can be acquired, it is not a major problem."

3. How does the approach to utilizing MDCT differ with mummified remains and clinical cases?

 "In the clinical setting, diagnosis is primarily made from the MPR images while 3D reconstructions are more for specific applications such as "virtual" colonoscopy/endoscopy, and treatment planning. When examining mummified remains MPR images can be reconstructed in a variety of nonstandard planes allowing optimal analysis of particular anatomic structures and suspected pathologic findings with 3D virtual imaging utilized to corroborated findings in MPR images."

References

Brier, B. *The Murder of Tutankhamun*. Berkley Books, New York, 1998.

Chhem R.K., and Brothwell, D.R. *Paleoradiology: Imaging Mummies and Fossils*. Springer-Berlin; Nov 20, 2008.

Chew, F.S., Relyea-Chew, A., and Ochoa, E.R. Postmortem computed tomography of cadavers embalmed for use in teaching gross anatomy. *Journal of Computer Assisted Tomography*, 2006; 30:949–954.

David, R. *Egyptian Mummies and Modern Science*. Cambridge University Press, 2008.

González, R. May 15, 2017. Personal communication (interview).

Haglund, W.D. and Sorg, M.H. 1997. *Forensic Taphonomy: The Postmortem Fate of Human Remains*. CRC Press, Boca Raton, FL.

Hawass Z. and Saleem, S.N. *Scanning the Pharaohs: CT Imaging of the New Kingdom Royal Mummies*. The American University in Cairo Press, Cairo, 2016.

Hawass Z. and Saleem, S.N. *Scanning of the Pharaohs: CT Imaging of the New Kingdom Royal Mummies*. AUC Press New York, Cairo, Jan 2016.

Pokines, J. and Symes, S.A. *Manual of Forensic Taphonomy*. CRC Press, Boca Raton, Fl., 2013.

Saleem, S.N. and Hawass, Z. Variability in brain treatment during mummification of Royal Egyptians dated to the 18th–20th dynasties: MDCT findings correlated with the archaeologic literature. *AJR*, 2013; 200(4): W336–W344.

Saleem, S.N. and Hawass, Z. Ankylosing spondylitis or diffuse idiopathic skeletal hyperostosis (DISH) in Royal Egyptian mummies of 18th–20th dynasties? CT and archaeology studies. *Arthritis and Rheumatology*, Dec 2014; 66(12): 3311–3316.

Villa, C. and Lynnerup, N. Hounsfield units ranges in CT-scans of bog bodies and mummies. *Anthropol Anzeiger*, 2012; 69:127–145.

Zádori, P.G. Special application of computed tomographic imaging in the field of human paleoradiology, PhD Thesis, Health Sciences Doctoral (PhD) School, Faculty of Health Sciences. University of Pécs. Pécs, Hungary, 2015.

Section 6
Integration of Bioarchaeology and Bioarchaeology of Care Models

9

RONALD G. BECKETT

Contents

Bioarchaeology

Imaging in non-traditional settings is often focused on human cultural remains and artifacts. Mummified remains and artifacts have held the interest of scientists since their discovery. Bioarchaeology is the study of ancient and historical human remains in a manner that approximates the reconstruction of the lives of those under investigation. Such reconstructions include the analysis of cultural, biological, and environmental impacts and their relationship to observed data. Bioarchaeology requires input from a large variety of specializations including anatomy, nutrition, paleopathology, epidemiology, forensics, medicine, paleoimaging, and others. This section will discuss the contributions made by non-traditional paleoimaging methods to bioarchaeological studies.

Paleoimaging is an important contributor to bioarchaeological research in that it adds information in the form of images of structures beneath the surface that cannot be seen with the unaided eye. When imaging data is used in concert with the archaeological record and other related data, important inferences can be made regarding the group being studied. Whenever practical, this data is collected within the original associated context. Image documentation in various settings, whether ancient or recent, is based on the need to collect and preserve accurate data about the subject. Usually, the most current technologies are used with images providing evidence to help the bioarchaeologist answer basic and advanced questions regarding specific individuals or populations, thus enhancing understandings about ancient lives and their relationships to anthropology.

When medical radiographic imaging is employed in the bioarchaeological context, the accepted descriptor is paleoradiology. However, it is important to recall that paleoimaging encompasses a broader array of image-capturing methods including photography, videography, ground-penetrating radar, satellite imaging, laser surface scanning, and the medical imaging technologies of radiography, endoscopy, multi-detector computed tomography (MDCT), micro CT, and magnetic resonance (MR). Using multi-modal approaches in paleoimaging yields a greater volume of data that is more meaningful. This data then has the potential to inform the bioarchaeological study regarding the life experiences within the study context. Given that bioarchaeological studies attempt to reconstruct the lives of past peoples, the preferred imaging techniques would be those conducted in the field at the site of discovery.

Bioarchaeological research is strengthened by the quantity and quality of the data considered for interpretation. While individual case studies using imaging methods are very useful from an informational perspective, data acquired in larger-population studies allows for more accurate and complete interpretations regarding the culture and their experience as a whole.

Population studies offer considerable information to bioarchaeological contexts, affording greater understandings of the life and health of past peoples. An early example of radiographic examination of large groups of mummies can be found in Harris and Weeks' 1973 publication of *X-raying the Pharaohs*. The authors brought field imaging to the forefront describing various bioanthropological and bioarchaeological concerns such as diseases present, medical and dental problems, age at time of death, cause of death, process of mummification, artifact analysis, and transport impact on mummified remains. The work of Harris and Weeks draws attention to the importance of conducting paleoimaging studies in the field whenever possible, given the potential damage caused by transport and resultant shifts in the internal context of the mummy. More recent paleoimaging studies demonstrate the importance of larger sample studies. Papagrigorakis *et al* (2012) compared 141 ancient skulls to 240 modern skulls. The findings

indicated that senile postmenopausal osteoporosis was similar in terms of distribution between the two groups. Researchers must be cautious when using population study data as more data needs to be collected and interpreted while considering taphonomy, post-depositional changes, and their impact on results.

Another population study examined the presence of atherosclerosis in ancient mummies. In their approach, the scientists employed a targeted diagnosis model using whole-body CT scans of 137 mummies from four ancient cultures (Thompson *et al* 2013). In this model, specific evidence is sought as related to the targeted diagnosis. The targeted approach focuses on a specific narrow question as related to the population being studied. It is important to recall that determining prevalence among ancient populations with any degree of accuracy is problematic even with a large sample size. While the presence of atherosclerosis in mummified remains has been previously noted, these findings add to our understanding of diseases among ancient cultures. A concern regarding targeted diagnosis studies is that valuable and useful data may be overlooked in the attempt to view only the targeted diagnosis and associated organs or structures. In the atherosclerosis study, whole-body scans were conducted, yet the main focus of the report was on the targeted diagnosis only. Given that CT scans are expensive and time consuming and that the data collected has the potential to be a valuable record of human conditions and artifacts beyond a specific diagnosis, researchers are encouraged to conduct more extensive analyses of the imaging data collected.

Imaging data then adds a great deal to the study of ancient populations. Whether the objects are artifacts or human remains, armed with quality images the bioarchaeologist has greater potential of making meaning regarding the lived experiences of past peoples.

Bioarchaeology of Care

The bioarchaeology of care (BOC) is a relatively new approach (Tilley 2015), which attempts to reconstruct the lives of past people and cultures. It seeks to determine whether, in view of the likely impact of a pathology within the particular lifeways context, care was required for survival. It does not suggest that care of human beings among past peoples is something novel; rather, it provides a framework for assessing the plausibility of care provision in any given instance.

Assessment of the clinical presentation and functional impacts of a particular pathology is at the heart of a bioarchaeology of care case study. It is grounded

in the understanding of pathophysiology as it relates to the paleopathological determination (Beckett and Conlogue 2018). Clearly, an in-depth understanding of the subject's lifeways context, be it historic or prehistoric in nature, is key in attempting to determine what care may have been needed and what may have been given. Knowledge of the subject's environmental surroundings allows the researcher to better understand what may have been needed in terms of addressing functional impacts of a given pathology. For example, a hilly or mountainous region would present different challenges to an individual with a pathology affecting mobility than to a subject with the same condition living in a more agrarian or flatland environment. Similarly, knowledge of the economic practices in the subject's community, such as farming versus fishing, might inform the researcher of possible challenges faced by this same individual in work participation. Ideas regarding what may have been done to render care to that individual may also be drawn from the archaeological record by positioning proposals for likely care within the lifeways context of what was probable or possible.

Given that the BOC approach requires the diagnosis of a specific or combined condition, imaging data can provide insight into what that individual or group of individuals may have been inflicted with. A clear diagnosis based on interpretation of radiographic and other imaging data is the cornerstone of the BOC model. Images can help determine if there was evidence of a condition that would have required care. Further, imaging can help determine if that individual lived with that condition beyond what would be expected without care.

Since the diagnosis is critical to the application of the BOC approach, it is important that the most accurate or most probable diagnosis be determined. The authors recommend the diagnosis by consensus approach to the interpretation of imaging data. The diagnosis by consensus approach requires that "many eyes" review the imaging data with each offering their informed interpretation based on their area of expertise. Interpreters should include medical specialists as well as context specialists, such as a bioarchaeologist. The diagnosis derived from imaging data along with additional contextual evidence dictates and drives the inferences regarding the presence or probability of care.

In summary, where evidence in human remains suggests that an individual lived despite experiencing serious disease, the BOC approach seeks to approximate this individual's need for care, ascertain the probability that care was given, and identify the pattern of care likely provided. In order to accomplish this, an accurate diagnosis is important. Was care needed? Was there a pathological condition that would have required care to

be rendered? Imaging data is a crucial step in the process of diagnosis and, along with other scientific disciplines, in determining the most likely pathology. Diagnostic potential is greatly enhanced when mummified soft tissues, such as organs, are preserved. Imaging plays an important role in the examination of human remains in which some soft tissues or organs are present. Once the diagnosis is made and differentials are established, the life experience and the need for care are determined by considering the functional impact on the individual in the context of their lifeways. Identifying the pathology alone is not sufficient to understand the experience of disease by the individual while alive. Detailed pathophysiological characteristics and their impact on the cells, organs, organ systems, and organism must be understood to fully appreciate functional limitations present in a given case. In both cases, in the diagnosis and in the understanding of functional limitations, teamwork is the critical factor. Deriving an interdisciplinary diagnosis by consensus is at the heart of this process and imaging data is of great value in the process.

While diagnosis of disease in mummified remains has made great advances, the BOC concept requires us to expand on current diagnostic models by including practitioners who can attest to the impact of the determined condition on functionality. Teaming with contextual experts is key to trying to work out what care might have been undertaken based on tools, aids, assistive devices, or obvious medical interventions present in the contemporary archaeological record. Consideration of the social structure that allowed the individual to survive the initial onset of a disease is also critical.

References

Beckett, R.G. and Conlogue, G.J. 2018. The importance of pathophysiology to the understanding of functional limitations in the bioarchaeology of care approach. *International Journal of Paleopathology* 2018 July. doi.:10.1016/j/ijpp.2018.06.006

Harris, J.E. and Weeks, K.R. 1973. X-raying the Pharaohs. New York: Charles Scribner's Sons.

Papagrigorakis, M.J. et al. 2012. Paleopathological findings in radiographs of ancient and modern Greek skulls. *Skeletal Radiology* 41(12): 1605–1611.

Thompson, R. et al. 2013. Atherosclerosis across 4000 years of human history: The Horus study of four ancient populations. www.thelancet.com Published online March 10, 2013. http://dx.doi.org/10.1016/S0140-6736(13)60598-X

Tilley, L. 2015. *Theory and Practice in the Bioarchaeology of Care*. New York: Springer.

Section 7
Field Paleoimaging Safety and Health Challenges

9

RONALD G. BECKETT AND MARK VINER

Contents

Introduction

It is the intent of this chapter to present the types of physical and biological hazards that one may encounter during fieldwork expeditions. The chapter is general in that it intends to call attention to those issues that need to be addressed for each journey. It is beyond the scope of this chapter to describe the specific cultural traditions and safety issues apparent in multiple countries around the world. Nor is it within the scope of this chapter to provide the reader with a detailed description of the signs and symptoms of the many biological hazards one may encounter while in these countries. Rather, this chapter will describe those variables which that must be considered before mounting a field expedition. The authors will draw from field experiences where appropriate. The chapter also offers practical considerations and preparation recommendations for travel and research in remote regions and describes several "'cultural'" challenges sometimes faced by paleoimaging expeditions. A helpful motto to adopt in any fieldwork setting is to be prepared and expect the unexpected.

Physical Hazards—or—If It Can Go Wrong, It Just May

Harm to the Self or Team

Physical hazards in the fieldwork setting can be described as anything that can cause harm to oneself or a member of the team. Physical hazards may include extreme temperature exposures, site construction incidents, noise, slips, falls, traffic accidents, heavy lifting, and paleoimaging instrumentation misapplication. While most physical harm is the result of an accident, physical insult can often be avoided by being knowledgeable about where you are going and, who you will be with, and preparing for any eventuality.

Clearly, accidents involving travel to and within the research site cannot be avoided. However, surviving an accident traveling by land, air, or sea may well depend on your or another team member's ability to assess, treat, and if possible, transport injured individuals to safety or health- care facilities. The research areas can be so remote that help may not be able to arrive for days. Survival skills are then critical to the outcome of the physical harm brought on by accidents.

While many of the hazards associated with working in the field seem obvious, it is important that everyone on the team is made aware of the possibilities. Dutiful preparation for an imaging project cannot be understated. Table 9.7.1 provides a summary of the various conditions and situations that may impact the team and which must be considered during the planning stages.

The political fabric of the host country may well govern and explain the behavior of citizens and military or police officials in large- to- medium communities. Such behavior cannot be expected to be the same in rural villages and remote locations of that same country. Regional politics are a critical factor to consider when organizing an expedition. It is usually best to work with local trusted researchers and guides whenever possible. These individuals will be more likely to understand the concerns and political interactions of remote regional villages. On one recent expedition into the Central Highlands of Papua New Guinea, inter-village rivalry was very apparent. While researchers were studying the mummies of one village, the neighboring village wanted to know why they and their mummies were not being studied. The village where the research was being conducted did receive some benefits such as food and pay for services to the research team. This was seen as a monetary discrepancy by the neighboring village whose leaders traveled to have a face-to-face meeting with the research team and the village leaders. The meeting became tense at times, and with the villagers carrying machetes the risk for personal harm was heightened.

Fortunately, the meeting ended peacefully. Regional and tribal politics and interactions must be explored to the greatest degree possible prior to embarking on an expedition into very remote regions.

Equipment Safety

Paleoimaging necessitates the use of varied technologies including photographic, radiographic, and endoscopic equipment, as well as radiographic film. Supporting instruments, such as power transformers, are often required as well. When mounting a paleoimaging expedition into remote regions, it is imperative that the equipment arrives safely and in working order.

Transportation of the equipment within countries in route to field sites must be carefully considered. If the packaging for international travel has been well thought out, safe transportation within the host country should be accomplished without problems. It makes sense to travel in the same vehicle as the equipment whenever possible and to oversee its safe handling. It is imperative, however, to test the equipment when the team arrives at its destination. Table 9.7.2 provides a brief summary of those considerations related to equipment safety.

In most field settings, paleoimaging personnel must have a rudimentary understanding of the behavior of electricity and electrical wiring. The use of step- down transformers, gasoline- powered generators, power inverters, and batteries may all be employed necessary in the field setting. Knowledge of necessary voltage,

Table 9.7.1 A Partial List of Potential Hazards Associated with Fieldwork

Physical Hazards	Psychological Hazards	Natural Hazards	Socio/Political Hazards
Falls	Remote settings	Earthquakes	Crowd control
Sprains	Work demands	Volcanoes	Crowd behavior
Cuts	Team compatibility	Torrential rains	Military actions
Bone Fractures	Exhaustion	Flooding	Police actions
Dehydration	Dangerous settings	Fires	Coup attempts
Illness	Cultural stresses	Tsunamis	Radical political factions
Violence	Mental breakdown	Floods	Radical religious factions

Table 9.7.2 Potential Risks Associated with Equipment Transportation and Application

Equipment Safety
Transport damage – structural integrity of devices
Electrical shock – frayed wires, wire integrity, faulty connections
Operational errors – untrained personnel – overheating, physical damage to instruments
Environmental conditions – condensate, sand/grit, flooding
Inadequate support systems – collapse, physical personal damage/injury
Chemical concerns – fumes, burns, toxic inhalations
Radiation (see Chapter 9 Section 8)

wattage, and amperage for the safe operation of the equipment is critical.

Safe function of the equipment depends on the environmental conditions as well. Paleoimaging equipment used for fieldwork should be rated for hostile conditions. Industrial rather than medical imaging technologies seem to function well in varied environments. Units rated for field hospital settings or on-site veterinary instruments have also proven to work and hold up well. Climatic factors conducive to condensate formation and damp or flooded areas must be considered as these conditions can create a shock hazard, potentially causing physical harm and rendering the equipment inoperable. Additionally, the impact of these conditions on the image receptors (film) must be considered.

Know the Current Culture

Any fieldwork requires the participants to be aware of the prevalent cultural traditions in the location of the research. Knowing these traditions will promote personal safety in that the team of outsiders will be seen as having taken the effort to understand local traditions and customs. The support of the local community cannot be understated. In some cases, your team may be one of the first or the very first outsiders with which the culture has interacted. Great care must be taken to understand their greetings and other social protocols to avoid creating friction within the host community. Any friction could lead to disruption of your research efforts and, quite possibly, physical harm.

If your paleoimaging expedition is going to involve conducting research on mummified remains, it is imperative that the team understands the relationship the current population has with those remains. In many cases there is a direct ancestral connection between the living and the mummified dead. Only by working cautiously and respecting those remains in the same manner the resident people do will the team be able to conduct their its research but also do so without breaking any practices that may be taboo to that culture.

Local Rituals

Respecting local cultural customs and rituals is important in that not only it may it lead to access to the remains, but, when sincerely appreciated, it establishes a base of mutual respect and often leads to unprecedented and necessary cooperation. Some of the cultural rituals are designed simply to "'cleanse'" the scientists prior to study. Other rituals may be designed to communicate with the mummified ancestors in an attempt to explain what is going to be done, affording them the same respect one would give the living. In other cases, rituals are conducted to ascertain if the ancestors give their permission to be studied.

Governmental and Political Culture

Avoiding physical harm may also involve knowing the current political requirements and protocols necessary to conduct research in the host country. Adhering to governmental agency policies designed to oversee the anthropological and archaeological studies within their country needs to be considered. Often, the paleoimaging aspect of a project is woven into the broader research proposal and is not an issue. However, some of these policies may dictate who can do the work within that country and, at the very least, establish the individual(s) who will be responsible for monitoring the project. Many countries have long since realized that scientific studies involving their ancestral heritage is are something that needs to be managed and that the data from those studies has the positive potential to create tourism revenues for impoverished areas.

With globalization brought on by technological advances, many countries are rapidly developing experts within their borders who are making wonderful contributions to the science and application of paleoimaging. Recall that the local or tribal political setting may be quite different than that of the national governing bodies. If a research expedition is being considered in any international setting, it is critical to be aware of and work within the regulations of those host countries.

Working with the proper agencies and individuals within those agencies helps to assure but does not guarantee safe research expeditions. Even if the team has followed all the agency rules and guidelines and you possesses the necessary permits and documentation, the teamit may still be faced with barriers, and therefore risks, at the local level.

Finally, each team member must be aware of the risks associated with each of the major cities or small villages they it will visit. A working knowledge of what types of crimes and how prevalent those crimes are in a given locality can help guard against physical harm. City safety should always be practiced, that is, travel in groups, work with locals, avoid distractions, think "'sober,'", be aware of your surroundings, and be aware of where you are.

It is also advised that each team member be aware of the current regional and local health- care and emergency response systems. In many cases, where mummies are found, it simply does not exist. Regardless, whatever information is available regarding the local emergency system is critical in the preparation of a safe expedition.

Table 9.7.3 Factors Associated with Cultural Awareness when Preparing for Fieldwork

Cultural Awareness
Local rituals and traditions – ceremonies, handling of objects or remains
Governmental and political culture – permissions, players, local vs national
City/village safety – local crime statistics
Regional health care – emergency response systems
Ancient cultural burial rituals – sharp objects, caves, tombs, crypts, cliffs

Know the Ancient Culture

Paleoimaging requires that the researchers work very closely with the mummified remains. It is imperative that whenever possible, the team be aware of how the remains were mummified, if any chemical process was used, and if any potentially sharp culture-specific artifacts are known to be associated with the remains. Examples of sharp culture-specific artifacts include edges of shells, metallic offerings, ceramics, pins, or obsidian edges. In an attempt to decrease the potential of injury to any team member, awareness coupled with the careful external direct examination using a hand lens prior to approaching a particular mummy is highly recommended. Survey radiographs can also detect metallic or sharp stone objects not seen by the unaided eye and an initial radiographic survey is a good practice standard.

In preparation for the expedition, knowing where the mummies are to be examined and how the mummies were interred is critical to conducting a safe paleoimaging expedition. Many cultures hold their mummified ancestors in caves, like the Ibaloi of the Kabayan Jungle, or on cliff sides like the Anga of Papua New Guinea and Chachapoya of Peru. Others, like the Chiribaya of Peru, are buriedbury their dead in individual tombs below the surface of the sand. Some cultures have elaborate tomb systems, like the Egyptians. Still others are heldhold their dead within crypts. Each of these burial settings carries with it associated risks. For example, cave mummies require the paleoimaging team to be prepared to travel to the caves with their equipment in tow. Depending on the cave location, getting there is often physically hazardous. Once at the cave, spelunking gear and skills may be required, adding still another layer of potential physical harm. Examining mummies housed on cliff sides carries with it obvious potential risks associated with mountaineering. Skills of rapepelling and technical climbing may be required for a safe research project. Shallow underground tombs may collapse under the weight of a team member, while more elaborate tombs may require support structure construction prior to beginning the paleoimaging project. The risks

associated with dust and fungal inhalations associated withpresent in various burial environments will be discussed in the biological hazards section of this chapter.

Reviewing all previous research regarding the ancient culture under study may offer insight into the hazards and pitfalls experienced by those who have been to the specific or nearby location. In addition to reviewing the literature, whenever possible it is quite useful to network with others who have had exposure to the mummified remains of the culture or have had experience in the given physical environment. It is necessary to prepare your team as much as possible to decrease the chances of a hazardous expedition or of repeating past mistakes made by others. Table 9.7.3 provides a summary of factors associated with the cultural awareness aspects of planning fieldled work.

Climatic Conditions and the Physical Environment

Even if a team member has traveled to your expedition destination in the past, careful considerations regarding the probable climatic conditions that may exist when your team arrives must be considered. Many of the considerations are straightforward, such as the time of year your team is arriving. This will dictate the necessary protective gear you will need to include. However, it would be shortsighted for the team to ignore the potential climatic changes brought on by such phenomena as El Niños, La Niñas, and the regional impact of global warming. Global temperature and precipitation patterns continue to change and what may have been a reliable seasonal climatic forecast two years ago may be totally different in a given particular season. The impact of rain and flooding cannot be under- emphasized. The roads that carry you into a remote location may not be there to get you out. These sometimes- dramatic changes in weather patterns can render the team unprepared and may increase the inherent risks associated with travel by any means, including by foot. The physical risks of falls, breaks, and cuts are all too real, not to mention the

potential of a vehicle transporting the team sliding off a muddy road into a canyon or ravine.

We recommend that team members be trained in being sun-safe on all expeditions. Using an appropriate hat, sunscreen, and loose light-colored clothing can all be used to provide protection in sunny environments. Each team member should also carry or have available at least two quarts of water per day. These containers should be filled at every possible opportunity. Each team member should be aware of the signs and symptoms of over-exposure to temperature extremes. Heat stress may present itself as a rash, facial redness, and cold and clammy skin. The individual may not be able to sweat and become nauseous. Additionally, the individual suffering from heat stress may become confused or delirious and become grow weak or lose coordination. Cold stress may present as frostbite, inflammation of extremities possibly leading to spasms and pain. In extreme cold stress conditions, hypothermia may result. Proper preparation and clothing is are crucial to the well-being of each team member.

The physical environment interacts with the climatic conditions as well. Consider an environment where the ground consists of mostly clay. While on a sunny dry day it is perfectly safe to travel, add a little rain and it becomes slick as ice and treacherous. Each physical environment carries with it specific risks. Frozen tundra, mountainous regions, high altitudes, regions with known seismic activity, deserts, rain forests, and coastal regions subject to tsunamis each dictate unique considerations with regards to personal safety. While it is likely impossible to plan for every eventuality, an enhanced awareness is the first step to not being caught off guard by the environment and its relationship to possible climatic change. This awareness should in turn lead to careful planning and reduce the potential for the physical risks associated with those conditions.

Biological Hazards

Travel to remote areas carries with it inherent risks dictated by the flora and fauna of the region. Regional public health concerns become the concern of the research team as well. A bBiological hazards can be defined as those hazards that pose a risk of infection to the individual. These biological risks may include viral, bacterial, parasitic, or fungal invasion of the body. Malaria, hantavirus, rabies, tetanus, poisonous plant exposure, and poisonous reptiles and insects are a few examples of the many biological hazards encountered in fieldwork. The possibility of contracting an endemic disease in a faraway land, then returning home with it without

knowing the etiological possibilities, may delay diagnosis and treatment by physicians not familiar with illnesses uncommon to their local practice area. Another important consideration is an accurate clinical history. The disorder one may be afflicted with may not have been the result of a biological hazard in some far away land, but rather some condition they came into the country with in the first place. Knowing your body's physiologic response to biological insult is a good way to document and report your clinical history to a healthcare professional.

When considering biological hazards, it is imperative to know the health risks associated with the country and specific region of that country to which you plan to travel. Excellent references regarding the health risk status of various countries are the Center for Disease Control (CDC) and the World Health Organization (WHO). Each of these organizations maintains up-to-date information about endemic diseases and outbreaks of unique diseases in most countries around the world. Each member of the research team must be prepared by having a clear understanding of what biological stew he or she may be heading in to.

Equally important to the team members beyond researching the CDC and WHO information is to consult your primary care physician and a physician who specializes in tropical medicine. It is critical to make arrangements to see these physicians well in advance of the trip, as appointment schedules often need to be made months in advance. In addition, if immunizations are required, appropriate lead time is required for many immunizations of them to be effective. Common immunizations may include yellow fever, tetanus update, hepatitis A, typhoid, and others dictated by the destination. Common required medications may include malaria prevention and prophylactic treatment for altitude sickness. In addition, tropical medicine physicians will often prescribe appropriate antibiotics to be taken should a team member contract a gastro-intestinal infections. Tropical medicine physicians will also be aware of any recent outbreaks in various global settings. With the information provided by the specialist in tropical medicine, the team members canould make an educated decision about the biological hazard potential regarding that specific outbreak.

Just as important as the preparatory immunizations and precautionary treatments, such as malaria prevention, is the need to know what the potentials are for contracting a community-acquired disease in the destination country. A community-acquired disease is defined as a cluster of illnesses usually brought on by an infection contracted from the general public and its communities. These diseases can be viral, bacterial,

fungal, protozoan, or parasitic in nature. Team members' knowledge of the potentials for acquiring such diseases as pneumonias, influenzas, tuberculosis, MRSA, and STDs cannot be understated.

The fundamental teneant for team members traveling to remote field sites or congested municipalities should be to know the environment. If, for example, there is a pathogenic fungal spore known to be endemic to a region, knowing the specific type of fungal infection is critical. Often remote fieldwork requires close contact with the soil in and around ancient tombs. Stirring up these soils can increase the potential for fungal spore introduction by inhalation. Artifacts can be filled with shifting sand and dirt over the centuries and when this soil is removed from a ceramic piece or brushed from the surface of textiles, the risk of rendering the fungal spores airborne is present.

When working in crypts or other subterranean environments, molds are often present. In addition, molds may be present on the mummified remains themselves. Inhalation of mold spores hasve varied effects on different people; however, it is advised to wear a properly fitted filter-type mask when working in these settings. A loosely fitting surgical- type mask may not be enough to adequately filter out the spores as the spores, which to can bypass the filtering surface of the mask, and so it are is not recommended.

Knowing the environment includes not only knowing what diseases may be prevalent in the region but also how those diseases are spread. It is well known that mosquitoes are the vectors for mMalaria, but there are many other diseases and some with unique modes of transmission. For example, Chagas disease is contracted by through the blood-sucking reduviid vector known as the "kissing beetle," that which defecates at the bite site, introducing the protozoan *Trypanosoma cruzi* into the host. Female sand flies found in moist soil, caves, forests, and rodent burrows can transmit forms of leishmaniasis. Again, it is beyond the scope of this book to list all of the potential vector--disease relationships, but awareness on the part of all team members cannot be understated. Pre-expedition research and orientation are critical to the safety of the team.

Although it should go without saying, knowing the food and water quality in the region of the research is critical. It is foolhardy to believe that any water during your travels is safe to drink and not worth the team's consideration. Many parasitic infections arise from drinking contaminated water. In particular, *Giardia lamblia,* which is probably the most common cause of parasite-induced diarrhea, is introduced by the ingestion of environmentally resistant cystic forms from water, food, or from unwashed hands contaminated with fecal matter.

Even water from the nicest hotels and restaurants are is suspect. It is critical to plan ahead for the water and food needs of the team.

Finally, the microenvironment of the mummy itself must be considered. Many embalming chemicals were used and experimented with, resulting in mummified remains. Early medical mummies were embalmed with a variety of heavy metals, such as mercury, zinc, and arsenic. Knowing the mummification chemistry is critical to the safety of the team members.

Practical Considerations and Challenges to Field Paleoimaging

Given the preceding descriptions regarding the various possibilities for physical and biological harm, it would be prudent to adopt a systematic way of preparing for each and every expedition, regardless of location. It is recommended that the research team, institute, or organization conduct a needs assessment regarding the preparation for expeditions and refine those guidelines for each and everyall expeditions. An organizational safety policy should be written, evaluated, and adopted. This policy should include plans for routine re-evaluation of the safety policy as well as training and implementation procedures. Finally, an honest review of the safety policy should be conducted and based upon an annual safety report generated by the organization with the goal of continued refinement.

When preparing for an expedition, one of the most critical considerations is an assessment of the characteristics of the individual team members. A questionnaire can be utilized to ascertain the experience level of the individual, languages spoken, special skills (e.g.: survival, first aid, etc.), food allergies, general medical concerns with a more detailed health statement to follow, demographic information, and level of training in the various aspects of paleoimaging. Knowing your team is critical to a safe expedition. These questionnaires can also be used to direct a formal orientation session targeted to the specific expedition.

One or more of the team members should possess special fundamental skills. These skills would include first aid training for all team members, emergency medical technician certification by at least one team member, and cardiopulmonary resuscitation certification by team leaders. An additional fundamental skill would include rudimentary host- country language abilities. Advanced- skilled personnel may include a health- care professional such as a registered nurse or a physician as a team member whenever possible.

In addition to the assessment of the potential physical and biological hazards, research conducted by the team leaders in preparation for a given expedition should also include an examination of the health-care practices and system (if any) available at the destination. A key factor is for there to be a plan for an alternate "way out." This would include the most expeditious route and the most practical means of transport. Prior arrangements and communication with individuals or organizations that may provide such emergency transport is are important as well. Even with careful planning, a secondary and tertiary plan should be developed. The team must be prepared for a long waiting period for unscheduled transportation needs. Also, a plan for in-country communications should be developed. Communication in the native language is a very helpful skill and understanding the phone or alternate systems for communications is helpful. Radio contact between and among team members is important and requires only a low-technology walkie-talkie system. Additionally, a satellite phone is crucial in extreme remote environments. Researching the road system, regional topography, and/or jungle pathways to the best of one's abilities impacts the safety of the entire team.

A Location Risk Assessment (LRA) document should be developed and presented to each team member. The LRA should begin with a clear statement of the purpose and extent of the research project. Each team member and their primary responsibilities to the team should be clearly stated. A day-by-day plan should be present including the travel plans and dates of the individual team members. Following the descriptive information, the LRA should contain a detailed assessment of a variety of potential risks associated with this specific location. This assessment may be in the form of a checklist using a rating scale or simply identifying those risks, which that appear to be "main risks," associated with the stated expedition. The list may include such variables as access, animals, confined spaces, political unrest, flammable materials, general public safety, as well as many more. The "main risks" are then to be analyzed and described in detail with a statement of what controls will be implemented to minimize that particular risk. The LRA is distributed to the team members prior to their orientation and becomes a reference for those orientations and for their informed consent statement. An example of a complete LRA can be found in the appendices of this book. Table 9.7.4 summarizes the biological hazards considerations to be used during the planning stages.

After careful assessment of the regional physical and biological risks, detailed expedition planning must take place. Many obvious needs of the team

Table 9.7.4 Biological Hazards Considerations—see Text for Details

Biological Hazards
Infection potential – viral, fungal, bacterial, parasitic
Immunizations – research, timing, tropical medicine specialists
Team member health profile
Community acquired disease – local, regional conditions
Disease transmission
Food and water quality
Microenvironment of research objects – fungus, heavy metals
Location Risk Assessment – the LRA document

members, such as food, water, shelter, transportation, and first aid should be considered. It is often recommended and dictated by the remoteness of a given expedition that each team member carry with them the means, supplies, and gear to be self-sufficient for a number of days. The "kit list" will be dictated not only by the identified health and biological risks, but also by the need to be prepared for the unexpected. Therefore, personal medical kits and water- purifying equipment will be recommended for each team member. Some of the less common equipment, such as a sSatellite phone and a Global Positioning System, should be the responsibility of the team leaders. An example of a kit list prepared and used in a recent expedition to the Central Highlands of Papua New Guinea is included in the appendices of this book.

Following the extensive preparatory work, the team leaders should plan a formal orientation session or sessions for the members of the expedition. This orientation should include educational materials and web site links to orient the participants to the geographical location, culture, and health and biological risks. The objectives of the expedition should be clearly presented in detail with specific work tasks for each team member described. Orientation to the instrumentation and techniques should be conducted. A specific presentation should be conducted to assure the participants are aware of the political climate, climatic conditions, and health risks associated with the expedition. The "kit list" should be covered in detail, giving justification to each item as it relates to specific conditions or risks.

It is imperative that the team leaders be aware of the medical condition of each team member. A statement of medical health, an example of which can be found in the appendices, should be on file for every participant. Also, following the orientation(s), a legal waiver and an informed consent consistent with the practices of the sponsoring institution should be on file. These health and consent records and all expedition records of the individual team members should be retained in the

expedition record for a period deemed appropriate by the sponsoring institution's legal counsel.

Several orientations may be in order to get the team field- ready. This includes ample up-front time to allow for proper immunizations and acquisition of country entry visas that may be required. Subsequent orientation sessions also allow the team leaders to assess the "readiness" of individual team members.

Challenges to Field Paleoimaging

Field paleoimaging applications, while desirable, are often faced with a variety of challenges that should be considered when organizing an expedition. In addition to the cultural traditions and the governmental or political challenges, other "cultures" may present as barriers to a field paleoimaging expedition. A field imaging expedition team leader may need to contend with museum culture, the culture of scientific hierarchy, and the culture found within academia. Also, an awareness of the technological aspects of paleoimaging impacts the willingness to grant access on the part of these "cultures." Unfortunately, all scientific endeavors are not altruistic and academic maneuvering may be encountered. Regardless of setting or intent, it is critical that paleoimaging researchers hoping to study mummified remains or artifacts in any of the mentioned cultures consider the impact of those cultures prior to conducting the studies. Varied culture concerns may have a direct impact on the necessary paleoimaging instrumentation and supplies required to obtain the data.

Logistics as a Challenge to Field Paleoimaging

Conducting field paleoimaging research in remote locations requires careful planning. Simply getting to the research site can be a daunting task. Considerations regarding the logistics of field research include equipment selection, supplies, permits and customs papers, visas, in-country travel arrangements, food, and lodging.

While some of these considerations are fairly obvious, the reality is often overwhelming. In planning a paleoimaging field expedition it is important to consider the environment in which the study is to be conducted. It may be as straight forward as driving to a museum. However, getting to more remote sites can be challenging and no matter how much planning is done, the unexpected should be expected. Utilities and transportation are both major considerations. Travel time can be deceiving as there should be time allotted for cancellations and delays that can last for days. Security too, may be an issue.

We offer these considerations only to demonstrate the genuine need to be prepared by knowing as much as possible about where you are going and what you will be doing as possible. In this way, the logistics, though daunting at times, become workable. As one might expect, working in varied field settings requires the paleoimaging team to prepare for additional technical needs that will be required to initiate and complete the study in a safe manner.

Summary

If an expedition is carefully planned, the associated risks can be minimized. When planning any expedition, a genuine assessment of the risk/benefit ratio should be considered. The team leadership must ask itself, are the risks associated with this project worth the potential benefits or outcomes of the research? To determine the risk/ benefit ratio, several scoring systems can be established in order to come to a decision more objectively. Once the risks are known, relative scores can be assigned according to the severity of that risk. Potential outcomes can also be objectified by assigning scores for to such characteristics as, "never been studied before," or, "potential data could add a great deal to the body of knowledge," and so on. The team leaders must realize that they are responsible for the safety of the entire team. Careful planning and team preparation can help control the associated risks and an honest assessment of the value of the potential outcome can reduce the possibility of taking unnecessary risks.

A formal orientation system and established risk-assessment guidelines are both key in any expedition planning. Orientation and awareness can reduce the apprehension level of participants and foster a more productive and risk-reduced fieldwork project.

Team leaders should put great effort into communicating with researchers who have conducted related work in the target geographic location. Realizing that situations can change rapidly and dramatically, past experience can help identify "in-country" individuals who may be useful if unexpected situations arise.

Primary, secondary, and tertiary planning is crucial to the successful safety and health of team members but also to the outcomes of fieldwork projects. Even the best plans can fall hopelessly apart. Critical thinking within the given environment must be fostered immediately upon arrival. It is imperative that ingenuity and improvisation as related to the direction of the research and continued field planning be allowed and openly

practiced, even discussed in daily meetings. The ideas developed on site can create a bank of possibilities for the current and future teams to draw from when the unexpected arrives.

The following references will allow the reader to delve more deeply into the topics introduced in this section. Of particular importance are the web sites for the Center for Disease Control and the regulations section of the Occupational Safety and Health Administration (OSHA) of the United States Department of Labor. The OSHA standards for archaeology are critical when working within the United States and are closely related to the standards for the construction industry.

Bibliography

Flanagan, Joseph. 1995. What You Don't Know Can Hurt You. *Field Archaeology* 8(2):10--13.

Howell, Nancy. 1990. *Surviving Fieldwork: A Report of the Advisory Panel on Health and Safety in Fieldwork, American Anthropological Association.* Washington, DC: American Anthropological Association.

Niquette, C.harles M. 1997. Hard Hat Archaeology. *Society for American Archaeology Newsletter* 15(3): 15--17.

Poirier, David D.A. and Kenneth L. Feder, K.L. (eds). 2000. *Dangerous Places: Health, Safety, and Archaeology.* Westport, CT: Bergin and Garvey, Greenwood Publishing Group.

www.cdc.gov

www.osha-sle.gov/OshStd-toc/OSHA-Std-toc.html

Section 8
Radiation Protection and Safety

9

MARK VINER AND GERALD J. CONLOGUE

Contents

Introduction

X-rays are part of the electromagnetic spectrum and due to their ability to ionize they are classified as ionizing radiation. Biological damage may arise from ionization and the biological effect of radiation is dependent upon the following:

- The intensity, energy, and type of radiation
- The exposure time
- The body area exposed and depth of energy deposition.

It is beyond the scope of this book to consider more than just the very basic properties of X-rays and the biological effects of radiation. A thorough discussion of those and other related topics may be found in Bushong (Bushong 2008a) and Bushberg et al. (2002a). Therefore, this section will review the biological effects of radiation, radiation protection legislation, the basic properties of X-rays, the principles of radiation protection pertinent to a field imaging setting, and finally discuss several plans for establishing a "radiation safe" field facility.

Biological Impact of Radiation

The biological hazards of radiation exposure are discussed in depth by Bushberg et al. (Bushberg et al. 2002b). The effects can be divided into two categories, stochastic and deterministic. Stochastic effects are random or chance occurrences, but the probability of an effect increases with dose. They are associated with low-radiation dose exposures, and Bushberg et al. indicate that radiation-induced cancers and genetic effects are examples of these stochastic effects. The deterministic effects are linked with much higher doses of radiation than would normally be received in a routine medical radiographic examination. The severity of the effect also increases with the dose. Bushberg et al. state that cataracts, erythema, and hematopoietic damage are all examples of deterministic effects.

X-ray photons are high-energy forms of electromagnetic radiation that will always transfer some form of energy to whatever material they interact with. We are most familiar with the photons' capability of knocking electrons out of the orbitals surrounding the nucleus, resulting in ionization of the atom. It is this *ionization effect* that is responsible not only for the biological damage but also for producing the image on the image receptor.

Photons can also create excitation of outer orbital electrons. With this effect, the electron is not knocked out of its orbital, but rather it is lifted or elevated *briefly* out of its orbital ground state. As it returns to the ground state, energy is released. This is the process that is responsible for the light emitted by the intensifying

screens that exposes the film in a traditional X-ray cassette.

The final type of photon energy transfer is thermal. According to Bushberg et al., although heat accounts for the majority of the energy transfer, it would require a *supra-lethal dose* to produce a minimal change in temperature.

Even a limited consideration regarding radiation-induced injury must begin at the atomic level. Our discussion will only consider three possible photon interactions. The first is known by several terms including *classical, coherent, Thomson* (Bushong 2008b), and *Rayleigh* (Bushberg et al. 2002c). With this interaction, the incident photon interacts with the entire atom, not a specific electron. The excited atom emits a photon equal in energy, wavelength, and frequency to the incident photon, but in a different direction. Because the path of this new photon is different, it is termed a *scatter photon* and doesn't contribute to the formation of the image. However, since an electron was not removed, there is no ionization. According to Bushong, this interaction occurs at very low energies, below 10 keV, and is therefore primarily encountered with living patients during mammography. Recall from the previous discussion in Chapter 4: Plane Radiography, Digital Radiography, Mammography, Tomosyntheses, and Fluoroscopy that kVp or peak kilovoltage is what the operator sets on the control panel of the X-ray unit. It represents the maximum kilovoltage during the exposure, whereas keV, or kiloelectron volts, represent the average energy output during the exposure. The keV is usually approximately 60 % of the kVp setting. Therefore, if an exposure is taken at 55 kVp, it will produce an average energy of about 33 keV. According to Bushberg et al. 2002d), only 12 % of the interactions at 30 keV can be attributed to classical scattering. Since the optimal setting for mummified and skeletal remains is 55 kVp, classical scattering will occur during these studies.

In the second interaction, termed *photoelectric effect*, the photon interacts with an inner shell electron of the atom and is completely absorbed. If the photon has sufficient energy, greater than the binding energy of the inner-shell electron, the electron will be knocked out of orbit resulting in ionization of the atom. Since a majority of the low-energy photons are absorbed by dense material, such as bone, photoelectric effect is the predominant interaction at low kV settings, and is responsible for high-contrast images. High-contrast images are composed primarily of black and white with few shades of gray. If the photon passes through the mummified remains or skeletal material unchanged but is absorbed by the phosphors comprising the intensifying screen within the cassette, the screens will fluoresce, exposing the film. The photoelectric effect is also responsible for the formation of the image in CR and DR.

In the third interaction, termed *Compton effect*, the incident photon interacts with an outer orbital electron. Since these electrons are held in place by lower binding energies, it is easier for them to be removed by even low-energy photons. The incident photon only expends a portion of its energy to knock the electron out of obit, ionizing the atom. The interaction not only results in the photon losing some of its initial energy, but also causes it to change direction. Because the photon's path is altered, it becomes a scattered photon and contributes to scattered radiation. Remember, the photon has not lost all its energy and is still capable of ionizing other atoms. The latter consequence presents two problems for the radiographer. If scatter radiation reaches the image receptor, the result will be degradation of the image by a decrease in the overall contrast and a rather gray, insipid image. Restricting the area irradiated by the use of collimation is one of the methods the radiographer will employ to reduce the scatter radiation reaching the image receptor.

Another problem to consider is that if the scatter radiation reaches the individuals participating in the X-ray examination, chemical and molecular changes can take place within them and possibly result in biological damage. The radiographers will apply the cardinal rules of radiation protection to safeguard themselves, patients, and other individuals who need to be in the area from scatter radiation exposure. The cardinal rules will be discussed later; first, a brief discussion regarding the chemical and molecular changes resulting from radiation exposure.

Although radiation interactions begin at the atomic level, they quickly lead to changes at the chemical and molecular levels. The mechanism by which the image begins to form on the film is initiated primarily by light photons from the intensifying screens lysing or breaking the chemical bond between the silver atom and the remainder of the silver halide molecule embedded in the film emulsion. Similarly, biological damage begins with chemical changes that affect important bio-molecules, impairing their ability to function properly. The most important bio-molecule is deoxyribonucleic acid, DNA, and when radiation directly damages the structure, this is classified a *direct effect*. Bushberg et al. (2002e) discuss various mechanisms that exist within cells to repair several types of DNA damage.

Indirect effect results from an X-ray photon cleaving the water molecule. *Radiolysis of water* can produce not only ions but also free radicals. The latter are extremely reactive, can act as a strong oxidizing agent, and have the ability to move through the cell membrane to reach the DNA molecule. In the presence of oxygen, this process is enhanced. Since approximately 80 % of a living

human is composed of water, free radicals are the primary cause of biological damage.

In a healthy individual, cells exposed to very low radiation doses have nearly a 100 % survival rate (Bushong 2008c). However, injury at the molecular level that cannot be repaired can progress through cellular to tissue damage and eventually advance to extensive organ involvement. At low levels of radiation exposures, these are the stochastic effects, and they are generally associated with a long latent period, possibly decades.

There has been some concern recently regarding DNA damage within mummified tissue. However, two factors must be remembered. First, mummified remains are dehydrated. Without the presence of water, the DNA will not be subjected to the byproducts of radiolysis of water. The other point to consider is that the DNA is probably already fragmented due to the mummification process before the remains are exposed to radiation. Ziegler et al. (2013) and Fehren-Schmts et al. (2016) have demonstrated that radiation exposure form plane radiography and MDCT scans did not affect the recovery of ancient DNA.

Radiation Protection Legislation

International recommendations and legislation governing the use of ionizing radiation date from the formation of the International Commission on Radiological Protection (ICRP) established in 1928. The recommendations of the ICRP are utilized by the World Health Organization (WHO) and the International Atomic Energy Agency (IAEA) to implement radiation protection in practice. These policies and recommendations are adopted and adapted by national radiation protection agencies in each country. For example, in the United States the recommendations of the National Commission on Radiological Protection (NCRP) should be followed, whilst in the UK it would be the requirements of the Euratom Basic Safety Standards Directive as set out in the Ionizing Radiation Regulations 2017 (HSE, 2018b).

In the absence of any more specific national or state guidelines, the central principles set out by the ICRP should be followed.

The ICRP considers three main categories of exposure: occupational, public, and medical.

Occupational exposure is defined by the ICRP as all radiation exposures of workers incurred as a result of their work arising from situations that can reasonably be regarded as being the responsibility of the operating management.

Public exposure encompasses all exposures of the public from a source other than occupational and medical exposures.

Medical exposure encompasses all exposures of individuals for diagnostic, interventional, and therapeutic exposures, including those for biomedical research and the exposures incurred knowingly and willingly by individuals such as family or close friends of those undergoing treatment (ICRP 2007; HPA 2009).

In the context of examining archaeological or forensic remains, the principles of radiation protection apply in order to minimize the radiation dose due only to occupational or public exposure.

The 2007 ICRP recommendations (ICRP 2007; HPA 2009) set out the following three central principles of radiological protection:

Justification—*"any decision that alters the radiation exposure situation should do more good than harm"*—This principle applies to all exposure situations.

Optimization of protection—*"the likelihood of incurring exposures, the number of people exposed, and the magnitude of their individual doses should all be kept as low as reasonably achievable, taking into account economic and societal factors."* This principle applies to all exposure situations.

Dose limitation—*"the total dose to any individual from regulated sources in planned exposure situations other than medical exposure of patients should not exceed the appropriate limits recommended by the Commission"*—This principle is related to individuals and applies in planned (and not emergency) exposure situations.

These guiding principles affirm that there must be an established and beneficial purpose of radiation, that procedures should be put in place to limit the radiation dose to individuals, keeping it to within the appropriate limits, and also to ensure that all radiation doses are kept as low as reasonably achievable. The process of optimization—keeping radiation doses as low as reasonably achievable—necessitates that all parts of the chain that is used in the production of X-ray images are working at their optimum. It is outside the scope of this chapter to consider in detail the ongoing quality-control procedures that should be put in place for any X-ray imaging service. However, as a minimum, the X-ray system should undergo regular periodic checks to ensure that there is no radiation leakage, that exposure values are

consistent, and that beam limitation devices, interlocks, and safeguards to prevent accidental radiation exposure are working correctly. Further aspects of quality assurance, including regular checks and maintenance of CR, DR, and film recording and processing systems, display systems, and ongoing training and audit of equipment operators etc. are detailed more comprehensively by Viner and Laudicina (2011).

Of course, there are various types of radiation exposure. Everyone on earth is exposed to ionizing radiation from both natural and artificial sources. Natural or environmentally occurring radiation includes three sources: cosmic or extraterrestrial radiation originating from beyond the earth; terrestrial sources found in the earth, such as radon emitted through a basement; and radiation within our bodies from metabolites of radionuclides such as potassium-40 (^{40}K). Bushong (2008e) has a more in-depth presentation of the topic, but the important point is that he reports the average accumulated annual dose for the USA population from natural sources in 1990 amounted to about 2.95 mSv/yr. Artificial sources, according to Bushong, are primarily from medical imaging, and account for 0.39mSv/yr. He cites that a chest radiographic examination provides a dose of 0.1 mSv.

Taking the above naturally occurring sources into account, recommended dose limits for additional artificial non-medical exposures have been defined by the ICRP and are set out below in Table 9.8.1.

The ICRP recommendations require that whenever radiation exposure is planned, a prior assessment of the risks is made, and that any necessary precautions identified by the risk assessment are put in place in order to restrict the radiation exposure to both operators of the equipment and the public, such that they could not exceed the above limits (ICRP 2007).

In order to understand the implications of these dose limits, it is important to have a basic understanding of how radiation doses are measured.

Table 9.8.1 ICRP Recommended Dose Limits in Planned Exposure Situations

Type of Limit	Occupational	Public
Effective dose	20 mSv per year (averaged over defined period of five years)	1 mSv in a year
Annual equivalent dose in:		
Lens of the eye	150 mSv	15 mSv
Skin	500 mSv	50 mSv
Hands and feet	500 mSv	–

Source: ICRP (2007)

Measurement of Radiation Dose

Radiation dose is measured as *absorbed*, *equivalent*, and *effective dose*. These different quantities are used to specify the dose received and the biological effect of that dose.

- Absorbed dose is defined as the energy deposited per unit mass of material. It is a physical measurable quantity and is measured in Gray (Gy). One Gray is equal to one Joule per kilogram.
- Equivalent dose takes into account the type of radiation and reflects the biological damage from different types of radiation. Thus, the damage from alpha particles for example is greater than that from X radiation, for example, as alpha particles are less penetrating and deposit more of their energy in the skin, thus creating more biological damage. To calculate equivalent dose, the absorbed dose is multiplied by the weighting factor. Equivalent dose is measured in Sieverts, where one Sievert (Sv) is equal to one Joule per kilogram. As only X-rays are used for examination of archaeological subjects, the context of this volume, it is only necessary to discuss the weighting factor for X-rays, which is equivalent to 1.
- Effective dose takes into account the type of tissue exposed to radiation as well as the radiation type. Radiation will have different biological effects in different parts of the body due to the different radio sensitivity of the organs and tissues. The effective dose provides a dose value for the whole body and precisely correlates to the radiation risk. To calculate effective dose, the equivalent dose to a specific organ is multiplied by the organs tissue weighting factor. This is repeated and summed up for all organs. The effective dose is also measured in Sieverts.

(The above section makes use of the standard Système International (SI) units of the Gray and Sievert, which was adopted in 1981 by the International Commission on Radiation Units and Measurements (ICRU). It should be noted here that some countries, including the USA, are still using the older system of units to measure radiation (Bushong 2008d). The older system, commonly termed *customary units*, includes the *roentgen, rad,* and *rem*. The roentgen (R), was the first, defined in 1928, and is used to monitor the ionization of air. The rad is the *radiation absorbed dose* for any type of ionizing radiation by any

organism or object except humans. It relates to the biological effectiveness of the radiation. The third unit, the rem, relates to the *radiation equivalent man*, although it applies to all humans, male or female. For X-ray, one roentgen equals one rad equals one rem. In SI units, the equivalent of the roentgen is the *Gray* dose in air, Gy_a and 100 R is the equivalent of 1 Gy_a. The Gray is also the basis of the SI unit for the radiation absorbed dose; however, to differentiate it from air, Gy_a, it is designated as Gy_t, where *t* indicates tissue; 100 rad are equivalent to 1 Gy_t. The SI unit for equivalent dose is the Seivert, Sv, and 100 rem are equal to 1 Sv.

International and national regulations will stipulate the requirement for radiation monitoring of individuals. This will usually occur if the individual is likely to receive a radiation dose above a certain level in any year. Although wearing one of the several types of monitoring devices does not, in itself, provide any protection from radiation exposure, it generates valuable information. Radiographers, those individuals who operate the equipment, are usually required to wear at least one monitoring device that is *read* on a routine basis, usually monthly, bimonthly, or quarterly. Those reports are posted, and the record follows the individual even if they change employers. Readings also serve as a mechanism to evaluate the radiation protection practices developed for a specific procedure. If high readings were reported, either the equipment operator was careless and requires additional education, or the procedure needs to be redesigned. It should be noted that monitoring is not required in all situations and the decision to do so will be taken based on the level of risk involved. For short, low-radiation-level projects involving few exposures at a low-dose level, it may not be necessary to employ monitoring procedures. It should be noted, however, that monitoring can be extremely useful in confirming the efficacy of radiation-protection procedures and should be considered as desirable in all situations.

Practical Radiation Protection

If the imaging studies are going to be conducted at any type of medical imaging facility within developed countries, strict radiation protection practices should already be in place. In the USA, the American College of Radiology (ACR) has established guidelines regarding practices and procedures that minimize radiation exposure to patients, staff, and the public, while insuring that the required diagnostic image quality isn't compromised (Brusin 2007). In addition, individual states may have their own radiation protection requirements

maintained either by the State Department of Health or a State Radiation Control Commission (Viner et al. 2011a). Similar guidance and legislation are in place throughout Europe, Australasia, and many other countries. It should be noted, however, that such guidance is primarily intended for radiation protection in situations where medical exposures are planned (see ICRP definitions above), and certain aspects do not apply to the examination of the deceased or inanimate objects. For example, it is usual for the radiographer to remain in the same room as the patient whilst an X-ray is taken and to be protected by the use of a lead shield and lead glass shield, or in some cases a lead rubber apron. This is so that the patient, who may be very ill or undergoing a treatment procedure, can be visually monitored throughout. It is usually not necessary for the radiographer to remain in the room (or controlled radiation area) if an inanimate object or mummy is being radiographed, and thus the shield in the area may not be required.

Notification

It may be necessary in some jurisdictions to inform the authorities of an intention to commence working with radiation and register with a regulatory body. In the case of field equipment, this is often a one-off process that registers the owner of the equipment and provider of the service as the responsible authority. In some jurisdictions, it is now required for this notification process to occur annually (HSE 2018a).

Radiation Risk Assessment

Before commencing any new activity involving radiography in an anthropological, archaeological, or forensic field setting, a radiation risk assessment should be conducted for the purpose of identifying the measures that need to be taken to restrict the exposure to radiation of the operator and any other person. The assessment should identify all hazards with the potential to cause a radiation accident and assess the nature and magnitude of the risks to operators and any other persons arising from these hazards.

The radiation risk assessment will assist with the development of a plan to ensure that the radiation exposure of all people is kept as low as reasonably practicable and identify the steps necessary to achieve this control of exposure by the use of engineering controls, design features, safety devices, and warning devices, and to develop systems of work. It will also identify whether it is appropriate to provide personal protective equipment

and, if so, what type is adequate and suitable. It should also take into consideration the need to alter any working practices of any operator who may be pregnant or breastfeeding and identify an appropriate investigation level to check that exposures are being restricted as far as reasonably practicable.

This is not, and should not, be considered as an onerous requirement, as in its simplest form it requires a table-top evaluation of the work to be undertaken and the likely radiation exposure settings to be used; a sketch (with dimensions) of the area, basic construction of walls, floors, and ceilings; and some knowledge of what and who lies beyond these. The risk assessment should be undertaken by either a radiation physicist or a radiographer or radiologist with appropriate training in radiation protection who is able to consult with such a radiation physicist. In many cases, an experienced radiographer may be able to use data from a previous and similar risk assessment from another project, consulting with a physicist where necessary to verify any calculations. A major medical imaging facility could serve as a source for the physicist and/or radiographer and also provide information regarding acquisition and the proper use of radiation monitoring devices (Viner et al. 2011b).

Radiation Protection Plans and Procedures

Following completion of the risk assessment it will be necessary to devise a radiation protection plan to ensure that appropriate measures are put in place in order to restrict the radiation dose to the operators and any other person. This radiation protection plan and procedures (sometimes called "Local Radiation Rules") should contain as a minimum (HSE 2018b):

1. Details of the management and supervision of the work; including
 a) Details of the person or body responsible for the work (employer or other).
 b) Details of the radiation physicist who has been consulted in preparation of the plan and who oversees the work (sometimes referred to as the radiation protection advisor).
 c) Details of the person who has been designated as being responsible for the day to day supervision of the work (sometimes referred to as the radiation protection supervisor and most likely to be the senior radiographer).
 d) Procedures for ensuring that operators have received sufficient guidance, information, instruction and training.

2. Details of the area covered by the rules and procedures
 a) The identification and description of the area covered, with details of its designation *e.g.: controlled area.*
 b) A plan of the area showing relevant entry and exits, the location of the X-ray source, and any permanent radiation protection barriers.
 c) A summary of the working instructions appropriate to the radiological risk associated with the source and operations involved, including the written arrangements relating to non-classified persons entering or working in controlled areas.
 d) Availability and use of any personal protective equipment.
 e) Details of any monitoring arrangements and the dose investigation level specified.
 f) Identification or summary of any contingency arrangements indicating the reasonably foreseeable accidents.
 g) Details of the equipment and inspection periods.
 h) Date of plan and date of revision.

The Radiation Area

There are three cardinal principles of radiation protection. They are time, shielding, and distance. These should be borne closely in mind when deciding the location and size of the radiation area and devising the radiation protection procedures.

Distance

Of the three, distance is the most relevant to a field situation. As previously discussed, the photon beam diverges from the X-ray source. If an individual doubles the distance between themselves and the source, for example from 3 ft (0.9 m) to 6 ft (1.8 m), the intensity of radiation decreases by 75 %. Therefore, in the field, the individual taking the exposure should be as far away from the source as possible. Most portable units are equipped with a cord that will permit a distance of 6 ft (1.8 m) to 10 ft (3.0 m); however, they can be easily modified to allow a minimum of at least 12 ft (3.7 m).

In many circumstances, where standard medical diagnostic exposures are used, a distance of 9 ft (3 m) will be more than adequate. The actual distance required will be related closely to the kVp setting and

will be calculated by the physicist as to be the distance at which the radiation dose is so reduced as to be equal to or lower than the annual maximum permissible dose for a member of the public as defined by the ICRP. Remember, the kilovoltage determines the penetrating power of the beam and both are directly proportional. Low kVp accelerated photons have a greater probability of being attenuated or absorbed by the material they initially encounter. Additionally, with the low setting, fewer of the photons exiting the object will result in scatter radiation. Since 55 kVp is the optimal setting for an examination of mummified remains, a distance of 9 ft (3 m) from the source should be sufficient. It is however important to point out that the 9 ft (3 m) should be measured in all directions from the X-ray source (including above and below, which are sometimes forgotten!) AND that this figure only applies for protection from scattered radiation and not "primary beam" radiation—when the source is pointing in the direction of the individual.

As a general rule, the primary beam should never be directed towards an occupied area. If this is not possible, then a much greater distance (or shielding—see below) should be used.

Shielding

If sufficient distance cannot be achieved due to space constraints, shielding can be used to attenuate the X-radiation and reduce the dose. In all circumstances, the distance plus any shielding should reduce the radiation exposure to be equal to or lower than the annual maximum permissible dose for a member of the public. There is a popular misconception that the only material that can be used is lead but this is not the case (British Institute of Radiology, 2000). Lead is indeed an excellent attenuator of radiation, and the thickness of lead that is required to reduce the radiation exposure to the necessary level is often determined in millimeters, making it an ideal material for lining walls, etc. However, other materials, such as concrete, brick, plaster, and even earth are just as good—but of course a greater thickness will be needed. Radiation barriers are thus described and measured in terms of their "lead equivalence"—i.e.: the thickness of lead (usually in millimeters) that would be required to attenuate the radiation to the same extent. Thus, a brick and plaster wall of several inches' thickness may be described as being 2 mm lead equivalent.

In a medical imaging facility, the department walls and doors are lined with lead or barium plaster. Leaded glass or acrylic windows permit the radiographer to directly observe the patient during a radiation exposure. Mobile leaded partitions with a leaded window have been employed in the operating room during fluoroscopic procedures. In addition, during fluoroscopy, leaded aprons, gloves, and thyroid shields are available to protect radiologist, radiographers, and other individuals required to be in the room with the patient during the examination. Shielding, such as a lead apron, can also be placed under the image receptor to absorb scatter radiation.

Certainly, aprons and lead sheeting can be brought into the field. However, the additional weight of the leaded material may create a transportation concern. In the field setting, it may be easier to employ materials at hand. For example, a 3 ft (0.9 m) concrete block wall can be constructed between the location of the X-ray unit and the person taking the exposure. In addition, the image receptor can be placed close to the floor in order to minimize scatter radiation.

Time

Time refers to limiting the amount of time that an individual is exposed to radiation. When working with live patients, limiting the number of repeat images would minimize the number of *times* that a patient would be exposed. Also in the clinical setting, the radiographer would rotate through various imaging areas, such as portable radiography and fluoroscopy, which would increase their probability of higher radiation exposure. However, with field radiography, all the images are done with a portable unit. Limiting the number of repeat radiographs will certainly decrease the exposure *time*. Still, the most effective approach to radiation protection would be to get as far from the X-ray source as possible and or use shielding to reduce the exposure.

Radiation Protection in the Field

With these basic principles in mind, the establishment of a field facility can be considered. However, before the design of the facility can be envisioned, the first step will be to determine the X-ray unit requirements. If the objective of the imaging study is limited to the examination of mummified and skeletal remains and utilizes conventional film as the recording media, the unit need not exceed 55 kVp. However, if pottery and similar objects are included in the study, the X-ray unit must be capable of 80 kVp. After the unit has been selected, test exposures should be made simulating the field situation. The DR plate or every CR or film cassette that will be used and samples of the film should be exposed at the intended SID. Testing the cassettes will insure that

all are free of artifacts and have good screen/film contact over the entire surface. Although the actual conditions in the field may be quite different from the test conditions, for example manual processing instead if an automatic processor, this provides an opportunity to establish a starting position once in the field. In addition, it will permit the radiation output of the X-ray unit to be calculated. The latter will be an important consideration in establishing a radiation protection plan. The device employed to obtain the reading, an mGy/mAs meter, should be available from a major medical center or a radiation physicist.

This unit records the quantity of ionization measured in milliGray per mAs set on the control panel of the X-ray unit. For an example, consider a study of mummies in Guanajuato, Mexico, where the typical exposure was 56 kVp at 1.9 mAs. The mGy/mAs meter reading for that exposure, at the center ray point on the cassette, was 0.053 mGy/mAs at a 100-cm (40-in) SID.

The next factor to be considered is the projected workload. The number of radiographs taken per day must be considered before deciding on the optimal location to place the X-ray unit. Continuing with the Guanajuato example, a total of 196 35 × 43 cm (14 × 17 in) films were taken in six days, or approximately 33 films per day. With an output of 0.053 mGy/mAs, the total exposure for each day at the film was 1.75 mGy.

With such information and calculations, the total radiation exposure for the project can be calculated and this can be extrapolated to give an estimated annual radiation dose. As mentioned above, the ICRP has established a recommended dose of 20 mSv/yr for operators. For the public, the dose limit is reduced to 1 mSv/yr.

The area in which radiation exposures are made will normally be designated as a controlled area, and this will need to be defined in the radiation procedures and Local Rules (above). The precise definition and dose requirements for designation of such areas will be set out in the regulations and recommendations pertinent to the jurisdiction in which the work will take place, but as a general rule an area should be designated as controlled *"if it is necessary for any person who enters or works in the area to follow special procedures designed to restrict exposure to ionizing radiation in that area or prevent or limit the probability and magnitude of radiation accidents or their effects"* (HSE 2018a).

Outside of this area, the radiation dose should be no greater than one third of the public dose limit (1 mSv/yr) = 0.3 mSv/year, and barriers, procedures, and design features should be put in place within the controlled area to ensure that this is the case.

Not only the number of radiographs but the projections required must be determined before the X-ray unit can be brought into the room or designated space. The X-ray unit should be positioned at least 2 m (>6ft) from the door and the tube directed toward the floor for AP or PA projections. If skeletal material is the object of the study, the remains can be rotated into a lateral projection; however, it is not advisable to rotate mummified remains. Consequently, a horizontal beam will be required for lateral projections and the tube should be directed toward the outer wall for these exposures. To minimize equipment manipulation, the unit should be placed into the area taking into consideration all projections that will be required. It is therefore necessary to select an area that will have enough space to permit manipulation of the X-ray unit and adequate access around all the equipment. The location of the X-ray unit should always be away from high traffic areas or adjacent to rooms or spaces that are going to be occupied during the radiographic examinations. The walls should be concrete block or some other masonry material. A basement area or a room in an out-building would be preferable.

Bushong (2008f) has an entire chapter, *Designing for Radiation Protection*, devoted to the topic in his book. However, only the points relevant to our discussion will be considered here. As indicated with the Guanajuato project, the output of the X-ray unit monitored by the mGy/mAs meter at the center of the film was 0.053 mGy/mAs. If an area of 12ft (3.7 m) was established around the X-ray source, applying the inverse square law [(0.053 mGy)(1/12)2], the exposure at 12 ft (3.7 m) would be reduced to 0.00037 mSv (0.37 microSieverts). Taking into account the entire 196 exposures during the six-day project, the total exposure at 12 ft (3.7 m) would be 0.07252 mSv without using any type of barrier.

If the radiation area is surrounded by walls, the radiation dose will be attenuated further. According to Bushberg et al. (2002f), a 3-in (76-mm) concrete block will reduce a primary beam from a 150 kVp exposure to its tenth value layer (TVL) or by a factor of 1028 (9.7×10^{-4}). Therefore, with the low kVp, there would be negligible radiation penetrating the wall from scattered radiation. Certainly, the other side of the concrete wall would satisfy the requirement to reduce the radiation dose outside the area to less than the annual public dose limit.

Ideally, the operator should be able to leave the room whilst making the exposure, and this can be achieved if a doorway is incorporated into the design. If we assume that the center of exposure is positioned 2.7 m (9ft) from the door, at the door, the 0.053 mGy exposure would be reduced to a dose of [(0.053) (1/9)2] 0.0654 mSv. If the cord is extended around the door so that the concrete block wall serves as a barrier, the exposure is reduced by

the attenuation of the concrete block as detailed above. If a doorway isn't available, a concrete block wall 3 ft (0.9 m) high and 4 ft (1.2 m) wide can be constructed virtually any place to serve as a barrier to crouch behind when making an exposure in the controlled area.

Worked Example

It was proposed that archaeological remains should be examined by direct digital X-ray at the offices of an archaeology team in Oxford, England. The room designated for use as the X-ray area was the ground-floor meeting room, which was 4.6 m × 4.2 m with only one entrance. The ceiling height was 3 m and there was no room below. Walls and ceilings were made of either 100 mm brick (external) or 25 mm plasterboard (internal) and there was a 3 mm plate glass window along one side of the room, which overlooked a path that was used by staff.

1. **Risk Assessment and Dose Calculation**

 The dose/shielding assessment calculations found in Appendix J.1 were undertaken by the radiation physicist using figures provided by the radiographer together with measured output values undertaken by the physicist during the annual QA tests on the unit.

2. **Local Radiation Rules**

 Following the risk assessment and site survey, Local Radiation Rules were put in place for the Oxford project and are found in Appendix J.2.

References

British Institute of Radiology (BIR). 2000. *Radiation Shielding for Diagnostic X-Rays* (Sutton and Williams, Eds). British Institute of Radiology.

Brusin, JH. 2007. Radiation protection. *Radiologic Technology* 78(5):378–392.

Bushberg, JT, AJ Seibert, EM Liedholdt, JM Boone. 2002a. *The Essential Physics of Medical Imaging*, 2nd ed., pp. 739–861. Philadelphia, PA: Lippincott Williams & Wilkins.

Bushberg, JT, AJ Seibert, EM Liedholdt, JM Boone. 2002b. *The Essential Physics of Medical Imaging*, 2nd ed., p. 814. Philadelphia, PA: Lippincott Williams & Wilkins.

Bushberg, JT, AJ Seibert, EM Liedholdt, JM Boone. 2002c. *The Essential Physics of Medical Imaging*, 2nd ed., p. 37. Philadelphia, PA: Lippincott Williams & Wilkins.

Bushberg, JT, AJ Seibert, EM Liedholdt, JM Boone. 2002d. *The Essential Physics of Medical Imaging*, 2nd ed., p. 38. Philadelphia, PA: Lippincott Williams & Wilkins.

Bushberg, JT, AJ Seibert, EM Liedholdt, JM Boone. 2002e. *The Essential Physics of Medical Imaging*, 2nd ed., p. 816. Philadelphia, PA: Lippincott Williams & Wilkins.

Bushberg, JT, AJ Seibert, EM Liedholdt, JM Boone. 2002f. *The Essential Physics of Medical Imaging*, 2nd ed., p. 765. Philadelphia, PA: Lippincott Williams & Wilkins.

Bushong, S. 2008a. *Radiologic Science for Technologist*, 9th ed., pp. 500–629. St. Louis, MO: Elsevier Mosby.

Bushong, S. 2008b. *Radiologic Science for Technologist*, 9th ed., p. 163. St. Louis, MO: Elsevier Mosby.

Bushong, S. 2008c. *Radiologic Science for Technologist*, 9th ed., p. 529. St. Louis, MO: Elsevier Mosby.

Bushong, S. 2008d. *Radiologic Science for Technologist*, 9th ed., p. 35. St. Louis, MO: Elsevier Mosby.

Bushong, S. 2008e. *Radiologic Science for Technologist*, 9th ed., p. 6. St. Louis, MO: Elsevier Mosby.

Bushong, S. 2008f. *Radiologic Science for Technologist*, 9th ed., pp. 586–587. St. Louis, MO: Elsevier Mosby.

Fehren-Schmits, L, J Kapp, KL Ziegler, KM Harkin, GP Aronson, G Conlogue. 2016. An investigation into the effects of X-ray on the recovery of ancient DNA from skeletal remains. *Journal of Archaeological Science*, 76: 1–8.

ICRP. 2007. *The 2007 Recommendations of the International Commission on Radiological Protection*. ICRP Publication (103. *Ann ICRP*, 37).

Health Protection Agency (HPA). 2009. *Application of the 2007 Recommendations of the ICRP to the UK—Advice from the Health Protection Agency*. HPA, Didcot, UK.

Health & Safety Executive (HSE). 2018a. *Ionising Radiations Regulations 2017, Approved Code of Practice and Guidance*, 2nd ed., p. 22. Her Majesty's Stationery Office.

Health & Safety Executive (HSE). 2018b. *Ionising Radiations Regulations 2017, Approved Code of Practice and Guidance*, 2nd ed. Her Majesty's Stationery Office.

Viner, MD, PF Laudicina. 2011. Organisation & management of forensic radiology. In Thali MJ, Viner, MD, Brogdon, BG (Eds), *Brogdon's Forensic Radiology*, 2nd ed., pp. 502–503. Boca Raton, FL: CRC Press.

Viner, MD, CW Newell, CM Jalkh. 2011a. Facility, equipment & radiation protection. In Thali MJ, Viner, MD, Brogdon, BG (Eds), *Brogdon's Forensic Radiology*, 2nd ed., p. 517. Boca Raton, FL: CRC Press.

Viner, MD, CW Newell, CM Jalkh. 2011b. Facility, equipment & radiation protection. In Thali MJ, Viner, MD, Brogdon, BG (Eds), *Brogdon's Forensic Radiology*, 2nd ed., p. 519. Boca Raton, FL: CRC Press.

Ziegler KL, G Conlogue, R Beckett, T Blyth, GP Aronson, L Fehren-Schmitz. 2013. An investigation into effects of X-ray on the recovery of DNA from skeletal remains. *American Journal of Physical Anthropology*, 150(S56): 299.

Appendices

Appendix A: Radiography Field Data Sheet

Project Name: _____Location: _____ Date: _____

Radiographer/Radiographers: _____

Students: _____

Others: _____

X-Ray Source: _____ Image Receptor: _____

Type of Object/Objects/ID: _____

Description: _____

Contacts _____

Location _____ Date: _____

Date	Image #	Beam Orientation	SID	Photos	Description	Time In	Time Out	Plate (CR/DR/ Film*)	Exposure	EI/S#

*** If film is the recording media, screen vendor, note screen speed, type of film used**

Appendix B: Recording Form for Multi-Detector Computed Tomography

Recording Form for Multi-Detector Computed Tomography (MDCT)

Object Identification:_____ Date: _____

Vendor _____ Model _____

Photographs of Set-up _____

Volume Acquisition

 kVp: Single _____ or Dual _____ , _____

 mA: Manually Set: _____ or Automatically Modulated: _____

 Field-Of-View (FOV): _____ Slice thickness: _____

 number of detectors activated: _____

 Helical Pitch (HP): _____ or Pitch Factor (PF): _____

 Reconstruction Algorithm _____

3D Reconstruction

 Slice thickness: _____ Reconstruction Interval _____

 Reconstruction Algorithm _____

Appendix C: Micro-CT Recording Form

Date: _____

Goal of Imaging Session:

Scan	kVp	uA/mA	watts	exposure (msec)	# of projection images	# of frames for frame averaging	length of scan (hrs:min:sec)

Scan	voxel size (single # if isotropic)	filter / thickness	target material	scan mode	file name

Scan	Shading correction details	reconstruction details	comment

Acquisition software name/version:_____
Reconstruction software name/version:_____

Operator:_____
Imaging facility:_____

Location of data & backup:_____

Comment:_____

Photo of object

Appendix D: Recording Form for XRF

RECORDING FORM FOR XRF EXAMINATION OF MUMMIFIED OR SKELETAL REMAINS AND RELATED MATERIALS

Site/Name/Number:_____ Case#: _____

Tomb/Burial Number:_____ Date: _____

Burial/Skeletal Number:_____ Operator: _____

Location of study:_____

Skeletal:_____ Condition:_____ Complete/Partial:_____

Mummified: Complete/Partial:_____ Observed state of Preservation:_____

 Wrapped/Material: _____

 Related material or artifacts _____

Radiographic Findings (include radiograph #/view/findings):

Endoscopic findings (include image ID) _____

Instrumentation/Recording Media:_____

Objective/Exploratory: _____

Additional Comments: _____

Calibration Y/N_____ kV_____ microA_____ Filter_____ Vac Y/N ___ Exp time_____

Special considerations:_____

Trace ID #	Trace Location Target	Major Elements	Element Confirmed in 2 shells Y/N	File Saved Y/N As: enter file name

Comments/Impressions/Plans:

Appendix E: Recording Form for Endoscopic Examination of Mummified or Skeletal Remains (see Chapter 2)

RECORDING FORM FOR ENDOSCOPIC EXAMINATION OF MUMMIFIED OR SKELETAL REMAINS

Site/Name/Number:_____ Case#: _____

Tomb/Burial Number:_____ Date: _____

Burial/Skeletal Number:_____ Endoscopist: _____

Location of study:_____

Skeletal:____ Condition:_____ Complete/Partial:_____

Mummified: Complete/Partial:_____ Observed state of Preservation:_____

 Wrapped/Material: _____

Radiographic Findings (include radiograph #/view/findings):

Instrumentation/Recording Media:_____

Objective/Exploratory: _____

Additional Comments: _____

Notes: Photograph and **use anatomical sketches** to demonstrate each **entry point** for inclusion in the report. With industrial **video-endoscopes note lens tip, angle, stereoscopic, etc. Cavities: C** = cranial vault, **T** = thoracic, **O** = oral, **A**= abdominal, **P**= pelvic, **LB** = long bone, **W**= w/in wrappings. **X-ray**: Use **two views** for endoscope location: record views **AP** = anterior posterior, **L** = lateral, **TNS** = Towne's, etc. and document **plate #.**

Cavity	Access	X-ray	Record#	Findings	Biopsy#	Spec Proc#
1						
2						
3						
4						
5						
6						
7						
8						
9						
10						
11						
12						
13						
14						
15						
16						
17						
18						
19						
20						

Case #: _____

 Endoscopist/date: _____

Biopsy Record: Biopsy instrument: _____

Analyses to be conducted: _____ Probable lab(s) _____

Biopsy#	Sample site	Probable tissue/organ	Approx. Vol.	Visual Description

Special Procedure Record:

Artifact retrieval: _____

Alternate Light: _____

CT/Fluoroscopic Guided: _____

Secondary Illumination: _____

Other: _____

Overall Comments/Procedural Efficacy:

'The Bioanthropology Research Institute at Quinnipiac University, Hamden, Connecticut'

Appendix F: Radiologist Report Form—Preliminary Interpretations

Field Radiography Study: Preliminary Interpretations: Mummified Remains

Project Name:

Mummy # _____ Position: Extended ☐ Flexed ☐

Photograph the remains in position for the radiographs. Later, include the photographer here and indicate the position of each imaging plate.

Radiologist _____ Location _____ Date: _____

Mummy #	Image #	Interpretation

Radiologist _____ Location _____ Date: _____

Skeletal Summary

Region	Image #	Findings
Skull		
C-Spine		
Chest/Ribs		
T-Spine		
Humerus		
Radius/Ulna		
Hand		
Abdomen		
L-Spine		
Pelvis/Hip		
Femur		
Tibia/Fibula		
Foot		

Approximate Age _____ Sex _____

Dental Radiologist _____ Location _____ Date: _____

Permanent Dentition: Gross Findings

Comments:

Dental Radiologist _____ Location _____ Date: _____

Permanent Dentition: Image Findings

Comments:

Dental Radiologist _____ Location _____ Date: _____

Deciduous Dentition: Gross Findings

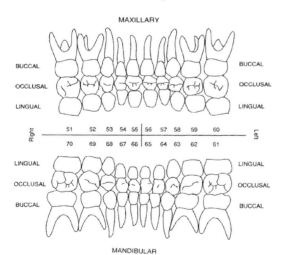

Comments:

Dental Radiologist _____ Location _____ Date: _____

Deciduous Dentition: Image Findings

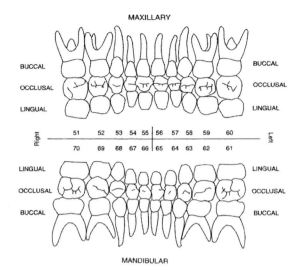

MAXILLARY

BUCCAL										BUCCAL
OCCLUSAL										OCCLUSAL
LINGUAL										LINGUAL

Right | 51 52 53 54 55 | 56 57 58 59 60 | Left
70 69 68 67 66 | 65 64 63 62 61

LINGUAL · · · LINGUAL
OCCLUSAL · · · OCCLUSAL
BUCCAL · · · BUCCAL

MANDIBULAR

Comments:

Appendix G: Example of Risk Assessment Documentation (see Chapter 9 Section 7)

Bioanthropology Research Institute at Quinnipiac University (BRIQ)
LOCATION RISK ASSESSMENT (inc Fire RA)

PROJECT NAME: PNG Mummies

DATES: 26th May – 17th June 2008

Project Manager:	**Office Telephone:**	**Mobile:**
Project Director:	**Phone:**	**Email:**
Health & Safety:	**Office Telephone:**	**Email:**

Written description of action covered by this RA:

This project will explore the culture of the Kukukuku people of Koke and Angabena villages in Papua New Guinea. The project will focus on local traditions of mummifying the dead.

Before every workday and specific activity, the Project Director will have a Health and Safety meeting with all team members, local contacts, and guides to go through all Health and Safety procedures where designated persons will be responsible for certain people or tasks for that day.

If the director is unable to contact either the office or the insurance company in case of changes to work sequence, the Health and Safety meeting must be documented before any changes are made, so that we have a record of what and who were made responsible for the filming sequences.

Team Members

Project Director –
Assistant Director –
Contributor – Paleoimager –
Other Contributors – Paleoimager –
Expedition Leader –
Director of Photography –
Animal Wrangler –
Local Contacts –
Students Leader(s) –
Students Participating –
Etc.

Project Day By Day Breakdown

26th May – Team leaders travel to PNG
27th May – In-country preparation
28th May – Contributors, students arrive, PNG
29th May – Work in Lae/travel internally in PNG
30th May – Travel internally in PNG
31st May – Recce

1st June – Recce
2nd June – Recce
3rd June – Equipment and additional personnel travel on to Lae/Aseki
4th June – Prep/rest day
5th June – Project begins
6th June – Project continues
7th June – Project continues
8th June – Project continues
9th June – REST and team travel to Aseki
10th June – Project continues
11th June – Project continues
12th June – Project continues
13th June – Project continues
14th June – All depart Aseki to Bulolo
15th June – All travel to Port Moresby
16th June – All depart Papua New Guinea

HAZARD CHECKLIST

No.		Tick	No.		Tick
1	Access/egress (blocked – restricted)	x	23	Live electrical equipment/tools/lasers/strobes	x
2	Alcohol/food/drinks/supplies	x	24	Manual handling/heavy loads	x
3	Animals/insects/wild	x	25	Lone working	
4	Any special tools under direct control of team		26	Night operations/camping/recces	x
5	Compressed gas/cryogenics/low temperatures (see also 34)		27	Noise/high sound levels/gunshot/cannon fire	
6	Confined spaces/tanks/tunnels	x	28	Practical fire/flame/flambeaux/camp fires	x
7	Dangerous activities/stunts/reconstructions		29	Radiation/infra-red/ultra-violet/radio frequency	x
8	Derelict buildings/dangerous structures	x	30	Scaffolds/rostra/platforms/practical staircase/ walkways/decking	
9	Diving operations/underwater activities		31	Scenic/materials (toxic/fire retardant/glass)	
10	Explosives/pyrotechnics/ordinance		32	Special 'flying'/technical rigs for transport	
11	Fatigue/long hours/physical exertion	x	33	Special needs/children/elderly/disabled/ language barriers/students	x
12	Fire prevention/evacuation procedures/smoking on location/fire risk assessments	x	34	Special climates: rain/snow/fire/ smoke/steam/dry ice/heat/rock fall	
13	First aid/medical arrangements/inoculations/infections disease/medical stock/tropical conditions	x	35	Scenery/props storage	
14	Flammable materials/film stock		36	Technical facilities/darkroom/film changing/ scanners/PSC/OBs etc.	
15	Flying (aircraft, balloons, parachutes)	x	37	Vehicles/motorcycles/speed/driving	x
16	Freelance crews and contractors to be advised of safety procedures	x	38	Water/proximity to water/tanks/boats (see also 9 – diving operations)	
17	General public/safety – crowds – arrangements for safety/ audiences/spectators	x	39	Weapons/knives/firearms	
18	Hazardous substances e.g. chemicals/dust/sand/fumes/ poisons/Asbestos/battery acid/waste disposal/animal waste/fuel/blood		40	Work at height: zip-up/ladders/ropes/climbing equipment	
19	Heat/cold/extreme climate/weather changes	x	41	Working on roofs/cliff tops/mountains/bridges	x
20	Hostile environments/political unrest/war/mines/local crime/crew communication/ETAs	x	42	Work areas/security/storage/welfare facilities	
21	L.P.G./bottled gases		43	Work in public places/roads/farms/airports/ railways	
22	Lifting equipment/forklifts/cranes/cherry picker		44	Others/misc. items/travel arrangements	

Hazard Number & Level of Risk	MAIN RISKS IDENTIFIED (Describe the risks and the people affected. State if you consider them to be high (H), medium (M), or low (L) before any controls are introduced)	CONTROLS TO MINIMIZE RISK Describe the controls you intend to introduce and indicate the risk state after control initiatives are introduced. i.e. (H/M/L) Ensure persons responsible for taking action in the control procedure are named and a copy of this assessment is given to them.
1	**Access/egress (blocked – restricted)** The project locations are in remote areas of Papua New Guinea. Due to the country's terrain and internal road infrastructure, compounded by the current weather conditions, the access and egress to these locations takes some time, there are poor communications along the route, and it can become blocked. Further to this, it is a poor country and there are known bandits that operate on these routes and the convoy of western visitors may attract unwanted attention.	In response to the risks identified, the following plan of action is in place. The BRIQ has employed the services of the Expedition Project Management Company EPM to facilitate this project. EPM Ltd is an established expedition logistics company working with private clients and researchers. The Expedition Leader ------------- has been on an extensive recce and traveled to the locations to check the route. **ARRIVAL – PORT MORESBY** Each member of the team shall be met at the airport by an EPM representative and either escorted directly to the hotel or a hotel car with a trusted driver who can speak English. Once the project equipment has arrived, the team and kit shall be accompanied by an EPM representative at all times. Security will be provided IF the crew end up driving the route between Lae and Aseki and we will have local security at all times in Aseki/Koke. **GETTING TO OUR BASE CAMP – ASEKI** The team are to make a base in the town of Aseki and from there travel to Koke village and gallery for project work (half-hour drive or 2-hour trek). There are 2 options for getting to the location: **1. A charter flight Port Moresby (or Lae) to Aseki** This is the preferred option because of the difficulties with the road. The flights are currently being researched. The company providing the flights will have to meet the criteria set by the BRIQ and the insurers over airworthiness. Please refer to point 15. There is a possibility of low cloud cover at Aseki which would prevent the pilot from being able to land. The advance team will already be at Aseki on the day the full team is due to arrive, so we will be in contact directly with the pilot about weather conditions. If the weather conditions are unfavorable at Aseki, the plane could land at Bulolo and then the team would need to drive the remaining route [see info below about drive]. **2. Scheduled flight Port Moresby to Lae, drive Lae to Aseki** The approximate journey time is a 45-minute flight plus a 7–12-hour car journey. The team would travel in 2 vehicles with a high wheel base clearance driven by an experienced known driver supplied by the hire company. The team would have onboard food and water provisions and stops would be taken along the way for rest and other food and refreshment. EPM will have communications equipment with them including local cell phones, satellite phones, and a Walkie-Talkie system. The drive can be broken down as follows: • Lae to Bulolo: Sealed road – 2 hours – GOOD ROAD • Bulolo to Angabena: Unsealed road – 3 hours – AVERAGE ROAD • Angabena to Tambia Point: Unsealed road – 2 hours – AVERAGE ROAD • Tambia Point to Aseki: Unsealed road – 1-hour drive or 3-hour trek – BAD ROAD Due to the recent weather conditions the roads have suffered and many are blocked by landslides or have collapsed from a build-up of water underneath. This is particularly a problem on the last stage of the journey between Tambia Point and Aseki.

		The vehicles will often have to stop and be pulled through deep gorges of mud or over semi-cleared landslides by bulldozers. If the road is impassable between Tambia Point and Aseki, the crew will have to hike the final stage of the journey (3–4 hours). The hike would be along a very muddy road and would be difficult going. Team will be pre-advised of risks if we have to take this route and porters will be employed to carry all kit and personal baggage. Therefore, not only can these journeys take considerable time and impede on the project schedule but there is a greater risk of fatigue for the team and concern over damage to the equipment from so much loading and unloading. **GETTING BETWEEN BASE CAMP (ASEKI), PROJECT VILLAGE (KOKE), AND THE KOKE MUMMY GALLERY** As mentioned above, the team shall have a base in Aseki and will undertake daily travel to the village of Koke. <u>Aseki to Koke</u> This is in part a good road, however due to the location of Koke the initial road is prone to landslides and road collapse. This is a considerable risk for the smooth running of the shoot. It is a 30-minute drive or a 2-hour trek between the two locations. EPM will dispatch a runner early each morning to check the road and implement repairs before the team departs. The team will travel in 4×4 ten-seater land cruiser with the experienced driver. If there is a problem with the road then EPM will advise the team of the options of access to the location on that day. It is possible to trek on foot. If this option is taken, all shall be advised of wearing the correct clothing and footwear. Food and refreshments shall be packed, and an experienced guide will take them along with the EPM representative and local security. The team shall be monitored for signs of fatigue. A nurse based in Aseki is on call throughout the project. As mentioned above, throughout the time in PNG, EPM will have full communications equipment with them. Porters will be employed to carry the heavy equipment. There is a possibility that the team may sometimes not be able to access Koke village or return to the base in Aseki from Koke – in this instance, a guest house with full provisions will be set up for the duration of the project schedule at Koke. <u>Travel between Koke village and Koke Mummy gallery</u> The team will need to trek from the village of Koke to the mummy site several times throughout the course of the project. It is a short, steep climb and there is a risk of tripping/falling. The EPM advice has recommended that a nurse is on site on project days at the mummy gallery and that better steps are cut into the slope. The site of the mummies is a narrow ledge overhung by a cliff face. Often water pours down onto the walking ledge and the bamboo walkway, making them wet and slippery. Bamboo support rails are built in some places. Further assessment of the safety requirements for working at this location will be made by the project director during the recce so that EPM can implement any required safety arrangement prior to the crew's arrival. **Risk is Medium (M)**

2	**Alcohol/food/drinks/supplies** In the remote areas of PNG, all food and refreshments are locally sourced. The water is not suitable for drinking.	All food and refreshments shall be supplied by EPM. Supplies shall be purchased in Lae and transported to the location. Other fresh food shall be purchased locally and prepared by local cooks. All water will be purified and tested so it is safe to drink by the team before it is handed out.
3	**Animals/insects/wild** Risk of malaria from mosquitos and an environment known to be inhabited by snakes.	The team have been asked to have the various vaccines recommended for this location. Further to this, the team are to take precautions against malaria. Therefore, the team are advised to wear appropriate clothing to protect them from bites etc. and they shall be provided with deet and other sprays to protect from insects. According to EPM, the only other wildlife to be wary of on the island are snakes. Normal precautions should be taken to zip up tents, avoid putting hands in holes, and to check shoes before putting them on. There is a full document attached about the most common snakes in PNG and the effect of a snake bite. We cannot buy anti-venoms in the UK, so EPM will investigate purchasing anti-venom directly from the hospital in Port Moresby on arrival. A full medical kit is with the team at all times. A nurse is on call at the project location and the EPM team have full communications system in the event of any serious event. **Risk is Low (L)**
11	**Fatigue/long hours/physical exertion** Due to the travel times to PNG from all the other countries that the team members are traveling in from, all of the team will be subject to jet lag. The internal travel may well be long and disrupted by the road and weather conditions. During the filming period, the team will have to travel along the troubled roads and trek with equipment.	For the jet lag, the schedule has been devised to give the team rest time. Project is not to start straight away and they shall be assisted in their passage through from entry to the country, arrival at the hotel, and with all subsequent travel. There will always be designated drivers and porters to assist with the kit. The team will look out for each other and are encouraged to say if they are feeling tired and need to rest. The schedule shall be set on a daily basis and take into account the actual weather and location conditions of the time, and therefore take into account the exertion of the previous working day/night before and going forwards. **Risk is Low (L)**
13	**First aid**	The team leaders are all experienced in working in remote locations. They will carry necessary items with them, including plenty of water, sun block, and insect repellant. Nurse A nurse has been appointed for the duration of the project. She is based in Aseki but will be able to travel with us to Koke if we require her to be on location for specific days. On the days when she is in Aseki, a runner can be dispatched to fetch her very quickly. Other EPM and the team leaders will have a first aid kit easily available at all locations. All team members have been instructed to ensure they have adequate supplies of any personal medication they require. The university has also ensured that all crew have the relevant vaccines. Hospitals/Medical Evacuation EPM and the team leaders will know all the nearest hospitals/doctors and medical evacuation procedures. These will also be written up in the daily sheet.

		EPM have already selected a location, 10 minutes' walk away from Koke, as the best location for the landing of an emergency helicopter, should it be required. If there is a medical emergency whilst we are in Aseki, there is an entire landing strip for the helicopter to land on. First Assist Medevac Pacific Services (MPS) will be our local service providers should we require emergency rescue. They have been provided with a full schedule, risk assessment, and contact details of all the team. Andrew Chin (Director of Operations) is our first point of contact and can be contacted 24 hours a day. Each emergency will be individually evaluated and the casualty will be evacuated to the most appropriate hospital. Hospitals in Port Moresby are able to provide basic medical treatment but in more serious cases, the patient will be taken to Cairns in Australia. MPS has access to a number of local aircraft (helicopters and fixed wing aircraft) and can coordinate medevacs as necessary. Evacuation times cannot be accurately calculated prior to the event as they will be dependent on the availability of aircraft, climatic conditions, and the time of day. However, an example evacuation time from Aseki to Port Moresby is 1 hour 20 minutes. For evacuations to Cairns add an additional 1 hour 30 minutes to the time quoted. **Risk is Low (L)**
15	**Flying (aircraft, balloons, parachutes)**	A charter flight is to be arranged from Port Moresby to Aseki. The flight is to be provided by Airlines PNG. It is a twin otter plane seating 19 people and able to take 1500kg weight. The details for the company and the pilot and all the relevant insurance documents have been checked and signed off by our insurers. The airstrip at Aseki is to be cleared of debris such as stones, and landing fires established to guide the planes in. This is being arranged by EPM.
16	**Freelance members and contributors to be advised of safety procedures**	Various members of the team are freelance. They are all highly experienced and trusted contractors and will be briefed of all activities taking place on the project beforehand and provided with all relevant paperwork and safety procedures in advance too. **Risk is Low (L)**
17	**General public/safety – crowds – arrangements for safety/spectators**	The team will be working in a remote area in a small village, where the team and equipment will attract a lot of curiosity and attention. The crew will be briefed by the location contact as to how to behave in the village. During work in crowded areas, a designated person will ensure that no one walks into the project activities and that they don't walk into anyone else. All equipment will be overseen so as not to create any trip hazards to members of the public. **Risk is Low (L)**
19	**Heat/cold/extreme weather**	The weather will be humid and in the high 20s °C during the day and cold at night. Torrential downpours are likely from 2pm each day. The team are aware of this and have been provided with a list of items to pack in advance of the project. The EPM will supply any additional kit required by the crew. EPM will ensure that there is always plenty of bottled water, sun cream, and umbrellas at hand. **Risk is Low (L)**

20	Hostile environments/political unrest/war/ mines/local crime/team communication/ ETAs	<u>This is an update from the Foreign Office website about Papua New Guinea:</u>
		Around 1,500 British nationals visit Papua New Guinea each year (Source: Papua New Guinea Tourism Office). Most visits are trouble-free. The main type of incident for which British nationals required consular assistance in Papua New Guinea in 2007 was for replacing lost and stolen passports.Law and order remains poor or very poor in many parts of the country; armed carjackings, assaults, robbery, shootings, and serious sexual offenses, including rape, are common. We advise you to be extra vigilant whilst traveling in all cities, particularly during the hours of darkness.Papua New Guinea sits along a volatile seismic strip called the 'Ring of Fire' in the Pacific. Volcanic eruptions, earthquakes, and tsunamis are possible. See the Natural Disasters section of this advice for more details. It is not confirmed if the following route will be used yet. However, from our research for the road between Lae Airport and Lae and in the town itself, there is a warning that this has in the past been a dangerous route due to the possibility of armed carjackings, particularly between the 1- and 10-mile settlement areas. EPM has advised that the frequency of carjackings along this route has fallen dramatically in the last couple of years since the road was tarmacked. Drivers are now able to drive at full speed along the road and they know never to stop along this road. Throughout the period that the team are in PNG, they shall be accompanied by security and an EPM representative at all times. The base camp and any other areas where the team's kit/belongings are kept shall also be guarded around the clock by local support. **Risk is Medium (M)**
26	**Night operations/camping/recces**	Our intention is to work a procedure at night. All team members involved in the night work will have a head torch. The other team will have head torches and LED lights where required to light the way. The student assistants will watch the trail to prevent any falls. Local contacts will brief the team about any potential risks involved in hunting at night. **Risk is Low (L)**
36	**Technical facilities**	The paleoimaging will be conducted with BRIQ equipment. The equipment will be tested to ensure it is in full working order before it departs the base camp. The equipment will be either looked after by the paleoimagers or by their assistants and made secure every night. The team shall also protect the kit from the environmental conditions. **Risk is Low (L)**
37	**Vehicles/motorcycles/speed**	The condition of the roads as mentioned above may well be difficult. No member of the team is to drive. All driving is to be done by experienced drivers employed by EMP. The vehicles hired will be hired due to their ability to manage the terrain and weather conditions. If it is deemed that it is not possible to drive to a location, the team shall take on board the advice from the drivers and EPM and continue the journey by foot or wait for assistance. **Risk is Medium (M)**

| 41 | **Working on roofs/cliff tops/mountains/ bridges** | The Mummy Gallery is a restricted location with a narrow space in front of the mummies and then a significant drop. The team will be briefed about the location prior to working and we will keep the team numbers to an absolute minimum during the work. Depending on weather conditions, EPM will work with the tribe to see if the ground surface can be dried or if any further handrails or supports are needed to protect the team. During work at the gallery, the nurse will be near to the team. **Risk is Low (L)** |
| 42 | **Other** Rushes safety | The data and media will be looked after every night to make sure that they are not damaged and all information needed to complete the study is acquired. They will also be looked after by the project director until the work is complete. They will then be taken care of by our BRIQ students, who will have them in their possession at all times. We will also inform all relevant embassies in all countries that we are working in of the countries that we are visiting and give them our dates of where we will be at all times. All emergency information will be on call-sheets. |

COMPLETED BY: (print) **POSITION: PROJECT MANAGER**

SIGNATURE: **DATE:16th May 2008**

PROJECT DIRECTOR: (print) **SIGNATURE:** **DATE:**

I am satisfied that the above constitutes a proper and adequate risk assessment in respect of this project:

HEALTH & SAFETY ADVISER (print) **SIGNATURE:** **DATE:**

I am satisfied that the above constitutes a proper and adequate risk assessment in respect of this production:

CONTINUATION SHEET FOR METHOD STATEMENT AND FIRE RISK ASSESSMENT (if appropriate):

Describe (written and/or visual) method statement of safe working practices to be used whilst on location. Include details of fire procedures and evacuation emergency plans.

Appendix H: Expedition Kit List—Papua New Guinea

Trousers—Lightweight full-length × 2

Shirt—Lightweight × 2

T-shirt/shorts—To relax/sleep in

Comfortable underwear—Lightweight, non-chafing

Fleece—Evening wear to stop the mosquitoes and may be cold in the evenings

Socks—Breathable wool × 3 (essential), lightweight liners × 2 (optional)

Boots—Suitable for jungle trekking

Sandals—Open, fixed strap—not flip-flops

Hat—With a brim

Bandana—Optional but makes a good sweat rag!

Small day sack—To carry water bottle, layers of clothes, snacks etc.

Light gloves—Optional

Sunglasses

Raincoat—Light jacket with hood

Light sleeping bag—One season lightweight *(for sleeping in village o/night)*

Silk liner—Cotton also acceptable *(for sleeping in village o/night)*

Therm-a-rest—Optional but recommended *(for sleeping in village o/night)*

Head torch

Travel towel

50% DEET—Insect repellent is essential, bring plenty!

Anti-malarials

Personal med kit—To include all your personal medication as well as a basic first aid set including paracetamol, rehydration sachets, Imodium, anti-histamines (good for calming rashes and bites), plasters, bandages, patches, water purification tablets (in case main supply fails), lip balm, sun cream, wet wipes, duct tape or zinc oxide, talcum powder (for feet), cold and flu tablets, energy tablets, matches/iodine tincture for leech removal and wound sterilization, bite/rash cream

(Project Director will supply this stuff also but if you want to bring your own supply, please do)

Project Kit Supply

Project Director will be carrying the above and extra items for the trip including –

Sat—phone—Limited calls/emergency use

Water purifying equipment

GPS

Comprehensive medical kit

Appendix I: Statement of Health

PLEASE COMPLETE IN BLOCK CAPITALS

RESPONSIBLE PARTY: Bioanthropology Research Institute Quinnipiac University	NAME IN FULL:
NATIONALITY:	ROLE:
PROJECT TITLE: PNG MUMMIY RESEARCH	No. OF DAYS/WEEKS ON PROJECT:

It is mandatory that you answer the following:

1. Birth Date _____ (D)/ _____ (M)/ _____ (Y) Age _____ Sex _____
2. Height _____ Weight _____
3. Have you to the best of your knowledge and belief, ever had or have reasons to know you had:

		YES	NO
A.	Convulsions, paralysis or stroke, fainting attacks, severe headaches or disease of the brain or nervous system ?	☐	☐
B.	High blood pressure, heart attack, pain in chest, angina pectoris, or any other disorder of the heart or blood vessels ?	☐	☐
C.	Tuberculosis, asthma, emphysema, persistent cough or any other disease or abnormality of the lungs or respiratory system ?	☐	☐
D.	Duodenal or gastric ulcer, colitis or any other disease or abnormality of the stomach, intestines, rectum, liver , pancreas, gall bladder, or hernia ?	☐	☐
E.	Sugar, albumin, blood or pus in urine, kidney stones, or any other disorder of the bladder, kidney or genito-urinary system?	☐	☐
F.	Diabetes, gout or any disease or abnormality of the thyroid or other glands?	☐	☐
G.	Any disease, disorder or injury of the bones, joints, muscles, back, spine or neck?	☐	☐
H.	In the past five years, cold sores on lips, or face?	☐	☐
I.	In the past year, any significant change in weight?	☐	☐
J.	Been treated for or had indication of excessive use of alcohol or drug ?	☐	☐
K.	Disorder of skin, lymph glands, cyst, tumour or cancer?	☐	☐

		YES	NO
L.	Disorder of eyes, ears, nose or throat?	☐	☐
M.	Allergies, anaemia or other disorder of the blood?	☐	☐
4.	Have you ever used LSD, Heroin, Cocaine or any other narcotic, depressant, stimulant or psychedelic whether prescribed or not prescribed by a doctor?	☐	☐
5.	During the last twenty-one days have you been exposed to any infection or contagious diseases?	☐	☐
6.	Have you consulted a doctor, been under a doctor's care, had surgical advice or treatment or been confined to a hospital during the past five years?	☐	☐
7.	Have you, within the past three years, been disabled as a result of any illness while working in any film or stage production?	☐	☐
8.	Are you now, or will you at any time during the period of this production, be taking part in any other film or stage production or other professional engagement?	☐	☐
9.	Are you now (or in the past 30 days) taking any medication or health treatments?	☐	☐
10.	Do you suffer from any phobias, or are you aware of any mental health problems that may prevent you from carrying out your scheduled production activities?	☐	☐
11.	Has any insurance company declined to insure you or imposed any special terms in regard to your acceptance for any Cast Insurance, Non-Appearance Insurance, or Accident, Health or Life Insurance?	☐	☐

12. FEMALES:
 A. Are you pregnant? YES _____ NO _____ If so, how many months? _____
 B. Have you ever had any disease of the breasts, uterus, tubes or ovaries? YES _____ NO _____ If yes, give full details _____

For "yes" answers, state details fully here, i.e. diagnosis, treatment, results, dates of disability, degree of recovery, name and address of attending doctor etc: _____

13) If under age 9, please advise what childhood diseases you have had, and attach a copy of your immunisation record _____

14) (A) When did you last receive a complete physical examination? _____

 (B) What were the results? _____

 (C) Name and address of doctor? _____

15) To the best of your knowledge and belief, are you now in good health and free from physical impairment or disease? YES _____ NO _____

 If 'no' give full details : _____

CONTINUED OVERLEAF

I declare and affirm that I am the person first named above; that the statements made hereon by me are true, correct and complete; that I have withheld no information known to me which might alter or otherwise conflict with the statements made by me. I understand that an insurance policy may be issued based on the statements made hereon by me. If a policy is issued and a claim is paid thereunder I understand that the insurer will seek recoupment from me if it is thereafter determined that the statements I made hereon are not true, correct and otherwise complete, or that I have withheld information known to me which might alter or otherwise conflict with the statements I have made, the insurer will hold me personally liable and will seek recoupment from me for such payment. I also agree to be re-examined by the insurer's doctors in the event a claim is made.

I authorise any doctor, licensed practitioner, hospital, clinic, other medical or medically related facility, insurance or reinsuring company having information available as to diagnosis, treatment and prognosis with respect to any physical or mental condition and/or treatment of me to give to XXXX Insurance Company of Europe or its legal representative, any and all such information.

I understand the information will be used by the Underwriting and Claims departments of XXXX Insurance Company of Europe for underwriting and claim settlement purposes.

I know that I may request a copy of this authorisation.
I agree that this authorisation shall be valid for a period of two years from the date on which it was signed.

_____ Date: _____ Name: _____
 SIGNATURE

_____ Address: _____
 WITNESS TO SIGNATURE

N.B. FAILURE TO FULLY COMPLETE THIS FORM, INCLUDING SIGNATURE AND WITNESS SECTIONS, COULD CAUSE DELAY IN APPROVAL THEREOF

FOR INSURANCE COMPANY USE ONLY

_____ Accepted

_____ Accepted for accident only

_____ Rejected

_____ Accepted subject to the following:

RESTRICTIONS: _____

Appendix J: Radiation Protection Examples from the Oxford Project (see Chapter 9 Section 8)

Appendix J.1 Risk Assessment and Dose Calculation for Oxford Project*

Description of Work with Radiation

A portable diagnostic X-ray unit (Sedecal SP 4.0) with a Canon digital imaging receptor will be used. For all imaging the primary beam will be directed towards the floor and so only scattered radiation needs to be taken into account.

The typical exposure factors are:

kV	50 kV
mAs	1.5 mAs
Source to image distance (SID)	100 cm
Field size at SID	15 cm × 15 cm (maximum)
No. of exposures per day	200

The meeting room is approximately 4.6 m by 4.2 m in size and has only one entrance.

Dose Estimates

Using the exposure factors and measured output data from the Sedecal system, workload in terms of dose area product (DAP) would be 1.6 Gycm2 per day. The scattered radiation dose can be calculated from the dose area product (BIR, 2000).

Scattered radiation dose per day (200 exposures) at 1 m from X-ray tube/object: 7 µSv.

The scattered radiation dose can be reduced by use of distance and shielding as seen in the following table:

	Dose per day	No. of days to reach 0.3 mSv
2 m	1.7	180
1 m plus 100 mm brick wall	0.007	>365
1 m plus 3 mm plate glass	3.5	86
2 m plus 3 mm plate glass	0.9	330
2 m plus 25 mm gypsum plasterboard	0.35	>365
2 m plus 0.35 mm lead apron	0.025	>365

From this table it can be seen that even if X-ray work of the workload specified above were to be carried out one day per week (52 days per year), use of 2 m distance alone provides adequate protection for 100% occupancy in all adjacent areas. The scattered dose from one day of the imaging workload is less than the average daily natural radiation dose.

Dose Comparisons

1 mSv = 1000 µSv

Average daily natural radiation dose in UK	6 µSv
Return flight UK to Spain (cosmic radiation)	20 µSv
Chest X-ray	20 µSv
Annual dose limit for member of the public from work with ionizing radiation	100 µSv
Return flight London to New York	1 mSv
Average annual natural radiation dose in UK	2.2 mSv
Annual dose limit for employee from work with ionizing radiation	20 mSv

The risk associated with radiation exposure is the risk of a radiation-induced cancer of 1 in 20,000 per mSv. The baseline lifetime risk of cancer in the UK is 1 in 3.

Summary

Use of 2 m distance from the X-ray tube/object being X-rayed will provide adequate protection for the planned work. There must be suitable barriers or controls in place to prevent access to the controlled area. A site risk assessment has been carried out and Local Rules drafted.

* Reproduced with kind permission of Reveal Imaging Limited, UK, and Professor Julie Horrocks, Department of Clinical Physics, Barts Health NHS Trust, London, UK.

Appendix J.2 Local Radiation Rules for Oxford Project*

LOCAL RULES

Ionizing Radiations Regulations 2017

1. **INTRODUCTION**

 These Local Rules are issued under the United Kingdom Ionizing Radiations Regulations 2017 and are the means of complying with these Regulations for staff working with the Reveal Imaging portable X-ray imaging equipment. The Local Rules must be brought to the attention of all staff working on the project.

2. **RESPONSIBLE EMPLOYER**

 The Responsible Employer is responsible for ensuring compliance with these Local Rules.

 > The Responsible Employer for this work is: Reveal Imaging Limited

3. **RADIATION PROTECTION SUPERVISOR (RPS)**

 The Radiation Protection Supervisor(s) must supervise the work to ensure it is being carried out in accordance with these Local Rules.

 > The Radiation Protection Supervisor(s) for this work are: Mark Viner, Wayne Hoban

4. **RADIATION PROTECTION ADVISER (RPA)**

 > The Radiation Protection Adviser is: Prof Julie Horrocks, Barts Health NHS Trust

5. **DESIGNATION OF STAFF AND PERSONAL MONITORING**

 All staff working with the portable imaging equipment are regarded as **non-classified**.

* Reproduced with kind permission of Reveal Imaging Limited, UK, and Professor Julie Horrocks.

All radiographers working in the area should wear the personal dosimeters issued. Badges for monitoring whole body dose must be worn beneath any lead protection. The monitoring period is 3 months.

The dose investigation level is set at 0.5 mSv over each 3 month period.

6. **DESIGNATION OF CONTROLLED AREAS**
 - A diagram of the controlled area for this site is shown in Appendix 1.
 - The controlled area exists when the system is connected to the mains power supply.
 - The controlled area extends to 3 m in all directions from the X-ray tube, or to any closer barrier identified in the individual site risk assessment as providing adequate shielding e.g. a solid brick or concrete wall.
 - The controlled area is under the control of Reveal Imaging Limited.

Access to controlled areas must be under written systems of work

7. **SYSTEMS OF WORK—ACCESS TO CONTROLLED AREAS**

 Access to the Controlled area is allowed as follows:
 - Under the supervision of the RPS/Radiographer in charge.
 - Only as necessary to position items for imaging.
 - No one may enter the controlled area when the beam is on, with the following exception:
 - Where the radiography is being carried out in a room where the distance to adequately shielded barriers is less than 3 m and the radiographer needs to remain in the room to take the exposure. The radiographer must wear a 0.35 mm lead apron and stand at least 2 m from X-ray tube.
 - All persons must follow the working procedures given in these Local Rules.
 - X-ray service engineers, radiation physicists must operate the X-ray equipment in accordance with service or maintenance instructions and any Local Rules prepared by their company.

8. WORKING PROCEDURES

- The portable X-ray unit must be isolated from the mains supply and the key removed when left unattended.
- Only Radiographers who have been approved by Reveal Imaging Limited shall operate the equipment (refer to Section 9).
- The Radiographer should ensure that a controlled area warning sign is clearly displayed on the door leading into the room, or on any barriers used to control access, when the X-ray equipment is connected to the mains power.
- The X-ray unit should be positioned so that there is a distance of at least 3 m between the X-ray unit and any barrier that does not provide adequate shielding.
- Any doors to the room must be locked during X-ray exposure, if access through them cannot be directly controlled.
- The radiographer should normally stand outside the Controlled Area when exposures are being made and in a position to control access to the controlled area. A lead apron is not required, with the following exception.
 - Where the radiography is being carried out in a room where the distance to adequately shielded barriers is less than 3 m and the radiographer needs to remain in the controlled area to take the exposure. The radiographer must wear a 0.35 mm lead apron and stand at least 2 m from X-ray tube.
- The radiation beam size should be kept to a minimum and procedures followed to keep the dose ALARP.
- No horizontal beam radiography is to take place.
- The radiography log for each exposure should be fully and accurately completed.
- Protective aprons should be stored appropriately in order to prevent damage and periodically inspected to examine for any visual damage.
- Any suspected overexposure or equipment malfunction should be reported to the RPS.
- Consideration must always be given to infection control and the health and safety of the operators.

9. CONTINGENCY PLAN: Equipment Fault Resulting in Continuous Irradiation

If the radiographer suspects a fault in the equipment that could lead to overexposure, the equipment must be disconnected from the mains supply immediately. A notice should be fixed to the equipment declaring that it must not be used until further notice. The consultant radiographer will inform the RPA.

Following inspection by the service engineer, a handover form should be completed to confirm that the equipment is safe to be used.

10. TRAINING OF OPERATORS

- Only Radiographers who are approved in writing by Reveal Imaging Limited shall operate the equipment.
- Approved radiographers will receive induction training on the operation of the unit and a minimum of 7 hours' supervised operation. Assessment of competence will be carried out prior to approval by Reveal Imaging Limited.
- All radiographers shall be required to undertake update training on the unit every two years.
- Radiographers may not operate the unit unsupervised unless they have completed Radiation Protection Supervisors (RPS) training as approved by the RPA.
- Update RPS training will be undertaken every 3 years.
- Records of training will be maintained by Reveal Imaging Limited.

Prior to receiving training on the use of this unit, radiographers will have achieved the following level of basic training:

- Diploma or Degree in Diagnostic Radiography leading to eligibility for Registration with the Health Care Professions Council or equivalent body in their country or state of origin.
- Current HCPC registration or equivalent body in their country or state of origin.
- Postgraduate training or sufficient equivalent experience in archaeological or forensic radiography.
- Evidence of current CPD activities sufficient to maintain level of competencies in Forensic and Archaeological Imaging.

DESIGNATED X-RAY ROOM

The downstairs meeting room has been designated as a Controlled Area. On the room plan below, the extent of the controlled area is indicated by a thick dark line.

*Reproduced with kind permission of Reveal Imaging Limited, UK, and Professor Julie Horrocks

Index